GW01090633

STUDIES

Volume 11 Number 1 January 1997

EDITORIAL STATEMENT

In the ten years since this journal was founded, the field of cultural studies has expanded and flourished. It has at once become broader and more focused, facing as it does the challenges of global economic, cultural and political reconfiguration on the one hand, and of new attacks on the university and intellectual work on the other. As we look forward to the next decade, we expect *Cultural Studies* to continue to contribute to both the expansion and the integration of cultural studies.

With this expectation in mind, the journal seeks work that explores the relation between everyday life, cultural practices, and material, economic, political, geographical and historical contexts; that understands cultural studies as an analytic of social change; that addresses a widening range of topic areas, including post- and neo-colonial relations, the politics of popular culture, issues in nationality, transnationality and globalization, the performance of gendered, sexual and queer identities, and the organization of power around differences in race, class, ethnicity, etc.; that reflects on the changing status of cultural studies; and that pursues the theoretical implications and underpinnings of practical inquiry and critique.

Cultural Studies welcomes work from a variety of theoretical, political and disciplinary perspectives. It assumes that the knowledge formations that make up cultural studies are as historically and geographically contingent as any other cultural practice or configuration and that the work produced within or at its permeable boundaries will therefore be diverse. We hope not only to represent this diversity but to enhance it.

We want to encourage significant intellectual and political experimentation, intervention and dialogue. Some issues will focus on special topics, often not traditionally associated with cultural studies. Occasionally, we will make space to present a body of work representing a specific national, ethnic or disciplinary tradition. Whenever possible, we intend to represent the truly international nature of contemporary work, without ignoring the significant differences that are the result of speaking from and to specific contexts, but we also hope to avoid defining any context as normative. We invite articles, reviews, critiques, photographs and other forms of 'artistic' production, and suggestions for special issues. And we invite readers to comment on the strengths and weaknesses, not only of the project and progress of cultural studies, but of the project and progress of *Cultural Studies* as well.

Lawrence Grossberg
Della Pollock

Contributions should be sent to Professors Lawrence Grossberg and Della Pollock, Dept. of Communication Studies, CB #3285, 113 Bingham Hall, The University of North Carolina at Chapel Hill, Chapel Hill, NC 27599-3285, USA. They should be in triplicate and should conform to the reference system set out in the Notes for Contributors. An abstract of up to 300 words (including 6 keywords) should be included for purposes of review. Submissions undergo blind peer review. Therefore, the author's name, address and e-mail should appear *only* on a detachable cover page and not anywhere else on the manuscript. Every effort will be made to complete the review process within six months of submission. A disk version of the manuscript must be provided in the appropriate software format upon acceptance for publication.

Reviews, and books for review, should be sent to Tim O'Sullivan, School of Arts, de Montfort University, The Gateway, Leicester LE1 9BH; or to John Frow, Dept. of English, University of Queensland, St Lucia, Queensland 4072, Australia; or to Jennifer Daryl Slack, Dept. of Humanities, Michigan Technological University, Houghton, MI 49931, USA.

CONTENTS

GILLIAN ROSE

SPATIALITIES OF 'COMMUNITY', POWER AND CHANGE: THE IMAGINED GEOGRAPHIES OF COMMUNITY ARTS PROJECTS

ABSTRACT

This article draws on current discussions about the discursive construction of space. Different organizations of space are produced in part by different discourses about social identity, as Stuart Hall, for example, has recently been arguing. This suggests that to change oppressive definitions of identity it is also necessary to rethink the spatialities which give both material and symbolic structure to those definitions. This article explores the politics of one particular spatialization of identity in the discourse of one group of cultural workers. This is the identity of those with whom the workers work – people living in the peripheral housing estates of the Scottish city of Edinburgh – which the workers spatialize through their complex use of the term 'community'. Drawing on in-depth interviews with community arts workers in the city, I argue that they radicalize the notion of 'community' by placing it in a geography of lack, and that in so doing they articulate both the costs of marginalization and fragile, non-essentializing possibilities for change.

KEYWORDS

community, spatiality, identity, community arts, Edinburgh

Introduction

Rosalyn Deutsche (1995: 169) has recently described 'the newly popular field of spatial-cultural discourse' as a convergence between arguments being made in cultural studies about the importance of the spatial to cultural politics, and the way many geographers are now theorizing spaces,

places and landscapes as culturally constructed and contested (see, for example, the contributors to Bird et al., 1993; Carter et al., 1993; Colomina, 1992; Keith and Pile, 1993; Pile and Thrift, 1995). This convergence is clearly signalled by Stuart Hall writing a chapter in (what it is now increasingly inappropriate to label as) a geography textbook. There, he comments that 'place, in short, is one of the key discourses in the systems of meaning we call culture' (Hall, 1995: 181). Certain forms of cultural identity, he argues, are imagined through a profound sense of belonging to a bounded and stable place. Elsewhere, he has argued that other understandings of identity depend more on notions of global mobility and connection (Hall, 1990). Like many of those working in this field, Hall understands the difference between these geographies of identity in terms of a cultural politics, in this instance of 'race'. Racist discourses construct racialized identities in part by erecting supposedly impermeable barriers which depend on an essentialist understanding of difference. One way of challenging that spatialized essentialism of Same and Other has been to imagine a fluid diaspora of hybridizing cultural translations (Hall, 1990; Gilroy, 1993; Mercer, 1994). Doreen Massey, in a parallel argument, has commented that reworking the politics of gender also means reimagining their geographies: 'challenging certain of the ways in which space and place are conceptualized implies also, indeed necessitates, challenging the currently dominant form of gender definitions and gender relations' (Massey, 1994: 2; see also Deutsche, 1991). The assertion that 'the spatial and the sexual constitute one another' is also being elaborated (Bell and Valentine, 1995: 2).

This field of work is diverse. What I want to draw from it is the argument that particular spatialities are produced by particular discourses of 'race', gender, sexuality and nation (and, by extension, class (Riley, 1988), ablebodiedness, and so on). Spatialities articulate the particular structures of those axes of identity by giving them a spatial form. These forms are also articulations of power: discourse engenders 'a spatial order [which] organizes an ensemble of possibilities . . . and interdictions' (de Certeau, 1984: 98). And because different articulations of identity exist, intersect and conflict, 'simultaneously present in any landscape are multiple enunciations of distinct forms of space' (Keith and Pile, 1993: 6). It is through such complex discursive ensembles that spaces, places and landscapes become meaningful in the context of power-ridden social relations, and why dominant forms of spatiality can be contested.

The politics of one spatial organization of identity have been discussed at some length recently: those of 'community'. 'Community' has been analysed by several of the contributors to the 'spatial-cultural discourse' as a regressive understanding of place. According to them, 'community' provides a structure for senses of identity which desire to be stable and harmonious, uniform within and hostile to what is positioned as without (Carter et al., 1993). Hall (1995: 181), for example, uses Anderson's (1983) description of nationalism as an 'imagined community' to define that version of nationalism which 'establishes symbolic boundaries around a culture, marking off those who belong from those who do not'. Similarly, Massey (1994: 121–2)

has criticized certain self-styled 'communities' for the 'seamless coherence and timeless-ness' with which their local boundaries are authenticated and essentialized in order to exclude those designated as outsiders. Both Hall and Massey see such bounded, exclusionary forms of 'community' as an 'expensive and sometimes violent and dangerous illusion' (Hall, 1995: 186). In opposition to such illusions, they posit a different understanding of place – one in which places are not spatially bounded but are the product of interactions with other places – and 'community' disappears from their discussion. Other writers, however, are more reluctant to abandon the term 'community', perhaps because, as Williams (1976: 66) pointed out, no other term of social organization carries such positive connotations of collective solidarity. For them, the task is to elaborate subversive concepts of community: a notion of 'community' 'envisaged as a project' and 'interstitial' between difference, for example (Bhabha, 1994: 3). Mercer (1994: 10) also continues to use the term as a description for a political collective, but redefines it as a dynamic process of diasporic 'communifying' dependent neither on essential identity nor authentic timelessness.

Diasporic understandings of 'community' pose a major challenge to the attempts at stability inherent in dominant imagined communities. In this article, however, I want to explore another attempt to rethink the geographies of 'community' in a radical way. During the first half of 1995, I conducted nineteen in-depth interviews with practitioners from a variety of community arts projects in the Scottish city of Edinburgh. These were tape-recorded and transcribed, and interpreted using a form of discourse analysis. My interpretation of the spatialities through which they map notions of 'community' suggests other ways of subverting essentialized understandings of the term. This article focuses on this reimagining of 'community'; I have explored its implications for the practices of these arts workers elsewhere (Rose, forthcoming), and only briefly comment on them here.

The 'community' of community arts

The notion of 'community' is obviously central to the community arts movement (Binns, 1991; Braden, 1978; Hawkins, 1993; Nigg and Wade, 1980; Rose, 1994). The community arts movement began in the late 1960s in Europe, North America and Australasia. Its diverse practices all depend on a critique of the mass media and high arts as reproducing only ruling-class ideologies by assuming a consensual set of values, and that outside this centre are other groups with different values who are excluded from the means of public self-expression. Community arts practitioners address themselves to such marginalized groups, using arts practices of all kinds to give them the skills and opportunities to articulate their worldview. They describe those groups as 'communities' (Berrigan, 1977; Community Development Foundation, 1992). 'Community' in this discourse means a group of people with shared values, the basis of which, it is now argued, could be place or identity. Much of the funding for community arts in Edinburgh depends on a place-based understanding of identity, however; almost

all the largest community arts projects in the city are funded by the Urban Aid programme of the Scottish Office, which only supports work in areas defined by the Scottish Office as 'multiply deprived'. So nearly all the workers I spoke to were in projects with place-based remits, and nearly all were located in Edinburgh's peripheral housing estates.

Whichever definition of 'community' used in the discourse of community arts – place- or identity-based – deployment of the term 'community' in this discourse produces a boundary which distinguishes between members and non-members of a 'community'. A recent study, for example, suggests that one role of the arts in relation to 'communities of interest' is the development of 'communication with an insight into an *outside* world' (Clinton, 1993: 21, my emphasis). Community arts workers in Edinburgh persistently describe people, processes and institutions as either in a particular community or outwith it, regardless of whether they are working with a 'community' of interest or in a spatially delimited 'community'. 'Community' in this context produces a sense of insiders and outsiders, and this means that 'communities' are discursively imagined as bounded entities.

However, I want to argue that this language of inside and outside 'community' does not necessarily depend on an essentializing definition of 'community' identity. The following sections attempt to specify the spatialities through which community arts workers in Edinburgh understand 'community'. I want to argue that they work with two rather different interpretations of 'community', each of which is structured by a different kind of space but performs a similar kind of critical anti-essentializing. The conclusion explores in more detail some of the implications of this doubled discursive construction for thinking about the politics of 'community'.

The spatiality of power

It has been suggested that community arts projects in Scotland have retained more of the radical edge which characterized the early community arts movement than have projects in England (Brinson, 1992). Certainly, community arts workers in Edinburgh have an elaborate understanding of power. Power is oppressive, it is located in a large number of institutions (whether named specifically or generically), and it is exercised through a wide range of processes. This is thus an understanding of power as instrumental, and a recurring theme in their discussions of power is the way the shape of the city of Edinburgh has been moulded by it. For example, a youth video worker described Edinburgh's postwar rehousing schemes as follows:

> The way a lot of these places were created where folk were shifted out so that people from Newhaven and Leith were shifted out to Pilton, um . . . or people from the Southside were shifted out to Craigmillar.

Power is understood as acting upon less powerful people, moving them out from central areas to new housing estates on the outskirts of the city, in Pilton, Craigmillar, Muirhouse or Wester Hailes. Power is thus seen as producing a particular urban geography, and, in the analysis of community arts

workers, its spatiality has several dimensions. My discussion will begin with these because one of the community arts workers' interpretations of 'community' is placed in this particular power-produced space.

The first dimension of the spatiality of power is a zonality. Powerful institutions are understood as producing a territory divided into a centre and a margin. Several workers commented on the marginalization of working-class people in the city, describing the modelling of Edinburgh's built environment as an act of socio-spatial segregation. The youth video worker, for example, described the District Council's postwar rehousing schemes further: 'having moved all the poor people out they were then in a position to start making [the city centre] nice for rich people to live in and er that's very much what happened.' This territorialization occurs because power is understood as dividing the social into the acceptable and the unacceptable. One community arts practitioner in a project working with people with disabilities described British society as structured by 'the culture of the, the one is more important than the other, and I think that, that we should start looking at how this society functions, it *is* either one or the other'. This analysis of the social as divided then enabled him to locate the people he worked with as marginalized; he commented that 'the context in which [they] live . . . is mostly isolated, and outwith mainstream society, whatever that means'. All workers, whether they work in places defined by their location or with people defined by their 'interest', positioned those they work with as marginal to Edinburgh's centre of power. Community arts workers also comment on the way the arts and mass media are located in what one described as this segregated 'cultural terrain'. An arts worker in Pilton argued that:

> there's been a sort of hijacking that's gone on, [art]'s been hijacked by the middle classes sort of about the, I don't know when, but probably about the 1920s or something like that, let's just say, and y'know people see it as a preserve of the middle classes . . . people thought 'art', that's where the posh folk, it's not for the likes of us', well I don't agree with that, and I think there's been fault on both, and I say both sides, say middle class, working class, it's been fault on both sides, and there's been terrible assumptions made by both camps and I don't hold with those assumptions.

The social then is divided into two: into two camps or two sides, a core and an edge, by power, and resources are then allocated accordingly.

> Council's saying 'oh well we'll shift money round from community art to disability art', and then ultimately it will be shifted from disability art back to community art, and that's kinda, that's how the money's shifted, it's around those edges. Scottish Chamber Orchestra gets more money, Scottish Opera gets more money, Scottish National Orchestra gets a standstill, but it has already a lot of money, so it's kinda like, y'know – they actually y'know, just tinkering around the edges, not looking at the core of the activity.

The core's resources are never questioned, while those on the edge suffer. This spatiality, produced by power's definition of social difference, means that when community arts practitioners who work in Edinburgh's housing estates describe those estates as 'outer' or 'peripheral', they are referring not only to their location on the edge of a conventional map of Edinburgh, but also to their location on the margins of Edinburgh's geography of power; this is a location which they see as both materially and culturally constituted.

The spatiality that power produces is also understood as hierarchical. Community arts workers describe the locations of power as 'high' and the places marginalized by power as 'low', and this is a hierarchy produced by the actions of power. Power acts from above. If threatened, commented the worker with people with disabilities, 'large organizations will start pulling strings', like puppeteers up above the social stage. The powerful are described as coming down when they leave the city centre and enter the margins, so that a Craigmillar arts worker told me about 'one thing that the Arts Council were saying to us when they were down' there. Again, dominant arts forms are located in this spatiality. Here is the arts worker in Pilton describing Edinburgh's theatre venues in these terms: 'I mean we've got certain companies coming down here, but they're sort of touring theatre companies that go into communities a lot of the time, who don't do the, deliver their stuff up there', in the city centre. The spatiality of power is thus both zonal and hierarchical; power produces its margins as low and peripheral in a three-dimensional spatiality.

The final dimension of the spatiality which community arts workers understand as made by power is that of scale. To these workers, the institutions of power are big. Professional arts companies are large – 'I mean big professionals often work, often work with a community, like Scottish Opera were always down here' – and they get large amounts of funding – 'there was a wee bit of controversy at the time, mainly started by me, about the big funding opera gets and how the community doesn't get enough'. Power *per se* can be huge. An arts development worker with a project involved with people affected or infected by HIV/AIDS placed the practice of community work in general in a spatiality of large (and high) power structures; she then asked about social change:

> Is that what community development work is about, and how much of that is possible within the wider structures of society? Do you just work and tinker away at the small things, when really the big structures are huge and up there, but then, y'know, if you're a community worker that's what you do, you go, you should go in to the work knowing that's what, y'know, that's what your parameters are.

To be marginalized is to have parameters binding your actions; it is to be constrained. A tape-slide worker said how recent funding cutbacks have 'cramped our style really', and that 'things have been tightening'. And the largeness of power makes the marginalized feel small. As other community arts workers said, 'we're only small fry', 'a little fish'. The spatiality of

power, then, feels to community arts workers as if it limits and reduces the actions of the marginalized.

Community arts workers in Edinburgh therefore see power as instrumental and as producing a simply structured spatiality, which makes the central part of the city huge and bulging and the margins of the city small and squashed down. This distended spatiality is understood as constantly reproduced by the actions of power. It is thus analysed as a space constantly in process, 'a play of economic and technical forces that no politics today subjects to any end other than that of its own expansion' (Nancy, 1991: xxxvii).

The space of the marginalized 'community'

Community arts workers in Edinburgh place the 'communities' with which they work within this spatiality of power; and when they locate a 'community' in this spatiality, they are able to describe the profound costs of such marginalization. This description has a discursive effect which could be interpreted as the invocation of 'community' as a general, coherent and inclusive category; as an essentialized category which evades some tricky questions about possible contests and coalitions between different 'communities'. However, I want to question that interpretation and to suggest that the naming of a 'community' as marginal in this spatiality of power can be a radical tactic too.

One of the ways in which community arts workers most commonly use the term 'community', then, is to position those marginalized by the actions of power. A 'community' is often evoked in contrast to one of those actions. The Craigmillar arts worker, for example, used the term 'community' in opposition to the economic geography of the District Council and the International Festival:

> I think we need to look at [Edinburgh District Council] as well, and say that their funding to the Edinburgh International Festival and so on is big, and maybe, maybe they could look at that. Of course the reasons they'll come up with is that y'know Edinburgh needs the money that tourism through the Festival bring in, and that's beneficial, but I wonder about it, I mean the council, where does the council get its finance from. Surely then maybe it should be a much more local focus of the council, I mean if the council's there to serve the community, and that's there, that is what it's there to do. I don't know what, I don't know maybe they are bringing in money from tourism, where does, how does that, who does that benefit, y'know? Obviously hotels and businesses, but it's difficult to see where it trickles down to the ordinary pensioner.

His analysis of the power of the District Council and the International Festival (envisaged as big and high) provides a way of understanding the position of 'the community' marginalized by that power. It places 'community' as not-power, as disempowered. This positioning encourages community arts workers to describe this 'community' in general terms, echoing in their

critique the binary spatiality of power: the margin is the 'community'.

Although this makes for some very generalized comments about the 'community', I would argue that it is not essentialist, for (at least) two reasons. First, to counterpose a 'community' to power in this way depends on a relational and constructed understanding of difference, not an essentialist one. The marginalized 'community' is nameable as such only because power has made it, not because of its inherent qualities. Second, the 'community' so named is not essentialized because the qualities which are given to it in the community arts workers' discourse are – none. Far from having an essence, these marginalized 'communities' are described through a discourse of lack. Their qualities are absent ones.

Most often, the margins that power creates are described as lacking money. As another arts centre worker remarked, 'poverty is the main issue for a lot of folk in Wester Hailes'. In the discourse of community arts workers, these 'communities' have little or no money, few jobs, few skills, few resources, no provision, little choice. The youth video worker continued his history of Edinburgh's postwar rehousing schemes as follows:

> you got this ridiculous situation, y'know rural housing estates with high rise flats, y'know people were forced to live in a very sort of tight area and no way kind of way of making sure they wanted to be there together or there was enough attraction to be there apart from the fact that they were poor and they were shoved out there. I mean you combine with the fact that these jobs aren't, y'know, aren't, y'know there's not much money floating about, so they're not close to industrial areas often, they're not, y'know retails, there's no work, so – what is there? There's nothing in fact.

Other workers also commented that to be marginalized was to live 'in a vacuum', to live where 'there's nothing':

> when people have got nothing in their lives except for how to get through that day, through the boredom and the desperation and the worry and the lack of worth, and the lack of activity or because, y'know, they've got no money or whatever.

But most important to almost all the community arts workers I interviewed is the lack of self-confidence of those living in such marginalized communities. In particular, to be marginalized is understood as the absence of the self-esteem necessary for speech. The HIV/AIDS project worker said she believed that people considering her project often thought:

> why should anyone want to hear about what I've got to say, or even, not even in a wider sense, but y'know, it's a lot about people not really valuing their experience, their life experience, and not thinking they've got anything important to say.

Placing a 'community' in the spatiality of power thus allows community arts workers to articulate the cost of such positioning: to be produced by power as lacking is to be so deprived as to have nothing, so devalued as to be silenced, so marginalized as to be nothing.

This particular mapping of 'community' occurs in the spaces of power's margins. 'Community' in this case is marginalized, constrained and bounded; the Craigmillar video worker said, 'it's such a price on the bus to go into town [*laughs*] you only end up stuck here all the time y'know, you end up stuck in Craigmillar. Sometimes we go "we never get out of this place" [*laughs*]'. But this boundary surrounds a place where the articulation of identity in the form of confident self-expression seems to be almost impossible. It marks something missing; it denotes a space in which identity is collective only through shared lack, a 'community' at once pressingly there yet strangely absent. For community arts workers, this is neither a bounded 'community' of authentic and oppositional essential identity; nor is it an empowering communifying. But its deployment does carry a critical edge. Its location in the spatiality of power allows community arts workers to use the term 'community' as a form of critique, as a way of naming that which is disempowered, as a way of arguing that these 'communities' lack what they should have; yet this is a name which refers only to absences. This 'community' of lack cannot therefore give form to an essence.

Although this discourse of 'community' may lead to a generalized rhetoric about 'community' which does not address issues about differences within itself, I would argue that its valuable radical effect is its refusal to essentialize difference. This refusal at least leaves open the possibility of alliances both within and between identities and communities, and the next section explores this question of alliance more fully.

The space of an other 'community'

Some community arts workers advocate a politics of resistance which aims to reverse the zonal, hierarchical and scalar polarities of power. However, this is understood as an extraordinarily difficult project. The Pilton arts worker acknowledges this:

> but you see for a woman who's living in relative poverty down here, and really should, five children, and y'know she's in her mid-forties and I mean you just can't step up, even if you're a brilliant writer, you cannot make that transition on your own, just to step up from the depths of West Pilton up into what is, really is in reality, is a sort of middle-class enclave. Although I mean it's not to say that all writers are middle class or anything, but the structure of the sort of – facilities y'know, that which enables somebody to get to the next stage, cos you can't just suddenly publish and everyone buys it, there are all these things in the middle, in between, it's even down to things like bus fares and stuff like that, but confidence and all that.

This is, after all, a space understood by community arts workers as produced by power going out from the centre, coming down from the centre, expanding out from the centre, speaking from the centre. Its processes and pronouncements have a direction of flow, and that, according to community arts workers, makes moving into the centre very difficult. Yet

community arts workers in Edinburgh insist that this situation can be changed. It is possible for the marginalized to speak, organize and struggle. The Old Town arts centre worker described the process succinctly: people from a 'community' get involved in a community arts project and then:

> you want to see, yeah and you do see, you do see different people developing in different ways out of that and then it gives people a general sort of sense of satisfaction that they've achieved something and that y'know leads on to them doing other things.

It is in the context of such claims about empowerment – 'the trendy word', as one arts practitioner put it – that an other kind of 'community' is described by community arts workers. They assume that an other 'community' not structured by marginalization does exist, and they do not map it in the spatiality they see as created by powerful institutions. This is a 'community' of connections and alliances, and it produces a different spatiality. Once again, this is a spatiality that does not give form to an essence of 'community'; it too has its absences and gaps. But this time it structures a 'community' which can speak and act.

This other 'community' is imagined as a body politic of positive affect. It is creative and full of energy: as the tape-slide worker said, 'everybody, d'y' know, everybody can be creative, and like kind of accessing that creative kind of core in everybody is like, is, erm, is – releases lots of like kind of valuable energy'. This other 'community' is a place of 'mutual support and interaction', inhabited by people with 'spirit' who can be 'dead keen' to get involved in community arts projects. This sense of 'a kinda active community' is often talked about as a natural state. Here is a Muirhouse worker:

> down here, there's much, it sort of seems to be much more organic sort of, like maybe it's sprung up, like y'know. It's like a group always springs up here and there.

This other 'community' is thus described as full of life, active and growing naturally. Other imagery naturalizing an aspect of 'community' was used by the Craigmillar video worker when he argued that getting involved in community activity:

> keeps your strength up and you can resist these things. It's like the body resisting germs, y'know, you keep fit and you resist germs generally, I mean, I mean things go wrong sometimes but it does make a big difference that way. I mean it lifts, it lifts the whole community.

The body politic of the other 'community' is thus understood as a kind of organism. But this discursive analogy does not work to naturalize a timeless 'community' of unchanging and pure identity: just the opposite. What is naturalized in this discourse is an other 'community' of unstable flux (cf. Nancy, 1991: 75–6).

The energy and growth of this other 'community' is almost always understood as articulating itself through connections between people. The

Muirhouse worker described what he thought was the best pantomime of the project he had facilitated:

> at the end of it, like everybody up on their feet and leaping about, it was just, really getting off on it like, really working and that got people involved in other things and from seeing that . . . a sort of snowball effect.

The production was full of the energy of this other 'community', and this was good because it 'snowballed' other people into participating in other things. It is this process of participation in projects and groups that is seen by community arts workers as being the other 'community'. For example, the Wester Hailes worker remarked that 'Wester Hailes is – had a focus formerly called the Festival Association', his effort to describe the nature of Wester Hailes leading him to describe its umbrella community organization; and when I asked the Craigmillar arts worker if he thought Craigmillar was a 'community', he answered by commenting on its 'united organizations'. Groups give structure to this other 'community', by getting individuals involved. The youth video worker said:

> I think any mechanism that brings people together, y'know even if it's a local café or – I mean, er, or a community arts project or mothers and toddler groups, or anything that brings people together and erm helps to develop relationships is gonna be a great thing. So – um, I don't, I don't – I mean that's, that's the only – I mean if you do, if you do bring people together and break down barriers that exist between them then you can think of events or activities that achieve some kind of local prominence, y'know like galas and these things are really important 'cos they pull people together.

But, importantly, this articulation of creative energy is understood as neither inevitable nor stable. To begin with, not everyone wants to participate in a group: 'some people do, some people don't.' And then the survival of a group is not guaranteed. A video access centre worker commented:

> It's almost like, you can't have a healthy human being without shelter, food and warmth, y'know and it's the same with groups. You can't have a well-established, a well sort of – a functioning group, without giving them basic sort of, just basic elements.

Groups that do survive change their nature. Indeed, the Old Town arts centre worker thought that they should: 'I think there is a sort of natural life cycle to a lot of the projects in community arts, I think the idea that you build up an organization that's exactly the same, and keeps doing the same kind of thing, is wrong.' Workers change – 'as workers we developed a lot, as well, learning how to work with people' – and participants change too. After all, the point of community arts is to change something, to develop participants' confidence and skills. In Wester Hailes, there are people 'who are with us every single day of the year, and moving on, in terms of their own development or whatever'. This discourse of 'community' does not assume that participatory organizations will represent everyone in the area,

nor that there is only one possible form of participation or organization. This other 'community' is both partial and mobile, changing its form as the particular individuals, groups and activities that constitute it change.

This discursive construction of an other 'community' as the growth, change and even decay of groups is mapped in a very different spatiality from that produced in these workers' critique of the manipulative body politic of power. Community arts workers see this spatiality as a network. The groups understood as providing foci for this other 'community' are imagined as nodes. This seems to be the case whether the other 'community' in question is one of interest or place. The worker with people with disabilities, for example, argued for a punctual geography of 'appropriate usable spaces throughout the city to the benefit of particular communities of interest, or race, or arts interest or disability interest or whatever'; and the tape-slide project worker explained how 'we worked with a group of mothers and tots in Blackridge, and their kind of aim was to put Blackridge on the map, so we worked with them to do that'. The 'other' community is thus scattered across a space, in a nodal distribution, but these nodes are imagined with links between them. Links can be sociable – the youth video worker commented that only when folk have developed 'a network of friends in the area is the point where they start to care about the area' – or institutional:

> well, I think probably what there is now is a whole network of area groupings. I don't think there's a single Old Town community and – I don't think there probably has been for quite some time. There's a network, there is a sort of network though of – y'know concerned groups and organizations that I think make up an overall sense of community, and if that's anchored anywhere it's in y'know like, there are residents' groups in each little area.

These links shift too; they are established and then end. Like the spatiality of power, this spatiality is highly dynamic, because this other 'community' is constantly changing. People 'move on', they 'get from there to there', they reach 'the next step', projects are described as 'stepping stones'. Yet this is not the same kind of movement as the unidirectional flows of power's processes, because the movements of the other 'community' do not occur in a zonally and hierarchically structured transparent spatiality.

In the discourse of community arts workers, this other 'community' is mobile and many-layered; its nodes and linkages are of their nature highly changeable; connections between nodes are made and unmade; and both groups and connections are contingent rather than essential. This produces a complex and uncertain spatiality. When, for example, the causes of change are listed – people change because they have fun, learn skills, create pleasurably, find training places, and this list is always recognized as partial – they are often described as an unclear number of 'levels', a phrase which produces a complexity and uncertainty of both spatiality and identity. The other 'community' is understood as producing a spatiality very different from the simply structured, expansive spatiality of power. Thus,

although community arts workers in Edinburgh frequently talk about 'community' as if it were a bounded entity – 'so y'know, we've had critics within and outwith the community, and that's fine, that's healthy I suppose' – I would argue that this does not mean that the workers are mapping 'community' boundaries in the same spatiality as they see as that produced by power. This is not a zonal spatiality which inflates a centre while producing a marginalized Other. Rather, it is a fluid, multiple, web-like spatiality of nodes and links in flux, in which positioning can never be stable.

The importance of rethinking the spatiality of 'community' in this way was made explicit by one worker:

> I think there's huge problems in terms of defining geographical communities, because it's, it's, it's, in a way it contributes to the image of that particular area. So if you say well we reserve our resources for the people of Craigmillar, and you build this in Craigmillar, all your way of doing is to participate in – the fact that people from Craigmillar live in Craigmillar, they should stay in Craigmillar and they shouldn't come from anywhere else.

To imagine 'community' through the same spatiality as that through which power produces its margins is only to reproduce that marginalization. A different spatiality is necessary if a different 'community' is to be articulated, a dynamic spatiality where nothing is fixed forever, where there are no essentializing inclusions and exclusions, and no hierarchies of power.

Conclusions

This is certainly a utopic vision of 'community'. In particular, it erases difficult questions about power relation within this other 'community', and several arts workers acknowledged that such questions had none the less to be faced: 'the process has to accommodate the fact that it's not all going to be sitting around saying "peace, love and power to the people", y'know, it disnae happen.' Nevertheless, such efforts to reimagine the spatiality of 'community' are sorely needed. Dominant visions of essentialized 'community' have been criticized in recent discussions about the violent costs extracted by a spatiality structured as transparently three-dimensional and territorialized by power into a centre and a margin (Bhabha, 1994; de Certeau, 1984; Deutsche, 1991; Lefebvre, 1991; Rose, 1996). It is a spatiality complicit with (at least) colonialism, the phallocentric constitution of sexual difference, and the bourgeois construction of classed difference. All these critiques suggest that the desire for this legible space is constitutive of essentializing fantasies of identity. While the centre's transparency supposedly renders it fully knowable to itself, the marginalized Other is positioned as the object of an (impossible) desire to know absolutely what is there. A conceptualization of 'community' structured by this kind of spatiality can only be exclusionary and essentialist about both its own and its Others' identities.

But there can be other ways of thinking about 'community', as these community arts workers, among other cultural-political critics, are demonstrating. 'Community' need not mean the articulation of an essence; 'community' need not be mapped in the dualistic spatiality of power/knowledge. Several such critics have argued persuasively that one element of a radicalization of 'community' must be to challenge the idea that 'community' has impermeable boundaries (Hall, 1995; Massey, 1994). But another element must be to think of 'community' through a space which does not structure essentialized identities. This rethought 'community' must be mapped in a spatiality which can acknowledge partial and changing membership; contingent insiderness; uncertainty, loss and absence. This is a concern shared in the diverse theoretical endeavours of (to cite just three authors) Bhabha (1994), Deutsche (1995) and Nancy (1991), all of whom argue that the violent consequences of spatially articulated epistemic closure are predicated on a refusal of such notions of lack.

In this article, I have tried to suggest that both of the spatialities through which a group of community arts workers map their two understandings of 'community' can be interpreted as spatialities of lack. However, the politics of this lack vary, according to community arts workers, depending on whether the absence is disavowed or acknowledged; and the spatialities in which a 'communty' can be mapped are symptomatic of that difference. Power produces its margins as its Other, and refuses to give its Other what-ever it needs, including even the resources to articulate an identity. The con-sequences for those so marginalized can be dire. They lack; they are made for and as nothing: 'the kids are told they'll never get a job'; they are refused recognition. In the other 'community' imagined by community arts workers, however, lack is acknowledged. This other spatiality is predicated on the acknowledgement of contingency, partiality and absence. Its nodes and connections are contingent, their links connecting differences and span-ning absences. The network is fragile with gaps, interruptions and absence. Its web-like form is an unstable, fluid matrix. Yet this network is con-structed by community arts workers as enabling those silenced by their mar-ginalization to speak for a while as collectives. By focusing people's energy they offer a collective articulation of 'community', the content of which is never pre-given. Perhaps this latter spatiality of a mobile 'community', the articulation of which is not the expression of an essence but another process of 'communifying', may also be a spatiality in which a new and more tol-erant 'community' can be placed.

Acknowledgements

The research on which this article is based was funded by the Economic and Social Research Council, grant number RR 000235698. Thanks to all the interviewees for their time and enthusiasm, to Sue Lilley for her transcrip-tion skills, and to Doreen Massey.

References

Anderson, Benedict (1983) *Imagined Communities: Reflections on the Origins and Spread of Nationalisms*, London: Verso.

Bell, David and Valentine, Gill (1995) 'Introduction: orientations', in David Bell and Gill Valentine (1995) *Mapping Desire*, London: Routledge.

Berrigan, Frances J. (ed.) (1977) *Access: Some Western Models of Community Media*, Paris: UNESCO.

Bhabha, Homi (1994) *The Location of Culture*, London: Routledge.

Binns, Vivienne (ed.) (1991) *Community and the Arts: History, Theory, Practice: Australian Perspectives*, Leichhardt, New South Wales: Pluto Press.

Bird, Jon, Curtis, Barry, Putnam, Tim, Robertson, George and Tickner, Lisa (eds) (1993) *Mapping the Futures: Local Cultures, Global Change*, London: Routledge.

Braden, Sue (1978) *Artists and People*, London: Routledge & Kegan Paul.

Brinson, Peter (1992) 'Report to Scotland' in *Arts and The Community: Conference Proceedings*, Edinburgh: Scottish Arts Lobby.

Carter, Erica, Donald, James and Squires, Judith (1993) *Space and Place: Theories of Identity and Location*, London: Lawrence & Wishart.

Clinton, Lola (1993) *Community Development and The Arts*, London: Community Development Foundation.

Colomina, Beatriz (1992) *Sexuality and Space*, New York: Princeton Architectural Press.

Community Development Foundation (1992) *Arts and Communities: The Report of the National Inquiry into Arts and the Community*, London: Community Development Foundation.

de Certeau, Michel (1984) *The Practice of Everyday Life*, trans. Steven Rendall, London: University of California Press.

Deutsche, Rosalyn (1991) 'Boys town', *Environment and Planning D: Society and Space*, 9(1): 5–30.

—— (1995) 'Surprising geography', *Annals of the Association of American Geographers*, 85(1): 168–75.

Gilroy, Paul (1993) *The Black Atlantic: Modernity and Double Consciousness*, London: Verso.

Hall, Stuart (1990) 'Cultural identity and diaspora', in Jonathan Rutherford (ed.) (1990) *Identity: Community, Culture, Difference*, London: Lawrence & Wishart.

—— (1995) 'New cultures for old', in Doreen Massey and Pat Jess (eds) (1995) *A Place in the World? Places, Culture and Globalization*, Oxford: Oxford University Press and The Open University.

Hawkins, G. (1993) *From Nimbin to Community Arts: Constructing Community Arts*, Sydney: Allen & Unwin.

Keith, Michael and Pile, Steve (1993) *Place and the Politics of Identity*, London: Routledge.

Lefebvre, Henri (1991) *The Production of Space*, trans. Donald Nicholson-Smith, Oxford: Basil Blackwell.

Massey, Doreen (1994) *Space, Place and Gender*, Cambridge: Polity Press.

Mercer, Kobena (1994) *Welcome to the Jungle: New Positions in Black Cultural Studies*, London: Routledge.

Nancy, Jean-Luc (1991) *The Inoperative Community*, trans. Peter Connor, Lisa Garbus, Michael Holland and Simona Sawhney, Minneapolis: University of Minnesota Press.

Nigg, Heinz and Wade, Graham (1980) *Community Media: Community Communication in the UK*, Zurich: Regenborg-Verlag.

Pile, Steve and Thrift, Nigel (1995) *Mapping the Subject: Geographies of Cultural Transformation*, London: Routledge.

Riley, Denise (1988) *'Am I That Name?' Feminism and the Category of 'Women' in History*, London: Macmillan.

Rose, Gillian (1994) 'The cultural politics of place: local representation and oppositional discourse in two films', *Transactions of the Institute of British Geographers*, 19(1): 46–60.

—— (1996) 'Distance, surface, elsewhere: a feminist critique of the space of phallocentric self knowledge', *Environment and Planning D: Society and Space*, 13(6): 761–81.

—— (forthcoming) 'Performing inoperative community: the space and the resistance of some community arts projects', in Michael Keith and Steve Pile (eds) *Place and the Politics of Resistance*, London: Routledge.

Williams, Raymond (1976) *Keywords: A Vocabulary of Culture and Society*, London: Fontana.

KATHLEEN McHUGH

ONE CLEANS, THE OTHER DOESN'T

ABSTRACT

The title of this article conveys the idea which shapes it: that the positioning and identities of 'the one' and 'the other' are affected by the performance of different social practices. The highly symbolic activity of cleaning inverts the distribution of groups that would usually be divided according to the one/other dichotomy, in that gendered, class and racial others usually clean for their social 'betters'. This redistribution allows for a look at the dynamics of social and psychic identification within an altered or inverted frame. In three different discursive locations – psychoanalytic theory, feminist film and theory, and advertising and popular culture – I examine diverse representations and implications of cleaning scenes. Each scene symptomatically collapses or merges sexual difference with other social distinctions conventionally marked by the labour involved in cleaning. As each of these discourses is concerned with articulations of identity, whether explicitly or critically (psychoanalytic theory and feminism) or implicitly (advertising and popular culture), these scenes reveal crucial links between social and symbolic practices and the vicissitudes of gender identity. In effect, gender emerges as a cleaning strategy, a representational system that masks or obfuscates the significance of other social differences.

KEYWORDS

gender, domesticity, cleaning, psychoanalysis, feminism, popular culture

The subject, the 'one' I will consider, is the 'one who cleans'.[1] My interest in this particular subject, its relation to the activity of cleaning and the dichotomy thereby posited with its other is twofold. First, the title phrase underscores the extent to which the construction of a subject[2] is inflected by that subject's relation (active or passive) to certain practices or actions. From this point derives the second, namely that the activity of cleaning inverts the positions usually inferred by the terms the 'one' and the 'other'. In contemporary theoretical terminology, 'the one' usually designates a position that implies agency, power, and a normative universalized invisibility that provides the backdrop for the difference or exception constituted by the disenfranchised or disempowered 'other'. Those who perform acts of cleaning, however, frequently belong to groups culturally coded as 'others'. Women, people of colour, members of the working class or lower castes tend to do the cleaning for their social superiors.

Cultural Studies 11(1) 1997: 17–39

Rather than focus on the identities of these groups or individuals *per se*, I would like to consider the ways in which cleaning practices interact with identity construction in modern bourgeois thought and culture. An investigation of the 'one who cleans' allows us to see the role played by this highly symbolic cultural practice in diverse constructions of difference – gender, class, and race. Cleaning, unlike speech, action, or desire (as in, 'one speaks, the other doesn't', etc.), belongs to a set of activities which confer an agency upon their subjects that usually *lacks* status and power. Further, a wealth of ambiguities and contradictions inhabit both the concept and the act of cleaning itself; linked both to the sublime and the banal, to social organization and the structuring of the symbolic, cleaning involves erasure, catharsis and purification, as well as drudge, monotony and manual labour. When cleaning is successful, it produces lack as value, but this value frequently does not accrue to the one who does the cleaning. The paradoxes of cleaning, in terms of agency, status, social and symbolic import, and material effects have profound consequences on the identity of the one who cleans.

To illustrate this point, I have chosen various representations and theorizations of cleaning scenes which demonstrate, in very diverse ways, how the ambiguities that inhere in the practices and effects of cleaning tend to be absorbed by or projected on to the identity of the one who cleans. Cleaning practices and their representations participate in the construction and maintenance of vital cultural distinctions, like those between nature and culture, inside and outside, public and private. My contention is that the tropes, narratives, or scenes used to represent cleaning naturalize these binaries in such a way that they override or obviate other types of difference. In modern bourgeois culture, the linchpin (and alibi) of this process is the housewife. While many people clean for a living, only in the housewife are these series of binaries wedded together. The presumably universal symbolic binaries of 'nature and culture' and 'inside and outside' reveal their historical specificity when considered in light of the modern configuration of gendered public and private realms. Unlike others who clean, the housewife works in the private sphere and does not receive a wage. In ways I will discuss below, 'she' therefore symbolically polices, maintains and coordinates these binaries through her cleaning practices, and thus effectively embodies their contradictory juncture. In becoming the impossible figure for these contradictions, the woman/wife becomes the enigma of a modern opposition, that of gender, which in our culture tends to predominate over all others. Thus other differences – class, race, ethnicity, sexuality – are often subsumed within the more cleanly (constructed as) universal dichotomy of gender difference. Gender itself operates as a cleaning strategy, an analytical category whose seeming ubiquity and obviousness tidies up, restores order to much more messy social identities.

Most of the cleaners with whom I will be concerned are white women. As Angela Davis points out, 'Although the "housewife" was rooted in the social conditions of the bourgeoisie and the middle classes, nineteenth century ideology established the housewife and mother as universal models of womanhood' (1983: 229). The process I will trace through several

diverse examples concerns the problematic construction of a white, middle-class, heterosexual femininity that has often been taken as the feminine *per se*.[3] Because I wish to trace the links between cleaning, modern identity and gender construction, and the mystifications of other differences, I will limit my consideration to representations of housewives and maids in three different discursive locations: feminist alternative film, psychoanalytic theory and popular media. Each of these discourses concerns articulations and constructions of identity, whether explicitly or critically (feminist film and psychoanalytic theory) or implicitly (advertising and popular culture). I will begin with a contemporary film that illustrates the paradoxical effects of cleaning on the character of the one who cleans.

Scene 1: *The Central Character*: Gender and cleaning

> Where there is dirt, there is system. . . . When we honestly reflect on our busy scrubbings and cleanings . . . we know that we are not mainly trying to avoid disease. We are separating, placing boundaries.
>
> (Douglas, 1966/1988)

The Central Character, a short experimental film by Canadian filmmaker Patricia Gruben, visually demonstrates the way in which cleaning practices and the space these practices maintain affect the character of the person who cleans: specifically, the director examines a contemporary housewife's role in the maintenance of the liminal social space of the home, a space riddled with ambiguity. Symbolically constituted as cultural border or boundary, the home serves as a margin between areas constructed as 'culture' and areas designated as culture's other – the 'natural' world. The activities that cultural convention dictates should be performed in the home relate to the body and to the provisions of physical necessity. As the place where we presumably eat, drink, defecate, rest, have sex and seek shelter, the home is linked with activities coded as physical and 'natural'. Yet it also figures as a sign of civilization and its distance from nature; as Oscar Wilde remarked, 'If Nature had been comfortable, mankind would never have invented architecture . . . I prefer houses to the open air' (1968: 117). Thus one task that the home, or better, the idea of the home, performs is a trans-formative one: as an intersticial space, it delimits an area in which specific practices create the distinctions between two territories – the natural and the cultural or the physical and the social – that appear to border it. Artic-ulating elements of both, the home is neither. Rather it figures as a place of paradox, connoting at once a refuge or area outside of the so-called frantic 'public' world and a shelter inside, protected from the natural elements. These conflicting significations are managed in part by housework. As housekeeper, as homemaker, as the agent of this semiotic operation, 'women' become identified with its contradictions and effects, contradic-tions *The Central Character* literalizes and thereby makes manifest.

In the film, an amorphous protagonist – initially a housewife – is trans-formed as her voice/persona moves from the emphatically organized

environment of the kitchen to the organic profusion of the woods. The film sets up an ambiguous relation between its central character, her activities and the locations in which she moves. While highlighting the ways in which housekeeping practices construct and maintain a domestic environment, Gruben also illustrates the effects this environment has on the highly unstable identity of its protagonist. In the film, 'she' moves from the kitchen to the garden to the woods in the performance of her tasks, her character changing dramatically in each milieu.

In an early sequence of the film, text superimposed over a schematic kitchen floorplan reads, 'Entropy is the main problem in the modern kitchen, regulating traffic flow, keeping fingerprints, food particles and other unhygienic particles out. A nucleus of order must be maintained. A kitchen is white steel and chrome for early detection. Why is it that disorder is more contagious.'

In the following sequence, stills of a broom sweeping the patio dissolve one on top of the other, as the woman's voice informs us 'the patio must be swept every day to reclaim it from the out of doors'. Margins are problematic; the patio – outdoors yet part of the home – borders on the woods and requires vigilant, daily attention. As the stills of a sweeping broom continue, the housewife notes the superimposition of the patio, of the cultural surface, on to the natural one – 'The clay bricks are set directly into the earth in the extensive backyard'. This attention to the cultural function of surfaces dominates the first half of the film, the half that concerns the indoors, the domestic; furthermore, most of the early images are flat and two-dimensional (a white floor, a floorplan on graph paper, a drawing of cabinets). These surfaces must be kept clean, free from the material that characterizes the outdoors ('dirt'), from all residue that indicate the work done in the kitchen ('food particles'), and from the signs of human presence itself ('finger-' or 'footprints'). Significantly, the presence of the housewife is conveyed strictly by implication, by sound and primarily by the effects of her housework. When she explains the logic of her cleaning, we see only a broom or her hand scrubbing a floor.

The narrative moves from indoors to outdoors in *The Central Character* according to a deconstructive logic which illuminates the differing senses of the words 'cultivation, cultivate, culture'. Deriving from the same Latin stem as 'culture' and almost synonymous with it, 'cultivate' means to till the soil, to plough and fertilize, to dig soil around growing plants. It also means to foster or nourish, and, finally, to refine or polish. Gruben uses the differing meanings of this term to reveal paradoxes relating to dirt, to depth and surface, and to indoors and outdoors that all affect the 'character' of housewifery, the home and, by implication, women who keep house. To cultivate out of doors, as Gruben's film illustrates, involves getting dirty, getting beneath the surface, and concerning oneself with growth, roots and fertility. Alluding to women's role in the primordial sexual division of labour, that of cultivators and gatherers, she wittily contrasts this function with the cultivation expected of them indoors. Such cultivation implies ridding oneself of dirt and vulgarity, cleaning and polishing all aspects of

one's person (physical, mental and social), and obsessively concerning oneself with surfaces and appearances. While the cultivation one practises outdoors often produces food, indoors one cultivates the intangible nourishments associated with a refined sensibility. Cultivation in its sense of 'refinement' implies activities of purification and discrimination; fertility, on the other hand, requires the mixing of disparate elements. Beginning with the inferred oppositions which structure the opening sequences of the film, between the sterility the housewife should strive for within the home and the messy fertility that is a necessary component of nourishment, *The Central Character* playfully explores the plethora of contradictions, both actual and symbolic, managed and provisionally effaced by the activities of housework.

The housewife performs tasks of erasure, of purification, that function to keep indoors separate from outdoors, activity from its effects or residue, the body, the traces of the body, from the work involved in satisfying its needs. One of the housewife's chores is to efface the signs of her own work (food particles) and those of her role in it (fingerprints). In so doing, her work makes manifest a system of spatial distinctions, at the cost of erasing all traces of her own labour. While Gruben's film illustrates the role of cleaning in establishing cultural boundaries and distinctions, it also suggests the fragility of these boundaries and the profound interdependency of the two realms created by them. By depicting household places and practices that differentiate and compartmentalize space (cabinets and floorplans), that make boundaries (bricks on the patio), and that erase the traces of outside from inside (sweeping, scrubbing the floor), the film visually suggests the degree to which the ideas of nature and culture, inside and outside, cleanliness and fertility depend on the everyday practices that construct and maintain them. Though the housewife's work keeps these distinctions 'neat', their implicit connections and interdependence resurface in the paradoxical, contradictory significations that permeate 'her' identity (as wife/woman). The gender binary presumably manages these significations by subsuming them all within a 'feminine' character that neatly opposes a 'masculine' one. However, if we examine popular representations of cleaning and femininity using the insights provided by Gruben's film, we can see that gender, though it appears to constitute a clean opposition, does not do so at all.

Scene 2: Dangerous domesticity and the role of e/liminators

It is thus not lack of cleanliness or health that causes abjection but what disturbs identity, system, order. What does not respect borders, positions, rules. The in-between, the ambiguous, the composite.

(Kristeva, 1982)

The 'feminine' embodies what must trouble and ultimately disrupt any opposition – the in-between, the ambiguous, the composite – and this 'trouble' reveals itself readily in popular advertisements containing cleaning

scenes. These scenes, invariably representing a middle-class milieu, illustrate the perverse parallels insistently constructed between cleaning as a practice, with certain symbolic effects, and feminine gender construction as signification, with kindred effects. These perverse parallels surface in representations of the housewife's character and sexuality.

As a result of the imperatives of purity inferred in various aspects of housework, the housewife is placed in what Mary Douglas would call a 'dangerous' cultural position. In order to clean, to separate, to keep dirt (nature) out, the housewife must 'get her hands dirty', do the 'dirty work'. As a cultural cleaning agent, she must come into contact with and handle the very pollutions she protects others from; she therefore runs the risk of being tainted with them herself. But she must also avoid being too clean, or becoming overzealous and maniacal. Mary Douglas remarks that

> the quest for purity is pursued by rejection . . . when purity is not a symbol but something lived, it must be poor and barren. Purity is the enemy of change, of ambiguity and compromise . . . it is an attempt to force experience into logical categories of non-contradiction. But experience is not amenable and those who make the attempt find themselves led into contradiction.

> (1966/1988: 161–2)

Traces or symptoms of the housewife's liminal and paradoxical role surface in advertisements for cleansers, soaps, dishwashing liquids, or floor-cleaning products. The same contradictions or paradoxes noted in Gruben's film as implicating the central character – between inside and outside, between 'nature' and 'culture' – shape the character of these products. In a television advertisement for an air freshener, three housewives move respectively through a living room, a dining-room and a kitchen, each spraying air freshener in front of them as they talk about visiting their 'favourite country'. This slogan indicates the name of the product and the country fresh air it produces when sprayed inside the home. Another advertisement for a floorcleaner is set in the middle of the night. It consists of a solitary mop secretly dancing a gleaming, shining trail across the kitchen linoleum to the tune of *The Sorcerer's Apprentice*. In these two representative advertisements, like many others for household cleaning products, assertions that the product cleans and sanitizes are coupled with claims that it freshens the home or leaves it smelling 'like the great outdoors'. Such advertisements stress that the effects of housework are effects of erasure, yet of an erasure that leaves traces in its wake – a gleam, a shine, the scents of lemon or pine. Cleaning products not only promise to evacuate dirt, grime and germs, aspects of the 'natural' that are dirty and dangerous, but also to import the scent and freshness of the outdoors, leaving behind olfactory traces of vegetal or floral growth. Because the effects of cleaning are a *lack* or *absence* of dirt and germs, the scents, the shine, as tangible presences, verify (for the housewife, for her family or guests, or for the maid's employer) that cleaning has taken place.[4] The fact that the residue of cleaning in our commodity culture, its proof, its product is often an olfactory trace resonates tellingly

with Sigmund Freud's work linking organic repression, civilization and the sense of smell. While I will discuss his thesis in detail below, here it is sufficient to note that these 'fresh scents' are given moral valence in the advertisements where they occur. They are subtly marketed both as instruments of surveillance (cleaning *has* occurred) and as signs (available for purchase) of the moral virtue our culture assigns to cleanliness and the clean (and to organic repression – 'cleanliness is next to godliness').

What is frequently erased *without a trace* from these advertisements is the sense that cleaning involves work, sweat, labour. The mop n' glow is a 'sorcerer's apprentice', its unattended, dancing mop producing a gleaming floor in the middle of the night. The floral, pine or lemon scents left by Lysol or Pledge signify a natural source of cleanliness, not that of human labour. What these advertisements promote are products that, in the absence of human labour, effect a contradictory construction and valuation of the concepts of natural and cultural, inside and outside, clean and dirty. In them, nature or the natural, often coded as the source of the dirty and taboo, is also commodified and chemically reproduced as a signifier of cleanliness that opens up and refreshes stuffy indoor domestic space. An intricate process of material exchange and human labour (moving dirt, germs, effluvia from inside to outside the home) is wedded to a commodity transaction (purchase of product which is then brought into the home) that employs symbolic values both in its promotion and its use (the significations within the advertisement; the scents or shine that the product leaves as its trace). These same advertisements repress the labour involved in cleaning, any sense of the housewife as labourer, and usually any but the most isolated, antiseptic image of dirt or filth. The matrix of social, economic and symbolic transactions instigated by these advertisements depends on the link they establish between two repressions – organic repression (a fundamental repression, ideologically expressed as 'we humans are not animals') and a more culturally recent repression concerning the housewife's labour. I will discuss this link more extensively below.

For now, it suffices to note that this conglomerate of the repressed returns. In the realm of commodity culture, we can see the extent to which the contradictory aspects of women's cleaning work and its effects are displaced to and replicated in constructions of appropriate feminine identity by examining advertisements for feminine hygiene products. These products tend to make use of the exact same rhetoric as the cleaning products discussed above. In television or print advertisements for feminine hygiene products, a woman, usually in a floral or white dress with a flared, lilting skirt, drifts through a garden or lounges on the stairway of a flower-laden porch or patio. These liminal spaces, which bring together an idyllic outdoors with an idyllically rendered domestic facade (often photographed or filmed with an excessive soft focus) externalize the dichotomies that advertisements for cleaning products tend to internalize and synthesize within a domestic setting. Here, the dichotomous signifiers suggestively join at the point inhabited by the woman's body, articulating that body as analogous to domestic space, a space in-between, ambiguous, dangerous, a space that

must be kept clean. Yet, as with domestic space, the 'keeping clean' involves, more than anything else, a synthesizing of disparate values that women's cultural position has designated they represent.

In these advertisements, nature infuses the domestic setting as a woman's voice sings 'Summer's Eve brings back freshness anytime'. The layers of allusive significations here – that invoke romance and sexuality with a coy, if overly saccharine suggestiveness – belie the fact that Summer's Eve is just another domestic cleaning product. Significantly, they infer a link between cleaning and sexuality which is related to the oppositions mobilized in the advertisements. Finally, they emphasize that the agent of cleanliness, the woman/wife, is also an object that must be cleaned. Her body, insistently figured as *the body*, signifies the threat of both animality and sexuality. While her body must signify these threats, they must also be tamed, domesticated, cleaned up. Indeed, the figurative similarities in contemporary advertisements for these two types of products has a literal connection in our culture: until the early 1960s, Lysol was advertised both as a domestic cleaning product and a feminine hygiene product – in the same solution, in the same bottle, and until the 1930s, often within the same advertisement.[5] For example, in a February 1923 magazine advertisement, two parallel columns of text proclaim Lysol's 'parallel' uses: on the left, its efficacy in getting rid of the 'millions of germs' that multiply 'in garbage cans . . . sinks, toilet bowls, cellars, dark closets, and out-of-the-way corners'; on the right, immediately opposite the text cited above, the copy notes its use 'by discriminating women for personal hygiene'. Other advertisements, singularly promoting Lysol as a feminine hygiene product, approach the relationship between cleanliness and sexuality from a different angle. Beneath a quote 'We're no longer happy, Mother!' and a picture of a distressed (white, middle-class) wife clutching her mother's arm, text from a December 1929 advertisement reads: 'For some time the young wife had realized that things were changing between herself and her husband . . . they did not enjoy the warm companionship they had at first. They were drifting apart. Why? So often the answer lies in the wife's neglect – or more often misunderstanding – of the delicate part of her toilette called feminine hygiene.' The striking parallels or, in the case of Lysol, identification between household cleaning products and feminine hygiene products must lead us to immediately enquire with regard to the latter: what exactly is being cleaned here?

As the culturally designated agent who constructs and maintains the symbolic boundaries (inside/outside, nature/culture) effected by cleaning, the housewife/woman absorbs or contains their contradictory and overlapping significations. These contradictions then surface as problems with feminine identity or, as indicated by these advertisements, with feminine bodies. Historically and culturally relegated to perform tasks which establish the distinctions between the natural and the cultural, inside and outside, dirty and clean, middle-class housewives, generalized as the 'feminine', come to represent extremes of both. Feminist analyses have long noted and critiqued the insistent ideological alignment of 'woman' with nature or the body – woman is animal. But the *highly cultured* is also consistently seen as

feminine, as evidenced in the negative stereotype of the effeminate man.[6] 'The feminine', as modernity has constructed it, therefore signifies and contains conflicting polarities that articulate, not an opposition to a male other, but an enclosure, a parentheses in which 'he' figures as norm/neutral/neither. Articulating this perception, Catherine Clement observes that women 'are double. They are allied with what is regular, according to the rules, since they are wives and mothers, and allied as well with those natural disturbances, their regular periods, which are the epitome of paradox, order and disorder' (Cixous and Clement, 1975/1986: 8). While Clement locates the source of this doubling in women's physicality, I would argue that the cultural coding of certain highly symbolic activities – cleaning – provides part of the frame in which we construct and understand sexual difference. Further, the ideological pressure of such a frame is evident in considerations of housekeepers' and, by inference, women's proper sexuality.

As a worker whose practices create, police and maintain the cultural border between purity and impurity, whose actions determine what comes close to the bodies of her family and what is kept at a distance, and who supervises what goes in and comes out of those bodies, the housekeeper's own body is subject to stringent limitations and cultural controls. These controls monitor the cleanliness of both her body and her sexuality. If we look at popular culture narratives about white, middle-class housewives, we can see that the stories they tell are often marked by a confusion of literal and metaphorical cleanliness. In accounts of bad or mad housewives, the woman is often associated either with a 'dirty' sexuality and slovenly housewifery or with frigidity and obsessive orderliness.[7] Indeed, these associations have been so reinforced in our culture that representations of a woman's deficient or excessive housekeeping immediately suggest her excessive or deficient sexuality. As the advertisement discussed above demonstrate, codes of personal cleanliness and sexuality are bound up with the diverse chores of the housewife, infusing cultural constructions of her sexuality with hygienic concerns – a 'slut' is both a slovenly housewife and a promiscuous woman. The housewife's role as cleaner becomes associated with her role as sexual partner. The concerns with cleanliness that inform her occupation or work are mirrored, perversely, symptomatically, in her sexuality and her body. Cleaning, a practice involved with the articulation of boundaries, marks the confusion, the lack of differentiation (between labour and libido) that haunts this body.

A host of contradictory imperatives shape the modern, white, middle-class housewife's identity, and thus (constructed and contrived) conceptions of women, overall: be clean, but not too clean; be natural, but not too natural; be cultivated and polished, but not too cultivated; be sexual, but not too sexual. These contradictions can be seen as deriving, at least in part, from the woman/wife's cultural role as a cleaner or preserver of boundaries. It seems then that her function, in both her practices and in the construction of her identity, is to serve as an e/liminator. As an entity (a universalized gender figure) who absorbs and embodies the contradictions of symbolic borders or boundaries, the idea of '*the* Woman' incorporates and

thereby effaces the liminal – the threshold or margin that dirties the clarity of distinct oppositions, the imbrication or connection that confuses or mixes the parties to any difference.

The modern entity 'Woman' has a history inseparable from the industrial revolutions, the coincident social and psychic separation of public and private spheres, and the rise and triumph of the middle class over an aristocratic social order. The contemporary ideological and symbolic operations of the gender binary discussed above can only be understood in this historical context. Nancy Armstrong cogently outlines this point:

> We are taught to divide the political world in two and to detach the practices that belong to the female domain from those that govern the marketplace. . . . In actuality, however, the changes that allowed diverse groups of people to make sense of social experience as these mutually exclusive worlds of information constitute a major event in the history of the modern individual. It follows, then, that only those histories that account for the formation of separate spheres – masculine and feminine, political and domestic, social and cultural – can allow us to see what this semiotic behavior had to do with the economic triumph of the new middle classes.
> (1987: 9–10)

Armstrong investigates the articulation of desire and femininity in eighteenth- and nineteenth-century domestic fiction to trace 'the emergence and domination of a system of gender differences over and against a long tradition of overtly political signs of social identity' (1987: 21). In order to pursue what I believe is a related phenomenon – the connections between cleaning, gender construction and sexuality, and the eradication or mystification of other differences – I would like to look at several cleaning scenes analysed and recounted by the most important theorist of bourgeois sexuality: Sigmund Freud.

Scene 3: Sigmund Freud, sexuality and the primal clean

Take care of sanitation and civilization will take care of itself.
(Reynolds, 1943: 16)

In a sense, psychoanalysis could be considered a theory of bourgeois housekeeping: Freud worked in the home, on the home, finding in the private life of the bourgeois family, in its individual members and in their unconscious the psychic dynamics fundamentally related to and determinative of cultural phenomena. While he asserted the universal relevance of his theories, particularly that of the Oedipus complex and castration anxiety, his work can be seen to be culturally bound and limited by, among other things, the conventions of bourgeois housekeeping. Because housekeeping practices establish norms of care for our bodies and domestic space, because we are born into and shaped by these norms, these practices and their cultural origins materially and conceptually effect such a construction of identity. Freud's reasoning frequently implied such a connection. The nuances of the

anal phase, as well as Freud's presupposition that the maintenance of an infant's hygiene could be expected to result in genital stimulation, depend profoundly upon bourgeois conventions of cleanliness.[8]

Freud's theoretical gifts, essential to contemporary thought and the development of feminism, of the unconscious, castration, and their complex relations to subject construction, diagnose the psychic and social nuances of modern sexual difference and gender formation as they are coming into being in the nineteenth century. This diagnosis addresses a specifically bourgeois subject whose subjectivity, because of the psychic and ideological particulars of bourgeois class ascension,[9] will become the normative model for all humanistically conceived subjects. Thus we can read Freud to discern the importance of cleanliness and cleaning and their function in the construction of modern subjectivity as it is formulated within a bourgeois social order.

The family romances, the psychosexual dramas Freud describes, *take place* within a historically and theoretically significant *mise-en-scène*, the nineteenth-century bourgeois home. Because of Freud's scrupulous attention to detail, we will find in the cleaning scenes that occur in his work traces of the class structure, as that structure inhabited the Victorian home. Included also are traces of the housekeeping practices that supported and/or qualified his theorizations of sexed positions, practices that also maintained the milieu and provided the leisure time for these theorizations to take place. We will also find a symptomatic inability to account for or theorize these practices even as Freud consistently suggests their importance.

Freud infers the significance of cleaning in his thoughts about the very beginnings of human sexuality and social organization. One of his theories about the origins of civilization develops from a complex phenomenal matrix involving sexual difference, odour, shame, propriety and cleanliness. In *Civilization and its Discontents*, Freud contends that the family unit derives from the very different but mutual needs that bring male and female together. The male, motivated by the need for readily available sexual objects, joined up with the female, who submitted to this arrangement in the interests of 'her helpless young' (1930/1953–74: 99). In a long, detailed footnote, Freud explains how these prototypically social motives for permanent sexual coupling came to supersede the transitory and primarily olfactory biological cues provided by the menstrual cycle. 'Visual excitations' which take over the role of the more archaic 'olfactory stimuli' allow for a more lasting effect. Freud links this transformation with what he sees as the act that initiated 'the fateful process of civilization . . . man's adoption of an erect posture' (1930/1953–74: 99).

Profound consequences ensue. '[T]his made his genitals, which were previously concealed, visible and in need of protection, and so provoked feelings of shame in him.' Shame induced 'devaluation of the olfactory stimuli' which then resulted in an 'organic repression' leading to menstrual taboos and the proscriptions against anal eroticism (1930/1953–74: 99). As Freud describes it, the scene involves the transformation of a survival instinct (a

sense of vulnerability and fear resulting from the exposure of delicate body parts) to a more social and normatively oriented sense of shame. Shame is induced by the threat of another's gaze (a social threat), not by direct attack (a physical one). A normative, moral sense enters this scene not because the genitals are unprotected, but because they are visible.

The same moral valence infuses the transformation concerning the instigation of sexual excitation – from olfactory stimuli, which presumably coincided with a human being's pre-erect physical postures, to the visual stimuli which will dominate and organize erotic life in erect civilization. Freud concludes that cultural concerns with cleanliness derive originally, not from concerns with hygiene, but from the 'organic repression' absolutely vital to the development of civilization. To be unclean, to smell bad is, by this reasoning, to be aggressively antisocial (1930/1953–74: 99–100). To be antisocial is to oppose civilization, to stand against the norms that facilitate coexistence in the social order. Thus the act of smelling bad, of being unclean, acquires negative, immoral or unethical implications.

By this same reasoning, cleaning, the management and disposal of filth and excreta, marks, along with man's assumption of an erect posture, the beginnings of civilization. As an implied part of the transformative matrix of odour, sight, sexuality, posture and repression, it too acquires a moral, normative valence. Freud's account highlights the assumption of a position (erect posture) and does not pursue the other implications of 'organic repression': the performance of cleaning practices necessary to implement its dictates.

In Freud's much more extensive work on sexuality and subjectivity, cleaning and hygiene also play a significant role in the advent of the individuated, sexed being. Writing on his discovery of infantile, polymorphous, perverse sexuality, Freud is eventually led to identify the mother as the figure who inaugurates the infant's sexual excitation:

> And now we find the phantasy of seduction once more in the pre-Oedipus . . . but the seducer is regularly the mother. Here, however, phantasy touches the ground of reality, for it was really the mother who by her activities over the child's bodily hygiene inevitably stimulated, and perhaps even roused for the first time, pleasurable sensations in her genitals.
>
> (1930/1953–74: SE 22: 120)

One of the ways in which the social, historical context inflects the psychic formation of the subject within the family romance consists precisely in bourgeois norms of cleanliness. These norms institute disciplinary procedures that profoundly influence subject formation. Yet cleaning practices also literally impress on the infantile body the marks of a social order characterized by multiple types of diversity. Variations in social position, gender, status, material wealth, occupation and domestic environment significantly inflect and alter such subject formation within the only apparently homogeneous (bourgeois) family. We can see the social order's simultaneous incursion into and marginalization from the bourgeois family romance in cleaning scenes that occur in Freud's analytic work.

The intimate links among cleaning practices, sexuality and sexual difference, although not noted as such by Freud, emerge in the form of small narratives or anecdotes embedded in several of his case histories. One example particularly suited to my interests bears upon the ideas later expressed in *Civilization and its Discontents*. I refer to the Wolfman's repressed image of Grusha, the housemaid, scrubbing the floor. As Freud interprets it, her image served the Wolfman as a cover for the more frightening memory of the primal scene he had witnessed as a child. 'When he saw the girl upon the floor engaged in scrubbing it, and kneeling down, with her buttocks projecting and her back horizontal, he was faced once again with the attitude which his mother had assumed in the coitus scene. She became his mother to him' (1909/1960: 285).

For the Wolfman and for Freud, an image of a woman on her hands and knees could only be a sexual image, her physical posture and *not* her activity the eroticized point of focus. But while the doctor and his patient view the woman's backside, the alarming site of fundaments and the fundamentals of psychoanalysis, the maid/woman sees and contends with something else. Rather than the configurations of the primal scene, Grusha perhaps views those of a primal clean, a dirty floor, the fundaments or grounds of a differently articulated manifestation of sexual difference and the problems of civilization. The men behind her, standing erect – the doctor, the wolfman – cannot see her activity, her function, as these movements are obscured by her 'prominent buttocks'. Where they see her, her veiled genitals, her potential relation to their possession, she sees, touches, smells dirt and suds, negotiating a transformation between them. The men behind her, the men captivated by her behind, are pointing, contemplating, fantasizing, theorizing. Their words make manifest certain crucial relations between fantasy, memory, repression and identity in the bourgeois imaginary. From their position, Grusha is an animalistic figure, regressed to a posture reminiscent of Freud's pre-civilized, pre-erect human beings. Yet beyond their purview, Grusha is moving dirt from one place to another, solving a geographic problem of inside and outside. Dirtied in the process, she keeps things clean and proper, rendering invisible the traces of these other civilizing relations. Seeing her in this pose, the Wolfman urinates, thereby assuming the position of his father in the primal scene. Freud does not mention who mopped up the effects of this seminal simulation. But we can confidently surmise that Grusha had a hand in it.

Scene 4: Cleaning and class: Grusha and the step girls

Dirt is matter out of place. . . .

(Douglas, 1966/1988)

Freud's analysis of Grusha's cleaning scene also has a hand in using sexual difference as a cleaning strategy, one that effectively mops up all traces of other differences from this tableau.[10] What allows the slippage from maid (social other) to (m)other in Freud's narrative is both the maid's presence in

the bourgeois household and her cleaning activities that cause her to resemble *or to be taken for* both the mother and an animal. These fantastic identifications reveal crucial features of the psychoanalytic imaginary. Freud's interpretation of Grusha (as both mother and animal) incorporates what Julia Kristeva identifies as the two places where we are confronted with the abject – the debased, the filthy, the absolutely defiled or rejected, the state of non-being:

> The abject confronts us, on the one hand, with those fragile states where man strays on the territories of *animal*. . . . The abject confronts us, on the other hand, and this time within our personal archeology, with our earliest attempts to release the hold of *maternal* entity.
>
> (Kristeva, 1980/1982: 12–13)

The struggle of the human subject to differentiate him or herself from helpless, mute physicality, to individuate, must first involve rejection of the non-human and a psychic/physical separation from the mother. Kristeva's theorization stresses the fundamental importance of dirt, filth (as 'not me') to abjection and subject formation; it also allows us to understand specifically how Freud maps a narrative of psychic/symbolic difference on to one involving social difference. The polarity animal/mother, within which (per Freud) the Wolfman psychically differentiates himself, naturalizes the class difference upon which the Wolfman's desiring structure depends.

Insisting upon the significance of Grusha's social position, Deleuze and Guattari elaborate this point:

> It is not a question of denying the importance of parental coitus, and the position of the mother; but when this position makes the mother resemble a floor-washer, or an animal, what authorizes Freud to say that the animal or the maid stand for the mother independently of the social or generic differences, instead of concluding that the mother also functions as something other than the mother, and gives rise in the child's libido to an entire differentiated social investment at the same time as she opens the way to a relation with the nonhuman sex? For whether the mother is from a richer or poorer background than the father, etc., has to do with the breaks and flows that traverse the family, but that overreach it on all sides and are not familial.
>
> (1972/1983: 355)

In Deleuze and Guattari's reinterpretation of this scene, desire and the social order are inextricably connected:

> Wouldn't the Great Other, indispensable to the position of desire, be the Social Other, *social difference apprehended and invested as the nonfamily within the family itself*? The other class is by no means grasped by the libido as a magnified or impoverished image of the mother, but as the foreign, the nonmother, the nonfather, the nonfamily. . . . [Thus] Class struggle goes to the heart of the ordeal of desire.
>
> (1972/1983: 354–5, my emphasis)

While Deleuze and Guattari theorize the significance of the maid's position – both on the floor and more generally, in the bourgeois family – they do not consider the significance of her cleaning activities (which control the encroachment of the abject) to this family. Yet the connection that Deleuze and Guattari make manifest between the economic, social structuring of difference (capitalism, bourgeois privilege, the financial resources to employ maids) and the psychosexual structuring of the (male, bourgeois) subject in the symbolic depends precisely upon the confusion of an economically contracted, debased cleaning practice with a libidinally contracted connubial sexual act. Erotically, in Freud's gaze, the mother's and the maid's positions in this fantasy tableau are the same; in their economic status and practice, of course, they are very different. Elided from the Wolfman's fantasy and Freud's analysis are considerations of money, work and dirt; arising from them are a fusion of two very different activities – cleaning and sex – where sexuality absorbs and displaces the significance of cleaning. Today, we can see the remnants of this imaginary matrix of displacements and confusions in culturally sanctioned discursive comparisons: metaphors of cleanliness and dirt are frequently used to evaluate both monetary ('filthy lucre', etc.) and sexual (the 'dirty deed') transactions, not to mention their even more frequent occurrence in judging the quality or value of female sexuality.

In addition, Grusha's 'animalistic' posture in the gaze of the 'Wolf' man indicates that the differences being simultaneously articulated and mystified in this cleaning scene are both complex and profoundly interrelated.[11] They include at least the following sets of binaries: male vs. female, gender vs. class, human vs. animal, voyeur vs. object, sex vs. labour, submissive vs. subservient. Freud's interpretation privileges the first term of each binary, but what interests me are the range of differences managed and put in place by the mistaking of cleaning for sex, a work practice for an erotic position.

In their reading of the Wolfman case, Peter Stallybrass and Allon White implicitly relate Freud's obfuscation of class differences to a particularly Victorian imaginary that linked sexuality and cleanliness. Class differences are disguised and articulated as hygienic problems; a cross-class sexuality becomes a dirty sexuality. And the discursive occurrence of these displacements is marked by 'dirt':

> To become his parents' child, [the Wolfman] must forego those pleasures which he associated with serving maids (Grusha and Nanya) and with what would henceforth be named 'dirt.' He must distance himself from the subordinated classes even as he distanced himself from the physical processes and products of his own body.
>
> (Stallybrass and White, 1986: 167)

In 'Class and gender in Victorian England', historian Leonore Davidoff (1983) illuminates the connections between the pragmatic and symbolic particulars of this historically specific imaginary. Citing another cleaning scene, she underscores the role of cleaning practices in maintaining appropriate social significations of gender, class and sexuality in Victorian

culture. Victorian middle-class households, even 'those who could not afford any other domestic services', hired 'step girls' to scrub the threshold and the front steps of the house:

> Showing oneself uncovered and dirty in public was . . . considered especially degrading. In their memoirs, several servants emphasized the humiliation they felt at having to kneel (thus showing legs and petticoats) to scrub the front doorsteps and paths every morning, open to the stares of passersby, the whistles and importunings of men and boys.
>
> (Davidoff, 1983: 44)

Middle-class women simply could not perform such tasks in public. To do so would involve an absolute foreclosure of their identity in terms of both gender and class. If economic deprivation forces them to clean, they must do so hidden in the privacy of their homes. Davidoff notes that, beginning in the late eighteenth century, 'there was a continued effort to shift the manual work, or at least the heavier, dirtier tasks onto domestic servants' (1983: 23). The progressive separation of middle-class women from both 'work' and 'dirt' as inappropriate to their identity coincides with and mirrors the formation of the same illusory distinctions that divided private from public sphere. Significantly, the normative, and therefore implicitly prescriptive, criteria for appropriate bourgeois femininity are an actual or at least apparent distance from both dirt and work. These criteria, we can assume, are vital to the cultural developments which, as Nancy Armstrong has argued, institute gender as a primordial difference that overrides all transitory social differences (1987: 21).

Middle-class women's physical liberation from manual labour and the handling of dirt coincides with their developing role in 'controlling middle-class male sexuality' (and of course, the notion that they had none of their own to control). Lack of sexual control serves as a mark of the working class, native blacks and women who were not ladies (Davidoff, 1983: 21). In this symbolic schema, the division of women into two groups – 'ladies' and 'women' (or those who don't clean, don't work and aren't sexual, and those who do clean, do work and are sexual) – becomes mixed, Davidoff argues, with other racial, colonial and class polarities – 'white and black, familiar and foreign, home and empire' (1983: 21). This division also, very significantly, 'has much to do with new divisions of labor in the middle-class home' (1983: 23).

Although Davidoff does not specifically highlight this point, her argument implies the practical and symbolic force, indeed the necessity, of regulating who cleans and who doesn't, who is clean and who isn't, who works and who doesn't, in implementing a gender standard that would discreetly maintain and symbolize class and racial differences as well. We have only to look at the bourgeois home, the site of subject formation, to understand some of the processes whereby social differences are transformed into transcendent, ahistorical, symbolic differences like those that animate Freud's interpretation of Grusha's cleaning scene. In both its topography and its division of labour, the middle-class home institutes the servants' class

difference based on their practical and symbolic proximity to dirt, work and, implicitly, to sexuality and animality. Spatially, the servants are segregated from the family:

> The servants . . . lived and worked in the dark underground parts of the house or slept in the inaccessible, often spooky attics. Their territory was the 'back passages' (nursery euphemism for anus) where the working parts of the household machine were visible and where waste and rubbish were removed.
>
> (Davidoff, 1983: 27)

The servants' duties, as part of the household machine, include all activities that involve manual labour and dirt, the two things that the bourgeois woman must remain separate from:

> Their most important job was to remove dirt and waste: to dust; empty slop pails and chamber pots; peel fruit and vegetables, pluck fowl; sweep and scrub floors, walls and windows; remove ash and cinders; black lead grates; wash clothes and linen.
>
> (Davidoff, 1983: 44)

Cleaning – who does it and who doesn't, and the inverse but complementary, who is clean and who isn't – coordinates, aligns and regulates the significations of Victorian gender and class hierarchies such that the social, monetary and practical bases of these distinctions are difficult to perceive. All through her piece, Davidoff emphasizes that Victorian society understood class and racial difference in the public as well as the private sphere according to registers of cleanliness or the lack of it, control over sexuality or the lack of it, regulation of all forms of physical expression or the lack of them. These criteria, which are precisely those which regulate appropriate bourgeois femininity, naturalize racial and class inequality, by reading the signs of that inequality on the other's body. What is not accounted for is monetary and economic difference.

Scene 5: Hysterical cleaning and the abhorrence of exchange

> Defilement is what is jettisoned from the '*symbolic system*.' It is what escapes that social rationality, that logical order on which a social aggregate is based, which then becomes differentiated from a temporary agglomeration of individuals and, in short, constitutes a *classification system or a structure*.
>
> (Kristeva, 1982)

In a reading similar to Deleuze and Guattari's, Jane Gallop deconstructs the Dora case, another of Freud's interpretative narratives laced with the concerns about cleanliness, dirt, class and gender. Specifically, Gallop investigates the composite figure of the governess/maid/nurse as she relates to the 'mother' and to the question of transference. For Gallop, the maid's presence in the family constitutes the most pointed 'intrusion of the symbolic

into the imaginary', an intrusion that inscribes the 'economic' and 'extra-familial' on to the otherwise imaginary homogeneity and unity of the family (1982: 144). One of the illusory features of the psychoanalytic imaginary is precisely the assumption of a private sphere that encloses the family absolutely, that psychically constitutes and positions all its members outside of economic exchange.

The fallacy of this assumption, made manifest in the Dora case, surfaces in the figure of the mother. As Gallop puts it, 'they [Freud and Dora] think there is still some place where one can escape the structural exchange of women. They still believe that there is some mother who is not a governess' (1982: 147). She concludes, 'In feminist or symbolic or economic terms the mother/wife is in a position of substitutability and economic inferiority. For the analysis to pass out of the imaginary, it must pass through a symbolic third term . . . a term that represents a class' (1982: 148).

Gallop draws a comparison between the psychoanalyst and the governess or maid on the basis that both are paid for their services and dismissed from the family at the whim of their employer. This connection is one that Freud did not analyse, because in Dora's narrative, the governess is seduced and abandoned, a debased and dirty identification that Freud could not tolerate (Gallop, 1982: 147). Yet the case, both as Freud wrote it and as Gallop interprets it, contains another narrative of familial contamination, debasement and payment for services, articulated once again around a related confusion of sexual acts and cleaning practices.

One of the very few comments that Freud makes about Dora's mother is that she suffered from 'housewife's psychosis'. Felix Deutsch, an analyst who treated Dora after Freud, observed that this psychosis consisted 'of obsessional washings and other kinds of excessive cleanliness', mannerisms that Dora inherited from her mother. Deutsch remarks: 'Dora resembled her [her mother] not only physically but also in this respect. She and her mother saw the dirt not only in their surroundings, but also on and within themselves' (1957/1985: 41). Indeed, Dora's mother apparently died from cleaning too much: 'I learned from my informant . . . [S]he worked herself to death by her never-ending, daily cleaning compulsion – a task that nobody else could fulfill to her satisfaction' (1957/1985: 43).

Writing about the notion of heterosexuality that Dora received from her mother, Maria Ramas notes that it was 'equated with contamination and self-destruction'. Dora's father had almost certainly infected her mother with syphilis and Dora 'knew how he had become so . . . she understood that he [had led] a loose life' (1985: 159). Ramas then identifies another cleaning scene, left out of Freud's account, that shapes the obscure margins of the Dora case. In this scene, Kathe Bauer (Dora's mother) desperately, obsessively cleans her home to rid it of contamination: 'No one could enter the Bauer home without taking off his shoes; on Fridays and other occasions of "thorough" cleaning, the apartment had to be avoided altogether' (Rogow, quoted in Ramas, 1985: 160). Kathe Bauer kept certain rooms, for example, the one 'where Philip Bauer kept his cigars . . . locked at all times to ensure against contamination'. Ramas notes that 'Kathe

Bauer's permission was necessary' to enter these rooms, as 'she had the only key' (1985: 160).

In their readings of the Dora case, Freud, Ramas and Deutsch all either posit or accept a psychic relationship between sexual frigidity and obsessive cleanliness. Ramas qualifies this relationship by citing statistics on venereal disease which indicate that bourgeois women of the period had very real reasons to fear infection by their husbands (1985: 160). However, the relationship between sex acts and pathological cleaning remains assumed, yet untheorized, as does Kathe Bauer's cleaning scene. If we accept this assumed connection, the logic of Kathe Bauer's cleaning obviously depends on the home space standing for her body. She closes this space off for thorough cleaning, refuses to have shoes, that article of clothing that must make contact with the world outside the home, within it. As a consequence of her sexual, internal contamination, she enhances and emphasizes the difference between her home and what is outside it by cleaning. The confusion in this narrative is not between a sexual act and a cleaning act, but rather between two very different interiors – a maternal, sexual interior (the housewife's contaminated body) and a social one (the home or private sphere, characterized by familial relations untainted by economic exchange). While the Wolfman's confusion or mistake involves the mother/maid in a position of either sexual submission or economic subservience in relation to him and his gaze, Kathe and Ida Bauer's housecleaning combats both real (Kathe) and imagined (Ida) sexual contamination in a space that figures as a displacement of their own bodies.

The inferred but unmentioned figure in this cleaning scene is the prostitute. She, like the maid or governess, supplements the services provided (without pay) by the wife. The prostitute performs her domestic services outside of the home, yet in such a way that their effects can still penetrate it. She is, in a sense, the mirror image of Grusha, another vacuole in the phantasy of the closed family circle, but one that opens it up from without. Her sexual services threaten to 'dirty' or 'contaminate' otherwise secure and isolated private, domestic (female) bodies. In compulsively cleaning their homes to offset sexual contamination, both Kathe Bauer and her daughter metaphorically attempt to emphasize the difference between domestic space and the public world of economic exchange outside it. Their cleaning symbolically shores up the ultimately illusory distinction between the public exchange of women and its private variation, of which they are both the objects.

Freud and the Wolfman's mistaking of cleaning acts for sex acts, of maid for mother, reflects the in/difference, the stability of these systems (economic and libidinal) in relation to their positions in them; in both, they are master. Their confusion, occurring at a juncture of sex and cleaning, marks the perverse relation of these systems as they are inhabited and enabled by the bourgeois housewife. What she inhabits, mystifies and e/liminates is the connection, the overlap of the economic and libidinal economies whose distinction and difference, as institutionalized in public and private spheres, is vital to both the modern bourgeois imaginary and the social order that it dominates.

From Kathe Bauer's point of view, from Grusha's very different point of view, these narratives, these cleaning scenes are not about gender, not about sexuality in and of itself. Rather they are narratives about the crucial differences between women in terms of labour, status and class. For the proper woman, for the lady, everything hinges on there being a clean difference between public and private sexuality, between the bourgeois wife and the prostitute, between the wife and the maid. Everything hinges on the making of symbolic boundaries whose significance overrides the intimate proximities of bodily contaminations and other threatening erasures of social difference. Everything hinges on there being a difference within difference, a splitting of the feminine into a symbolic binary – clean and dirty – that organizes and naturalizes contingent, historically relative distinctions between women, such as their varied relations to money or to work. The obsessions with cleanliness and hygiene that arise in the modern period and that symbolically bolster the social division of gendered spheres provide normative, naturalizing and visible criteria for discriminations between women. A woman who must perform manual labour or cleaning, who must have explicit, public congress with dirt, reveals, in the effects of these practices on her body, her imposture as a lady. Class difference is absorbed within and masked by propriety, cleanliness and one's success or failure to assume the position of a lady. The ruse, finally, in the question of any difference is the implicit fantasy of ever determining a clean difference.

Coda: Lily-white hands and the odour of things

This article has been very difficult to clean up, finish up. Issues spill over. In American advertising for products like Bon Ami and Ivory soap, there is an insistence from the turn of the century up to the 1930s on the dilemma of 'wives who must do their own work'. For these women, non-abrasive, gentle cleansers are a necessity, because delicate, unblemished white hands are the indisputable mark of a lady (ladies don't work, don't clean, but if they must . . .). Margaret Mitchell uses this cultural truism to great effect in *Gone With the Wind* when Scarlett visits Rhett in jail, ostensibly for a social call, but actually because she desperately needs money. Attired in a dress made from velvet curtains, her face lightly painted, her charade of affluence is a tremendous success until Rhett, in a moment of tenderness, takes her hands to kiss them. They are calloused, the nails broken and dirty. 'You've been working like a field hand,' he says. Signs of work on a white woman's hands align her with racial and occupational degradation. And the emphasis on soft, white, lovely hands persists, lingers, even today.

With apologies to Mary Douglas, I would like to amend her statement to say 'Where there is dirt, there is difference'. Trivial cultural references to cleanliness, dirt, odour, to who cleans and who doesn't, frequently serve as ideological and, more important, practical shorthand to connote, naturalize and subtly devalue individuals marked as racial or class others. They become marked by their relation to cleaning or cleanliness. With two brief examples, I will close my essay:

In the collection of Lysol advertisements I examined, the latest I found for Lysol as a feminine hygiene product was also the only advertisement in the category addressed to African-Americans. Dated February 1959, it features a photograph of a middle-class African-American woman, dressed in a tailored suit, looking slightly worried. The copy touted, among other things, Lysol's effectiveness in controlling 'embarrassing odour'. Of all the advertisements that promoted Lysol as a feminine hygiene product, it was the only one to mention odour.

King Vidor's *Stella Dallas* (1937) structures its narrative about Stella's class rise and fall in part with motifs of cleaning. Stella intentionally impresses Stephen Dallas when she first meets him by insisting that she wipe his glass clean before he drinks from it. (She has, unbeknown to him, already observed him doing the same thing.) Their daughter Laurel, separated from her father and raised primarily by her mother, nevertheless takes after him. The film gives us this information by depicting Laurel, as a toddler in her highchair, wiping her tray clean with her bib. Stella laughs and says, 'She's the spit of her old man.' Laurel's cleanliness, fastidiousness in dress and innate reserve differentiate her from her mother in terms of their class proclivities. Stella's aspiration to the middle class fails. Laurel's will not, not because of her father's wealth, but because she is characterologically middle class. In the novel and film, the class difference between Stella and Steven becomes a difference in sensibility, delicacy and taste between Stella and her daughter Laurel. Stella admires the ostentatious, the vulgar; from a very young age, however, her daughter Laurel shuns ruffles and bows, preferring simple, austere, 'classic' lines. Her innate cleanliness designates her middle-class status as genetically bestowed, not acquired. Laurel is clean; her mother is not.

Notes

1 Special thanks to Erika Suderburg, Stephanie Hammer and Catherine Lui for their careful consideration of and suggestions about earlier versions of this article.

2 Many theorists have addressed psychic and semantic relations or identification between the grammatical subject and the discursive or symbolic subject. On the concept of enunciation and its application, see Benveniste, 1971: 206–8; Barthes, 1977: 107–9. The work of Jacques Lacan is predicated on the identification of these two subjects; see, for example, Lacan, 1977: 146–78.

3 Nancy Armstrong addresses the modern construction of gender through the vehicle of domestic fiction. Her introduction contains a fascinating account of this process that emphasizes the interaction of cultural, economic and political forces (Armstrong, 1987, especially pp. 3–27).

4 I thank Stephanie Hammer for the insight that the 'scent' is what verifies that the cleaning has really been done.

5 The D'Arcy Collection at the University of Illinois Communications Library has Lysol advertisements, collected from an array of magazine and newspaper sources, dating from 1917 to 1969. They are contained in a category labelled 'Household disinfectants and Bleaches misc., 1917–69'.

6 See also Lacan's provocative closure to 'Guiding remarks for a congress on feminine sexuality' in which, commenting on 'Feminine sexuality and society', he alludes to the particularly refined and cultured quality of groups of women (1982: 88–98).

7 Because of the moral slant of our popular culture, the 'slob/slut' type is usually only a bit player – as in Dana Andrew's first wife, played by Virginia Mayo, in *Best Years of Our Lives* (1946) or Paul Muni's wife in *I Am a Fugitive from a Chain Gang* (1932). The construction of this type is used melodramatically in King Vidor's 1937 version of *Stella Dallas* when Stella is mistakenly assumed to be sexually 'loose' in a scene immediately following one where her house is depicted as untidy. *Craig's Wife* (1936) is the exemplary instance of the frigid obsessive type.

8 See, for example, Freud's comments in 'Femininity' (1933/1953–74, v xxii: 120).

9 The bourgeois claim against the aristocracy and its values is to a spiritual, moral interiority that overrides or obviates class hierarchy based on lineage and property. Hard work and an austere morality comprise the worth of the individual, not his family background. The figure of the individual is crucial both to the successful rise of the bourgeois and the universalization of middle-class ideas and values. For two related discussions of this social transformation, see Ian Watt's *The Rise of the Novel* (1957) and Nancy Armstrong's insistence on the importance of gender to its functioning (1987).

10 Many theorists and social historians note the ways Freud repressed class issues in the family romance by glossing over the social implications of the maid's or governess's presence in the bourgeois home. See Peter Stallybrass and Allon White's discussion (1986: 163–5); Jane Gallop (1982: 142–8); and Gilles Deleuze and Felix Guattari (1983: 352–5).

11 Stallybrass and White, who analyse this scene in terms very similar to mine, but with very different emphases (gender is less important to them than the productive effects of transgression in the maintenance of the social order) comment on the Wolf Man's name: 'Rat Man and Wolf Man, for instance, find their metaphorical proper names not in an unmotivated raid upon the taxonomic categories of rodents and mammals, but in the terrors conjured up by semantic material from cultural domains (the slum, forest) extraterritorial to their own constructed identities as socio-historical subjects' (1986: 196).

References

Armstrong, Nancy (1987) *Desire and Domestic Fiction*, Oxford: Oxford University Press.

Barthes, Roland (1977) 'Introduction to the structural analysis of narratives', in *Image Music Text*, trans. Stephen Heath, New York: Hill & Wang.

Benveniste, Emile (1971) *Problems in General Linguistics*, trans. Mary Elizabeth Meek, Coral Gables: University of Miami Press. (Originally published 1968.)

Cixous, Helene and Clement, Catherine (1986) *The Newly Born Woman*, trans. Betsy Wing, Minneapolis: University of Minnesota Press. (Originally published 1975.)

Davidoff, Leonore (1983) 'Class and gender in Victorian England', in Judith L. Newton, Mary P. Ryan and Judith R. Walkowitz (eds) *Sex and Class in Women's History*, London: Routledge & Kegan Paul.

Davis, Angela Y. (1983) *Women, Race & Class*, New York: Vintage Books.

Deleuze, Gilles and Guattari, Felix (1983) *Anti-Oedipus: Capitalism and Schizo-phrenia*, trans. Robert Hurley, Mark Seem and Helen R. Lane, Minneapolis: University of Minnesota Press. (Originally published 1972.)

Deutsch, Felix (1985) 'A footnote to Freud's "Fragment of an analysis of a case of hysteria"', in Charles Bernheimer and Claire Kahane (eds) *In Dora's Case: Freud-Hysteria-Feminism*, New York: Columbia University Press. (Originally published 1957.)

Douglas, Mary (1988) *Purity and Danger*, London: Routledge & Kegan Paul. (Originally published 1966.)

Freud, Sigmund (1953–74) *Civilization and its Discontents, The Standard Edition of the Complete Psychological Works*, v xxi, trans. and ed. James Strachey, London: Hogarth Press. (Originally published 1930.)

—— (1953–74) 'Femininity', in *New Introductory Lectures, The Standard Edition of Collected Works*, v xxii, trans. and ed. James Strachey, London: Hogarth Press. (Originally published 1933.)

—— (1960) *Three Case Histories*, New York: Macmillan Publishing Co. (Originally published 1909.)

—— (1963) *Dora: An Analysis of a Case of Hysteria*, New York: Macmillan Publishing Co. (Originally published 1905.)

Gallop, Jane (1982) 'Keys to Dora', in *The Daughter's Seduction*, Ithaca: Cornell University Press.

Kristeva, Julia (1982) *Powers of Horror: An Essay on Abjection*, trans. Leon S. Roudiez, New York: Columbia University Press. (Originally published 1980.)

Lacan, Jacques (1977) 'The agency of the letter in the unconscious', in *Ecrits: A Selection*, trans. Alan Sheridan, London: Tavistock. (Originally published 1966.)

—— (1982) 'Guiding remarks for a congress on feminine sexuality', in *Feminine Sexuality*, trans. Jacqueline Rose, New York: W. W. Norton.

Mitchell, Margaret (1936) *Gone With the Wind*, New York: Macmillan.

Ramas, Maria (1985) 'Freud's Dora, Dora's hysteria', in Charles Bernheimer and Claire Kahane (eds) *In Dora's Case: Freud-Hysteria-Feminism*, New York: Columbia University Press.

Reynolds, Reginald (1943) *Cleanliness and Godliness*, London: Allen & Unwin.

Stallybrass, Peter and White, Allon (1986) *The Politics and Poetics of Transgression*, Ithaca: Cornell University Press.

Watt, Ian (1957) *The Rise of the Novel*, Berkeley: University of California Press.

Wilde, Oscar (1968) 'The decay of lying', in *Literary Criticism of Oscar Wilde*, Lincoln: University of Nebraska Press.

FILMS

The Central Character (1982) Dir. Patricia Gruben.
Stella Dallas (1937) Dir. King Vidor.

P. G. KNIGHT

NAMING THE PROBLEM: FEMINISM AND THE FIGURATION OF CONSPIRACY

ABSTRACT

This article takes as its starting point Naomi Wolf's claim that the argument of *The Beauty Myth* (1991) does not amount to a conspiracy theory. In order to understand what might cause her rhetorical insistence, the figuration of conspiracy is traced through the trajectory of popular American feminism from Betty Friedan to Wolf. A reading of *The Feminine Mystique* (Friedan, 1992) demonstrates its reliance on the cold war language of brainwashing, as well as a conspiracy theory of mass culture, in its description of being a housewife in the early 1960s. If the language of conspiracy provides Friedan with a metaphor which highlights the political dimension of personal experience, then an analysis of some of the feminist groupings later in the decade reveals an increasing literalization of the figure. A discussion of Mary Daly's *Gyn/Ecology* (1984) provides the next key moment, leading to the observation that during the 1970s and 1980s the emphasis in popular feminism shifted from 'naming the problem' to the problem of naming. A close reading of the rhetorical strategies of *The Beauty Myth* indicates that Wolf's text marks a crisis point over the distinction between the literal and the metaphorical, centred on the notion of conspiracy. It emerges that what this textual anxiety points to is a deeper division between academic and popular feminism. In effect, this article argues that feminist cultural studies should seek to read popular feminism in a fashion similar to its engagement with popular culture.

KEYWORDS

conspiracy theory; American popular feminism; figuration

Having outlined in the Introduction to *The Beauty Myth* the 'now conscious market manipulation' of the diet, cosmetics, and pornography industries, Naomi Wolf insists that 'this is not a conspiracy theory' (1991: 17–18). And, having described how the 'ideology that makes women feel "worth less" was urgently needed to counteract the way feminism had begun to make us feel worth more', she then announces that this view 'does not require a conspiracy'. Likewise, in the Introduction to *Backlash*, the

book that consolidated the analysis of contemporary anti-feminism started in *The Beauty Myth*, Susan Faludi performs a similar rhetorical manœuvre. Having just given a brief overview of the many elements of the 'backlash' that her book is to deal with, she then warns the reader that 'the backlash is not a conspiracy' (1991: xxii).

This article explores why writers like Wolf and Faludi should insist so strongly that their analysis does not amount to a conspiracy theory. Metaphors of conspiracy, I want to argue, have played an important role within a certain trajectory of popular American feminist writing over the last thirty years in its struggle to come to terms with – and come up with terms for – what Betty Friedan famously called the 'problem with no name'. On the one hand, conspiracy tropes have been crucial not only in organizing questions of blame, responsibility and agency, but also in linking the personal and the political in one transcoding metaphor around which a women's movement might coalesce. On the other hand, the language of conspiracy establishes a series of implicit divisions within American feminism. Conspiracy theory, I will suggest, can become the site of an unspoken intellectual elitism, producing a situation in which 'academic' (cultural studies) feminism ignores, repudiates and contains its 'popular' other, by which I mean that tradition of feminism typified by writers like Betty Friedan and Naomi Wolf.[1] First, I will discuss Friedan's *The Feminine Mystique*, then trace through the gradual literalization in the use of conspiracy metaphors in the following two decades, before returning in the final section to an analysis of Wolf in the 1990s.

The problem with no name

The Feminine Mystique was an immediate success, staying on the *New York Times* bestseller list for nearly two years. Its popularity was no doubt due in part to its lively style: in many places the book reads like a thriller, with Friedan as the lone detective chasing up the clues to the mysterious mystique. She describes how she listened to middle-class housewives talking about their dissatisfactions with married life, until 'gradually I came to realize that the problem that has no name was shared by countless women in America' (1992: 17). At the end of her first foray into suburbia, for example, she writes that:

> I reported back to my [psychoanalyst] guide and said that while all four seemed 'fulfilled' women, none were full-time housewives and one, after all, was a member of his own profession. 'That's a coincidence with those four', he said. But I wondered if it *was* a coincidence.
>
> (1992: 205)

As the search continues, so the little voice of doubt – presumably the one which also speaks to Raymond Chandler's Philip Marlowe – becomes more insistent as the pieces of the puzzle fit together:

> These were fine, intelligent American women, to be envied for their homes, husbands, children, and for their personal gifts of mind and spirit.

Why were so many of them driven women? Later, when I saw this same pattern repeated over and over again in similar suburbs, I knew it could hardly be a coincidence.

(1992: 207)

Friedan reads coincidences as signs of a conspiracy. She finds 'many clues by talking to suburban doctors, gynaecologists, obstetricians, child-guidance clinicians, pediatricians, high-school guidance counsellors, college professors, marriage counsellors, psychiatrists, and ministers' (1992: 28). What the clues reveal is a concerted effort by welfare, educational and media institutions to manipulate women in the postwar period into returning to a life of domesticity, despite the gains which Friedan attributes to the 'first wave' of late Victorian and early twentieth-century feminism.

In trying to 'fit together the puzzle of women's retreat to home' (1992: 181), Friedan develops the notion of the feminine mystique. It amounts to a devastating ideology, part of a cunning and ruthlessly efficient programme to persuade women to forgo self-fulfilment through careers in favour of home-making and child-rearing. Friedan describes, for example, how 'Freudian theories were used to brainwash two generations of educated American women' (1992: 109). Even more disturbing, the 'feminine mystique has brainwashed American educators' (1992: 155), those very college professors who themselves brainwashed their women students into expecting no more than a home and a husband out of life.

In developing an account of a conspiracy to brainwash American women into domesticity, Friedan draws on one of the key terms of cold war politics. The word (which is a translation of a Chinese phrase) came into popular usage in the USA in the wake of the scandal that only Americans among the Allied troops captured in Korea had apparently succumbed to the enemy programme of propaganda and indoctrination. Although a US Army report on the incident concluded that it was mainly poor morale that accounted for the disproportionate rate of collaboration in the American contingent, it was popularly believed that brainwashing must be a deadly, efficient technique of psychological warfare (Brown, 1963/1983; Bromley and Richardson, 1980). The term conferred a scientific legitimacy on suspicions that no American soldier in his right mind would wittingly choose the alien ideology of Communism; the only thing that could account for the shocking sight of American servicemen cooperating with the enemy was the belief that their minds had been taken over by force. The concept of brainwashing became popularized in novels and films such as *The Manchurian Candidate* (1959/1962), which portrayed the assassination of a presidential candidate by a brainwashed US Army officer.

In *The Feminine Mystique* the idea of brainwashing creates a picture of women as innocent victims of a scientific process of mind-manipulation by external forces. Friedan describes 'American housewives around forty [who] have the same dull lifeless look' (1992: 222); similarly, she writes about the 'vacant sleepwalking quality in a thirteen year-old girl in a Westchester suburb', a zombified child who acted 'like a puppet with

someone else pulling the strings' (1992: 246). These descriptions were familiar from accounts of the brainwashed soldiers in Korea. In the same way that accounts of brainwashing in Korea played down un-American leanings, so too does Friedan's book imply that any undesirable beliefs which would seem contrary to the best interests of women (as defined by Friedan) must have been planted into their brains by the feminine mystique. Although Friedan seems to open up the possibility that women might have complicitous and 'politically incorrect' desires, the notion of external infiltration in fact serves only to confirm her faith in the fundamental innocence and rationality of women. 'It is easy to see the concrete details that trap the suburban housewife,' Friedan writes, 'but the chains that bind her in her trap are chains that are made up of mistaken ideas and misinterpreted facts, of incomplete truths and unreal choices' (1992: 28). The feminine mystique, on this view, is merely a set of false beliefs, which can easily be set straight once the relevant facts are produced. Not only is lengthier education conducive to more and better orgasms, Friedan claims, but it is the only thing that will really break these mind-forged manacles. Although she may be infiltrated by bad ideas, for which the media, the psychologists and the professors are to blame, the American housewife is still fundamentally her own woman: such is the hidden persuasion of *The Feminine Mystique*.

Yet at crucial moments in Friedan's text this conspiracy scenario – which relies on a clear separation of inside and outside, self and other, victim and perpetrator – becomes compromised. If a woman is brainwashed into the false ideals of the feminine mystique by external influence, Friedan suggests, then she could also be conditioned into accepting a 'new identity'. The concluding chapter of *The Feminine Mystique* adopts the imagery of brainwashing in its proposals for the creation of the New Woman: 'drastic steps must now be taken to re-educate the women who were deluded or cheated by the feminine mystique'; there is also talk of 'a concentrated six-week summer course, a sort of intellectual "shock-therapy" ' (1992: 323–4). If positive images of femininity as much as negative ones are to be implanted from without, then there is precious little left that could constitute an essential core of authentic personality.[2]

In a similar fashion, Friedan acknowledges that 'a mystique does not compel its own acceptance', suggesting that there must have been some form of collaboration:

> For the feminine mystique to have 'brainwashed' American women of nonsexual human purposes for more than fifteen years, it must have filled real needs in those who seized on it for others and those who accepted it for themselves. . . . There were many needs, at this particular time in America, which made us pushovers for the mystique: needs so compelling that we suspended critical thought.
>
> (1992: 160)

The scare quotes around 'brainwashed' signal an awareness that the idea of mind-manipulation is, after all, only a metaphor. The rigid conspiratorial division into Them and Us cannot be maintained, and Friedan must instead

look to an account of the hegemonic orchestration of women's needs and desires. But these needs are 'so compelling' that 'critical thought' is suspended, making the acceptance of the feminine mystique a seduction scene in which a woman's desires are so intense that she is no longer able to think straight: she becomes a 'pushover', an easy conquest. In this way Friedan's rhetoric works repeatedly contain the dangerous possibility that women may be cooperating with the enemy, by the implicit reassertion of a picture of women as victims of a male conspiracy.

Though at times in danger of undermining itself, Friedan's appropriation of the cold war language of a brainwashing conspiracy does succeed in producing a transcoding metaphor which conjoins the 'personal' aspect of women's lives to the 'political' realm of national issues. This strain of imagery produces an account of sexual politics which reinterprets all aspects of personal experience into a coherent causal story of patriarchal institutions conspiring to keep women trapped in domesticity. In many ways, then, Friedan's appropriation of cold war scenarios formed a breakthrough for feminism in its recognition of the political dimension of personal experience.

What makes her use of these culturally available narratives even more problematic, however, is that at the same time that *The Feminine Mystique* borrows from a Hollywood version of cold war politics, it also develops an attack on the culture industry. Nowhere does Friedan revel more in the narrative technologies of the thriller than in the chapter in which she gains access to the secret files of an advertising agency boss. Friedan states clearly whom she holds responsible for the brainwashing of women. Contrary to what we might expect (given the vehemence of her attack on Freud), 'the practice of psychoanalysis . . . was not primarily responsible for the feminine mystique'. 'It was', she declares, 'the creation of writers and editors in the mass media, ad-agency motivation researchers, and behind them the popularizers and translators of Freudian thought' (1992: 111).

In seeking to lay the blame for social ills on a deliberate conspiracy by the practitioners and managers of the culture industry, Friedan participates in the line of analysis developed by the Frankfurt School and anti-Stalinist intellectuals such as Dwight MacDonald. More specifically, Friedan draws on Vance Packard's *Hidden Persuaders*. Like Packard, she is horrified at the potential power advertisers wield in shaping the hearts and minds of consumers. Where Packard emphasizes the clinical efficiency of the 'ultramodern techniques' of 'Motivation Research' (which turn out to be no more than crass Freudian generalizations), so Friedan, as we have seen, lends a patina of scientific credibility to her argument with the adoption of the language of brainwashing. And just as Packard seems to believe every single claim about the efficacy of advertising made by the 'admen' in their trade magazines, so too does Friedan repeat as fact the comments that are made to her 'in confidence' by an anonymous source in the advertising industry: both are in effect duped by the industry's own promotion of its influence.

Friedan emphasizes the gendered separation of agents and victims, with her account, for example, of the systematic collaboration between the

advertising industry and the editors of women's magazines. She is in no doubt as to the effectiveness of the advertising agency/women's magazine conspiracy to brainwash women:

> It all seems so ludicrous when you understand what they are up to. Perhaps the housewife has no-one but herself to blame if she lets the manipulators flatter or threaten her into buying things that neither fill her family's needs nor her own. But if the ads and commercials are a clear case of *caveat emptor*, the same sexual sell disguised in the editorial content of a magazine or a television programme is both less ridiculous and more insidious. Here the housewife is often an unaware victim.
>
> (1992: 202)

Though tempted to blame women for (literally) buying into the feminine mystique, Friedan is ultimately concerned to point out how the devious advertising campaigns are targeted specifically against women. The crowning moment of realization in *The Feminine Mystique* comes with the discovery that during the postwar period of rapid suburban expansion women spent three-quarters of the household budget. Friedan therefore asks pointedly, 'why is it never said that the really crucial function, the really important role that women serve as housewives is *to buy more things for the house*?' (1992: 181). *The Feminine Mystique* works against the familiar alignment of mass culture with femininity, with its argument that women are not so much in league with the culture industry as the victims of its brainwashing campaigns.

Despite the insistence with which this case is made, Friedan repudiates the logic of conspiracy in a fashion similar to the disavowals by Wolf and Faludi. Halfway through the book, Friedan finally fits the last piece of the puzzle together, realizing that 'somehow, somewhere, someone must have figured out that women will buy more things if they are kept in the underused, nameless-yearning, energy-to-get-rid-of-state of being housewives' (1992: 181). Just in case we might begin to expect a place, date and face to be fitted to that anonymous 'figuring out', Friedan cautions us that 'it was not an economic conspiracy directed against women'. Similarly, having spelled out the insidious uses to which pseudo-Freudian theories were put in 1950s America, Friedan disavows the possibility that they amount to a conspiracy. 'It would be ridiculous,' she admonishes the reader, 'to suggest that the way the Freudian theories were used to brainwash two generations of educated American women was part of a psychoanalytical conspiracy' (1992: 109).

But why is Friedan so adamant in rejecting the notion of a conspiracy? Her vehemence must be read in part as a rhetorical manœuvre to bring under control the figurative language through which her argument has proceeded. In other words, she must insist that it would be 'ridiculous' to believe in a conspiracy theory, precisely because her text has already opened up that possibility. It must also be noted that for left-liberal intellectuals in the post-McCarthy – but pre-Kennedy assassination – context in which *The Feminine Mystique* was written, conspiracy theories were still the mark of

an unacceptable political demonology (Hofstadter, 1967; Rogin, 1988). Perhaps also motivating Friedan's explicit rejection of conspiracy is an awareness that her analysis of the political dimension of women's personal experience was in danger of not being taken seriously as a work of scholarship. Not only does Friedan excoriate the culture industry, but she also seeks to avoid contamination by mass cultural forms and figures in her own text. The book opens up the possibility of a conspiracy theory of sexual politics, only for that conclusion to be denied. In summary, then, we might say that *The Feminine Mystique* offers an account of what would come to be known as patriarchy *as if* it were a conspiracy, without ever fully cashing out the metaphor into literal fact.

The language of conspiracy

In the decades following *The Feminine Mystique*, however, the various figurations of conspiracy in popular feminist writing increasingly became statements of fact. In her survey of 'proto-feminist' fiction of the 1960s, Paulina Palmer (1989) endeavours to account for the prevalence of conspiracy images in the writing of that period. She does this by confirming – in a tone which combines historical authority and confessional intimacy – the accuracy of those figurations of 'what many women feel living in a phallocratic culture'. 'There can be few women,' she asserts, 'who, at some time or other in their lives, have not experienced the frightening sense of being trapped in a conspiracy of male domination' (Palmer, 1989: 69). But, in a similar fashion to Friedan's retractions, having asserted that most women in early 1960s suburbia had the experience of living in a conspiracy, Palmer goes on to acknowledge that 'in material terms this notion of a "conspiracy" may be a simplification and exaggeration'. Potentially simple-minded and exaggerated, the notion of conspiracy in the early 1960s was perhaps, in Palmer's words, no more than 'a projection of imaginative reality', a metaphor which merely gestured towards women's experience. Yet, having set out such a characterization of the trope of conspiracy, she immediately performs a double-take, suggesting that 'it may not be, in fact, the exaggeration which it first appears'. Palmer's tergiversations between a literal and metaphorical understanding of conspiracy imagery map out in miniature the convoluted development of feminist debates on figuration in the decades following Friedan's first book.

In the late 1960s, some feminist writers were concerned not merely to express their experience, but to present a coordinated account of What Was Really Going On: the task was not so much to name the problem as to name the oppressor. Conspiracy and its related tropes became a focus of debate between feminist groupings in the question of who or what was basically to blame for 'the oppression of women'. The three most cited candidates were, as the analysis of the time framed it, individual men, women in complicity with male institutions, or 'the system'. In the late 1960s these possibilities were articulated, for example, with the formation, fragmentation and repositioning of various radical feminist groups, which defined their

differences through their manifestos. Groups such as Cell 16 of Boston and The Feminists of New York favoured talk of conditioning and internalized oppression, employing a vocabulary of brainwashing, self-surveillance, infiltration, complicity and double agency to account for why women seemed to believe in and conform to stereotypes of their inferiority and submissiveness. What became known as the 'pro-woman' line, on the other hand, explicitly rejected such conspiracy-minded psychological talk in favour of 'external' factors, thereby removing blame from individual women. For example, the Redstockings, a break-away group from the NYRW, declare in their 1968 manifesto that 'women's submission is not the result of brainwashing, stupidity or mental illness but of continual, daily pressure from men' (1968: 533–6). If women seem to collaborate with their oppression, 'pro-woman' feminists like the Redstockings maintained, it is only because they are reluctantly forced through circumstance into making complicitous compromises in order to survive. In the manifesto they go on to argue that:

> Attempts have been made to shift the burden of responsibility from men to institutions or to women themselves. We condemn these arguments as evasions. Institutions alone do not oppress; they are merely tools of the oppressor.

In effect, then, the Redstockings aimed to replace the abstract and metaphorical language of brainwashing with a particularized and literal naming of the enemy. By this logic, believing anything less played into the oppressor's hands.

What made these debates about the figuration of patriarchy even more fraught, however, was the increasing suspicion that women's groups had been infiltrated by real double agents. So, for example, when in the autumn of 1968 the NYRW began to disintegrate, some of the original members, feeling that their former tight-knit camaraderie had in fact been deliberately undermined, began to talk about the presence of *agents provocateurs* and double agents. Patricia Mainardi, a member of the inner circle of NYRW who went on to form the Redstockings, looked back on those meetings in an interview during the late 1980s:

> As the movement grew, so did the number of women whose commitment to the women's liberation movement was more tenuous. Your feeling was that these were people who were there to stop anything from happening. I would not be the slightest bit surprised [to discover] that there were agents and reactionaries there.

> (Echols, 1989: 99)

Radical feminists thus had to confront the possibility that the very meetings in which discussion of the conspiracy of patriarchy was on the agenda were themselves subject to the all-too-literal conspiracies of the CIA and FBI. When the Redstockings re-formed in 1973 (after an absence of several years), they devoted much of their energy to denouncing what they now saw as a liberal plot to take over the radical feminist movement. The

desire to construct what had gone wrong in the 1960s in terms of a literal, personalized conspiracy reached its apotheosis when the Redstockings began to accuse Gloria Steinem and *Ms.* magazine of being involved with the CIA (Echols, 1989; Willis, 1984). Talk of the literal surveillance carried out under COINTELPRO (the government's conspiratorial counter-intelligence programme) thus coexisted uneasily with a more metaphorical understanding of hegemony as a form of complicitous self-surveillance.

Much feminist writing of this time finds itself caught between a desire to create a new set of terms, and a need to continue to appropriate the language and ideas of an older, more literal and more male-identified form of political activism. The problematic engagement with the language of conspiracy takes place within a wider struggle during the 1960s over an appropriate language for feminism. Where some women sought to expunge all trace of a male-identified political vocabulary, others enacted a satirical appropriation of that language. Injecting a measure of humour and anarchic confusion into an already tense situation was the formation in the late 1960s of groups like WITCH (Women's International Terrorist Conspiracy from Hell) and Lavender Menace. The formation of WITCH in the summer of 1968 by Robin Morgan and Florika of NYRW can be read partly in response to the success of the Yippies. One of WITCH's first actions, for example, was to put a 'hex' on Wall Street, recalling Abbie Hoffman's throwing money at the Stock Exchange the previous year. WITCH's formation and choice of name was also an ironic yet serious allusion to the Conspiracy, aka the Chicago Seven, the group of activists who were at this time on trial before the House Un-American Activities Committee (HUAC) for allegedly inciting a riot at the 1968 Democratic Convention. The HUAC was brought back into the limelight for the first time since the McCarthy years as part of the government's heavy-handed attempt to break the power of the increasingly militant movement. Referring to the fact that the HUAC had not included any women in the subpoenas to appear before the Committee – a list which included Abbie Hoffman and the founder of the Yippies, Jerry Rubin – Ros Baxandall of WITCH asked, 'How come we, the real subversives, the real witches, aren't being indicted?' (Echols, 1989: 97). Her question is both a demand to be taken seriously by the exclusive all-male club of 'real subversives', and an insistence that the 'metaphorical' conspiracy of feminism would in the long run be more subversive than the macho posturings of what Baxandall referred to as the 'boy's movement'. In this way, the rhetoric and rationale of WITCH provided both a mocking debasement of the conspiracy mania of the masculinist New Left, and an implicit recognition that repressive government policies were once again being mobilized under the justification of 'counter-subversion' in cases like the trial of the Chicago Seven. Similarly, though most of their street actions consisted of merry pranksterism, WITCH were also quick to announce in a more serious vein that 'WITCHes must name names, or rather we must name trademarks and brand names' (WITCH, 1970: 545–50). Joking talk of conspiracy coexisted uneasily with a literal desire to name names.

The formation of Lavender Menace tells a similar story of the parodic appropriation of the rhetoric of conspiracy at the turn of the decade. A group of lesbian feminists staged a disruptive protest at the 1970 Congress to Unite Women, adopting the tactic of embracing many of the accusations made against lesbianism by liberal feminists and those outside the movement. They called themselves the Lavender Menace in response to a comment made by Betty Friedan at this time about the potential infiltration of lesbians – a 'lavender menace' – within the women's movement. Satirically confirming the charges made against them, they declared in their first resolution that 'Women's Liberation is a lesbian plot' (Echols, 1989: 214–15). The formation of Lavender Menace served to materialize the demonological fears of feminists like Friedan, ensuring that, as one of their slogans put it, 'I am your worst fears / I am your best fantasy'. Within the feminist movement at the beginning of the 1970s, then, groups like WITCH and Lavender Menace turned the language of conspiracy back against its originators (both macho revolutionaries and liberal feminists), disrupting the distinction between the literal and the metaphorical.

The conspiracy of language

If the breakup of radical feminism towards the end of the 1960s was in part marked by a parodic recycling and deflation of the language of conspiracy, the emergence of cultural feminism in the 1970s was caught up in an inflationary circuit of literalness which saw the notion of patriarchy as a conspiracy solidified into factual statement. And whereas some radical feminists had countenanced the possibility that women could be conditioned (brainwashed) into collaboration with patriarchal institutions, cultural feminists maintained the position that all men are entirely guilty of creating a conspiracy to control women, who are all innocent victims.

Probably the most influential proponent of this position is Mary Daly (1978/1984). In *Gyn/Ecology* Daly makes it clear that America – and perhaps the whole world – is organized by a male supremacist conspiracy. She insists that being logical 'would require that we admit to ourselves that males and males only are the originators, planners, controllers, and legitimators of patriarchy' (1978/1984: 29). For Daly, 'the fact is that we live in a profoundly anti-female society, a misogynistic "civilization" in which men collectively victimize women' (1978/1984: 29). No detail of social arrangement is accidental, as Daly goes on to declare that 'within this society it is men who rape, who sap women's energy, who deny economic and political power'. Patriarchy 'appears to be "everywhere"': not only have 'outer space and the future . . . been colonized', but patriarchal control 'is also internalized, festering inside women's heads, even feminist heads' (1978/1984:–1). In *Gyn/Ecology*, the conspiracy of male power is total.

Daly repeatedly insists on the brutal facts of patriarchal power. She explicitly counsels against collapsing a literal understanding of the male-supremacists' plot back into metaphorical talk of abstract forces:

women – even feminists – are intimidated into Self-deception, becoming the only Self-described oppressed who are unable to name their oppressor, referring instead to vague 'forces', 'roles', 'stereotypes', 'constraints', 'attitudes', 'influences'. This list could go on. The point is that no agent is named – only abstractions.

(1978/1984: 29)

Despite Daly's insistence on literal facts instead of abstractions, *Gyn/Ecology* is often densely metaphorical. The book forms a remarkable attempt to escape through linguistic creativity from what Daly considers to be the 'mind-poisoning' of patriarchy, which has even infected the women's movement. 'This book,' states Daly, 'can be heard as a Requiem for *that* "women's movement", which is male-designed, male-orchestrated, male-legitimated, male-assimilated' (1978/1984: xvi). Daly endeavours to create not just a new form of woman-centred politics, but a new form of feminist language which is not designed, orchestrated or legitimated by men. Whereas earlier feminists like Friedan were concerned to identify the problem with no name, Daly comes to see naming itself as the problem. For Daly, then, what is significant is that women are 'unable to *name* their oppressor' (1978/1984: 29, emphasis added). The point is, Daly warns, 'no agent is *named*'; and recognizing that patriarchy amounts to a conspiracy requires not only 'the courage to be logical', but also 'the courage to *name*'. Literally naming the agents of patriarchy therefore becomes an important act in itself.

The emphasis on finding the right words and naming things for what they are is crucial to Daly's project, for she portrays language itself as a patriarchal trap. In addition to her use of the language of conspiracy, Daly turns her attention to the conspiracy of language. She writes about the 'hidden agendas concealed in the texture of language', going on to argue that 'deception is embedded in the very texture of the words we use, and here is where our exorcism can begin' (1978/1984: 3). Daly uses various strategies in her campaign to combat the conspiracy of patriarchal language. One method is to revalorize the very terms which have been used against women. Daly takes the figure of witches, for example, and turns the negative associations of the word into a positive model for feminist activity. Daly aims to rewrite the 'deception plotted by the male-supremacist scriptwriters' by (re)creating a new mythology – a new plot – for 'Lesbians/Spinsters/Amazons/Survivors' (1978/1984: 20). Unlike the playfulness of WITCH, however, Daly always takes her reappropriation of the term seriously.

A second tactic is the creation of woman-centred counterparts for male terms and characteristics. In place of men's 'own paranoid fears' (1978/1984: 29), for example, Daly offers the notion of 'pronoia', or positive paranoia, which she defines as 'seeing/making new patterns of perception as preparation for the latter/deeper stages of Journeying' (1978/1984: 401). 'Pronoia' is just one of the countless new coinings Daly employs in *Gyn/Ecology*. Her prose is shot through with a series of neologisms, which aim to bring about in miniature a disassembly and

recombination of the patriarchal conspiracy. As Meaghan Morris (1988) argues, Daly's emphasis on the individual sign forecloses discussion on the effects of discourse as a whole. In addition to new words, Daly also concentrates on the etymology of key terms. Her analysis, however, is often directed less to the deep cultural histories embedded in certain words than to the surface appearance and literal inclusion of particular syllables. 'Manipulation', for example, reveals within itself the word 'man'. Daly's emphasis on particular signifiers results in a shift towards a 'literal-minded' view of language in the 1970s, in which individual words can come to cause social effects.

This concern with the material and the literal effects of representation has been fundamental to the campaigns against rape and pornography which began to dominate feminist activism from the late 1970s. The literature on these topics is too large for me to analyse in detail here, but I want to outline a few important issues which arise from these interlocking campaigns. The first is that the logic of conspiracy became indispensable to the analysis of rape, in books such as Susan Brownmiller's *Against Our Will*. Brownmiller defined rape as the 'conscious process of intimidation by which *all men* keep *all women* in a state of fear', establishing a Manichean division of society into men who are all guilty and women who are all victims (1975: 14-15). In an analogous fashion to the way belief in a lone gunman in the Kennedy assassination was superseded by analyses of systematic conspiracy in American society, feminist analyses of rape began to describe it as the 'all-American crime', and as the principal fact of patriarchy which ensures 'the perpetuation of male domination over women by force' (Griffin, 1970: 3–22; Brownmiller, 1975: 209). In addition, the cold war paranoid figuration of bodily invasion, infiltration and contamination returned as literal descriptions, as the female body became not a displaced metaphor for the political, but the very site of politics itself. Whereas the language of conspiracy in feminist writings of the early 1960s formed an appropriation and reconfiguration of contemporary political scenarios, its use by feminists in the 1980s produced disturbing echoes of long since discredited sexual and national politics.

The second point is that pornography became theorized not just as a representation of an act of violent sex, but as a violent act in itself. In this way the distinction between the literal and the metaphorical was strategically collapsed, thus producing an insistence that pornography is not just like rape, but is rape itself; and that rape is not just like violence, but is violence itself. Once again, naming becomes a political act. As Andrea Dworkin comments in the introduction to her book on pornography, a man 'actively maintains the power of naming through force and he justifies force through the power of naming' (1981: 18). By the 1980s, then, the issue of naming the problem had been replaced by the problem of naming, an issue which has become crucial to the discussions of whether 'date rape' counts as 'real' rape.

Finally, the emphasis on the causal power of pornography to incite men to violence – a view summed up by Robin Morgan's slogan, 'pornography

is the theory, and rape is the practice' – in effect marked a return to a conspiracy theory of mass culture, except that now it was men rather than women who were the duped and robotic consumers of ideological messages. Andrew Ross, in his study of intellectuals and popular culture, argues that during the 1980s 'the vestigial Cold War opposition between the advanced minority of an "adversary culture" and the monolithically victimized mass was being played out by the new feminist intellectuals', leading to the 'moral panic and conspiracy mania that are shared features of the discourses of both anticommunist and antiporn intellectuals' (1989: 186–8). In the anti-rape and anti-porn campaigns, then, the language of conspiracy and a conspiracy theory of representation became intertwined, producing a disconcerting return to earlier formulations in the discourse of paranoia.

Crying wolf

I now want to return to *The Beauty Myth*, in order to show how the debate over what is to count as the literal or the metaphorical reaches a crisis point in this popular feminist polemic. Wolf tells a parallel story to Friedan's account of an ideological backlash against the previous gains of feminism. For Wolf, 'the more legal and material hindrances women have broken through' in 'the two decades of radical action that followed the rebirth of feminism in the early 1970s', 'the more strictly and heavily and cruelly images of female beauty have come to weigh upon us' (1991: 9–10). And, like Friedan, Wolf often presents this not as a congruence of diverse historical forces, but the result of conscious planning, particularly by the advertisers and the very industries which stand most to gain from such a return to domestic virtues. At times Wolf is explicit about her rewriting of Friedan for a new generation, with, for example, a recapitulation of the scenario of women being duped into the stupified condition of Stepford Wives, automata who have been programmed to spend money no longer on their homes but on their bodies. 'To paraphrase Friedan,' writes Wolf, 'why is it never said that the really crucial function that women serve as aspiring beauties is *to buy more things for the body?*' (1991: 66). At other times, however, Wolf is less specific about her intellectual inheritances, with the result that *The Beauty Myth* reads more as a palimpsest of the last thirty years of feminism, in which the faint outlines of previous positions and figurations are still visible. The history of feminism's coming to terms remains sedimented within the body of Wolf's text, but keeps resurfacing at key moments.

The Beauty Myth is punctuated by moments of textual anxiety over what is to be understood metaphorically, and what is to be taken literally. Wolf frequently insists that many of the tropes she employs to describe women's oppression by the beauty myth are no such thing: she means them literally. 'Electric shock therapy is not just a metaphor', she warns (1991: 250). Wolf presumably means that the manipulation of women's minds is not just comparable to ECT, but is sometimes actually instantiated by shock therapy. A similar hesitation between the literal and the metaphorical occurs in a

comparison between the physical mutilation of slaves and the 'employment demand for cosmetic surgery' (1991: 55). 'The surgical economy is no slave economy, of course,' explains Wolf, but adds that, 'in its demand for permanent, painful and risky alteration of the body, it constitutes – as have tattooing, branding, and scarification in other times and places – a category that falls somewhere between a slave economy and the free market'. Wolf seems caught 'somewhere between' a desire to produce elaborate comparisons and figures, and an awareness of feminism's long history of making itself a distinct project that cannot be collapsed into other terms.

As the book progresses, Wolf engages in an endless process of bolstering up her rhetorical claims: when the comparisons seem to fall short and lose their force, Wolf redoubles her insistence. Tellingly, the closer to her own personal experience she comes, the more this strategy intensifies. In her heartfelt discussion of eating disorders Wolf is less equivocal, more certain that women's oppression is not somewhere between the metaphorical and the literal, but constitutes instead a literalization of the metaphorical:

> Women must claim anorexia as political damage done to us by a social order that considers our destruction insignificant because of what we are – less. We should identify it as Jews identify the death camps, as homosexuals identify AIDS: as a disgrace that is not our own, but that of an inhumane social order. Anorexia is a prison camp. One fifth of well-educated American young women are inmates. Susie Orbach compared anorexia to the hunger strikes of political prisoners, particularly the suffragists. But the time for metaphors is behind us. To be anorexic or bulimic *is* to be a political prisoner.
>
> (1991: 208, emphasis in original)

Wolf first advocates regarding anorexia *as* political damage. The fact that this observation must be claimed rather than merely stated suggests that such comparisons are more for strategic reasons than a mere desire to describe the situation of anorexic women in itself. Next she suggests making comparisons with other analogous groups; the movement is towards a more complete identification, but the figure still remains a simile ('as Jews', 'as homosexuals'), if only in form alone. Finally, feeling herself to be beyond metaphor in an extreme situation for which Orbach's comparisons are no longer adequate ('the time for metaphors is behind us'), Wolf insists on a total identification between eating disorders and political imprisonment. The element of comparison in the original metaphor is cancelled out.

The implications of Wolf's rhetorical insistence on full identification in her metaphors have received much criticism – as have Friedan's comparisons of being a suburban housewife with living in the Nazi concentration camps. The reiteration of the equivalence between the personal and the political leads to an erasing of any differences that might inhere in the various cases she mentions. Can anorexia 'be' a prison camp in the same way that Auschwitz was a prison camp? Could a PLWA or a concentration camp internee escape their 'prison' through a recognition of the false images of homosexuality or Jewishness, in which, by Wolf's logic, they are trapped?

The comparisons are surely ill-conceived, but the passage is nevertheless revealing in its focus on the problem of figuration itself. The declaration that 'the time for metaphors is behind us' cuts both ways. It draws attention to Wolf's sense of redoubled urgency in a time of backlash, in which rhetorical circumlocution is a luxury that feminism can no longer afford. History, as far as Wolf is concerned, has in effect played a sick joke on women, turning their once figural language into literal fact. But the assertion also manifests an anxiety about language itself, speaking of a thwarted desire to match description with experience, to reach an unmediated realm beyond representation. The implication is that language – metaphor in particular – has repeatedly failed to do justice to feminism's project to make people see how things really are. Figuration, it would seem, has become an enemy of feminism, conspiring against women, preventing them from being understood.

Wolf is weighed down by the last three decades of feminist writing, which have become littered with dead or absorbed metaphors, requiring an ongoing forging and strengthening of new comparisons. For example, in the second chapter, which forms an extended comparison between the beauty myth and the worst aspects of religious cults, Wolf points out that 'what has not been recognized is that the comparison should be no metaphor'. She continues:

> The rituals of the beauty backlash do not simply echo traditional religions and cults but *functionally supplant them*. They are *literally* reconstituting out of old faiths a new one, *literally* drawing on traditional techniques of mystification and thought control, to alter women's minds as sweepingly as any past evangelical wave.
>
> (1991: 88, emphasis in original)

In such passages the author of *The Beauty Myth* finds herself in the position of crying wolf: this time, the frenetic italics seem to say, it's really real, no longer a false alarm, no longer a metaphor. The movement towards a literalization of the figurative has pushed the language of her feminism to a crisis point, in which the more Wolf insists on the non-figural nature of her assertion, the more it draws attention to its rhetorical status. The more her words slip from control, the louder she must shout them.

It is therefore extremely significant that the one image which Wolf does not insist upon is the figure of conspiracy. *The Beauty Myth* begins with the following epigraph from Ann Jones:

> I notice that it is the fashion . . . to disclaim any notion of male conspiracy in the oppression of women. . . . 'For my part', I must say with William Lloyd Garrison, 'I am not prepared to respect that philosophy. I believe in sin, therefore in a sinner; in theft, therefore in a thief; in slavery, therefore in a slaveholder; in wrong, therefore in a wrongdoer'.
>
> (1991: 7)[3]

If this passage is quoted approvingly – and Wolf's page of epigraphs would be a strange place to introduce such irony if the excerpt is not meant to set

the tone for the coming analysis – then we might expect a book on 'How Images of Beauty Are Used Against Women' to contain much denunciation of 'male conspiracy'. Yet, as we saw at the beginning of this article, Wolf's work exhibits a self-conscious cautiousness in connection with the term 'conspiracy'. In the Introduction Wolf does indeed use the phrase 'cultural conspiracy', but places it in scare quotes. She is prepared to embrace many other extravagant characterizations of the beauty myth, but feels obliged to signal her distance from conspiracy theories.

Although conspiracy theories are expressly rejected in *The Beauty Myth*, the narrative structure of personification on which they rely makes a return – even in the very passages in which the repudiations are made. Conspiracy theories allow the possibility of apportioning blame for what might otherwise appear to be a series of unconnected and overdetermined events, attitudes and practices. They betray an attraction to the notion of reading history personally, of seeking a hidden cause behind every event, and behind every cause an evil conspirator who deliberately plots those events; in short, of giving a name to the faceless 'problem'. Wolf begins by pointing out that it is the *idea* of repressive beauty, rather than any particular item in the list of guilty industries, that is doing the damage. What to call this 'idea', however, emerges as a problem in her prose. Following Henrik Ibsen she sometimes calls it a 'vital lie' told by society to itself. Using the work of psychologist Daniel Goleman, she talks about 'necessary fictions' and 'social fictions that masqueraded as natural components'. The title of the book, in a modulation of Betty Friedan's famous title, calls it the beauty *myth*. And, in the least precise formulation of all, when she claims that the beauty backlash does not require a conspiracy, she qualifies it by adding 'merely an atmosphere' (1991: 18).

But having removed all trace of malicious conspiratorial agents in these careful circumlocutions of what – if this were not a book directed towards the American popular market – might be termed ideology, patriarchy or hegemony, Wolf then describes how 'the resulting hallucination materializes'. At the very moment of insistence on materiality, then, literal conspirators give way to figurative ones, as the text becomes crowded with prosopopeia. 'No longer just an idea,' Wolf continues, 'it becomes three-dimensional, incorporating within itself how women live and how they do not live.' The verb forms once again are active, conjuring up the spectre of a meta-conspiracy, an ideology with a human face, as we hear how 'it [the contemporary backlash] has grown stronger to take over the work of social coercion that myths about motherhood, domesticity, chastity, and passivity, no longer can manage'.[4] In the tone of Senator McCarthy sounding the alarm about a personified version of the communist peril infiltrating America, Wolf goes on to tell how 'it is seeking right now to undo psychologically and covertly all the good things that feminism did for women materially and overtly'. But just at the end of the Introduction this rhetorical return of the disavowed trope of prosopopeia is itself inverted, in a move invoking what can now only be described as a meta-meta-conspiracy. In a reversion to a sinisterly anonymous passive verb form, Wolf

explains how 'after the success of the women's movement's second wave, the beauty myth was perfected to checkmate power at every level in individual women's lives'. But by whom was it perfected? Just when we had a grip on the Beauty Myth (to capitalize it in the same way that Wolf capitalizes Friedan's phrase, the 'Feminine Mystique') as a Frankenstein's monster, a fabricated mishmash of cultural attitudes and images at once grotesque and desirable, so now we need to be on the look out for the shadowy scientist himself, malevolently fulfilling his conspiratorial projects through the cunning manipulation of the poor dumb monster of the Beauty Myth. In this way, each repudiation of a conspiratorial mode of analysis only seems to restore an even more paranoid formulation, as each abstraction of agency is refigured into an act of deliberate contrivance by shadowy agents.

The conspiracy of theory

The reason *The Beauty Myth* manifests such anxiety about figuration in general, and the figure of conspiracy in particular, is doubtless due in part to Wolf's self-conscious rewriting of *The Feminine Mystique*, which, as we have seen, likewise exhibits a wariness about identifying its argument as a conspiracy theory. And, given the three decades of feminist struggle with the problem of naming which intervenes between the two books, it is not surprising that Wolf should betray a redoubled cautiousness in acceding to an image which by the 1990s has a long and troubled history. Wolf's reluctance to characterize her strategy as a conspiracy theory must surely also be understood in the context of a post-cold war scepticism about the apparently outdated political rhetoric with the collapse of Eastern European communism at the end of the 1980s, in the same way that Friedan's downplaying of conspiracy takes place in the post-McCarthy intellectual backlash against political demonology. Moreover, there are surely strong parallels between the Eisenhower era which Friedan describes (her initial moment of revelation comes 'one April morning in 1959'), and the Reagan/Bush years in which Wolf's analysis takes shape, not least in the way that the individual presidents gave institutional legitimation to a paranoid rhetoric of national security.

Yet these explanations do not fully make sense of Wolf's vehemence that, despite appearances, her argument is not structured as a conspiracy theory. What must also be taken into account, I believe, is Wolf's implicit recognition that conspiracy theories are a mark of the unscholarly. When in her second book, *Fire with Fire*, Wolf declares that 'it's time to say fuck you, I'm gonna have footnotes, I'm gonna have breasts', her anxiety seems as much about not being taken seriously by 'academic' feminism as it is a challenge to the anti-feminist backlash (1993: 201). Although her message is obviously that in the 1990s there should be nothing remarkable about being a woman with ideas, she seems as keen to emphasize the presence of her footnotes as the fact that she is a feminist. It is therefore important to note that the language of conspiracy is usually associated with 'crackpot

theorists' like holocaust revisionists and assassination buffs. In a certain sense, the concept of 'conspiracy theory' functions as an accusation of unprofessional research – compounded by the fact that the main cultural outlet for conspiracy theories is in popular thrillers and detective fiction, and exposés in the tradition of *National Enquirer*. And here we must recall that Wolf, like Friedan, directs her most impassioned attacks at the culture industry; indeed, they both construct what amounts to conspiracy theories of advertising and the media. At times, then, Wolf's anxious denial of conspiracy theories is motivated by what seems to be a paranoid fear of being contaminated by this popular, unscholarly logic.

What makes this situation more complicated is that academic feminists have positioned themselves precisely in opposition to the conspiracy theorizing of popular feminists like Wolf. For example, one of the 'three insights' which conclude Lynne Segal's analysis of feminist strategies for the future is, quite simply, 'the recognition that women's subordination is not a result of a conscious conspiracy by men' (1987: 165). If we can clear up this embarrassing tendency, Segal seems to imply, we will be well on our way to ridding feminism of its persistent attraction to such annoying patterns of analysis. 'We' in this case refers to those who, like Segal, feel that the project of 'radical feminism' begun in the 1960s has been hijacked by what has passed under the sign of 'cultural feminism'. Segal's forthright repudiation of conspiracy theories – combined with a hint of attraction to such explanations – is, I want to suggest, typical of the fraught relationship between academic and popular feminism.

There are several reasons for the repudiation of conspiracy theories by academic feminists. In Mica Nava's recent reassessment of theories about advertising, she notes how 'current theories of culture and subjectivity take much more seriously notions of personal agency, discrimination and resistance, as well as (drawing on psychoanalysis) the contradictory and fragmented nature of fantasy and desire'. This 'new, more nuanced understanding of subjectivity', Nava goes on to explain, is crucial to

> recent critical refutations of the notion that the media and advertising have the power to manipulate in a coherent and unfractured fashion and represent a move away from the notion of mass man and woman as duped and passive recipients of conspiratorial messages designed to inhibit true consciousness.
>
> (1992: 165)

Feminists like Nava who are sympathetic to cultural studies have begun to employ the language of desire, fantasy and identification in place of conspiracy theories of, say, mass culture or Freudian psychoanalysis. Instead of a paranoid fear of infiltration, contamination and indoctrination by external forces, emphasis is placed on the way that people use culture to create meanings, as much as those meanings are imposed on them from above by the culture industry. These 'refutations' of conspiracy theories, I would suggest, have been integral in shaping the kind of feminist cultural studies performed by critics such as Nava.

Furthermore, feminisms informed by psychoanalytic accounts of subjectivity and poststructuralist theories of language position themselves precisely in opposition to the notions of psychology, agency and causality on which conspiracy theories rely. For example, in her reassessment of *Sexual Politics*, Cora Kaplan draws attention to the way that Millett's analysis amounts to a conspiracy theory of Freudian analysis. Kaplan argues that

> Millett . . . had to reject the unconscious, the pivotal concept in Freud, and something common to both sexes, because she is committed to a view that patriarchal ideology is a conscious conspiratorial set of attitudes operated by men against all empirical evidence of women's equal status in order to support patriarchal power in office.
>
> (1986: 21)

Kaplan's accusations are doubly significant because, in her view, what popular feminist conspiracy theories of patriarchy fail to provide is any account of the workings of the unconscious and desire in social formations. Conspiratorial versions in effect cash out the unconscious into the rational and the deliberate, producing a deterministic and thoroughly efficacious portrait of social agency. 'What distinguishes psychoanalysis from sociological accounts of gender,' writes Jacqueline Rose, 'is that whereas for the latter, the internalization of norms is assumed roughly to work, the basic premise and indeed starting-point of psychoanalysis is that it does not' (1986: 90). What Rose's position suggests is that there should no longer be an unproblematic adherence to conspiracy theories of patriarchal history, for the concept of the unconscious will always implicitly call into question the picture of a conscious, coherent and entirely efficacious conspiracy. In this way, the accusation of using a conspiracy theory has joined that list of untenable feminist positions which includes essentialism and functionalism, marking a boundary between sophistication and vulgarity – indeed, the very mention of the word 'conspiracy' is often enough to end discussion.

Viewed from the other side of the divide, however, it is academic feminism which is the problem. Some feminists have even characterized poststructuralism itself as a cunning conspiracy by male theorists and their female dupes. Just when women as subjects were beginning to receive attention from historians, the argument goes, along came poststructuralism which 'conveniently' announced that the subject was a fiction anyway (Moore and Looser, 1993; Waugh, 1992). The accusation of a conspiracy of theory speaks of the divide between feminists who concentrate on the literal and material dimensions of male oppression in cases such as pornography and rape, and those theorists whose emphasis is on the figurative and the representational. In the introduction to *Bodies that Matter*, Judith Butler talks about 'the exasperated debate which many of us have tired of hearing'. Butler is referring to stock criticisms of poststructuralism – such as 'If everything is discourse, what about the body?' – in which the kind of insistence on the literal which we saw in Wolf prevents any discussion of the way in which the very construction of the limit category of the material is caught up in a series of powerful political

exclusions (1993: 6). For Butler, what is to count as the material can never be guaranteed in advance.

What really exasperates Butler, however, is 'when construction is figuratively reduced to a verbal action which appears to presuppose a subject', leading 'critics working within such presumptions . . . to say, "If gender is constructed, then who is doing the constructing?" ' In other words, 'where there is activity, there lurks behind it an initiating and wilful subject', and, Butler continues, on such a view 'discourse or language or the social becomes personified' (1993: 6–9). In effect, Butler is taking issue with the tendency of feminists like Wolf to find deliberate conspirators lurking behind any social processes. Butler's focus on the trope of prosopopeia is, as we have seen, born out in the case of *The Beauty Myth*. Yet what Butler fails to take into account in her argument against the personification of agency is any sense of the narrative pleasures which it affords. The prose of Friedan, Wolf and Faludi offers some of the dramatic popular pleasures associated with the plots, characters and scenarios of thrillers. Their popularity as feminists is in part due to their use of popular generic conventions.

A bizarre situation arises, then, in which academic (cultural studies) feminism leads the way in displaying a sympathetic and perceptive approach to popular culture, yet reserves an often unacknowledged antipathy towards popular feminism for its attraction to the popular charms of conspiracy theory. Conversely, popular feminists such as Wolf and Faludi repudiate the term 'conspiracy' in their desire to be taken seriously, even as they succumb to the attractions of personification and usher in a barely disguised version of the conspiracy theory of mass culture. In this way, conspiracy becomes not so much the indication of a pre-given division between the popular and the scholarly, but the site and the very structure of a series of shifting exclusions, silences and moments of rhetorical crisis through which a division between a vulgar and a sophisticated feminism is effected.

Cultural dupes

The language of conspiracy has produced divisions and exclusions not just between academic and popular feminism, but also within popular feminist writings. Quite simply, it seems that it is always other women who are brainwashed. This sense of superiority – of having transcended the historical and intellectual forces in which others are still immured – manifests itself in the contradictory positionings effected by the pronoun 'we'. The use of a collective 'we' in feminist writing answers an understandable desire to assert a solidarity, to forge a sisterhood to oppose patriarchy. Yet, conversely, the use of the first-person plural produces an implicit polarization between those who are subjected to the conspiracy to brainwash women, and those who are strong and wise subjects, able to recognize, criticize and even to transcend it. As we have seen, Friedan mainly discusses the brainwashing of American women in the third-person plural, giving the impression that – as she openly admits – once she was brainwashed by the feminine mystique, but now she has escaped the conditioning. Occasionally,

however, she does use the first-person plural. For example: 'there were many needs, at this particular time in America, that made *us* pushovers for the mystique: needs so compelling that *we* suspended critical thought' (1992: 160, emphasis added). Friedan's momentary alignment with the duped majority sits uneasily with her self-promotion as the heroic lone detective who has managed to uncover the secret conspiracy.

By the time of *The Beauty Myth*, the problem of the collective pronoun has become pervasive. Sentence after sentence of Wolf's prose enacts a basic but contradictory division between those who are duped and those who are in the know. Usually in the first half of the sentence she quotes a fact or figure about the oppression of women, phrasing it in the objective third-person plural, only in the second half to effect an identification with that oppression through her use of the collective pronoun. Sometimes this has a disconcerting poignancy, particularly in the chapter on anorexia when Wolf reveals that she had suffered from eating disorders as a teenager: 'they' could indeed include 'me'. But in many other places the shift of pronominal stance midway through a sentence positions Wolf uneasily both on the inside and the outside of the brainwashing conspiracy: 'If *those* women who long to escape can believe that *they* have been subjected to a religious indoctrination that uses the proven techniques of brainwashing, *we* can begin to feel compassion for ourselves rather than self-loathing; *we* can begin to see where and how *our* minds were changed' (1991: 128, emphasis added). As Tania Modleski points out, however, the desire to position oneself clearly 'outside' ideology is misleading. 'Today,' writes Modleski,

> we are in danger of forgetting the crucial fact that like the rest of the world even the cultural analyst may sometimes be a 'cultural dupe' – which is, after all, only an ugly way of saying that we exist inside ideology, that we are all victims, down to the very depths of our psyches, of political and cultural domination (even though we are never *only* victims).
>
> (1991: 57)

The tension in Wolf's syntax thus gestures towards her contradictory positioning as both duped and knowing, with the trope of conspiracy producing complex negotiations between and within each of the terms.

In the same way that *The Beauty Myth* almost inevitably constructs its own category of the culturally duped, so too is it very hard not to regard American feminists like Wolf – and, more worryingly, her large readership – as dupes of their *Zeitgeist*, unthinkingly spouting the language of the day, victims of modes of thought to which 'we' have now seen through.[5] Not only can it become easy to dismiss popular feminism of the present as the work of those immersed in various 'ideologies' to which 'we' are immune (including, no doubt, the 'ideology' of popularity), but there is an equally common conviction of having gone beyond the primitive ideas of feminism's past. Jane Gallop, in her rereading of some of the now more ignominious collections of feminist theoretical essays from the 1970s, draws attention to the tendency of dismissing the writings of the past as

embarrassing mistakes, the products of women who inevitably become characterized as 'cultural dupes'. She describes moments in her classes when discussion was foreclosed with the exchange of knowing grimaces, when her 'audience assumed that [she] was describing an error of earlier days, a foolish . . . stance, that we were comfortably beyond, thanks to the post-structuralist critique'. What Gallop discovers in such moments is 'a notion of our history as a simple progress from primitive criticism to ever better and more sophisticated' (1992: 136, 179).[6] How to read the works of early 1960s feminists like Friedan – without immediately assuming a narrative of progress – becomes a real problem. One possibility, like Wolf, is to recycle the former analysis, struggling to make its terms and figures work in a new context. Another possibility is simply to view them as mistaken analyses which have now been superseded. What I have attempted to do in this article, however, is to understand how popular feminists from Friedan to Wolf have engaged with one particular figuration, namely the image of conspiracy, and to see how its logic continues to function in feminist writing today, not least in the construction of the very category of the popular. In effect, then, I am arguing that academic/cultural studies feminism needs to bring the same strategies of reading to both its own past and to popular feminism as it has already developed in its reading of popular culture, informed neither by an uncritical acceptance of all feminisms in the name of sisterhood, nor by a conspiracy theory of duped masses and unrelenting domination.

Notes

1 In this article I am using 'popular' to designate not so much the degree of popu-larity (although the two books I concentrate on, *The Feminine Mystique* and *The Beauty Myth*, were both bestsellers), but rather the way in which a certain tra-dition of 'middlebrow' American feminism is marked out as 'popular' precisely because of its modes of address and rhetorical structures, one of the most favoured of which, I am arguing, is the trope of conspiracy. Since writing this piece, I have come across the excellent article by Jennifer Wicke, in which she argues that 'to the extent that academic feminism has an opposite, it is not move-ment feminism per se, but the celebrity pronouncements made by and about women with high visibility in the various media'. Instead of immediately vilify-ing 'celebrity feminism' as 'a realm of ideological ruin', counsels Wicke, 'we must recognize that the energies of the celebrity imaginary are fuelling feminist dis-course and political activity as never before' (1994: 753).

2 In her persuasive rereading of *The Feminine Mystique*, Rachel Bowlby makes a similar point: 'Friedan is constantly caught in this contradiction, which can be smoothed over only by accepting the arbitrary distinction between true and false dreams – between those that are from within and correspond to the "human" potential, and those that are from without and are imposed by the manipulators of the "feminine mystique" ' (1992: 87). Bowlby also draws attention to the con-spiratorial aspects of the book, but does not elaborate this observation.

3 The passage comes from Ann Jones's Foreword to her *Women Who Kill* (1981: vii–xviii). Noting that 'among academic historians and literary historians' it 'seems to be incumbent upon the author to say that readers who gain the

impression from the book that men as a group have done something unpleasant as a group to women as a group are entirely mistaken', Jones concludes that, 'if this book leaves the impression that men have conspired to keep women down, that is exactly the impression I mean to convey; for I believe that men could not have succeeded as well as they have without concerted effort' (1981: xvii).

4 Compare, for example, Faludi's portrayal of the backlash: 'In the last decade, the backlash has moved through the culture's secret chambers, traveling through passageways of flattery and fear. Along the way it has adopted disguises. . . . It manipulates a system of rewards and punishments. . . . Cornered, it denies its own existence, points an accusatory finger at feminism, and burrows deeper underground. . . . The backlash line blames the women's movement' (Faludi, 1991: xxii).

5 Recently in Britain Wolf and other celebrity feminists like Katie Roiphe have come under fire not only for their media-hyped 'Ivy League glamour', but also for their being another example of unwelcome American cultural imperialism. See, for example, Linda Grant (1994), writing about a panel (sponsored by the *Sunday Times* to debate Roiphe's *The Morning After*), on which sat Roiphe, Wolf and Erica Jong: 'This is not about flag-flying and Buy British jingoism. . . . The problem is that by marginalizing or even silencing our voices, a powerful message is sent to young British women. Be a feminist, by all means, but if you want your words to have any impact, be American.'

6 Bowlby (1992) likewise points out the blindnesses of a feminist criticism which can on the one hand attack masculinist myths of progress, yet, on the other, unwittingly reinscribe such narratives into an implicit teleological history of feminist theory.

References

Bowlby, Rachel (1992) ' "The Problem with No Name": rereading Friedan's *The Feminine Mystique*', in *Still Crazy After All These Years: Women, Writing and Psychoanalysis*, London and New York: Routledge.

Bromley, David G. and Richardson, James T. (1980) *The Brainwashing/Deprogramming Controversy: Sociological, Psychological, Legal and Historical Perspectives*, New York and Toronto: Edwin Mellen.

Brown, J.A.C. (1983) *Techniques of Persuasion: From Propaganda to Brainwashing*, Harmondsworth: Penguin. (Originally published 1963.)

Brownmiller, Susan (1975) *Against Our Will: Men, Women and Rape*, New York: Simon & Schuster.

Butler, Judith (1993) *Bodies that Matter: On the Discursive Limits of 'Sex'*, London and New York: Routledge.

Daly, Mary (1984) *Gyn/Ecology: The Metaethics of Radical Feminism*, London: The Women's Press. (Originally published 1978.)

Dworkin, Andrea (1981) *Pornography: Men Possessing Women*, London: The Women's Press.

Echols, Alice (1989) *Daring to Be Bad: Radical Feminism in America, 1967–75*, Minneapolis: University of Minnesota Press.

Faludi, Susan (1991) *Backlash: The Undeclared War Against American Women*, New York: Crown.

Friedan, Betty (1992) *The Feminine Mystique*, Harmondsworth: Penguin. (Originally published 1963.)

Gallop, Jane (1992) *Around 1981: Academic Feminist Literary Criticism*, London and New York: Routledge.

Grant, Linda (1994) 'She swoops in to conquer', *Guardian*, 26 January: 9.

Griffin, Susan (1970) 'Rape: the all-American crime', in Griffin (1979) *Rape: The Power of Consciousness*, San Francisco: Harper & Row.

Hofstadter, Richard (1967) *The Paranoid Style in American Politics and Other Essays*, New York: Random House.

Jones, Ann (1981) *Women Who Kill*, New York: Ballantine.

Kaplan, Cora (1986) *Sea Changes: Essays on Culture and Feminism*, London: Verso.

Modleski, Tania (1991) *Feminism Without Women: Culture and Criticism in a 'Postfeminist' Age*, London and New York: Routledge.

Moore, Pamela and Looser, Devoney (1983) 'Theoretical feminism: subjectivity, struggle and the "conspiracy" of poststructuralisms', *Style*, 27: 530–58.

Morgan, Robin (1970) editor, *Sisterhood Is Powerful*, New York: Random House.

Morris, Meaghan (1988) 'A-mazing Grace: notes on Mary Daly's poetics', in *The Pirate's Fiancée*, London: Verso.

Nava, Mica (1992) *Changing Cultures: Feminism, Youth and Consumerism*, London: Sage.

Palmer, Paulina (1989) *Contemporary Women's Fiction: Narrative Practice and Feminist Theory*, Hemel Hempstead: Harvester Wheatsheaf.

Redstockings (1968) 'Manifesto', rpt. in Morgan (1970): 533–6.

Rogin, Michael (1988) *Ronald Reagan, The Movie; and Other Episodes in Political Demonology*, Berkeley: University of California Press.

Rose, Jacqueline (1986) 'Femininity and its discontents', in *Sexuality in the Field of Vision*, London: Verso.

Ross, Andrew (1989) *No Respect: Intellectuals and Popular Culture*, London and New York: Routledge.

Segal, Lynne (1987) *Is the Future Female?: Troubled Thoughts on Contemporary Feminism*, London: Virago.

Waugh, Patricia (1992) 'Modernism, postmodernism, feminism: gender and autonomy theory', in Waugh, editor, *Practising Postmodernism/Reading Modernism*, London: Edward Arnold.

Weed, Elizabeth (1989) 'Introduction: terms of reference', in Weed, editor, *Coming to Terms: Feminism, Theory, Politics*, London and New York: Routledge.

Wicke, Jennifer (1994) 'Celebrity material: materialist feminism and the culture of celebrity', *South Atlantic Quarterly*, 93 (4): 751–78.

Willis, Ellen (1984) 'Radical feminism and feminist radicalism', in Sohnya Sayres *et al.*, editors, *The 60s Without Apology*, Minneapolis: University of Minnesota Press.

WITCH (1970) Various 'Spell Poems'. In Morgan, editor, pp. 538–53.

Wolf, Naomi (1991) *The Beauty Myth: How Images of Beauty Are Used Against Women*, London: Vintage.

—— (1993) *Fire with Fire: The New Female Power and How It Will Change the 21st Century*, London: Chatto & Windus.

JOHN NGUYET ERNI

OF DESIRE, THE *FARANG*, AND TEXTUAL EXCURSIONS: ASSEMBLING 'ASIAN AIDS'[1]

ABSTRACT

This article documents and discusses the neo-orientalist tendencies in the First World's sporadic coverage of 'Asian AIDS', with a particular focus on the localized context of Thailand. It takes the problem of 'Asian AIDS' as a critical point of articulation between a health crisis and the specific geopolitical movements of capital, tourism, and desire within the processes of globalization. In order to highlight the episodic nature of the First World's narrative about HIV/AIDS in Thailand and to witness the necessarily fragmentary quality of representation in the global sphere involving competing and constantly moving voices, I attempt to enact an imaginary dialogue in the form of what Trinh T. Minh-ha has termed 'textual excursion'. The purpose of this imaginary dialogue is to elaborate on the various strands of narratives and different levels of discourse (for example, the documentary, the theoretical, the imaginary, the political) that comprise the field of jumbled voices. As the HIV/AIDS pandemic in Pacific and Southeast Asia is taking shape around the configurations of globalist imperatives, it illuminates a dual process: the revitalization of orientalist fantasies in the global sphere and the self-orientalizing tendencies within the Asian world captured by global development. It also illuminates the necessity of addressing the problem of 'Asian AIDS' as a migrating vector.

KEYWORDS

HIV/AIDS; Pacific and Southeast Asia; Thailand; global capitalism; orientalism; subaltern theory; the media

The language of critique . . . opens up a space of translation: a place of hybridity, figuratively speaking, where the construction of a political object that is new, *neither the one nor the other*, properly alienates our political expectations, and changes, as it must, the very forms of our recognition of the moment of politics.

(Bhabha, 1994)

© 1997 Routledge 0950–2386

I

I begin with a rather obvious observation: HIV/AIDS is a migrating pandemic. Over the last few decades, the developing countries have been extraordinarily affected by global, and by definition mobile, developments. Since the 1980s, many of them have also been the epicentres of the pandemic. By the mid-1990s, it is becoming terribly clear that across many nations and regions the pandemic is taking shape along the lines of transnational forces, such as that of capital flow and distribution, new patterns of human and labour migration, tourism (including sex tourism), postcolonial and neo-colonial forms of government responding to the pulls of globalization, new and continuing military presences in the Third World, and the signifying practices of race, class, gender, and sexual identities in the historical, mediated, literary as well as nationalist public health discourses. As of December 1995, the World Health Organization estimates a total of eighteen million cases of HIV infection worldwide. About three million cases have been reported in South and Southeast Asia, three times more than the caseload in all of North America. The number of AIDS cases totals about six million worldwide as of 15 December 1995.

For almost a decade now, I have been writing about the cultural politics of HIV/AIDS within the American setting. The current project that I am engaging in, of which this article is a part, concerns the crisis of AIDS in Southeast Asia, with a special focus on Thailand. In it, I attempt to understand global AIDS in relation to Asian modernity within the framework of migration as a historical material movement, as well as an analytic, a mode of being, a teleology. In Asia, modernity is linked to disjunctive processes of decolonization, democracy movements, and westernization (Appadurai, 1990). As an Asian who grew up in one of the most modernized Asian cities, I have always understood Asian modernity as an egregiously awkward celebration. Even before but especially after Edward Said, critics have pointed out that orientalism has functioned to invent the orient in such a way that it exists in the shared and coincided coordinates of Euro-American and Asian political and cultural fantasies, which explains why you do not have to be inside the orient to have orientalism. In this way, the phenomenon of Asian modernity – which I take to be contemporaneous to the rise of orientalism, although in varied periodization for different regions of the Asian world – is as much an administrative and cultural discourse for the West as it is for the East. Put in a different way, Asian modernity is a travelling vector within the global imaginary. While it claims the Asian territory as its object and target, Asian modernity is in fact a *re-doubling historical trajectory*, first as a relational, or in Homi Bhabha's term, a 'translational' project with the West as partner in the global field, and second as a self-administered moment of identity and authority within the Asian world itself. In this way, one may say that there can be no orientalism without also the phenomenon of self-orientalism. And this in part explains my bewildering sense of Asian modernity as an awkward celebration.

My main concern is whether and how the emerging HIV/AIDS pandemic in Asia may be duplicating and rearticulating such global epistemological and political processes. I wonder whether the epidemiological patterns of infection in the developing countries articulate and are articulated by the underlying global processes of change. I want to find out whether, how, and where the discursive vectors about Asian AIDS – including, for example, transnational biomedicine, anthropology, and the media – are constructed and distributed along the configurations dictated by globalist imperatives. I wonder also how the Asian regions that have been affected by the pandemic respond to and cope with it and how they negotiate their response to AIDS with their response to pressures of global development.

This article focuses on the vectors of representation that give rise to and frame the problem of 'Asian AIDS'. It discusses the *episodic* nature of the First World's narrative about AIDS in Thailand, one of the epicentres of the epidemic in Asia. I should want to read this episodic nature as something characteristic of a kind of *ambivalent* colonial impulse void of a sustained, univocal sense of racial superiority or sexual innocence *vis-à-vis* the Other.

II

International AIDS-control efforts, which have by and large focused on epidemiological surveillance, have only recently acknowledged the devastation of the Pacific and Southeast Asian region by the HIV/AIDS pandemic, especially in Thailand, India, and the Philippines. Meanwhile, the press of the developed world has been anxiously silent about it. The handful of media reports from the United States, as we shall see, has created a classic orientalist heterosexual 'Asian AIDS' that reinaugurates the postcolonial discourse of global economic development and precolonial fantasies about militarized and leisurized masculinity, both firmly etched in the spatial and temporal movement and class-based consumption of interracial desire and pleasure in the form of *sanuk* (the term *sanuk* in Thai language connotes 'fun' coyly coded as casual sexual exchange). Such discourses and fantasies are a paradoxical mode of knowledge in which Pacific and Southeast Asia appears as an ambivalent territory: it is something that is always already known and wholly predictable, and something that must be eagerly reinvented and repeated.[2] In this kind of neocolonial moment, 'Pacific and Southeast Asia' and 'Asian AIDS' follow the same paths of imaginings that gave rise to 'Africa' and 'African AIDS' in the 1980s, but with a difference.[3] Besides positing (and eagerly repeating) the conceptual superiority of the developed world over the economically disadvantaged countries by way of correlating heterosexuality with the danger of exotic microbes, the very label of 'Asian AIDS' reinscribes Euro-American bodies and desires – the travelling *farang* (the figure of the ornate but vulgar male foreigner, in Thai language) – as part of the resonating narrative of disaster now experienced by the peoples of Pacific and Southeast Asia.

The grand narratives of Pacific militarism and Asian economic development in the 1990s, coinciding with the historical narrative of Thailand as

'concubine' to the West that was first articulated in the European literature of the early twentieth century, continue to invent a certain global conception of Thai sexuality as the primary site of exotic maladies evolving into the AIDS disaster. Yet in continuing this orientalist impulse, these narratives bring into focus the world's attention on the scandal of promiscuous pleasure that was once hailed by the military-industrial-tourist complex as its justifiably naughty rights. Seen in this way, Asia in the ruins of AIDS functions as a giant confessional, a space in which open secrets, half-truths, dodges, and sometimes outright lies and denial are most productive, and therefore a space most capable of mystification. In the neocolonial construction of 'Asian AIDS', what is historically and geopolitically marginal and in need of control turns out to be symbolically and psychosexually central. As with Africa, 'Asian AIDS' is about the global distribution and trafficking of resources, desire, and power. But unlike it, the First World's construction of 'Asian AIDS' reverberates with a charged, suggestive, nagging silence.

I am convinced that the story of HIV/AIDS in Asia is realistically a fragmented narrative, punctuated by orientalist, anti-orientalist, and self-orientalizing tendencies, and is therefore necessarily jumbled, shuffled, and agitated by these political and cultural thrusts. More of a 'war of positions' made up of contrasting and shifting voices than a monolinguistic and unified narrative, and less unidirectional than circular, this story realistically resists stable and totalizing definitions. Nor is the story complete at this historic moment. The challenge of discussing the media representations of the pandemic in Asia is to highlight the provisional and jumbled nature of competing voices in the First World/Third World divide, as well as the racial and gender divides. I propose to treat the representational voices as moving vectors that travel inside and alongside the forces of power, despair, confusion, and community empowerment that the global pandemic has forged. The conceptualization of the mobile, travelling voices enables us to think of them as temporary, mimetic, and adaptive.

What follows is an imaginary dialogue on the devastating reality of the AIDS epidemic in Thailand. The purpose of the dialogue is to elaborate some of the arguments sketched above. I weave together a kind of tapestry of narratives, vignettes that are drawn from media orientalism. Whether these narratives are included here simply to witness or to be commented upon, they have a tendency to cross over to each other, so that no one voice tells a definitive story, so that every voice poaches. I want to use the tapestry to suggest that the historicity and specificity of the HIV/AIDS pandemic in Asia depends on how the global vectors of the transnational trafficking of capital, bodies, desires, pleasures, and ideologies are translating and retranslating this very historical moment of crisis in the Asian region.

III

'Asian AIDS' emerged in mid- to late 1980s. In the same period, global development has deeply transformed the East and South Asian region into

new economic centres modelled after Euro-American economies. The historical parallel makes the celebration of 'Asian capitalism' a highly ambiguous, and deeply anxious, event. In his bestselling book, Julian Weiss writes,

> The Asian Century *has* arrived. It is an unexpected shooting star in the night sky of world events from which great possibilities emerge. The 'Asian Century' concept embodies far more than economics. It is the kernel of new geopolitics, a basic realignment in an information age and postindustrial era. The shape of the next century is being cast in the Pacific.
>
> (1989: vi)

Precisely in the context of postindustrial global capitalism, what exactly is 'more than economics' in Asian development today and what is cast upon the Pacific are complicated by the presence of a raging pandemic. Terms in global capitalism like 'divergent investment', 'free trade', and 'bilateral collaboration' now carry ironic connotations in the narratives of economic development on the one hand and AIDS on the other. The triumph of global stories like that provided by Weiss lies in the complete disavowal of any connection between these two narratives.

In the global AIDS narrative, the Third World is seen simultaneously as the culprit or the origin of the modern plague as well as its victim. To the First World – and the First World always seems to be the vantage point from which we speak – 'they' gave us AIDS, 'their' AIDS is now killing their own people, and 'they' try to deny both. In the international AIDS story, this triangular indictment – this triple assault – shapes the meaning of the name 'AIDS in the Third World'.

In November 1992, the *New York Times* published its first in-depth report on AIDS in Asia. The headline, 'AFTER YEARS OF DENIAL, ASIA FACES SCOURGE OF AIDS', immediately cues the reader to a familiar narrative elsewhere: the narrative of AIDS in Africa and government denial. In fact, the article opens its report about Asian AIDS by way of a comparison with African AIDS. The journalistic coverage of Third World AIDS therefore rests heavily on what can be called pan-narratives, so much so that the existence of AIDS in Asia is constructed *by way of* stories from another time, another place, another discursive space. This coupling of Asia and Africa, however, has a historical structural basis within the classic global narrative of post-Second World War development that has cast the Asian and African worlds as the vast testing ground for Western economic and social development. From the neocolonial point of view, what was the tragic duo of economic depravity in the past becomes the misfortunate pair of sexually and medically underdeveloped worlds in the 1980s and 1990s. In this context, one may say that the figure of 'the Asian' is imagined as that of 'the African'.

The *New York Times* article features a photograph of an Asian male AIDS patient in an AIDS ward in Bangkok. The patient is lying in a hospital bed, his body wasted and completely covered with tattoos. He looks at the camera, caught in the ambivalent gaze of the foreign journalist. Once again, the AIDS patient is unmistakably marked by the signs of *danse*

macabre: extreme weight loss, bedridden, swollen face, helpless, near death. But this image has more: a body of Asian AIDS covered with tattoos. The tattoos provide the signifier of an infectious environ; mystic orientalism is recorded as contamination. In this double exoticism, we are reminded once again of the discursive folding of the Asian on to the African *through* the horrified but ambivalent gaze.

This gaze directed at the Other is exactly what Franz Fanon remembers, in his much quoted rendition of the highly charged racist scene:

> My body was given back to me sprawled out, distorted, recoloured, clad in mourning in that white winter day. The Negro is an animal, the Negro is bad, the Negro is mean, the Negro is ugly; look, a nigger, it's cold, the nigger is shivering, the nigger is shivering because he is cold, the little boy is trembling because he is afraid of the nigger, the nigger is shivering with cold, that cold that goes through your bones, the handsome little boy is trembling because he thinks that the nigger is quivering with rage, the little white boy throws himself into his mother's arms: Mama, the nigger's going to eat me up.
>
> (Fanon, 1991: 80)

In this Fanonian traumatic scene, the black subject caught in the white gaze appears to be an ambivalent text of projection and introjection, what Homi Bhabha calls 'the masking and splitting of "official" and phantasmatic knowledges' (1992: 327). Might we see the same psychic process at work in the delivery of the image of the tattooed Asian man with AIDS? In the folding together of the black and Asian objects in colonial discourse, the Fanonian transfer may sound something like this, *deceptio visus*: Look, an Oriental AIDS victim, he is contaminated, he is shivering . . . the colonial subject is trembling because he thinks that the Oriental AIDS victim is quivering with a deadly raging virus . . . 'he is going to eat me up'.

The AIDS epidemic has reached crisis proportions in Thailand. Since the first cases of HIV infection in Thailand were reported around 1984, the figures of newly reported cases have been steadily soaring. The Economist *reported that in 1989, with only limited diagnostic technologies, Thailand had already accounted for half of all the cases of HIV infection in all of Asia ('Thailand: AIDS homes in,' 1989). In 1994, the National Public Radio claimed that one in every fifty Thais is now infected with HIV, and the ratio could climb to one in fifteen infected by the end of the decade (National Public Ratio, 1994). More recently, in December 1995, the regional office of the World Health Organization in Southeast Asia reports that of all the Southeast Asian countries that report to WHO, Thailand has 88% of the total number of HIV infection cases in the entire region. Both the World Health Organization and the Public Health Ministry of Thailand have projected that if public awareness and education can change drug use and sexual behavior rapidly and positively, the rate of HIV infection will peak in mid to late 1990s and the cumulative number of HIV cases by the turn of the century will be four million*

(Rhodes, 1991). The World Health Organization estimates that at least 10 million Asians will be infected by 2000 and that AIDS will kill more people on the Asian region than in any other (. . .). (Shenon, 1992)

In Thailand, the growing awareness of the serious consequences of the HIV pandemic has built an impressive system producing a large quantity of statistical information and other non-quantitative forms of knowledge about the epidemic in the country. This is evident in the sentinel surveillance system initiated in 1989 that reports seroprevalence in a number of target groups in all provinces every two years. Supplementing this data with information about the impact of the epidemic on specific subpopulations are cohort and follow-up studies that have been carried out among military recruits, commercial sex workers, pregnant women, and newborns. Dutch researcher Han ten Brummelhuis suggests that contrary to popular belief, Thailand could claim to be one of the first countries where the HIV/AIDS epidemic is systematically documented with the greatest detail and reliability. He observes that '[n]o western country will be able to compete due, among other things, to ethical juridical constraints in blood testing' (1993: 3).

Brummelhuis also suggests that the first AIDS cases since 1984 could be traced to foreign contacts, although not with complete certainty in all instances. He writes, 'There is no evidence to establish the first route in this intercountry-transmission. Probably it happened almost simultaneously: Thai who had sexual contacts abroad bought the virus back home, Westerners having sex with Thai took it to Thailand, and HIV entered Thailand also through sharing of drug use equipment between foreigners and Thai' (ibid.). He argues that since 1988 a pattern has developed that makes it difficult to apply Western epidemiological categories in terms of exclusively heterosexual, homosexual, and bisexual behaviour. He mentions, for instance, the case of a male AIDS patient who had sex with his male foreign employer with the consent of his wife (ibid.). As reported at the International AIDS Conference in Berlin, any attempt in the Thai situation to isolate specific risk groups is rapidly becoming obsolete. The obsession to focus only on female prostitutes and single males has occluded the steady rise of incidence among married men and their wives.

The Thai profile is also complicated by the internal mobility of its people, largely migrants from the rural North to the urban centres in the South and Southeast. The concentration of HIV infection in the Northern region of Thailand – nearly 50 per cent of all AIDS/ARC cases reported in 1993 are from five provinces in the upper North with only 4.7 per cent of the Thai population (Brummelhuis, 1993: 4) – may be changing due to the internal migration patterns.

A poster in a bar in the Philippines near a United States military base greets its customers with this poem:

A tiny little shade of light
A little bed with sheets so white
A little loving in the gloom

A little pair of lips, so warm and wet
A little whisper, 'Please not yet'
A little pillow from the head
Slipped beneath the hips instead
A little effort to begin
A little help to get it in
A little arm that grips me tight
Then I ask, 'Does it feel all right?'
She smiles and says 'It feels so good'
And I reply 'I knew it would'
Two little legs around me wind
Two slanted eyes look into mine
A little movement to and fro
A little whisper 'give me more'
Two little hearts beat as one
Two little lovers having fun
A little hunch, a little sigh
A little phrase, 'You come, GI?'
A little effort to repeat
A little spot upon the sheets
A little bath when you are through
A little drink or two
A little sleep and finally then
A little breakfast at half past ten
And as you dress and put on your hat
You look back and say . . .
'Did I fuck "that"????!!!!'

Similar, but more concise, messages about the delicatesse can be found on baseball hats, T-shirts, and bumper stickers.

In 1987, the Thai national planning authorities officially designated it to be the Visit Thailand Year. Many events were planned to attract a record number of foreign tourists. It was the same year that the Thai government began to take actions to address the impact of the AIDS crisis on Thailand. The conflict between dealing with AIDS and promoting tourism became apparent. The Thai government was determined to play down the scope of AIDS. The rationale: to avoid public panic and hysteria.

Today, it has become customary for service girls and bar boys in the entertainment districts to wear round their necks an ID card – known as the 'green card' – issued by the local health officials stating their HIV test results, proving to their local and foreign clients that *they* were safe, without being offered a reciprocal proof from the clients.

The United States Pacific Command, a massive military complex, spans over five major Asian countries and the vast area of Micronesia. With three hundred bases and facilities stationing about 330,000 servicemen and women, this military complex has had a profound economic impact

on the host countries. A whole host of small businesses is stimulated and sustained by the presence of the military personnel; these businesses will not survive had it not been for the whole economy of sexual labor (Sturdevant and Stoltzfus, 1992). In Thailand, next to the production of rice, prostitution is the largest industry.

In addition, the modern tourist industry in Southeast Asia is modeled after the 'rest and recreation' (R & R) centers that were established during the Vietnam War. The understanding of the specific shape in which the AIDS crisis is taking in the 1990s cannot be separated from the understanding of what transpired in the war of the 1960s, and the global economic tales of the 1970s and 1980s.

In the realm of the military, sexual relations always take on particular meanings. The military depends on certain presumptions about masculinity in order to sustain soldiers' morale and discipline. It goes without saying that the construction of militarized masculinity goes hand in hand with the construction of feminized poverty and sexual submission.

In the *New York Times* article, a long report spanning more than a full page, no mention is made of the historical conditions in which Southeast Asia finds itself, nor any mention of the militarization of the region. In one very short passage, the encounter between foreign military personnel and local Cambodians is briefly mentioned as follows:

A United Nations peace settlement reached late last year, ended Cambodia's isolation and brought a torrent of foreigners and thousands of United Nations peacekeeping troops. *They were met* on the streets of Phnom Penh by hundreds of prostitutes who had left their impoverished native villages in search of work in the capital.

(Shenon, 1992: A1, my emphasis)

The key linguistic turn in the passage lies in the three simple words *They were met*, skilfully suggesting that the encounter between the soldiers and native Cambodians is initiated by the prostitutes, by which the soldiers are seduced. In a nine-part series on AIDS in Asia broadcast on National Public Radio in 1994, which explored a wide range of related subjects, including the economic impact of AIDS on Thailand and India, the 'problematic' local sexual customs, the educational efforts to curb the spread of HIV, the tragic plight of young women sold to prostitution, and so on, again *did not once mention* the prevailing presence of foreign military forces in those countries.

If you were to write a storybook about contemporary Southeast Asia, you may consider telling the story of a brothel:

Outside the brothel, there would be a big red sign with only an 'A' written on it. The bar down the street with the 'Off-limits' sign issued by the local Social Hygiene Clinic backed by the military authority would look deserted. But here, there would be navy officers interacting with tourists from their home countries, reminiscing about old times. The owner of the business would be busy greeting the customers, some of whom are here for their favorite waitresses, others are looking for their loyal male servers. The women might be dressed in bright saris and gaudy

jewelry, or simply miniskirts topped with T-shirts with the Coca-Cola or Florida palm tree prints. The male servers might wear nothing except a G-string, always smiling.

The story might be illustrated with narratives of the women and men who describe how they end up in this brothel. They might express their anger at how their boss cheat on their wages, all the while worrying about the children, parents, siblings, and lovers whom they try to support with their meager earnings.

Several of them would tell stories about the sexual practices of these foreign men, what turns them on, what makes them come back for more. In these stories, you would hear their subtle analyses of how the American, British, French, Australian, and United Nations troops, and tourists from Japan, Hong Kong, and the United States came to occupy their city and country.

You might also tell the stories, the longing stories, of the soldiers and tourists who patronize the brothel. They would describe how homesick they are when they are thinking about their friends and wives in their own countries, and how they know, but are no longer bothered by, the fake loyalty and submissiveness displayed by their temporary Asian partners. You might have a character or two who are especially brazen about their sexual prowess. Some of the tourists, however, might be more serious in their quest for the unique beliefs, cultural codes, and even ethics of the Asian body in bed.[4]

A travel guide from the US written for gay tourists travelling to Thailand has this to say:

The Thai are becoming tired of Western emphasis on and distortion of the sex trade – and we can't blame them. Whatever one's personal, emotional and moral reaction to 'pay/being paid for sex' might be, Thailand is among many countries in the world that view prostitution differently than do many Anglo-Saxon nations. It may be that some Westerner's concern to protect the 'poor, exploited' Thai is in fact an insulating, patronizing view of Thai innocence and helplessness. It is most certainly a reflection of Western guilt and confusion about sexuality. The often-heard judgment that Western participation in the Thai sex trade is 'sexual exploitation' is pure emotionalism.

(Allyn, 1991: 260–1)

To help Western gay tourists to further enjoy themselves in Thailand, now that they have been led to accept that sexual labour is part of the 'natural' fabric of Thai life, the same travel guide also contains a handy list of sexual terms for tourists to use to interact with Thai barboys. It explains, 'Words that refer to sexual organs and sex acts are among the first that foreigners learn in a foreign country, perhaps because they help establish a kind of intimacy between native and foreign friends. To some degree, the words help give an insight into another culture's attitudes about sex' (276).

Several years ago, during the Gay and Lesbian Film Festival in Minneapolis, I saw Macho Dancer, *a film about the gay male sex industry in the Philippines. The film takes the audience to the underbelly of*

contemporary Manila, to the streets and bars where young Filipino men from poor, rural regions of the country are trying to make a living by macho dancing for a predominantly older white gay male audience.

The film opens with the sound track of a man moaning in bed. Voyeuristically, the camera traces the shiny body of a young Filipino boy at the bottom of a middle-aged white American male, whose moaning we heard earlier. Throughout this opening scene, the young boy does not make a sound. To me, his face expresses a combination of pleasure and terror which consummates in his silence. The feeling of terror later becomes evident when the American reveals, in a casual manner, that it is his last visit. He is going to return to the United States, a sign of the termination of financial support the boy receives from the 'relationship'. The boy's worst nightmare has just become reality.

Under the circumstances, who can blame the boy for being silent and passive?

The queer cult film of 1994, *Priscilla: Queen of the Desert*, puts drag extravaganza on the road. In the queer *jouissance* found in the carnivalesque celebration of the crisis of gender – what Marjorie Garber (1992) has called the articulation of the 'Third term' – the Australian film inserts an Asian showgirl into the male redneck country. In the film's general overestimation of the transvestic object – again, a third term embroidered on the bodies of three drag queens – this Asian showgirl descends on the carnival scene, stereotypically, from the misty underworld of a Bangkok or an Olongapo. In a spectacular move, she outperforms the queer trio. Her special talent is at the same time her 'indigenous' gift: shooting ping-pong balls from her vagina. Thus, in the hysterical thrust of queer parody of the feminine masquerade, *Priscilla* lingers long enough in its reinscription of the woman, as a hysterical figure of the Asian showgirl and as *femme castratrice*. Apparently, in the competition for male fetishism, the Asian-woman-as-vagina serves as the stable surface upon which the high heels of queer performativity trample. The cultural overestimation of white transvestic sovereignty – the 'queen of the desert' as queer articulation – relies on the resubordination of diasporic Asiatic femininity.

Later, when this Asian woman decides to get on the road herself (it seems that Asian women are always constantly on the road), don't expect her to display feminine bravada, like a Thelma or a Louise, because her only ammunitions against male captivity are her ping-pong balls.

Still later, at the very end of the queer saga, in the film's continued emphasis on the pleasure of the fetish, one may say that she makes a dramatic return as the figure of a sex doll back to the bosom of the archaic orientalist scene of an Asian temple. The woman, *as* the temple of the perfect fetish, remains as plasticity, as hole.

Marjorie Garber theorizes the transvestite in this way: 'The "third" is a mode of articulation, a way of describing a space of possibility. Three puts in question the idea of one: of identity, self-sufficiency, self-knowledge' (1992: 11). In this theoretical construct, it seems clear that the ascendance of the transvestic 'space of possibility' is achieved through questioning, if

not *in expense of*, the possibility of 'identity, self-sufficiency, self-knowledge'. In the context of *Priscilla*, what space of possibility is accorded the diasporic Asian woman, that is the not yet decolonized subject, when the questions of identity, self-sufficiency, and self-knowledge are never raised by or for her?

> *In the popular representations of Asians, we appear in the timidity of our bodies, unable to express our pleasures, and reveled in the obscure religious complexity of our pains. Such representations cast us as the handmaids of bourgeois history, the servants of some larger economic machine, as servants, cheap labor, and whores.*
>
> *The Orientalist imagination sees South and Southeast Asia as societies worthy of embarrassment, if not ridicule: there is the image of the cheap sexual labor on the one hand, and the idea of a sexually 'craved' race on the other. Therein lies the double humiliation rooted in a diasporic economy, and in the political, religious, and psychical repression associated with the Asian character.*

In general, the US media assures us that in Asia, AIDS is spread by Asian-to-Asian heterosexual contact, not by contact with foreigners. Stories of female prostitutes are told to suggest their ignorance and helplessness when it comes to protecting themselves and their foreign customers. Scattered throughout the First World media's sporadic coverage of Asian AIDS are images of and obligatory references to the Asian society and the cultural traits of the Asian people: they are poor, underdeveloped, reserved and custom bound, complacent, superstitious, and war-stricken. Moreover, there are tales of Thai and Indian men who drink profusely, visit brothels regularly, and bring home to their wives AIDS and other sexually transmitted diseases. Visiting brothels, we are told, is a cultural sign of Asian masculinity, a local custom, even an ethic. Here, media orientalism delivers an *ethnicization of the virus*. In this ethnic turn, AIDS in Asia is constructed as a crisis internal to the Asian world, cultures, peoples, indigenous character; in short, its 'Third Worldness'.

The impotence of the Asian character, it seems, may have been the reason for the West to call into question the ability of the Asian region to deal with AIDS, a crisis associated with drug use and sexual labour. A sexual and narcotic crisis, in a tautological turn, confirms the cultural marker of 'Asian' as the tragic by-product of civilization, unable to control our fate and reduced to narcotic and sexual indulgences.

The metaphors of depravity, filth, darkness, repression, and illness have once again delivered the Orient to the West.

'Excuse me, how much is an Asian body worth?'

Notes

1 I have presented a portion of this article as a performance piece using slides and sound-tracks at the Second Asian American Renaissance Conference, Minneapolis – St Paul, March 1993, at the Race, Culture, Power lecture series at the University

of New Hampshire, March 1994, and at the University of Massachusetts – Amherst, April 1996. I want to thank the Center for the Humanities and the Graduate School at the University of New Hampshire for their generous support of this research. Thanks also to Terry Brown, Briankle Chang and Lisa Henderson for their support and assistance.

2 Homi Bhabha (1992) has argued that the notion of ambivalence constitutes the force of colonial stereotype, because the vacillation between the 'already known' and the 'endlessly repeated' produces the combined effect of predictability and probability, thereby ensuring the sign of the colonial Other as one of *excess*. I suggest that the desire for the colonial Other in the developing world assumes just such excess, especially in economic and cultural terms.

3 The best discussion of the popular constructions of 'African AIDS' to date are Patton (1990: 77–97), Treichler (1989), and Watney (1994).

4 This passage is inspired by Enloe's (1992) excellent essay on the military construction of masculinity.

References

Allyn, Eric (1991) *Men in Thailand: Trees in the Same Forest*, Vol. I, Bangkok: Bua Luang Publishing Company.

Appadurai, Arjun (1990) 'Disjuncture and difference in the global cultural economy', *Public Culture*, 2(2): 1–24.

Bhabha, Homi (1992) 'The other question: The stereotype and colonial discourse', in Screen, *The Sexual Subject: A Screen Reader in Sexuality*, London and New York: Routledge, 312–31.

—— (1994) 'The commitment to theory', in Bhabha, *The Location of Culture*, New York: Routledge, 19–39.

Brummelhuis, Hanten (1993) 'Between action and understanding'. Paper presented at the Fifth International Conference on Thai Studies, London, July.

Enloe, Cynthia (1992) 'It takes two', in Saundra Sturdevant and Brenda Stoltzfus, editors, *Let the Good Times Roll: Prostitution and the U.S. Military in Asia*, New York: The New Press, 22–7.

Fanon, Frantz (1991) 'The fact of blackness', in Fanon, *Black Skin, White Masks*, London: Pluto Press, 109–40.

Garber, Marjorie (1992) *Vested Interests: Crossdressing and Cultural Anxiety*, New York: Routledge.

National Public Radio (1994) 'AIDS in Asia' (nine-part series), Washington DC, 17 February to 6 March 1994, Executive Producer: Ellen Weiss. Transcript enquiry: (202)–414–3232.

Patton, Cindy (1990) *Inventing AIDS*, New York: Routledge.

Rhodes, Richard (1991) 'Death in the candy store', *Rollingstone*, 28 November 1991: 62.

Shenon, Philip (1992) 'After years of denial, Asia faces scourge of AIDS', *New York Times*, 8 November 1992: A1.

Sturdevant, Saundra and Soltzfus, Brenda (1992) 'Disparate threads of the whole: an interpretive essay', in Sturdevant and Stoltzfus, editors, *Let the Good Times Roll: Prostitution and The U.S. Military in Asia*, New York: The New Press, 300–34.

'Thailand: AIDS homes in' (1989) *Economist*, 4 February: 310 (7588), 37.

Treichler, Paula A. (1989) 'AIDS and HIV infection in the Third World: a First World chronicle', in Barbara Kruger and Phil Mariani, editors, *Remaking*

History. Dia Art Foundation Discussions in Contemporary Culture, No. 4, Seattle: Bay Press, 31–86.

Watney, Simon (1994) 'Missionary positions: AIDS, "Africa", and race', in Watney, *Practices of Freedom: Selected Writings on HIV/AIDS*, Durham: Duke University Press, 103–20.

Weiss, Julian (1989) *The Asian Century*, New York: Facts on File.

INTERVIEW AND TRANSLATION BY

PATRICK D. MURPHY

CONTRASTING PERSPECTIVES: CULTURAL STUDIES IN LATIN AMERICA AND THE UNITED STATES: A CONVERSATION WITH NÉSTOR GARCÍA CANCLINI[1]

ABSTRACT

In this interview Latin American scholar Néstor García Canclini discusses the emergence of Latin American cultural studies. García Canclini argues that the development of cultural studies specific to Latin America has merit because it provides a multidisciplinary tool for exploring regional relationships between folklore, the rural and the indigenous, the urban and the mass media, and the intersections of social structures and traditions. Differentiating the Latin American perspective from other, more textual orientations, he fields questions concerning the emerging enterprise's theoretical influences, the role of ethnographic enquiry, the place of multiculturalism, the contribution of feminism, its relationship to Chicano scholarship, the influence of changing cultural policies and frustrations of democracy, and its roots in anthropology and sociology.

KEYWORDS

cultural analysis; García Canclini; hybrid cultures; Latin American cultural studies; multiculturalism; postmodernism

Néstor García Canclini has written extensively on the cultural transformations of contemporary Latin America. His prolific production of books, research articles and essays focusing on popular, urban and transnational cultures has established him as one of the most important cultural theorists in Latin America. Moreover, García Canclini's multidisciplinary approach (anthropology, sociology, philosophy, art criticism and economic analysis) to the analysis of contemporary cultural formations has become the calling card of Latin American critical/cultural research, and has situated him as

Cultural Studies 11(1) 1997: 78–88

perhaps the central figure in the emergence of 'Latin American cultural studies'.

While most of the author's work remains available only in Spanish, several recent translations have made his scholarship more accessible to readers of English, including his book *Transforming Modernity* (1993) and *Hybrid Cultures* (1995), an article in *Media Culture and Society* (1988) and chapters in *On Edge* (1992a) and *Media, Communication, Culture* (Lull, 1995).

García Canclini is Professor in the Anthropology Department at the Universidad Autónoma Metropolitana in Mexico City, where he is director of the Urban Cultural Studies Program.

Our conversation took place on 1 July 1994 at a Sanborn's diner in the southern part of Mexico City.

PDM: *Alan O'Connor (1991) and George Yúdice (1993) have both written articles about the emergence of Latin American cultural studies. You are mentioned by both of these writers as one of the central figures in the formation of this scholarly enterprise. Can you define what you see as the central characteristics or investigative tendencies of Latin American cultural studies?*

NGC: One way to answer your question would be to look at a series of articles that I edited a few years ago for a magazine published by the Universidad Autónoma Metropolitana de México. That particular edition was entitled 'Los estudios culturales en America Latina' (Cultural Studies in Latin America). In the first article, I discuss the anthropological and sociological conceptions of culture which pervade Latin American scholarship, and develop a balance of the last few years of theorizing. What I try to show is how these conceptions have contributed to theoretical shifts in the 1980s and 1990s, and the emergence of new ways of analysing culture. As far as I am aware, this is the first magazine in Latin America that has been published as a title suggesting that there exists something in Latin America that can be considered to be cultural studies. What is the justification for this? Well, I believe that necessarily these kinds of declarations must be made in an effort to clarify the movement. For instance, understanding that while cultural studies was born in England and further developed in the United States, in Latin America it has had its own unique development.

It appears to me that there is a certain relevance, a certain space, for adopting cultural studies as a critical tool which is beginning to become more common. Specifically we could speak of different authors; earlier you mentioned José Joaquín Brunner, Jesús Martín-Barbero and myself; I would add Renato Ortiz in Brazil, Beatriz Sarlo in Argentina, among others. I believe that this scholarship is useful in the sense that it is generated from a variety of different disciplines: Brunner from sociology; Martín-Barbero from communication and semiotics; my background is in philosophy, but also sociology, art criticism and anthropology; Sarlo from literary studies;

and Ortiz anthropology and sociology. I think that what we have in common is the desire to find a better way to study cultural processes in a multidisciplinary fashion. Combining these approaches is central to the project, as we understand cultural processes as processes that should be problematized as interconnected and interdependent rather than as isolated phenomena, which is how they are treated by most disciplines. All of us are interested in the relationships between folklore, the rural and the indigenous, and the urban and the mass media, the intersections of social structures and traditions. As you can see, to mix so many focuses implies the combination of anthropology and sociology, communication studies, literary criticism, and so forth. This is similar to what has occurred in the formation of cultural studies in the metropolis (Europe and the United States) and is therefore one of the reasons that I believe it is pertinent to call these studies in Latin America – which refuse to be closed off into one discipline – cultural studies.

But I believe that there are some differences. One of these differences is the roots from which the majority of scholars working in cultural studies come. For example, in England and the United States most scholars are linked to literary criticism and communication studies; also, in the United States, historical studies and revisionism have become important as in the case of Jameson, Yúdice, Jean Franco and others. In Latin America there are scholars representative of communication studies, others with literary backgrounds, but most scholars involved in cultural studies work come from, or at least have emerged out of, sociology and anthropology. This is an important point that helps distinguish Latin American cultural studies from other regional forms of cultural studies.

You may be aware that we formed a network of Latin American cultural studies, and that last year for the first time we held a conference (Primer Encuentro Inter-Americano sobre los estudios culturales, Universidad Autonoma Metropolitana, Mexico City, 3–5 May 1993). The network was formed through the initiative of George Yúdice, Juan Flores and Stanley Aronowitz. We in Mexico collaborated as well by organizing the facilities for the conference, offering financial support and also by suggesting some additions to the list of presenters. While this was the first collective effort by writers working in what can be considered cultural studies, the nucleus of the network was really from New York.

Recently (May 1994) we had another conference (in Bellegio, Italy), but this one had a more international scope, not just Latin American. Only seven Latin American scholars attended, but there were also writers from the United States, Europe, Asia and Africa. It was a conference of twenty-five specialists in cultural studies. I think that there was a very broad scope of ideas presented, but unfortunately this contributed to difficulties in dialogue and articulation. Points of interest, it would seem, are very different, as well as experiences with empirical work.

PDM: *Would you characterize the Latin American work as being more empirically oriented?*

NGC: Well, I wouldn't define it precisely as empiricism. Rather, I would have to say that Latin American work is more preoccupied with the social base of cultural processes, and of course this has a lot to do with its emergence out of anthropology and sociology; whereas, in the United States and in other places such as Asia – at least according to papers and ideas represented in Italy – there is more of a connection to the humanities and so studies appear more concerned with texts than with social processes.

PDM: *In terms of investigating these processes, how important has ethnographic enquiry become?*

NGC: Ethnography has been important in various ways. For me, it has been a necessary component in supporting the development of theory. My concerns are for the most part theoretical. My background is in philosophy, which comprised the centre of all my studies through my doctoral work, but I have always fed my understanding of philosophy through other intellectual territories. In my dissertation, which I developed with Paul Ricoeur – whom I would characterize as a philosopher with a multidisciplinary approach – I focused on epistemological concerns of the social sciences. In Argentina, I worked on questions related to the sociology of art, and later my focus shifted to anthropology and literature until my arrival to Mexico. So, as you can see, my focus was mainly on texts.

However, since arriving in Mexico I began to get involved in much more field work, first in Michoacán, later in Mexico City, Tijuana and other places. For me, there should be a constant dialogue between the two dimensions. Now, I am not an ethnographer, but ethnography needs to charge the development of theory, and theory should inform ethnography. My real interest in ethnography is a means by which to nurture and adjust theory. Ethnography repositions theory in accordance with the concrete conditions of cultural existence; processes and negotiations inflected through cultural life can be used to confront and redirect theory.

But, there are other concerns when assessing how theory relates to cultural processes, and how distinct discourses develop. For instance, political questions, which I would say are quite distinct, frame much of how discourses emerge. And this applies to all the continents. For example, I would say that political concerns in the United States are more focused on multiculturalism within the US society, coupled with problems concerning citizenship (at least for now) and with the role of minorities and intellectuals. In Latin America the focus may involve some of these concerns – the preoccupation with citizenship has just recently been raised by a few investigators – but overall, political discourses are still very much in reference to national politics. There also continues to be a strong tendency on the part of some intellectuals in Latin America to try to play a political role in respect to national culture, through official channels, as in the case of Mexico, Brazil, Colombia, to a certain degree Argentina but less so, and perhaps Venezuela. In certain cases the role of some Latin American intellectuals is vindicated by the majority party.

These tendencies are what appear to me to be what situates the distinct discourses of cultural studies. For example, during the past few years I've been working in the theme of multiculturalism in Latin America, but not in the tradition of US scholarship. Clearly, in Latin America there are other ways to address the problems of multiculturalism. It is an old theme considering the work of anthropology and the history of cultural policies. More precisely, multi-ethnicity is what is being addressed now, but it is a multi-ethnicity which is understood very differently from that in the United States because it draws heavily on the indigenous experience. In the United States we could say that the different ethnic identities play a much larger role in the processes of modernity, while in Latin America there is a wide array of indigenous peoples who are continuing to reproduce traditions that are not necessarily modern, or that have a fragile relationship with modernity.

Anyway, these are some of the differences between the development of cultural studies here and in other places.

PDM: *It seems that more Latin American scholars are turning their attention to issues concerning cultural plurality, heterogeneity and social inequality. Why have these themes called so much attention in the past few years?*

NGC: There are many reasons, but without a doubt one of the major ones is the Latin American intellectual's increased connection with the kind of theory radiating from the metropolis, the most notable conception being multi-ethnicity. There is, however, another area of focus that has emerged in the last few years in Latin America which is something that I would consider even more important and more conditional. In Latin America there has been a process begun in the 1970s and 1980s in which we passed from military regimes to modes of democratization; and then later there came a period of disenchantment with democracy. Democracy had become a central hope, a space for political participation, a solution for economic problems and cultural distress. However, democracy does not necessarily promise these effects. Sometimes democracy just opens up spaces where existing problems become more visible, more apparent, but it does not solve the problems. Democracy permits a plurality of voices, opens channels for debate, and all of this permits issues to emerge with more force, such as issues related to multiculturalism and cultural heterogeneity that in the past remained undefined and out of focus in society.

Repositioning the focus of scholarship also has much to do with the weakening of nation-states. In some Latin American countries this has been very important, as in the case of Mexico. The state has been the central actor in social life and has configured the modern nation. In the last few years, however, neoliberalism has weakened the position of the state, as the state has reformed to privatize large sectors of state apparatuses. Some of these sectors are communicative and cultural. So, there is a weakening of the national identify, at least as prescribed by the state, which appears along with the emergence of multiple sectors of the population calling for rights,

conquests, and many other different demands. In Mexico I believe that the case of Chiapas is illustrative, but social demands also appear in the form of urban agendas, youth culture, feminism, etc. The role of the press has been very important also as an actor in the changes, as has radio in some cases. So as we can see, this growing social presence of these different players that have not traditionally been political forces is contributing enormously to the heterogeneous currents of our society. The incapacity of nation-states to unite this heterogeneity has made much more visible the questions concerning multiculturalism, at least for researchers and intellectuals.

I also think that the crisis of traditional paradigms is increasing as more and more classical modes of analysis seem incapable of negotiating these complexities. They cannot be reduced to classes, nor can class simply be constituted as a function, nor can we continue to turn to traditional counter-positions. What is called for is a different mode of analysis that is responsive to multiculturalism, responsive to increasingly apparent social complexities. This is precisely why we need the advancement of cultural studies. The segmentation of audiences, the impossibility of generalizing about the public concern of consumers without first foregrounding diversity, different lifestyles, different ways of thinking, feeling, and so forth – these kinds of complexities dictate that a more sophisticated means by which to interrogate society must be developed.

PDM: *If these themes are so important, or at least becoming more common in the discourses of many writers and researchers, why hasn't there been more attention to questions concerning race and ethnicity as spaces of social struggle? I am aware that these concerns are much more a part of a US perspective concerning marginal peoples, but have these kinds of themes manifested themselves in the writings of Latin American scholars?*

NGC: The denomination 'race' has had a very turbulent history, and not only in Latin America. In large part, it is problematic in that it has been degraded and disqualified by the social sciences because it is preferable to speak of ethnicity rather than race. Ethnicity is a term that appears more neutral; race is more representative of biological concerns and less indicative of culture. Nevertheless, in the last few years I believe that questions of ethnicity have become very prominent in Latin America, at least depending on the literature that you familiarize yourself with. In anthropological references the theme of ethnicity is central and this has had a significant impact on other disciplines. At the same time, there is a certain decline in respect of some traditional organisms created specifically to contend with questions concerning ethnicity, particularly indigenous institutions. So, there exists a complex situation where there is a degeneration of the indigenous institutions of multi-ethnic traditions, but there is also a new emergence of multi-ethnicity in Latin American society via social struggles, increased vocalization of demands and also in the manner by which academics are articulating these struggles. And it appears that this is not only happening

in Mexico, but also in Ecuador, Peru, Bolivia, Guatemala, all places where questions of ethnicity have been increasingly visible.

PDM: *In* Culturas híbridas *(1990: 71) you wrote that 'modernity is not the expression of socioeconomic modernization but the mode in which elites take charge of the intersection between different historical temporalities and attempt to elaborate with them a global project'. Considering Mexico's turbulent past year – the ratification of NAFTA, the insurrection in Chiapas, the assassination of Colosio, Mexico's first ever televised debate, and so on – how do you see this intersection being negotiated?*

NGC: Well, it appears that the crisis that the Mexican political system has endured during the last year, year-and-a-half, is evidence of the conflicts and the unresolved coexistence of different traditions and modernities that exist in Mexico; huge inequalities – regional, ethnic, socioeconomic – which are linked to the government's/PRI's inability to integrate segments of the Mexican population and to promote an even and accessible modernization. While problems of inequalities and disparities have been resolved for some segments, most problems of access continue to go unresolved. Clearly Mexico isn't Yugoslavia, but here questions concerning multi-ethnicity, for instance, remain more unresolved than in other countries.

PDM: *Speaking of inequalities, how have women's issues been addressed, or more specifically, has a feminist perspective emerged as part of Latin American cultural studies?*

NGC: There is very little participation from feminist writers of women's studies in cultural studies, or for that matter any real kind of reciprocity. Nevertheless, there are some important groups in Latin America that have focused specifically on women's issues. There are, however, some important differences from the feminist work of the United States. In the United States it appears to me that feminist studies are closely involved in political struggles for the rights of women, or for questions of gender, empowerment, etc. In Latin America there are important works concerning the condition of women, but these have been articulated in reference to broader issues (for example, class, ethnicity, etc.). A case in point is Rosa María Alfaro in Peru, who works directly with women and whose central concerns are women's issues, but her studies are developed in reference to communication studies.

PDM: *So you wouldn't necessarily define her work as feminist?*

NGC: No. And in fact I feel that that is usually the case. That is, there is more work that would fall under the category of women's studies than feminism. But this shouldn't be surprising because plainly the social sciences in Latin America are biased towards masculine perspectives, which is what frames much of the work produced. This is not only because there are many more men working and writing, but also because many of the women

working in the social sciences overlook the specificity of women's issues. But this doesn't mean that there are not fine studies dedicated to women's issues. In fact there are quite a few books and many articles that expand on women's issues in Brazil, Mexico, Peru, Chile, Argentina and other countries. In addition, there have been feminist contributions to our cultural studies, such as the case of Nelly Richard, but such work has not necessarily found its own place in the current development of Latin American cultural studies. I think that this is one of the investigative concerns of English language cultural work that should be taken more into account by the social sciences and humanities in Latin American.

PDM: *Has the Chicano movement influenced the work of Latin American writers?*

NGC: Unfortunately very little. I think that maybe there is an underlying connection there, but the gap has yet to be bridged between the two sides. I think that is beginning to change, but very slowly. One barrier may be language, but a bigger one is the incredibly low rate of diffusion of Chicano literature in Latin America. Nevertheless, in Mexico (especially in the north) the shared, intercultural border has become more problematic. There have been many conferences where ideas have been exchanged, but much more in terms of artists than researchers. I've been in quite a few conferences in both Mexico and the United States, mostly in the border areas such as California, Texas, Tijuana, in which we have discussed identity issues. Quite a few common themes emerge, but the overall feeling is that there is a certain defence of issues; a certain intellectual and cultural territory being defended. I feel that when the Chicanos meet they prefer to focus on the problematic of Chicano identity. Under these cirumstances, it is very difficult to shift the focus to broader issues of culture and society that would be more mutually oriented. Now, I am not referring to all Chicano scholars, but this does seem like a problematic that frustrates attempts at addressing issues in a more unified manner.

PDM: *According to O'Connor (1991: 60–61), one of the ways to identify Latin American cultural studies 'is to follow networks of influence and the diffusion of ideas, for example from England to Latin America'. Reading your work, and the work of other researchers associated with cultural studies such as Jesús Martín Barbero, José Joaquín Brunner, Carlos Monsiváis and Jorge Gonzalez, there are references to Raymond Williams and Richard Hoggart, but I don't really see a huge influence by the Birmingham School. From your perspective, what European theorists have been the most influential in the development of cultural studies in Latin America, particularly in your own work?*

NGC: The Birmingham School has had a certain influence on the formation of Latin American cultural studies, specifically in the area of communication studies. I think that the scholarship of Martín-Barbero and

some of the Brazilian scholars demonstrates this. For instance, the critique of the Birmingham School that Martín-Barbero (1993) develops in his book *Communication, Culture and Hegemony: From the Media to Mediations* offers some interesting commentaries, as do his views of the Frankfurt School. But the thing is that this is not that big an influence when compared with other influences, other dialogues. In addition, I think that Latin American cultural studies' relationship with the discourses of the metropolis is relatively recent – maybe little more than ten years. There have been other influences that have been very strong but have not traditionally been associated directly with cultural studies, especially Pierre Bourdieu. Such work has nourished the emergence of cultural studies in Latin America, particularly in the realm of investigative orientation. It appears to me that to understand Latin American cultural studies you need to consider the work of Pierre Bourdieu. I have the impression that in England and the United States Bourdieu's work has also been important: about ten years ago his work appeared in *Media, Culture and Society*, and in the United States his work is often cited. But oddly, Bourdieu's work is like the powerful influence or great source that hasn't been officially recognized or invited into cultural studies. We invited him to the conference in Italy, but he didn't accept. In any case, I see him as having a powerful influence in Latin American work, even if his influence is perhaps in decline right now.

PDM: *In the United States and England postmodernism has proved to be a very provocative notion, receiving quite a bit of attention from some of cultural studies' central theorists such as Lawrence Grossberg, Angela McRobbie, bell hooks and others. Latin American writers, on the other hand, have approached postmodern theory with a little more caution, to some extent even an apparent resistance to it. For example, Jesús Martín-Barbero rejects postmodern arguments for the analysis of culture. Your work, on the other hand, demonstrates a certain receptiveness to post-modern theorizing. Can you explain how you understand postmodernism and its application to questions concerning culture?*

NGC: I don't have much more to add to what I've already written about in *Culturas híbridas*. For me, this book was an attempt to take into account both modern and postmodern questions, and negotiate an interpretive space within the two discourses. Speaking broadly, I can say that post-modernism is more a defined current of social thought than a theory, and it can act as a space to reinterpret the crisis precipitated by modernization, the limits and frustrations of modernity. So, I don't consider postmodernity a theory, but it does generate some interesting questions by radicalizing problematics associated with modernity, and has shown how certain assumptions about modernity need to be questioned because of their formulaic and totalizing tendencies. While there has been little theory generated directly below the banner of postmodernism in Latin America, what we can see is that it has contributed to our reinterpretation of modernity. What has emerged is an understanding of modernity as a relative process which plays

on ironies, contradictions and disenchantment. Postmodernism facilitates new understandings of style, rhetoric, fragmented sensibilities and disconnections, but I wouldn't credit it with much more.

PDM: *What differences do you perceive between the interpretations of postmodernism by Latin American writers such as yourself, José Joaquín Brunner and George Yúdice, and more classical interpretations such as Jameson, Lyotard or Baurillard?*

NGC: Well, there are some differences, yes. For this question what I said earlier is also valid: that in Latin America a set of distinct political circumstances charges the articulation of culture; that is, that there are different ways in which traditional modes of existence are articulated through modernizing processes. In this respect, Latin American writers have shown a heightened sensibility for recognizing cultural formations that are not necessarily 'modern'; that popular memory is an important contributing element in the reformation of contemporary cultures. This, I believe, is important, in that remaining sensitive to processes of change and adaptation reveals much about contemporary cultural sensibilities that are multitemporal and hetero-geneous. This is what constitutes Latin American societies.

I am under the impression that the theoretical developments of these concerns are what draw the attention of scholars from the metropolis, such as Jameson, Jean Franco, Renato Rosaldo and James Lull, to the scholarship of Latin American writers. In fact, this is what I would suggest has facilitated, in the last few years, a dialogue both intense and frequent with these writers that was largely absent in the past.

Note

1 This interview was made possible through a Fulbright-García Robles fellowship.

References

García Canclini, Néstor (1984) 'Gramsci con Bourdieu', *Nuevo Sociedad*, 71.
—— (1987) '¿Dé qué estamos hablando cuando hablamos de lo popular?', *Communicación y culturas populares in latinoamerica*, Mexico City: FELAFACS.
—— (1988) 'Culture and power: the state of research', *Media, Culture and Society*, 10.
—— (1990) *Culturas híbridas, estrategias para entrar y salir de la modernidad*, Mexico City: Grijalbo.
—— (1992a) 'Cultural reconversion' (trans Holly Staver), in G. Yudice, J. Franco and J. Flores, editors, *On Edge: The Crisis of Contemporary Latin American Culture*, Minneapolis: University of Minnesota Press.
—— (1992b) 'Los estudios sobre comunicacion y consumo: el trabajo interdisciplinario en tiempos neoconservadores', *Dia-logos de la comunicion*, 32.
—— (1993a) *Transforming Modernity, Popular Culture in Mexico* (trans Lidia Lozano), Austin: University of Texas Press.

——, editor (1993b) *El consumo cultural en México*, Mexico City: Consejo Nacional para la Cultura y las Artes.

Lull, James (1995) *Media, Communication, Culture. A Global Approach*, New York: Columbia University Press.

Martín-Barbero, Jesús (1993) *Communication, Culture and Hegemony: From the Media to Mediations* (trans Elizabeth Fox and Robert A. White), Mexico City: Gustavo Gili.

O'Connor, Alan (1991) 'The emergence of cultural studies in Latin America', *Critical Studies in Mass Communication*, 8: 61–73.

Yúdice, George (1993) 'Comparative cultural studies traditions: Latin America and the U.S.', unpublished paper. City University of New York.

KATYA GIBEL AZOULAY

EXPERIENCE, EMPATHY AND STRATEGIC ESSENTIALISM[1]

ABSTRACT

This article examines the implications of the language of 'cultural diversity' and 'difference' for syllabi, curricula and educators in academic institutions. The author suggests an intellectual orientation which moves away from the social vocabulary of 'inclusion' to that of 'multivocality'. Such an approach requires an interdisciplinary model whose departure point anticipates the need to teach students the skills of interrogating the relationship between power and knowledge and the political implications of this link.

It is argued that such a perspective would encourage a more careful consideration of bibliography and presentations which take into account the complex diversity in the backgrounds of students – the target audience. This would simultaneously diffuse the tendency to depoliticize and domesticate race relations under the labels of 'culture' and 'multiculturalism' and require educators to assume that more than a few have family histories which mirror heterogeneity and pluralism. The embodiment of difference, however, may not always be visible. As a pedagogical strategy, thinking explicitly about the assumptions behind who, what and how one teaches will further the epistemological and political objective of educating students to develop informed opinions as well as help to cultivate a heightened sense of personal accountability to their responsibilities in the multiple communities to which they belong.

KEYWORDS

diversity; culture; multiculturalism; pedagogy; race; identity; politics

This article focuses on an inescapable core issue facing the American academy: how to confront the question of '*difference*', with its corollary questions, such as the relationship between identity and politics on the one hand, and knowledge and power on the other. It is an invitation to reflect on how the idea of 'difference' relates to, and is conceptualized and represented under, the umbrella of *culture*. A number of difficult, and perhaps uncomfortable, questions will be mapped out as challenges facing educators whose long-term goal is not merely to prepare students for life in a world still troubled by racism, poverty and intolerance, but to motivate them towards contributing to its betterment.

Cultural Studies 11(1) 1997: 89–110 © 1997 Routledge 0950–2386

My departure point is predicated on the belief that the academy is indeed a place where a student's consciousness should be politicized, not domesticated; inspired, not indoctrinated. Students should leave with the tools to develop informed opinions and a heightened sense of personal accountability to their responsibilities as human beings, members of communities and global citizens. In anticipation of a conservative response, I argue that this goal does not, as some might claim, evidence political correctness, nor is it a reflection of facile relativism. On the contrary: educators are always projecting their own politics even where there is a sincere investment in maximizing objectivity. The enquiry here, therefore, centres on some of the implications for intercultural programmes, an approach with explicit epistemological and political objectives, as it pertains to the American context. Race anchors this study, for I do believe that historian Michael Goldfield accurately identifies white supremacy as the defining, paradigmatic, idiographic characteristic of the United States (Goldfield, 1991). In this context, therefore, I suggest that the issue of race (despite its status as a scientifically untenable notion) pervades many of the challenging problems for the academy with regard to what, how and whom we teach.[2]

It is an understatement to note the antipathy people of colour have expressed towards the labels 'multiculturalism' and 'diversity'. In the first place, the prefix 'multi' in multiculturalism alternately evokes the unsavoury images of the melting-pot or the equally apolitical mosaic. This portrayal of pluralism renders invisible the causes of fragmentation along class, gender, religious and most of all, racial, lines. The issue of race and racism – particularly the dominant popular discourse which centres on a black/white binary – intrudes and intervenes in any discussion which links culture, diversity and identity. Significantly, the term 'multiculturalism' also obscures the persistent tenacity with which the conception of 'race' and 'culture' are confused. This occurs both within and outside educational institutions where the terms (multiculturalism and diversity) were introduced. Within the academy, in particular, the language of culture and cultural pluralism often provides a refuge in which race relations are depoliticized, domesticated and managed.

Can these issues be tackled more productively if we change the labels under which discussions of curricular reform or transformation are conducted? As Grant Cornwell and Eve Stoddard emphasize, 'interculturalism', as an enquiry into cultures interacting, is a term deployed to signal cultures as dynamic processes and to highlight the power relations which inform cultural interchange[3] (1994). While the prefix 'inter' escapes the polemical weight of 'multi', retention of the root word 'culture' remains problematic. Culture, after all, is the invention and key concept of anthropology. Yet, as anthropologist Terence Turner, among others, has pointed out, the word culture is as unstable as its referent. It is a shifting signifier – in other words, its meaning changes depending on the context and the speaker.

For over a decade, the ambiguity of the 'culture' concept has engaged the attention of anthropologists spurred on by the intervention of literary critics with historians treading cautiously behind the sidelines. Turner notes that

these intellectual contestations produced a proliferation of theorizing, advantageously opening a space for cultural studies as well as an erasure of clear disciplinary boundaries.

I suggest that 'culture', as a key word, warrants our attention. It is a theme I will pursue here as a reminder that 'culture' itself is a metaphorical construct which served as the foundation for a literary genre – 'ethnographic realism'. That is, writing representations of others, usually defined as non-white (a category that has periodically included Irish Catholics, and eastern and southern Europeans),[4] non-Western people in general and 'exotic primitives' in particular. The social vocabulary of culture is intimately linked to issues of representation and therefore refers to questions of power: who has the power to define whom, and when and how and, finally, for what purpose. This echoes the cautionary remarks expressed by bell hooks against the danger of reinscribing patterns of colonial domination if the 'Other' remains an object of study in newly established cultural studies programmes. The relevance of calling the social vocabulary of culture into question is intentionally to provoke conversation about how to avoid developing (or alter existing) programmes of study which, as Cornel West writes, 'highlight notions of difference, marginality and otherness in such a way that it further marginalizes actual people of difference and otherness'.

Women's studies scholar, Chandry Mohanty, persuasively argues that 'culture' has become a leading commodity for prejudice reduction in what she aptly labels 'the Race Industry'. She contends that culture 'is seen as noncontradictory, as isolated from questions of history, and as a storehouse of nonchanging facts, behaviors and practices' (1994: 158). Difference is thus often erroneously defined as cultural, rather than explicitly examined as the product of structural inequalities and asymmetrical social relations. This tendency manifests itself most prominently in undergraduate curriculum requirements, which have commodified racial inequality under the label 'cultural diversity'. As a result, 'diversity' and 'multiculturalism' have come to serve as euphemisms for 'non-white Others' (the impolite translation of 'minorities'). Furthermore, in this playing field of diversity, insufficient attention has been drawn to the manner in which W/whites are either an explicit or an imaginary target audience yet both *exclude* themselves *and have been excluded from* the performance.[5] Critics of this development contend that until the language of inclusion – with its patronizing overtones – is replaced by an emphasis on multivocality no real curricular transformation is possible.

At the core of the debate over identity is a struggle over, and fascination with, representation. It is the triad of race, identity and representation which dominates and characterizes the debates over national identity, particularly in countries with a majority population of European ancestry. Sociologists Michael Omi and Howard Winant emphasize that whiteness is becoming *less* transparent and *more* a matter of anxiety, as Pat Buchanan and his constituency effectively demonstrate (1986). In the United States, this phenomenon necessitates educators to specifically think about their

own racial positions in the classroom on the one hand and the experiences and personal narratives of their students on the other.[6] Let me immediately stress that race is not the *only* standpoint position which calls for critical self-consciousness; others, such as gender, religion and religiosity, should definitely not be neglected and, of course, one individual may have several standpoint positions.

There is little question that it is crucial to expose students to a more global perspective within which to situate and understand the complexity of their own personal, community and national identities. The interdisciplinary approach within the framework of general education is the best means for accomplishing this. No doubt the devolution of strict disciplinary boundaries is slowly but surely taking place although, as cultural anthropologist Ulf Hannerz reminds us, 'career paths, socialization patterns, and administrative decisions all contribute to keeping boundaries neat, and areas of incoherence safe' (1992).

Learning about local, regional and global diversity, as well as the structures and organization of social meaning within and between a diverse range of publics, *may* sensitize students to the heterogeneity of any given social group, including their own. In addition, precisely because this global orientation encompasses an integrated reading of different types of social formations and their meaning systems, an intercultural approach introduces most students, for the first time, to the permeability of group boundaries which are the points for interaction, change and struggle.[7]

I want to underscore that this is 'an introduction' for most but not all students. This is therefore an opportunity for educators and students to think in terms of microdiversity or microuniverses. In other words, the kinds of personal narratives, experiences and previous knowledge which individual students of any colour have *before* they enter the lecture hall or seminar will impact on the way texts are encountered, read and digested. For instance, students from families whose immediate histories mirror many of the patterns of cultural pluralism that an intercultural programme highlights will have very different responses from those from more homogeneous backgrounds. Educators have to anticipate the nuances that this implies for teaching all students the skills of interrogating knowledges they have previously taken for granted.

Although it is open to debate, I do believe that the United States should be the centralizing grid around which intercultural studies in an American university should be structured. But the standard representations of diversity and pluralism in this country, especially in matters of race and ethnicity, need to be abandoned. This is not an easy task to accomplish. It means candidly recognizing, confronting and contesting negative stereotypes and general misrepresentations of people of colour from commercial films to the news media. And it means formulating pedagogical strategies to repair the damage done to *all* students from the cumulative effect of this silent violence. This brings us back to the issue of conceptualizing the format, content and practice of teaching cultural encounters and, more to the point, the target audience.

It is important to personalize this: take a moment and think about courses you have offered and ask yourselves if you considered the following three questions when you were designing the syllabus: (1) To whom were you speaking (that is, to which body of students in the classroom were the texts directed)? (2) For whom were you speaking (that is, who was being represented by the selected texts)? (3) Against whom and what were you speaking (that is, what were the underlying political messages which the course was meant to convey)? In other words, whose histories are excluded, distorted or misrepresented? Whose identities are negated and at the expense of whom?

Parenthetically, this is rather tricky and not a solicitation for a relativist notion of sensitivity. For instance, I would vehemently protest the inclusion and presentation of white supremacist and Nazi perspectives as legitimate cultural points of view. This of course raises the issue of how to tread the thin line between revisionism and falsification. Specifically, a firm effort should be undertaken to arrest the Holocaust denial propaganda which has insidiously penetrated the academic arena as though it were entitled to the benefits of free speech and the privilege of being incorporated as conscientious scholarship.[8] And here one can turn to Franz Fanon's insightful comment:

> At first thought it may seem strange that the anti-Semite's outlook should be related to that of the Negrophobe. It was my philosophy professor, a native of the Antilles, who recalled the fact to me one day: 'Whenever you hear anyone abuse the Jews, pay attention, because he is talking about you.' And I found that he was universally right – by which I meant that I was answerable in my body and in my heart for what was done to my brother. Later I realized that he meant, quite simply, an anti-Semite is inevitably an anti-Negro.
>
> (Fanon, 1967: 122)

It cannot be overstated that the invisibility of whiteness, as a raceless subjectivity,[9] is reproduced and reinforced when persistently 'the Others' – those about whom one reads in a course of study – not only include those already marked by the language of marginality (as in the word 'minorities') but the texts about 'the unequally empowered' often reinforce the very stereotypes which should be under target. For instance, law professor Randall Kennedy points to undisciplined generalization in social science literature which has reinscribed black as a signifier for poor, culturally deviant/deficient and criminal, even where the intent has been to refute pathological depictions. It is a literature which has ignored the diversity of black people's experiences including regional, ethnic, class and gender differences. Kennedy notes further that one of the hallmarks of this social science literature asserts that 'black traits are superior to white traits or are functionally valuable to blacks given the social context in which they live' [Kennedy, 1989: 1817: n. 304].

I am not suggesting that different types of cultural articulations – what perhaps may be more usefully seen as styles – and specific institutional

structures did not develop among sectors of the African-American community in the United States which were significantly different from various white European-American communities. I am, however, insisting that these are practices and productions which need to be specified, contextualized and problematized – not presumed. Instead, texts dealing with African-Americans tend to romanticize, mystify or dramatize behaviours as culturally distinctive *black* practices – a representation further fostered and reinforced in the news media and entertainment world.

From ghetto studies of the 1960s to analyses of gangsta rap in the 1990s, the black underclass has been marketed as representative of the authentic black experience.[10] In the 1960s, social scientists targeted black communities without problematizing and defining the criteria for privileging racial boundaries as opposed to the specificity of class which would have furthered an inter-racial and intra-racial dimension.[11] In the 1990s, as cultural critic bell hooks argues, there is a remarkable resistance to viewing gangsta rap as 'an embodiment of the norm of [American] mainstream culture' (hooks 1994).

In the 1920s and 1930s, a new emphasis on researching common links across a black diaspora served the purpose of a project of vindication. In the context of the United States, this also encouraged a conceptual segregation of blacks and whites which has been more ubiquitous than spatial segregation.[12]

With anthropologist Melville Herskovits's ideas of acculturation – which focused on the survival and diffusion of African culture within the black slave population and inherited by their descendants – Herskovitz channelled interest away from the process of inter-racial cultural dynamics.[13] The American South, for instance, a crucial site for researching continuities with Africa, was the one region where the process of acculturation had an inescapable inter-racial dialectic involving blacks, whites and Native Americans.[14] In retrospect then, the objections of black sociologist Franklin Frazer to Herskovits were not without merit. The culture concept never quite replaced race thinking – it merely provided a new terminology which was less blatantly offensive.[15] But the problem remains: how do we recognize difference without reifying it, and how do we translate this recognition in teaching critical enquiry?

I suggest that in the absence of a conscious decision to assume diversity rather than homogeneity – given the fact that diversity is both visible and invisible – educators will continue to offend and silence some, and reproduce racialist thinking among most. Of course, I am not so naive as to believe that most professors will make this effort – many white professors (and even a few professors 'of colour') see the topic of race sensitivity as exhausted, contentious, tedious, tiresome and boring. However, in the aftermath of the O. J. Simpson trial, the Million Man March and the anticipation of whether Colin Powell would announce his candidacy, the rude intrusion and raw saliency of race thinking were reminders that the discourse is as potent and explosive as ever. Parenthetically, one might question why attention to gender issues in the academy have not followed a

similar course. But let me demonstrate this with a seemingly innocuous anecdote.

The notion of body odour is culturally specific and the use of deodorant, perfumed soaps and so forth are a rather recent phenomenon, although those of us who were born or raised in the United States and under the age of 60 have probably taken it for granted all our lives. In fact, as late as the 1950s, most Americans did not take a shower on a daily basis whereas in the 1990s it is not unusual for people to bathe twice a day.

In a course whose topic was visual representation and the production of consumer culture, the professor, always careful to use correct terminology and instead of saying 'black' made a point of saying African-American, told the following story. A white woman, an American researcher, was working in Africa and conversing with a black African woman. The African woman kept backing away from the American, who in turn would make up for the distance by taking a step towards her. After a few moments of this pursuit and retreat, the American became self-conscious and suddenly asked, 'Am I doing something to offend you?', whereupon the African immediately answered, 'Well, quite frankly, you smell like a corpse.'

This narrative is less amusing than it appears, particularly when it is offered in a lecture by someone who has explicitly deferred any discussion of race (referred to as 'multiculturalism') to one separate week in the semester. I was intrigued by the fact that not one student in the large lecture hall laughed, although, frankly, I did chuckle. Since the topic of anything but white Americans rarely came up in this class, and the naturalization of whiteness was never interrogated, I suspect that the students were uncertain how to respond without offending anybody – indeed, they seem to be extra-ordinarily politically correct. The very fact that two women, a white American and a black African, were juxtaposed racially and not merely culturally, immediately signalled something serious, best left untouched, and under these circumstances no reaction at all was preferable to a disrespectful response.

The professor went on to explain that whereas in America saturating the body in perfumed scents was a positive deterrent against body odour, in Africa this was reserved for the dead. The not very subtle implication, of course, was that the black African woman did not smell as 'clean' as her white American counterpart. The professor's conscious intention was to illustrate an example of cultural difference which has personal, as well as commercial, significance. The context in which it was offered, however – a course in which whiteness is never addressed, yet informs every aspect of the topic, material and method of instruction – was inescapably racialist. The anecdote may well be true; however, if the purpose was to highlight cultural difference which Revlon or Proctor & Gamble need to take into account as they seek overseas markets, the same point could have been made without implicitly, if inadvertently, relying on a long history of stereotypes about Africa and Africans.

I leave it to you to consider whether this would have been understood differently if the tale had been about an unspecified American in an unspecified

foreign country or a black American and a black African – or if indeed the same point about cultural differences might have been made with a completely different type of example.

Whiteness, as an unmarked category, is neither fixed nor obvious, but has become so naturalized that it is hard to get at its unmarked-ness. Cornel West, among others, advocates the need for an examination of ways in which whiteness is 'a politically constructed category parasitic on "Blackness",' a project Toni Morrison effectively carries out for literature in her book, *Playing in the Dark* (West, 1993: 19; Morrison, 1992). Poet and professor Ishmael Reed provides a telling example from his students. When asked to draw on experiences from their own ethnic backgrounds, the white European-American students nevertheless tended to write stories about a 'black' person (Reed, 1989).

Related to the ways whiteness is rendered colourless and monolithic under the auspices of 'pre-fixed' cultural studies, is a pervasive silence over white anxiety in the face of racial ambiguity.[16] I suggest that this needs to be disrupted along with essentialist notions of blackness. The following example illustrates the kind of internalized misconceptions that most students – in fact probably most people – bring to the academy. In the public sphere of visual images, you may recall that the performers chosen to portray the central characters in the television series *Queen* (Alex Hailey's sequel to *Roots*) and in the film *Malcolm X*, were both significantly darker than the people whom they were chosen to represent – despite the fact that skin colour was a crucial aspect of identity in the real lives of Hailey's grandmother and Malcolm Little. Film-makers Kathe Sandler and Haile Gerima (professor of drama in the Communications Department of Howard University) have both used their art to challenge the black community to confront pigmentation stereotypes in contemporary visual representations of a notion of blackness.[17] This type of effort also needs to be directed at a white audience.

In sum, in the context of thinking about general education as the place where students learn how to think critically, race has to come out of the closet and be disentangled from the notion of culture. Where a particular sector of the population is defined as a distinctive group – a cultural entity – the markers of race and ethnicity often reinscribe the very boundaries which negate the effort to convey the porousness and interrelationship of group identities as well as the complexity of an individual's identity. An alternative is suggested by educator William Pinar in an instructive essay entitled 'Notes on understanding curriculum as a racial text' (1993). He asks the question 'who are we as Americans?' and the answer he provides exemplifies not a revision but a transformation in teaching on pluralism in the United States: '[the] African-American's presence informs every element of American life. For European American students to understand who they are, they must understand that their existence is predicated upon, interrelated to, and constituted in fundamental ways by African Americans.'

Pinar emphasizes that educators have to acknowledge in order to pass on to students the inseparable, intertwined historical experience which black

and white Americans share and have been profoundly affected by, and this in turn must be seen in the context of the relationship between the North and the South. John Philips underscores these insights in a provocatively titled essay, 'The African heritage of white America':

> In conditions of culture contact in the New World, common aspects of European and African culture tend to reinforce each other. Previously, when the same cultural traits survived among both blacks and whites, they were considered to be European cultural survivals among whites but African cultural survivals among blacks. It would be easier to consider a dual origin for these cultural traits in both cases . . . African culture among whites should not be treated as just an addendum to studies of blacks but must be included in the general curriculum of American studies. Black studies must not be allowed to remain segregated from American studies but must be integrated into our understanding of American society, for our understanding of white American society is incomplete without an understanding of the black and African impact on white America.
>
> (Philips, 1990: 237)

I refer again to poet Ishmael Reed who relates: 'I told a professor of Celtic Studies at Dartmouth of my Irish-American heritage; he laughed. This was an intellectual at one of our great Ivy League colleges.'

Where Philips's integrationist model and Pinar's approach to examining the constitution of the American self as a racial self are adopted, the influence of educators like the Dartmouth professor may not be neutralized, but at least it will be called into question. The task of an educator is to cultivate an awareness of how knowledge is made as well as restructuring ways of seeing. And I propose that the guiding principle for criteria, selection and organization of material should be ultimately aimed at the lofty goal of furthering social justice. Having said that, one cannot overlook the terrible lack of correlation between knowledge and the dissolution of prejudice; this is a subject which should perhaps solicit some of our attention. More knowledge and information does not make for less ignorance or bigotry.

The overall advantage that should be accentuated is that where *inter*- demands that we examine interaction, processes and the power relations that inform interchange between groups of people, it also arrests the prevailing tendency to ghettoize African diaspora and ethnic studies as an addendum to general education requirements. In other words, the artificiality of these categorizations also becomes more pronounced.

Protestations notwithstanding, the concept of culture, traditionally linked to a geographical site, continues to evoke a sense of boundedness and homogeneity. In part, this slippage explains why mention of the term includes an obligatory qualification which insists on the fluidity and porousness of culture. The problem, I think, is that in spite of this stipulation, culture remains a code word for accentuating commonalities within certain ethnic and racial groups, rather than their internal diversity. Yet, even where difference in itself has become a form of identity, reference to

culture is used to author and authorize its authenticity. What seems to have been forgotten is that culture is a metaphorical construct.

Here I want to shift my focus and return to the culture concept which is inescapably associated with anthropology. Traditionally, the objective of anthropology has been to account for difference. Thus diverse and distinctive ways of acting, thinking and speaking have been defined, investigated and then translated as customs and practices which are unfamiliar. But pause here a moment: *unfamiliar?* To whom? That is the question which students should learn to always ask and never take for granted. The answer, of course, is that 'unfamiliarity' is relative and has been defined against the social locations of the anthropologist and his or her audience. The West became the norm against which to look at and evaluate others.

The goals of anthropology reflected a general Western and Christian anxiety about boundaries in real and imagined terrains. The interest in human diversity, I would suggest, hinged on a will to knowledge and, through this, an affirmation of being. To reflect on and grasp the Other, and thus to understand their place (spatially and temporally), presented the possibility of appropriating and seizing a position of authority in the domain of knowledge and power.[18] The predicament facing European thinkers has been the realization that an apprehension of self as a totality requires the presence of the Other and is therefore intrinsically bound up with the notion of intersubjective relations, the freedom to act responsibly and finally the ethical implications of these aspects of self and Other.[19] At the moment when reason and knowledge are privileged in Western discourse, knowledge comes to be seen as an end in itself: discovery, revelation and appropriation. It is here that we find a self-consciousness looking outside itself and concluding that the world which can be described can also be possessed. Western thought inheres an aggressive ontology, 'in which the same constitutes itself through a form of negativity in relation to the other, producing all knowledge by appropriating and sublating the other within itself' (Young, 1990: 13; Montag, 1993). In that context, the shift to a *scientific* interest in mapping out the origins and diversity of human beings was also a secularization of the European Christian project towards self-definition:

> The time of history and of collective memory provides the basis for the objectivization of the world, and thus for a new definition of alterity. It is no longer a question of including or translating the other in its subjectivity which characterizes Christian historiography. Western epistemology claims that it exclusively controls true knowledge, and thus is purportedly supported by the evidence of what exists and what has happened. Only such an epistemology is permitted to picture the future in terms of the present produced by the past in its right direction, the direction of progress.[20]
>
> (Jewsiewicki and Mudimbe, 1993: 6)

If thinking 'difference' is not unique to the West, it was instead the Western classification and construction of hierarchies which enabled a

three-fold political, as opposed to an ontological move. First, they are not like us; second, we can dominate them, and finally, we can colonize them and make them be like us.[21] Difference, as I will argue, comes to be an object of scrutiny for the purpose of managing what have always been inter-cultural encounters. Here is where we might step back somewhat and revisit the manner in which difference roots itself as a mode of thinking which privileges the West.

I want to make a detour in order to underscore my proposition for the necessity of thinking carefully about the social vocabulary of culture as masking a discourse on race. Here I will briefly present an interpretation of how race and culture fuse in the nineteenth century and how culture comes to serve as an organizing mechanism for Europeans to make sense of a different social order.

Consider the question of how meaning is made of sensory categories and how 'race' is imagined through seeing. In an examination of classical texts, V. Y. Mudimbe finds that space – geographical distance – organizes under-standings of barbarity, savagery and Amazons (Mudimbe, 1993). Imagin-ing and categorizing cultural differences takes place across distance and is mapped out without privileging sight or, in turn, the primacy of physio-logical attributes (Hymes, 1974: 21f; Hodgen, 1964). But the mode of thinking difference through this spatial reference – as characterized by Greek geographers – changed when physical attributes such as skin colour ceased to be merely a curious observation, and instead became a phenom-enon to be explained through biology. Race then structured and was struc-tured through slavery and colonialism.[22] Not incidentally, while travel on land – by foot and camel – meant gradual adjustments to change in the social and geographical landscape, the invention of oceangoing transport – with the monotony between points of departure and arrival – facilitated the process of thinking in racial terms (Shreeve, 1994: 60).

The point to be stressed is that interest in physical differences and dis-tinctive religious markers existed prior to the nineteenth century, but a pre-occupation with the idea of savages and primitives, integral to the repertoire of difference, required the intervention of science which sought the expla-nation of different social practices through visible physical differences. In other words, although racial difference was registered before the fifteenth century within Western understanding through sight,[23] in the nineteenth century it was to be rethought in terms of science (Gould, 1993; Stepan, 1993; Stepan and Gilman, 1993). In sum, two moments were uncritically interwoven when observable features, on the one hand, and underlying claims about essential true nature on the other, were incorporated into an idea of 'culture'.

The sixteenth century ended in a fascination with spatial mobility, new resources and territories, manifested in the discovery of Europe's *alter ego*, the American utopia.[24] These events conditioned the manner in which European thinkers could take up issues of identity as an academic problem, a political project and, at the individual level, as a personal struggle. In the late twentieth century, this project has been reformulated, not rescinded, by

the deconstruction of science, contraction of global space, and destabilization of a European identity as well as a corollary destabilization of the identity of its colonized others[25] (Harvey, 1990).

Looking at culture from another perspective, literary critic Christopher Herbert argues for an analysis of the culture concept against the background of Victorian England (1991). He demonstrates that the culture concept was a counter-narrative to theological beliefs concerning original sin and its inherent existence in man, in the form of uncontrollable desire.[26] Reading the texts of Wesleyan missionaries in the South Pacific, Herbert traces the culture idea as it slides along a continuum from religion to secular science.

The missionaries arrived with preconceptions and a conviction that the social lives of the dark-skinned islanders were characterized by behaviour that represented the incarnation of sin and vice. In order to carry out their religious project, the missionaries had to establish a rapport with their prospective converts. They had to learn the local language which then became a vehicle of entry into the society. Specifically, to convert the locals to Christianity, the missionaries had to become conscious of the existence of an order. Thinking in terms of culture consequently provided the key for a strategy of conversion:

> The missionaries' will to power leads directly in this way to the distinct formulation of the principle of the indivisible integrity of culture.
>
> (Herbert, 1991: 199)

The social vocabulary of culture is thus related to policies of domestication which required knowledge of a particular group of people. Viewing 'culture' as an organizing mechanism demonstrates the process through which the existence of the alien other might be comprehended and explained. In this context, I suggest that the issue of how difference is to be 'grasped' and brought under control continues to be both an exhausting intellectual *project* as well as an intractable administrative *problem*.

In the ambiguous discourse of diversity, culture is still called upon to clarify different social practices and explain social antagonisms. When cleavages in the social fabric are treated as if they were rooted in 'cultural' differences – in other words, attributed to meaning systems rather than the politics of inequality – the social vocabulary of culture is a hindrance rather than an aid to examining the relationship between the political and material conditions as they operate at local, national and global levels.

Permit me to suggest, as a hypothesis for reflection, that within the academy, if the drive for transforming curricula to reflect cultural diversity has been pushed by advocates of critical pedagogy, its actual formulation and implementation has been undertaken by proponents of liberalism. The liberal view of society is rooted in the premise that consensus and sameness are integral to political and social equilibrium. The apparent harmony of this perspective, however, is marred by its dependency on assimilation and common denominators which seek to obscure particularism and parochialism. This attitude has provoked critics of liberalism who point to its

fundamental conservatism which they denounce as hypocrisy. For example, I think philosopher Yedullah Kazmi, who has written on the limitations of multiculturalism as a liberal palliative, is correct in censoring its accentuation of cohesion and tolerance (1994). Kazmi highlights the tendency to blame the Other for non-conformity. In his estimation, liberalism adopts an accusatory stance towards the Other's refusal to accept the pre-established ground rules, thus impeding consensus and disrupting cohesion. The transferral of blame to the Other – let's say the subordinate group – for non-compliance relieves liberals from acknowledging their own implication in foreclosing real dialogue.

Political philosopher Seyla Benhabib draws on the insights of Hannah Arendt, the Jewish political theorist and refugee from Nazi Germany. Against a tradition of universalism which masks ethnocentrism, Benhabib proposes a model of moral conversation whose goal is the process of dialogue, conversation and mutual understanding, *not* consensus. A moral conversation instantiates a reversal of perspectives; 'that is, the willingness to reason from the other's point of view' (Benhabib, 1992). This formulation – thinking from the standpoint of others – accentuates the egalitarian and potentially radical possibilities for public culture. As Benhabib reminds us, the modern public sphere no longer allows a distinction between 'the social' and 'the political' precisely because the struggle to make something public is intrinsically a struggle for recognition, inclusion and justice. The public sphere, then, is the intersection of interaction, intercommunication and intercultural encounters.[27] Against this background, as Benhabib persuasively claims, 'the self-centered perspective of the individual is constantly challenged by the multiplicity and diversity of perspectives that constitute public life' (Benhabib, 1992: 141). In other words, the particularity and otherness of an individual can be known only through her self-definition which, in turn, requires that she have a voice.

I have raised the critique of liberalism to redirect attention to the sharp contrast between inclusion and multivocality – in the first, inclusion, the Other is always the outsider, the one who is always already defined as different and therefore is responsible for accommodating to the situation in which s/he is entering. Inclusion therefore means permission to enter – a permission which can always be rescinded. The space has already been carved out by the powerful participants – members of the dominant group. Rebels and resistors are marginalized or excluded.

In order to actualize multivocality as a norm, we need to question how the Other is created. Who is the Other? Who is constructing the definition of Other? Indeed, who is represented by the word 'we' in any given conversation? These questions condition the very possibility of even thinking that there is such a thing as an 'alternative' perspective. It is the neglect of this unspoken process that explicitly informs the liberal stance.

Kazmi underscores the necessity of evaluating the power dynamics in a conversation by asking who is speaking, from what social location and in which domain. If legitimacy is accorded only to those who accept confinement within pre-established guidelines defining common concerns, then any

dissent is necessarily irrational, argumentative and unconstructive. Again we face the unspoken – indeed unthought question – Who has the power to define what encompasses the 'common concern'? It is in the silence, or inaudibility, of the Other – either through intimidation or resignation – that is the severe indictment of liberal hypocrisy. The reconceptualization of curricula through an intercultural focus will need to address, in order to circumvent, the pitfalls of its liberal precursors.

Let me conclude with three comments. First, the challenge to educators in the academy is that most students, and some professors, enter the classroom without knowledge of the sophisticated theories about culture. Furthermore, it may not be possible or even necessary to introduce students to more than a passing reference to the intricate, and sometimes tedious, arguments over the concept of culture. What is important, however, is that careful thought be given in advance to the various assumptions brought to the classroom, and to the implications of how the material and presentation will unveil these assumptions, disrupt common-sense views and bring students to an understanding of the complex relationships between power and knowledge and between representation and identities.

Second, the title of this article – 'empathy, experience and strategic essentialism' – intentionally suggests that an appropriate departure point for reflecting on cultural encounters should explicitly privilege and make salient the subject positions from which we speak. If experience shapes perspectives and provides a lens through which to empathize with other people, neither empathy nor experience should be mistaken for the homogenization or transcendence of differences. Thinking from the standpoint of others, as Hannah Arendt emphasized, means 'coherent reversibility of perspectives' in which the boundaries of self and other are always clear. It follows, then, that a prerequisite for dialogue, in the sense of encounters and interaction in public spheres, is that the other has a voice which is not merely heard, but which is *taken into account*.

From this standpoint, strategic essentialism does not preclude alliances between different social groups; nor does it presume that communities are bounded, fixed or that 'race' is an essence shared by all members of any given group. Instead, these 'discursive invented space[s]' take the beingness of black as experiential sources which can be drawn on without apology.[28] Therefore, while we *should* delegitimize the use of race and culture as metonyms for one another, this *need not* invalidate a notion of race-based communities of meaning.[29] Such a notion reflects the efficacy of *political strategies* rather than the biologization of ideology. Furthermore, contrary to the claims of both its staunch adversaries and blind advocates, constructive strategic essentialism does not negate the plurality of identities and their mutability (De Lauretis, 1993). While it may be poor philosophy, strategic essentialism does register the politics of commitment described in the following quotation from British cultural studies scholar Stuart Hall:

> Political identity often requires the need to make conscious commitments. Thus it may be necessary to momentarily abandon the multiplicity of

cultural identities for more simple ones around which political lines have
been drawn. You need all the folks together, under one hat, carrying one
banner, saying we are for this, for the purpose of this fight, we are all the
same, just black and just here.

(cf. Grossberg, 1993: 101)

Finally, a third comment, which is actually a question, evolves from my
own biography and commitment to strategic essentialism as a political posi-
tion to which I am sympathetic – as a Jewish-Israeli whose mother became
a refugee from Nazi Austria at the age of 8 while most of her relatives,
including the great-grandmother for whom I am named, were murdered in
Hitler's concentration camps; and as an American black[30] whose father is
of West Indian heritage as a result of the trans-Atlantic slave trade, and
includes, along the way, a Scottish great-grandfather as well as Jamaican
relatives of Chinese descent. Slavery, segregation and discrimination are
therefore historical legacies of my past which I choose not to forget and
against which I am always engaged in struggle.

Having noted this, the question with which I conclude is neither facile nor
facetious: *How do we separate our personal politics from our pedagogy
without compromising our principles and ideals?* For, in the final analysis,
if our objective in the classroom is to politicize the consciousness of our
students by opening up a world of ideas and introducing the variety of
environments and circumstances which shape the different ways of think-
ing and acting of people across the globe – which is what teaching cultural
encounters is all about – then I believe we *also* have an obligation to strive
for maximizing objectivity in the best sense of the word. Of course, this
leads into a debate on whether the notion of objectivity is still thinkable
after the triumph of deconstruction.[31]

Notes

1 This is an expanded version of my Keynote Address presented to the 'Teaching
 Cultural Encounters as General Education Conference', organized by St
 Lawrence University and American Association of Colleges and University held
 in New Orleans 2–4 March 1995. I am grateful to the organizers of the con-
 ference for the opportunity to articulate and share my ideas, and particularly to
 Grant Cornwell and Eve Stoddard who invited me, and Patricia Alden and
 Louis Tremaine who recommended me. I thank I. M. A. Lederer, Shireen K.
 Lewis, Denise Eileen McCoskey, V. Y. Mudimbe and Charlie Piot for comments
 on earlier drafts of this article.
2 E. San Juan, jnr. succinctly points out that 'race implicates peoples and social
 structures in historical processes of dissociation and exclusion that have distin-
 guished the trajectory of Western civilization, particularly since the European
 colonization of the Middle East, Africa Asia and the Americas' (1992: 5). For a
 full development of his theory of race against the inadequacy of ethnicity
 theories see San Juan jnr., 1992.
3 Grant Cornwell, professor of philosophy and associate Dean of the First Year,
 and Eve Stoddard, professor of English and Director of International Education,
 have spent the last three years involved in an intensive faculty development

seminar at St Lawrence University, which brought together seventeen faculties from across the disciplines to read, discuss and design an interdisciplinary curriculum about central issues in interculturalism for undergraduates.

4 Gloria Marshall discusses the fact that whiteness as a monolithic category is a very recent phenomenon and racial classifications of European people in the United States laid the foundation for the 1924 Immigration Bill which imposed restrictions on Southern and Eastern Europeans seeking entry into the country. The question of 'ethnicity' which Irish, Italians, Greeks, Portuguese and Jews have struggled over – a hyphenated identity which has not always been voluntary – is a legacy from the period when they were viewed as being a 'racial' other (Marshall, 1993).

5 See King (1991: 133–45).

6 For one of the most articulate analyses of the grave consequences which result from neglecting power and subject positions of teachers and the urgent need for developing antiracist pedagogy, see Giroux, 1992.

7 At the same time, theorizing about cultural fluidity needs to be tempered by a conceptual framework that persistently interrogates the space of theoretical procedures and the conditions of theory's claims. For instance, David Scott challenges the way theory is taken for granted as a 'narrative that has authored (and authorized) the hegemonic career of the West'. In this context he questions the move to undermine the notion of *culture*: 'this recognizably "anti-essentialist" characterisation of "culture" as mobile, as unbounded, as hybrid and so on, is itself open to question: for *whom* is 'culture' unbounded – the anthropologist or the native?' (Scott, 1992: 375f).

8 For a full discussion of this argument see Cesarani, 1994: 81–4.

9 On white identities, Peter MacLaren writes: 'being white is an entitlement . . . to a raceless subjectivity. That is, being white becomes the invisible norm for how dominant culture measures its own civility' (MacLaren, 1991: 244).

10 For instance, in a scathing commentary on violence and sexism of rap group 2 *Live Crew* (who met critics by claiming they were representing black culture), Abiola Sinclair, veteran journalist for the New York black weekly *The Amsterdam News*, wrote: 'The fact that the persons who created it are Black does not necessarily make it representational of Black culture. Suddenly, but not really so suddenly this filth gets wrapped up in Blackness' (Sinclair, 1990: 30–6).

11 See William Julius Wilson, with attention to the Appendix, 'Urban poverty: a state of the art review of the literature' (1987: 165–87), and, in particular, Thomas Sowell, 1981. For an earlier essay which, indirectly but significantly, addresses these issues, see Huggins, 1971: 5–19.

12 One of the few exceptions to this dichotomous line of research is to be found in Davis and Gardner, 1965.

13 Herskovits defined acculturation as 'those phenomena which result when groups of individuals having different cultures come into continuous first-hand contact with subsequent changes in the original cultural patterns of either or both groups' (Herskovits, 1937: 259). An excellent illustration of the suppression of research projects during this period is instanced in Guy Johnson's discussion of Negro spirituals and white revival camps where the data are clearly pregnant with questions on inter-racial relations, interactions and exchange. Johnson's discussion however aborts this direction – despite the recognition of similarities between black music and white folk music, Johnson's position is to see these dynamics in contrasting terms rather than as a dialectic: 'It would be strange indeed if there had *not* survived at least a few tunes from Africa and it

is certain that a few white songs have grown out of negro songs.' Having made this observation, he retreats and states: 'on the whole it appears . . . borrowed from white music' (Johnson, 1931: 170).

14 Nathan Huggins points out that 'black–white dualism has always been manifest in American life' and therefore black 'cultural boundaries are very loose and must be seen in the broader context of American history' (Huggins, 1971: 16f.).

15 The methodological and conceptual disconnection between race and culture led to 'a logical dead-end. Having debunked the racist concept that blacks were biologically inferior, Boasian anthropologists assumed that there was not much else of interest to the anthropologist in the study of African-American culture. Taken a bit further, there was also the inference that to acknowledge cultural differences between whites and blacks was to invoke race/biology as a factor in the development of culture' (Fraser, 1991: 407).

16 During the slave period the binary racial opposition was persistently destabilized by the presence of 'mulattoes' ranging in skin colour from brown to white who 'were a sore upon the social sight of white Southerners; each was a living indictment of the failure of the strictly biracial society envisioned by the white Southern ideal, a walking, talking, and mocking symbol of a white man's lapse in morality' (Williamson, 1971: 216). The tenacity of white American dis-ease over racial classifications which challenge whiteness is reflected in the film production of Alex Hailey's *Queen*. Consider the fact that although the text of the film specifically refers to his grandmother as phenotypically white, the televised mini-series cast brown-skinned Halle Berry who did not challenge American representations of blackness and whiteness. One might compare this to the calculated treatment of gender in the American/Irish film, *The Crying Game*, where audiences were deliberately challenged by the duality of Jay Davidson's physical presence. For two personal accounts from phenotypically white African-American women who have encountered raw racism from white liberals threatened by the rupture of their schemes of racial order, see Derricote, 1993, and Piper, 1992: 4–32. An interesting anthropology of the production of representation in *National Geographic* magazine was weakened by presupposing, instead of problematizing, the 'whiteness' of white-skinned informants. Therefore no attention was given to considering the responses of 'white' Americans who suspect, or suppress their suspicion of, a black relative who crossed the colour line, and how this might have significantly affected their responses to representations of dark-skinned Others (Lutz and Collins, 1993).

17 *A Question of Color*, dir. Kathe Sandler, PBS, 1992. In an interview with Pamela Woolford (publisher and editor of *Jambalaya Magazine*), Haile Grime discusses his efforts to demystify stereotypes which the black community imposes on itself. Describing the casting of light-skinned blacks in *Sankofa* and *Ashes and Ember*, Grime says, '[T]he fact is that in the diaspora a mixing has taken place. For example, when I did *Ashes and Embers* some Black people would see the movie and they would say something to me about the white guy in the TV repair shop. But he was actually a light-skinned Black man. And to me, these are very important challenges I have to bring to my society in the way we play with pigmentations' (see Woolford, 1994, esp. pp. 97–8).

18 Emmanuel Levinas discusses the correlation of knowing and being in which knowledge, a mode of thought which involves our material existence in a physical world, is directly related to perception and as such refers back to an act of grasping (Levinas, 1992: 85). To know slides easily into the desire for mastery

and it is this tension that Sartre relates to conflict: 'one must either transcend the Other or allow oneself to be transcended by him' (Sartre, 1956: 555).

19 See Young (1990) for a discussion of Emmanuel Levinas in relation to Sartre, Levi-Strauss and Derrida.

20 This theme is treated by Kovel (1970). See Jewsiewicki and Mudimbe (1993) for their discussion of the theme of redemption and resurrection in post-colonial African discourse inherited from Western epistemology.

21 Claude Levi-Strauss's project has been to radically contest the eurocentric sociologization of the Western subject and received its best articulation in his essay 'History and dialectic' (Levi-Strauss, 1966). For an excellent study of Claude Levi-Strauss which situates his anthropology within the framework of his philosophical approach, see Pace, 1983.

22 See Hannah Arendt's discussion of a distinction between race-thinking and racism in *The Origins of Totalitarianism* (1958).

23 For instance, Hans Burgkmair's painting 'Exotic Tribe' painted in 1508 presents a family of 'blackened whites'. V. Y. Mudimbe considers pictoral representations of blacks and whites from the sixteenth to the twentieth centuries and demonstrates that transformations in paintings and aesthetic distinctions parallel 'a silent but powerful epistemological configuration'. 'Exotic Tribe' brings together 'two representational activities: on the one hand, signs of an epistemological order which, silently but imperatively, indicate the processes of integrating and differentiating figures within the normative sameness; on the other hand, the excellence of an exotic picture that creates a cultural distance, thanks to an accumulation of accidental differences, namely, blackness, curly hair, bracelets, and strings of pearls' (Mudimbe, 1988: 9).

24 Michel-Rolph Trouillot situates the inauguration of European constructions of otherness in the fifteenth century. He notes that 1492 marks the fall of Muslim Granada, the expulsion of the Jews, the consolidation of political borders in Europe and concentration of political power in the name of a Christian God. In retrospect, Trouillot sees these events as having more contemporary significance than Columbus's landing in Antilles (1991).

25 It should be noted that even among Third World intellectuals, there is disagreement over the conceptual limitations imposed by the paradigm of 'intercultural hybridity'. For instance, Aijaz Ahmad criticizes Gaytri Spivak and Homi Bhabha, pointing out that: 'The idea of hybridity – which presents itself as a critique of essentialism, partakes of a carnivalesque collapse and play of identities, and comes under a great many names – takes essentially two forms; cultural hybridity and what one may call philosophical and even political hybridity.' Ahmad notes that this is obviously 'a truism' and the real problem is that the figure of 'the migrant (postcolonial) intellectual residing in the metropolis, comes to signify a universal condition of hybridity and is said to be the Subject of a Truth that individuals living within their national cultures do not possess' (1995: 13). A similar theme has been expounded upon by Ali Behad (1993: 40–9).

26 Herbert proposes that the emergence of an idea of culture and the puritanism of the era should be attributed to the success of John Wesley. The Evangelical theologian was a catalyst in the formation of modern social thought. Wesley's notion of original sin and its inherent existence in man, in the form of uncontrollable desire, led to an obsessive concern with puritanism. As a theory and a practice, puritanism was embodied in everyday life through a self-control and discipline which were fetishized against the background of the Industrial

Revolution. This period of political and economic upheaval and transition inspired a need to make sense of, and find order in, life.

27 See also Nancy Fraser's discussion of how subordinate groups are silenced, marginalized and interrupted by the imposition of 'protocols of style' of which they are unfamiliar (Fraser, 1994: 82).

28 In this context, the manner in which the personal background, life history and experience of critics and supporters of W. E. B. Dubois's position on race consciousness cannot – and indeed should not – be overlooked. For two opposing perspectives, see Appiah 1989) and Outlaw (1992).

29 This perspective demands a cautious and critical stance on postmodernism. One invaluable critique of postmodernism and 'the epistemological fantasy of *becoming* multiplicity' with its insistence on transcending specific gendered, racial and religious positions – despite the material, historical and political relation to language, intellectual history and social forms – can be found in Bordo (1990: 133–56).

30 I deliberately use american as an adjective and Black as a noun.

31 Allan Megil has gathered together an excellent collection of reflections on objectivity/objectivities from contributors who come from a range of disciplines. See Megil, 1994.

References

Ahmad, Aijaz (1995) 'The politics of literary postcoloniality.' *Race* and *Class*, 36(3): 1–20.

Appiah, Kwame Anthony (1989) 'The conservation of "Race",' *Black American Literature Forum*, 23(1): 37–60.

Arendt, Hannah (1958) *The Origins of Totalitarianism*, Cleveland, Ohio: The World Publishing Company.

Behad, Ali (1993) 'Travelling to teach: postcolonial critics in the American Academy', in Cameron McCarthy and Warren Crichlow, editors (1993), pp. 40–9.

Benhabib, Seyla (1992) *Situating the Self: Gender, Community and Postmodernism in Contemporary Ethics*, New York: Routledge.

Bordo, Susan (1990) 'Feminism, postmodernism, and gender-scepticism', in Linda J. Nicholson, editor, *Feminism/Postmodernism*, pp. 133–56, New York: Routledge.

Cesarani, David (1994) 'A trenchant counter-attack against evil: review of Deborah Lipstadt, *Denying the Holocaust: The Growing Assault on Truth and Memory*', *Patterns of Prejudice*, 28(1) (January): 81–4.

Cornwell, Grant H. and Stoddard, Eve (1994) 'Things fall together: a critique of multicultural curricular reform', *Liberal Education* (Fall): 40–51.

Davis, Allison and Gardner, Burleigh B. (1965) *Deep South: A Social Anthropological Study of Caste and Class*, Chicago: The University of Chicago Press.

De Lauretis, Teresa (1993) 'Upping the anti [sic] in feminist theory', in Simon During, editor, *The Cultural Studies Reader*, New York: Routledge.

Derricote, Toi (1993) 'At an artist colony', in Kathleen Aguero, editor, *Daily Fare: Essays from the Multicultural Experience*, Athens, Georgia: University of Georgia Press.

Fanon, Franz (1967) *Black Skin, White Masks*, New York: Grove Press.

Fraser, Gertrude (1991) 'Race, class, and difference in Hortense Powdermaker's *After Freedom: A Cultural Study in the Deep South*', *Journal of Anthropological Research*, 47(4) (Winter): 402–15.

Fraser, Nancy (1994) 'Rethinking the public sphere: a contribution to the critique of actually existing democracy', in Giroux and McLaren, editors (1994), pp. 74–98.

Fredrickson, George M. (1972) *The Black Image in the White Mind: The Debate on Afro-American Character and Destiny, 1817–1914*, New York: Harper Torchbooks.

—— (1988a) 'The black image in the white mind: a new perspective', in Genna Rae McNeil and Michael R. Winston, editors, *Historical Judgments Reconsidered: Selected Howard University Lectures in Honor of Rayford W. Logan*, pp. 99–109, Washington, DC: Howard University Press.

—— (1988b) *The Arrogance of Race: Historical Perspectives on Slavery, Racism and Social Inequality*, Middletown, Connecticut: Weslyan University Press.

Giroux, Henry A. (1992) *Border Crossings: Cultural Workers and the Politics of Education*, New York: Routledge.

Giroux, Henry A. and McLaren, Peter (1994) *Between Borders: Pedagogy and the Politics of Cultural Studies*, New York: Routledge.

Goldfield, Michael (1991) 'The color of politics in the United States: white supremacy as the main explanation for the peculiarites of American politics from colonial times to the present', in Dominick LaCapra, editor, *The Bounds of Race: Perspectives on Hegemony and Resistance*, pp. 104–33, Ithaca: Cornell University Press.

Gould, Stephen Jay (1993) 'American polygeny and craniometry before Darwin: blacks and Indians as separate, inferior species', in Harding, editor (1993), pp. 84–115.

Grossberg, Lawrence (1993) 'Cultural studies and/in new worlds', in McCarthy and Crichlow, editors (1993), pp. 89–105.

Hannerz, Ulf (1992) *Cultural Complexity: Studies in the Social Organization of Meaning*, New York: Columbia University Press.

Harding, Sandra, editor (1993) *The 'Racial' Economy of Science: Toward a Democratic Future*, Bloomington: Indiana University Press.

Harvey, David (1990) *The Condition of Postmodernity: An Enquiry Into the Origins of Cultural Change*, Cambridge, MA: Basil Blackwell, Inc.

Herbert, Christopher (1991) *Culture and Anomie: Ethnographic Imagination in the Nineteenth Century*, Chicago: University of Chicago Press.

Herskovits, Melville (1937) 'The significance of the study of acculturation for anthropology', *American Anthropologist*, 39(2): 259–64.

Hodgen, Margaret T. (1964) *Early Anthropology in the Sixteenth and Seventeenth Centuries*, Philadelphia: University of Pennsylvania Press.

hooks, bell (1990) 'Culture to culture: ethnography and cultural studies as critical intervention', in *Yearning: Race, Gender and Cultural Politics*, pp. 123–33, Boston: South End Press.

—— (1994) 'Gangsta culture – sexism and misogyny: who will take the rap?', in *Outlaw Culture: Resisting Representations*, New York: Routledge.

Huggins, Nathan I. (1971) 'Afro-American history: myths, heroes, reality', in Huggins, Kilson and Fox, editors (1971), pp. 5–19.

Huggins, Nathan I., Kilson, Martin and Fox, Daniel M. editors (1971) *Key Issues in the Afro-American Experience*, New York: Harcourt Brace Jovanovich, Inc.

Hymes, Dell H., editor (1974) 'Introduction: the use and abuse of anthropology: critical, political and personal', in *Reinventing Anthropology*, pp. 3–79, New York: Random House, Inc.

Jewsiewicki, B. and Mudimbe, V. Y. (1993) 'Africans' memories and contemporary history of Africa', *History and Theory* 32 (December): 1–11.

Johnson, Guy B. (1931) 'The Negro spiritual: a problem in anthropology', *American Anthropologist*, 33(2): 157–71.

Kazmi, Yedullah (1994) 'Thinking multi-culturalism: conversation or genealogy and its implication for education', *Philosophy and Social Criticism*, 20(3): 65–87.

Kennedy, Randall L. (1989) 'Racial critiques of legal academia', *Harvard Law Review*, 102: 1745–819.

King, Joyce E. (1991) 'Dysconscious racism: ideology, identity and the miseducation of teachers', *Journal of Negro Education*, 60(2): 133–45.

Kovel, Joel (1970) *White Racism: A Psychohistory*, New York: Pantheon Books.

Levi-Strauss, Claude (1966) 'History and dialectic', in *The Savage Mind*, Chicago: University of Chicago Press.

Levinas, Emmanuel (1992) 'Ethics as first philosophy to *The Levinas Reader*', pp. 75–87, Oxford: Basil Blackwell.

Lutz, Catherine and Collins, Jane L. (1993) *Reading National Geographic*, Chicago: University of Chicago Press.

McCarthy, Cameron and Crichlow, Warren editors (1993) *Race, Identity and Representation in Education*, New York: Routledge.

MacLaren, Peter (1991) 'Decentering culture: postmodernism, resistance and critical pedagogy', in N. B. Wyner, editor, *Current Perspectives on the Culture of Schools*, Boston: Brookline.

Marshall, Gloria A. (1993) 'Racial classifications: popular and scientific,' in Harding, editor (1993), pp. 116–27.

Megill, Allan, editor (1994) *Rethinking Objectivity*, Durham: Duke University Press.

Mohanty, Chandra (1994) 'On race and voice: challenges for liberal education in the 1990s', in Giroux and McLaren, editors (1994), pp. 145–66.

Montag, Warren (1993) 'Spinoza and Althusser against hermeneutics: interpretation or intervention?' in E. Ann Kaplan and Michael Sprinkler, editors, *The Althusserian Legacy*, pp. 51–8, London: Verso.

Morrison, Toni (1992) *Playing in the Dark: Whiteness and the Literary Imagination*, Cambridge: Harvard University Press.

Mudimbe, Valentin Y. (1988) *The Invention of Africa: Gnosis, Philosophy and the Order of Knowledge*, Bloomington: Indiana University Press.

—— (1993) 'The power of the Greek paradigm', *South Atlantic Quarterly*, 92(2)(Spring): 361–85.

Omi, Michael and Winant, Howard (1986) *Racial Formation in the United States*, New York: Routledge & Kegan Paul.

Outlaw, Lucius (1992) 'On W. E. B. Du Bois' "The conservation of races" ', *SAPINA*, 4(1): 13–28.

Pace, David (1983) *Claude Lévi-Strauss: The Bearer of Ashes*, Boston: Routledge & Kegan Paul.

Philips, John Edward (1990) 'The African heritage of white America', in Joseph E. Holloway, editor, *Africanisms in American Culture*, pp. 225–39, Indiana: Indiana University Press.

Pinar, William F. (1993) 'Notes on understanding curriculum as a racial text', in McCarthy and Crichlow, editors (1993), pp. 60–70.

Piper, Adrian (1992) 'Passing for white/passing for black', *Transition*, 58: 4–32.

Reed, Ishmael (1989) 'Is ethnicity obsolete?', in Werner Sollors, *The Invention of Ethnicity*, pp. 226–9, New York: Oxford University Press.

San Juan, jnr., E. (1992) *Racial Formations/Critical Transformations*, NJ: Humanities Press International, Inc.

Sartre, Jean Paul (1956) *Being and Nothingness: A Phenonmenological Essay on Ontology*, New York: Washington Square Press.

Scott, David (1992) 'Criticism and culture: theory and post-colonial claims on anthropological disciplinarity', *Critique of Anthropology*, 12(4): 371–94.

Shreeve, James (1994) 'Terms of estrangement', *Discover,* 15(11) (November): 56–63.

Sinclair, Abiola (1990) '2 Live Crew revisited', *The Amsterdam News* (18 August): 30–6.

Sowell, Thomas (1981) *Ethnic America: A History*, New York: Basic Books.

Stepan, Nancy Leys (1993) 'Race and gender: the role of analogy in science', in Harding, editor (1993), pp. 359–76.

Stepan, Nancy Leys and Gilman, Sander L. (1993) 'Appropriating the idioms of science: the rejection of scientific racism', in Harding, editor (1993), pp. 170–93.

Szwed, John F. (1974) 'An American dilemma: the politics of Afro-American culture', in Hymes, editor (1994), pp. 152–81.

Trouillot, Michel-Rolph (1991) 'Anthropology and the savage slot: the poetics and politics of otherness', in Richard G. Fox, editor, *Recapturing Anthropology: Working in the Present*, pp. 17–44, Santa Fe, New Mexico: School of American Research Press.

Turner, Terence (1993) 'Anthropology and multiculturalism: what is anthropology that multiculturalists should be mindful of it?', *Cultural Anthropology*, 8(4): 411–29.

West, Cornel (1993) *Keeping Faith: Philosophy and Race in America*, New York: Routledge.

Whitten, jnr., Norman E. and Szwed, John F., editors (1970) *Afro-American Anthropology: Contemporary Perspectives*, New York: The Free Press.

Williamson, Joel R. (1971) 'Black self-assertion before and after emancipation', in Huggins, Kilson and Fox, editors (1971), pp. 213–39.

—— (1980) *New People: Miscegenation and Mulattoes in the United States*, New York: The Free Press.

Wilson, William Julius (1987) *The Truly Disadvantaged: The Inner City, the Underclass, and Public Policy*, Chicago: University of Chicago Press.

Woolford, Pamela (1994) 'Filming slavery: a conversation with Haile Grime', *Transition*, 64: 90–104.

Young, Robert (1990) *White Mythologies: Writing History and the West*, London: Routledge.

CAROL MAVOR

COLLECTING LOSS

ABSTRACT

'Collecting Loss' develops themes from *Pleasures Taken* (Mavor, Duke University Press, 1995) with an emphasis on the fetishization of photographs and old clothes (exemplified, on the one hand, in Elin O'Hara Slavick's own girlhood dresses that she has stitched with haunting memories of her childhood, and on the other hand in the lush photographs taken by Sally Mann and the Victorian photographer Clementina Hawarden). As Christian Boltanski has written: 'What they [clothing and photographs] have in common is that they are simultaneously presence and absence. They are both an object and a souvenir of a subject, exactly as a cadaver is both an object and a souvenir of a subject.' Reading an old photographic album made by her own grandmother against other maternal collections of plenitude (whether they be old clothes or photographs or domestic bric-a-brac), Mavor reveals how such accumulated goods are made to fill in for the pangs of loss: lost childhoods, lost family histories, lost memories, lost friends. Mixing corporeality and critical theory, Mavor engages with Emily Apter's notion of 'maternal collectomania' as a site of provocative meanings worthy of placement alongside more conventional discourses on visual representation and collecting.

KEYWORDS

photography, clothing, childhood, maternality, family album, collecting

All women . . . are clothing fetishists.

Sigmund Freud[1]

What they [clothing and photographs] have in common is that they are simultaneously presence and absence. They are both an object and a souvenir of a subject, exactly as cadaver is both an object and souvenir of a subject.

Christian Boltanski[2]

I fetishize two things in my life: clothing, especially old clothing, clothing with a past, and photographs. And it was not until recently that I understood that my desires for each were closely woven together. My story feminizes the fetish.[3]

But according to Freud's work on fetishism, the fetish is solely the prerogative of men: while women are often hysterics, they are almost never fetishists. As Emily Apter has pointed out, 'despite his [Freud's] admission

at the Vienna Psychoanalytic Society in 1909 that 'all women . . . are cloth-
ing fetishists', Freud typically supplied a male agent to the perversion by
associating it with male homosexuality and coprophilic pleasure.[4] In her
essay, 'Splitting hairs: female fetishism and postpartum sentimentality in
Maupassant's fiction', Apter seeks to undo a gender-biased reading of
fetishism. She finds the fetish objects of women spilling out of the drawers
of turn-of-the-century French literature (Guy de Maupassant), the history
of French psychiatry (Gaëtan Gatian de Clérembault, a psychoanalyst who
was Lacan's teacher and who is famous for his photographs of Algerian
women wrapped in excessive drapery), and even in the work of the con-
temporary American artist Mary Kelly (who collected and framed her son's
nappies, cotton T-shirts, his early gifts of flowers and bugs and his first writ-
ings). While sniffing out traces of female fetishism, Apter comes across
special boxes and bureaus and albums and other private places enshrouded
with veils, fabrics and fur – mostly belonging to women – whose sole
purpose is to preserve the relics of departed loved ones. The stories of loss
range from spoiled love to death to merely growing up. Inside these femin-
ine spaces we find letters, pressed flowers, locks of hair, nail clippings,
pieces of clothing. The fetish objects (from the trivial to the exquisite) are
most often passed down and gathered by the women of the family, 'by hook
or crook' (a translation of *à-bric-à-brac*) in a continual process of 'acqui-
sition and exchange' – which can be met with heated emotions (ranging
from intense love to harboured jealousy to violence) between sisters,
mothers and daughters.[5] Apter points out that this 'bric-a-brac-cluttered
world' has been largely overlooked, even when it reaches a space of 'manic
collectomania' because it has been naturalized as part of feminine culture.
Apter's examples of female fetishes, taken from literature and art, are often
visual, sometimes olfactory, but the majority of them relate to a sense of
touch.

My 'bric-a-brac-cluttered world' is also haptic. My fingers are beckoned
by a baby dress of white cotton and white eyelet, an abandoned pink baby
blanket woven with pink and green satin ribbons, a once white wedding veil
yellowed crisp, Grandfather's old camel mohair coat eaten by moths, a tiny
but heavy glass-beaded bag (royal blue, deep rose, white and gold) cinched
with a silk cord, tiny shoes of soft worn mildewed leather pressed flat by
storage and polished powder blue. These are the things that clutter and fill
the recesses of my home, my memories, my body.

Crucial to this world are my photographs: some are made of soft matte
paper printed with sepia tones, others are made of glossy paper printed with
stark black and white, others are losing themselves in the faded colours of
early colour photography, still others feature the surreal spaces of the
Polaroid camera. My family's drawers, albums and boxes (and those of
many other middle-class families) have been filling up with photographs
ever since the invention of the *carte de visite* (the beginnings of cheap pho-
tography) and the never-ending succession of photographic inventions:
mass-produced hand cameras (the Brownie, the Kodak, the Lilliput, the
Tom Tumb, the Frena); drugstore developing; Sears' value packs; school

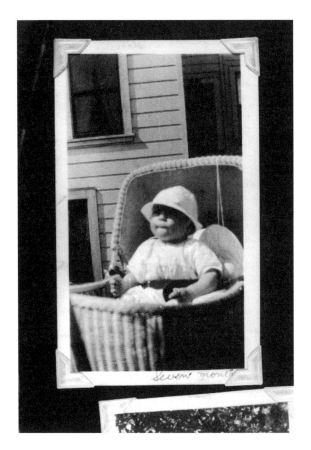

My father '. . . lips tucked in, as silent as he is today.'

portraits; class photos; disposable cameras. Using such products of the photographic enterprise, my own grandmother spent the last years of her life preparing elaborate scrapbooks/photograph albums on each of her two sons to be left to us after her death.

My father's album (which he sent directly to me after my grandmother's death) begins with photographs not of himself, but of my mother when they were first married: the year was 1953. This blunt, one might even say shocking, beginning is an ending. It is the ending of something that I am only beginning to understand now: a final severing of that (umbilical) something between a mother and her son – that something which began with my father's tumbles inside his mother, his elbow poking between her ribs, in the months before his birth in 1926. Though my father remained devoted to my grandmother, marriage changes things between a son and a mother – especially when his father/her husband was barely there. As I turn the black pages weighted with pictures and other memorabilia (cards, an occasional newspaper clipping), I feel as if I am watching one of the old Super 8 family movies that we never had – only in reverse. (When I was a

'. . . *my mother as a young bride, her lips darkened with red lipstick (when I came along her lips would be frosted pink)* . . .'

child I loved watching other people's home movies this way.) Stopping and starting, the timing is all off; parts are left out. My heart feels heavy with the weight of the black and white photographs. I discover that the album finally ends (begins?) with pictures of my baby-father at seven months: white wicker pram, floppy cotton brimmed cap, lips tucked in, as silent as he is today.

In between the first page with the pictures of my mother as a young bride, her lips darkened with red lipstick (when I came along her lips would be frosted pink), and the last page with pictures of my father as a baby, there are many more pictures and things: a small lock of hair inside a tiny, tiny envelope, inscribed in my grandmother's writing (small tight cursive), with the words 'My curl', meaning my father's curl (I cannot bear to look inside); military pictures of my father in sailor caps and active-duty clothes and dress uniforms with harsh brass buttons; photographs of the three of them (my grandmother in a white dress with an enormous dark cotton bow under her collar that covers her chest, my laughing father in short pants, his brother in long pants) taken in succession as they happily stride towards the

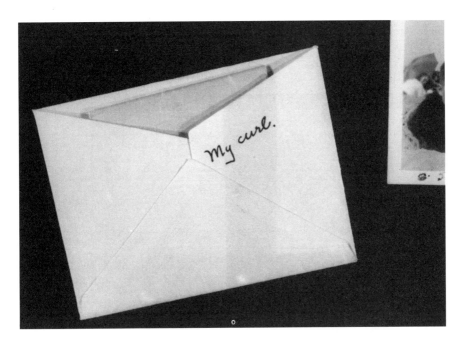

The envelope. '. . . a small lock of hair inside a tiny, tiny envelope . . . (I cannot bear to look inside) . . .'

camera at the 1935 Chicago World's Fair – my grandfather out of the frame, as he almost always is.

By arranging his life backwards, my grandmother has reconstructed my father's life as if it ends like some forbidding myth, with *their* beginning. As James Clifford has told us, 'Living does not easily organize itself into a continuous narrative.'[6] It is only after we have lived through cycles of our lives, in recollection, in photographs, that a narrative comes through. Afterwards, we tell narratives that may be partly true, but they are also narratives that must be fictionalized in order for us to make sense of our lives . . . in order to survive. 'We are condemned to tell stories', but we cannot (in our hearts of hearts) believe that they are altogether true.[7]

I learned from my grandmother that it is the mother's duty to create palpable narratives of our lives. It is the mother's duty to love things. My grandmother passed on to me this love of things (which is both wonderful and burdensome). Yet, not all things can be passed on; not all pictures make it into the album. Though I begged for and got my grandfather's old chair, he is virtually absent in the album. He is barely visible in the front seat of the Packard. Striding into the back door of the cabin, he turns his face away from the camera – the old Ford grimaces and returns the camera's gaze for him. In a family picture with unknown aunts, he stands so far apart from my father's hand which reaches out, futiley trying to pull him in, that it is as if he were not in the picture at all. There is a silent gap between them. Like a parenthetical phrase skipped, the space between them is calling to be read. (With

My grandmother, uncle and father at the Chicago World's Fair. '. . . my grandfather out of the frame, as he almost always is.'

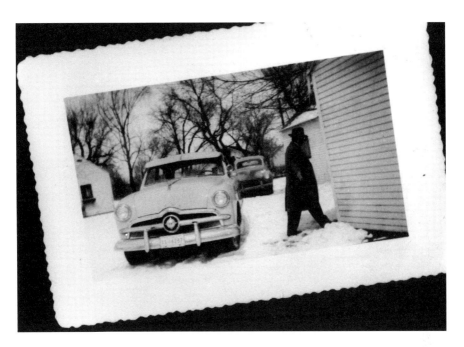

My grandfather '. . . he turns his face away from the camera – the old Ford grimaces and returns the camera's gaze for him.'

each successive look, the silence between them bristles more and more. I feel my father's pain. I catch sight of my father-as-boy huddled on the front porch with his older brother: the crashing sound of the china cabinet overturned in a drunken rage by the silent man fills the brackets, amplifies the space.) Despite the scary silences that many of my grandmother's objects give way to, I collect the things that she has given to me: the chair, the albums, the huge Parisian turn-of-the-century glass vase whose surface imitates carved turtle shell, the odd dark little oil painting of a monk playing the trombone (painstakingly painted with a fine brush and plenty of linseed oil), the silver spoons collected from all over the world, the white fluted wedding teacups, so thin that you can see through them, as if they were made of paper or skin.

Henriette Barthes, Roland Barthes' mother, was also a 'keeper' of bric-a-brac. Shortly after her death, Barthes, finding himself lost, went through boxes of photographs, relics of their lives spent together and apart. Barthes claims that at that moment, he was not looking for her, that he had no hope of finding her. He, after all, had already cut himself off from her, had faced his/her absolute loss. 'I had acknowledged that fatality, one of the most agonizing features of mourning, which decreed that however often I might consult such images, I could never recall her features (summon them up as a totality).'[8] Yet his desire belies him, he continues his looking. Sorting through the pictures, he finds her not caught so much by the camera, but rather by the objects in the picture that define her. The objects that he writes about, some of which are clothing, are rich in fetishistic lure.

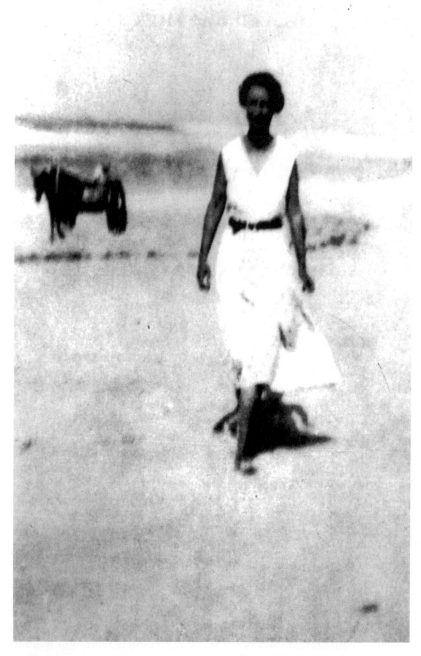

'*Henriette Barthes, Roland Barthes' mother, was such a "keeper" herself.*'

Source Family photograph of Henriette Barthes from *Roland Barthes by Roland Barthes*.
Courtesy Éditions du Seuil.

With regard to many of these photographs, it was History which separated me from them. Is History not simply that time when we were not born? I could read my nonexistence in the clothes my mother had worn before I can remember her. There is a kind of stupefaction in seeing a familiar being dressed *differently*. Here, around 1913, is my mother dressed up – hat with a feather, gloves, delicate linen at wrists and throat, her 'chic' belied by the sweetness and simplicity of her expression. This is the only time I have seen her like this, caught in a History (of tastes, fashions, fabrics): my attention is distracted from her by accessories which have perished: for clothing is perishable, it makes a second grave for the loved being. In order to 'find' my mother, fugitively alas, and without ever being able to hold on to this resurrection for long, I must, much later, discover in several photographs the objects she kept on her dressing table, an ivory powder box (I loved the sound of its lid), a cut-crystal flagon, or else a low chair, which is now near my own bed, or again the raffia panels she arranged above the divan, the large bag she loved (whose comfortable shapes belied the bourgeois notion of the 'handbag').[9]

The photographs, objects themselves, record objects within them (dress, dressing table, ivory powder box): things that stand in for her, not wholly, but partially. It is no wonder that he never 'recognized her except in fragments'.[10] These mother-objects are tied to her and to Barthes, who (despite his claims) could never really cut the cord.

Because photographs so poignantly speak of death and loss, they (as Barthes has written) wound us, prick us, reach us like 'the delayed rays of a star'.[11] Every photograph is a record of a moment forever lost – snapped up by the camera and mythically presented as evermore. The family album is always torn by the sorrows of loss: lost childhoods, lost friends, lost relatives, lost memories, lost objects, lost newness. Pressed into the album, not without joy, the images depress the beholder; they speak in melancholic tones. 'With the Photograph, we enter into *flat Death*.'[12]

And like childhood and new woollen winter coats and linen blouses and mothers and silk dresses and felt hats and distant cousins and grandmothers, photographs deteriorate, spoil, die, benumb, weaken. 'Not only does it [the photograph] commonly have the fate of paper (perishable), but even if it is attached to more lasting supports, it is still mortal: like a living organism, it is born on the level of the sprouting silver grains, it flourishes a moment then ages. . . . Attacked by light, by humidity, it fades, weakens, vanishes.'[13] The photograph dies like a body. And like a body, we simply cannot throw it out. (We bury the dullest, even the ugliest, photographs in drawers and boxes.) To tear or to cut the photograph is a violent, frighteningly passionate, hysterical action, which leaves behind indexical wounds, irreparable scars. (My friend Patricia snatched some albums away from her father. I was shocked to see that he had cut her mother out of each and every one of the pictures – even the wedding photographs. What absolute violence!)

I experience my friend's missing mother, or the ripped picture found at the bottom of a box, or those blank spaces in my father's album where paper photo-corners mark a picture's escape, as 'convulsive beauty'.[14] Such undue alterations captivate me for the ways in which they suggest untold, unimaged, lost and often purposely forgotten stories. My attraction to ravaged photographs lies behind my love for the endless photographs taken by Lady Hawarden of her ravishing daughters in fancy dress (1860s). I fetishize and desire these some 800 pictures, not only because the girls (Isabella Grace, Clementina, Florence Elizabeth) wear old clothes that their mother collected – magnificent party dresses, boys' velvet breeches, laced underwear, black riding habits, and silk flowers in their hair – but because their edges have been torn and cut, ripped and scissored. 'Originally they were pasted into albums, but before presentation to the Victoria and Albert Museum [by Hawarden's granddaughter] the pictures were cut or torn from the album pages.'[15] Hawarden's 'family albums' were preserved by her

'Their damaged edges invite me past seeing towards touch . . . I am torn by what lies between these young women.'

Source Lady Hawarden, *Clementina and Isabella Grace Maude c.* 1864. London, Victoria and Albert Museum.

relatives, only to be destroyed by them. Almost all the photographs bear the mark of this final gesture that completed their short flight from home (5 Princes Gardens, South Kensington) to institution (the Victoria and Albert right around the corner). Their damaged edges invite me past seeing towards touch. Looking at *Clementina and Isabella Grace Maude* (*c.* 1864), my fingers move along the picture's chewed edges only to feel the crispness of Isabella's net petticoats, the pull of Isabella's back sash, the tightness of Isabella's bound hair, the warmth of Isabella's forearm where it is graced by Clementina's hand, the burning of Clementina's gaze as it shoots like a star into the eyes of Isabella. I am torn by what lies between these two young women.

Yet most of us are anxious to preserve our images of ourselves and our loved ones (as whole and as undamaged), like 'flies in amber' (as Peter Wollen has written).[16] So, we often ask ourselves, what are we to do with these traces of bodies that fill drawers, boxes, shelves, attics, basements, closets? It is as if our pictures contained thin ghosts of the actual person photographed (of our aunt, our cousin, our mother, our childhood friend, our self). We are haunted by our family photographs. If thrown away – 'What is it that will be done away with, along with this photograph which yellows, fades, and will someday be thrown out, if not by me – too superstitious for that – at least when I die? Not only "life" (this was alive, this posed live in front of the lens), but also, sometimes – how to put it? – love.'[17] As Barthes has told us, photographs have an umbilical connection to their referent, to life itself.

Likewise, because clothing is 'perishable' and because it takes on the body (it takes form, smells, dirt), 'it makes second graves for the loved being,' even before death, but especially after death – when we found ourselves confronted, not only by dresser drawers, and shoe boxes and vinyl albums of photographs that have traced the loved one's body, but also their clothes. For me, wearing the clothes of a loved one or a friend, in which their smells come forth, in which their body has worn the cloth smooth or through, is akin to carrying a photographic image with me. Their body caresses me. I like to wear lockets with photographic images tucked inside. The locket (say, with a picture of my youngest son inside) or a friend's old dress, or a grandfather's retired jacket, or an aunt's abandoned hat – all carry spectres of my loved ones: I sense them skin to skin.

I guess that is why we have to keep so much in our dresser drawers (which function as miniature museums of our archived selves): 'the function of any drawer is to ease, to acclimate the death of objects by causing them to pass through a sort of pious site, a dusty chapel, where, in the guise of keeping them alive, we allow them a decent interval of dim agony.'[18] Like a photograph, the drawer of saved objects functions as a space between life and death. For not only do our photographs, our objects, signify death, they also (in the spirit of the fetish) keep death away. Collecting these objects in the nooks and crannies of our homes keeps them and our memories and ourselves alive. Objects keep death away by helping us to remember. Milan Kundera writes on memory's close link to death: 'Forgetting . . . is the great

private problem of man; death as the loss of self. But what of this self? It is the sum of everything we remember. Thus, what terrifies us about death is not the loss of future but the loss of past. Forgetting is a form of death ever present within life.'[19] I am so afraid of forgetting.

Elin O'Hara Slavick's mother never wanted to forget the childhoods of her five daughters. She feared the loss of the past. And, she must, I imagine, have feared a loss of herself. I know that, as a child, my own mother imagined me as a miniature copy of herself and I have always felt in turn that I was her mirror. Our connected identities register my birth as never complete. For the birth of a girl can be an everlasting process of cutting and stitching between mother and child, between stereoscopic images. (One of my students recognized this complex imaging and re-imaging in an old high school photograph of her mother, and wrote: 'Not only does it have a sense of aura because it is old, but because it is my mother/me. Like the multiple photographic copies of this image, I am a copy of my mother.'[20]) In addition to the family photographs and the Super 8 home movies, Slavick's mother saved most of their dresses. The dresses were worn by Elin O'Hara Slavick and her sisters to Mass, to school, to birthday parties and to family gatherings. As a result, the girls were often photographed in these dresses.

Not long ago, Slavick told her mother that she wanted to use the worn and mended dresses in an art work – she wanted to embroider her own text

'The dresses were worn by Elin O'Hara Slavick and her sisters to Mass, to school, to birthday parties and to family gatherings.'

Source Elin O'Hara Slavick, *A Wall of Incoherent Dresses*, 1991. Collection of the artist.

on to them. Slavick's mother, a female fetishist in her own right, agreed to send the material of her maternal collectomania to her youngest daughter – the one who used to get mad and kick people's shins. (I am still surprised that the mother agreed to give them up.) The dresses, like my father's family album, came to Slavick in the mail. Like my father's family album they contained the histories of a family. Like my father's album, they prompted memories.

Trained as a photographer, Slavick has reconstructed her childhood, not with photographs, but in response to photography. (As Susan Sontag writes in *On Photography*, 'Now all art aspires to the condition of photography.'[21]) Slavick sees the dresses as photographs of how she remembers her body:

> The work is informed . . . primarily by my own small memory of being a girl. An investigation of my childhood produces a synthesis of distorted memory, my real history, and my adult desire to interpret and remember. Poetic and confessional texts are sewn in the dresses that my mother saved since my childhood. Each dress becomes a surrogate of my body, a photograph of the memory of my body. The absence of actual photographic imagery of that body implies the loss of multiple bodies; the hiding body, the invisible body and the dead child body which we all possess within our adult selves.[22]

But unlike the photographs that are found in the usual family album, Slavick's dressed take on images that are almost never found in family

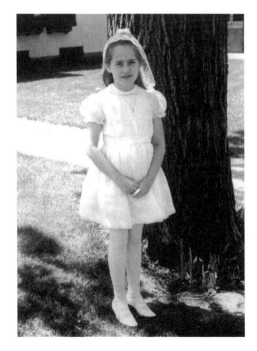

A photograph of Slavick's sister in her First Communion dress that would eventually bear the text: 'In thy womb have no shame'.

Source Family photograph taken by William H. Slavick. Collection of the artist.

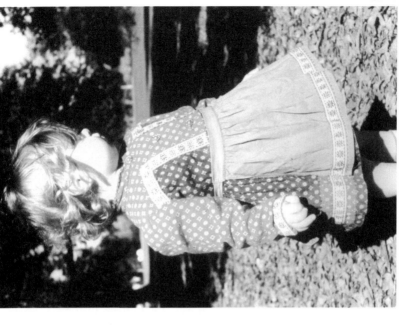

Slavick wearing the dress she would eventually embroider with the words 'mutter mutter mutter mutter mutter'.

Source Family photograph taken by William H. Slavick. Collection of the artist.

'. . . Slavick told her mother that she wanted to use the worn and mended dresses in an artwork – she wanted to embroider her own text onto them.'

Source Elin O'Hara Slavick, from A Wall of Incoherent Dresses, 1991. Collection of the artist.

pictures. 'Slavick's childhood dresses no longer can pretend innocence. They are transformed through adult texts and become surreal evidence in the absence of the original snapshots that they might have been.'[23] The dresses function like the missing pictures in an album, or the tears alongside Hawarden's photographs. They manage to *picture* the unsaid. For example, on the creamy soft bodice of a beautiful cotton dress – with a full green skirt whose hem holds the extra weight of a full four inches from being turned up for one of the girls so that it could dance just above her knees – Slavick has stitched:

> MOTHER, YOU PUT COLD VINEGAR
> CLOTHS ON MY SUNBURNT
> BODY.
> THE CLOTHS WERE STEAMING WITH YOUR BREATH
> AND I KEPT BREATHING.
> I FELL ASLEEP AND DREAMED
> I LOVED YOU.

It is a family picture: a child's sunburnt body, maternal care, child sleep, a child's profound love for the mother. But it is not an image that many of us

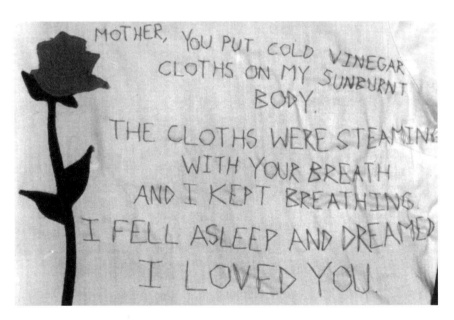

'. . . it is not an image that many of us could find in our family album.'

Source Elin O'Hara Slavick, detail of one of the dresses from *A Wall of Incoherent Dresses*, 1991. Collection of the artist.

could find in our family album. Pain, nakedness, the unposed, the unconscious, the smells of the home, the breath of the mother, the unmasked, a grown child's sleep, the everyday, a sensual confession – such steam and chill are rarely there.

Like most of us, Reynolds Price can only find 'innocent' and 'posed' pictures in his family's shoe boxes, albums and drawers. As he writes in the afterword to Sally Mann's *Immediate Family*,

> [My parents] exposed yards of film, not only in their frank satisfaction in a child but also in pursuit of visible proof that I was glad to be their product, a moon to their sun – and I generally was – but they likewise early enlisted my cooperation in a long concealment or denial that my becoming moon had hid a dark face, which was where I lived for far more hours – and now for nearly six decades – than any of them would have wanted to hear, not to mention confirm in permanent image. Like most veterans of family photographs then, my face and body – so far as they manage to outlast me – will survive as a highly edited version of the whole person I managed to be behind an ever-ready grin.[24]

Price would 'give a lot to have a stack of black-and-white pictures of moments' that captured such things as the 'furious look' in his 'father's gray eyes on a warm Sunday evening' when he told his wife that 'she'd stolen his share' of Price and his brother.[25] But there are no such pictures for Price, for most of us. Family albums are closely edited; they 'tend to include [only] those images on which family members can agree, which tell a shared story.'[26]

Most families agree on the same shared stories: Happy Holiday, Happy Vacation, Happy Graduation, Happy Birthday, Happy First Bicycle, Happy New Home, Happy New Baby, Happy Wedding. Though, as family members we can read other stories between the lines; there are solid similarities between family pictures (the pose, the occasion, the smiles, sometimes the clothes), a general covering over that 'perpetuate[s] dominant familial myths and ideologies.'[27] It is in this way that all family pictures are masked: they assume the mask of the familial. 'Photography,' writes Barthes, 'cannot signify (aim at a generality) except by assuming a mask.'[28]

Yet in a play of contradiction, childhood photographs often seem like an extraordinary touch with the real: as evidence of the unmasked self. Looking through my father's family album, I see all the essential traces of him: his quiet way, his tight-lipped smile, something moral and self-assured, his surprising love for wearing silly hats that stands in direct contrast to his hatred for costume, the pure pleasure he feels in being with the right people, his always very thick hair, a comfortableness with his own body, his love for dogs, his devotion to his mother. Some will say that I am reading what I want to see into these photographs, but I say, 'Nevertheless, I see it.' I know that you can see it too (a little bit of truth) even in pictures of people you and I only know through pictures.

I have found such kernels of truth lodged in the baby and childhood photographs of artists and cultural critics that are reproduced in the centre

pages of *Out There: Marginalization and Contemporary Cultures* – the fourth volume in a series ('Documentary Sources in Contemporary Art') edited by Marcia Tucker.[29] It has been said that the book is one of the most important texts on the topic of cultural marginalization, but rarely do I get past the old family photographs. I guiltily admit that these childhood snapshots are my favourite part of this book. I take perverse pleasure in matching up what I know (or what I imagine must be so) of the adult as it exists in the childhood photograph. I am especially delighted to find a picture of Simon Watney (the cultural critic who is one of the most important AIDS activists of our time) framed by grass and backyard shadows, head down, bottom up, pants short, shoes sweet, face buried. The photograph is familial; it is reminiscent of a photograph of my own father-as-boy, in which my father's face (like Watney's) is also buried in a grassy heaven of seclusion and childhood privacy. (My grandmother, with her familiar and comforting cursive, has inscribed the picture of my father with the words 'Asleep. 18 months'; yet I suspect that my father is wide awake and hiding.) But in *Out There*, it is the little picture of Nancy Spero (the painter whose biting, figurative works have been central to feminist art since the 1970s) that gives me what Barthes has so famously referred to as *punctum*: a sometimes unexplainable, but always personalized, sense of being wounded or pierced by a photographic image. Looking at the charming snapshot of her sitting on an oriental rug that has only temporarily landed, that appears ready for take-off, I see a flash of *her*. I recognize her startlingly wide-eyed smile, the tightness of her skin, the clarity of her ears, the fall of her hands, a certain love of the world, an excitement that I swear I have seen before in photographs of her as an adult. In the childhood picture, I see an essential image of her that has achieved 'utopically, *the impossible science of the unique being*'.[30]

Simon Watney as a little boy. 'The photograph is familial . . .'

Source Photograph from *Out There*. Courtesy of Simon Watney.

My father asleep, 18 months. '. . . I suspect that my father is wide awake and hiding.'

Nancy Spero as a little girl. '. . . I see a flash of her.'

Source Photograph from Out There. Courtesy of Nancy Spero.

Our childhood photographs are an extraordinary touch with the real because they are able to capture an essence of a unique being that we carry within ourselves from birth to death *indexically*. Like footprints in the sand or fingerprints in wax, photographs leave a trace of the referent. All photographs are traces of a skin that once was. Balzac understood this; that is why he feared losing thin ghosts of himself, like layers of skin, with each photograph 'taken'.[31] Barthes is in touch with Balzac when he writes:

> The photograph is literally an emanation of the referent. From a real body, which was there, proceed radiations which ultimately touch me, who am here; the duration of the transmission is insignificant; the photograph of the missing being, as Sontag says, will touch me like the delayed rays of a star.[32]

Maybe this is why when I see an old childhood photograph of my father, my grandmother, myself, I have an urge to touch it, to really feel it. And, even though I (really) feel nothing but smoothness – in my body, in my heart I feel a weighty ache, a pang of loss. I believe like Balzac, like Barthes, that the child before me is touching me. He weighs me down, she weighs me down, with grains of light that emanate from a small body that wears such childhood things as short trousers, cotton dresses, white cotton shirts (without collars), striped sweaters (with pointy collars), socks that bag and crinkle at the ankle.

Childhood clothes, like childhood photographs, link up (indexically) with our past childhood selves. Like old family photographs, our saved and cherished and often ravaged clothes from babyhood and childhood remind us that we have changed: that our bodies were once very small; that we dressed differently then from now; that we wore different kinds of clothing from children today. But most dramatically for me, childhood clothes contain traces of lost selves. Worn soles, stained collars, scents abandoned by the body attest to a body that once was, but no longer is. Such traces allow me a glimpse, a touch, a sniff at the child body that I have lost. And, in the case of my children's baby clothes, a glimpse, a touch, a sniff at the bodies that they have already lost.

Like Slavick, many of us feel the loss of the body/bodies of our own childhood. Indeed, many of us feel that our childhood selves are dead. We mourn the loss. We try to bring the child back. We save toys and clothes and other mementos from our childhood days: souvenirs that try to replace the loss. Childhood and death (as Lynn Gumpert has remarked) are closely linked:

> Although these themes at first appear at odds with one another, they share some fundamental similarities. We never know death directly; as Wittgenstein has succinctly observed, 'Death is not lived through.' Thus we must broach the subject from a distance, from observation. And while childhood is most definitely lived through, when analyzed or discussed, it is again almost invariably from a distance, from the vantage of adults who must rely on fragmented recollections and observations.[33]

Bringing the dresses out of the closet was a way for Slavick to touch the child that had died, that she had left behind – not only the death of her own child-body, but also that of the little brother who drowned. On a small silken slip that once rubbed against small silken girls, Slavick stitches the following:

I ATE FOOD IN THE BASEMENT.
I SUCKED LILACS.
I KICKED MY SISTER'S SHINS.
I PICKED DANDELIONS AND SOLD THEM
FOR A QUARTER.
I WANTED UGLY THINGS AND COULDN'T SWIM.
A BROTHER HAD DROWNED.
SICK EVERY SWIMMING DAY, HANDS UNDER
MY DRY THIGHS,
BROTHER, YOU HELD ME OVER THE WATERS.

Reading Slavick's dress pulls me into the closet of the family album of my mind's eye. Childhood images flash before me. Though I had no brother who drowned, I had a little cousin who left this world. I hid behind my bed. And even though he did not drown and even though I could swim, I hid in the bushes on swimming day. I did not sell dandelions, but I sold things that I made, really dumb things, door to door. Ugly things were really beautiful to me too . . . like my favourite toys made of brightly coloured plastic on various themes of grotesque cuteness. But like most of us, I have no photographs of such things, and maybe it is just as well.

But Sally Mann has taken pictures of such things. She has published her own family album, *Immediate Family* (1992). Pictures like that of (her son) Emmett sporting a shockingly bloody nose (*Emmett's Bloody Nose*, 1985), or Emmett with a back speckled by frightening chicken pox (*Pox*, 1986), or daughter Jessie with an eye painfully swollen and saddened by what I hope is only a bug bite (*Damaged Child*, 1984), mar the perfection of childhood that we all try to invent, not only for ourselves but for our own children. With each smiling photograph of the combed and primmed child that we dutifully place in the album, the box, the frame, the note to Grandma, we image childhood as prettied-up, overdressed, untouched, undamaged, undamaging and so unreal as to remain, always, far away from death. We preserve our children in an emulsion of Neverland, an imaginary place of tiny first teeth that never pop out. Yet, Jessie bites (*Jessie Bites*, 1985) and Slavick kicked her sister's shins.

Jenny's mom, Barbara, showed me where my boys were to sleep for the night. The two beds were covered with beautiful ageing quilts made of hundreds of tiny squares, the very size of old photographs, like those taken and printed and pasted in my father's album. Caressing one of the old quilts, Barbara explained to me that each square was from an old dress worn by her and her sisters. Each square, patterned with tiny flowers, dots and funny abstractions, lightly colourful in their muted washed-out colours, were

The text embroidered on the dress reads:

I ATE FOOD IN THE BASEMENT.
I SUCKED LILACS.
I KICKED MY SISTER'S SHINS.
I PICKED DANDELIONS AND SOLD THEM
FOR A QUARTER.
I WANTED UGLY THINGS AND COULDN'T SWIM.
A BROTHER HAD DROWNED.
SICK EVERY SWIMMING DAY, HANDS UNDER
MY DRY THIGHS,
BROTHER, YOU HELD ME OVER THE WATERS.

'Childhood images flash before me.'

Source Elin O'Hara Slavick, from *A Wall of Incoherent Dresses*, 1991. Collection of the artist.

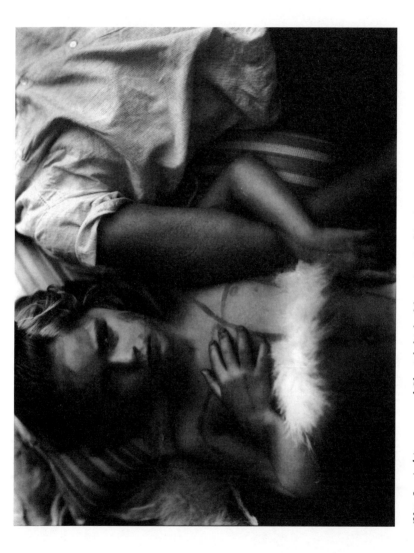

'Yet, Jessie bites . . . and Slavick kicked her sister's shins.'

Source Sally Mann, *Jessie Bites*, 1985. Copyright © Sally Mann, courtesy of Houk Friedman, New York.

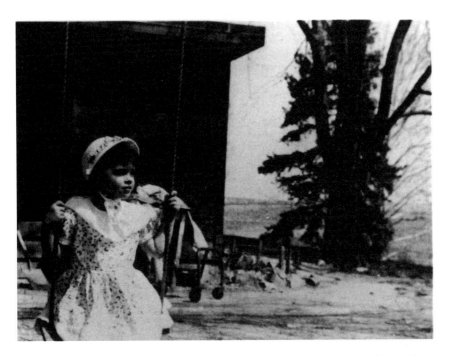

'. . . *wearing the Easter dress that had been made for her by her mother and grandmother – she is only 6 years old.*'

Source Family photograph from *Immediate Family*. Courtesy of Sally Mann.

dresses *taken*, like photographs: they represented years at home, with mother, father and siblings. Infused with the 'texture of perfume', each square, as if bites of (Proustian) madeleine cake, brought back memories.[34] Some good. Some bad. Some banal. They too, like my father's album, carried the weight of the past. Each seam was a memory, a seed sown. I thought of Slavick's dresses and I thought of the things that I hoarded in my closets.

Remembering that rainy night in Virginia and the quilts made of lost dresses, I recall a photograph, not taken by, but of, Sally Mann. Perched on a swing, wearing the Easter dress that had been made for her by her mother and grandmother – she is only 6 years old. You can see the lovely little dress showing its bright face again in Mann's *Easter Dress* (1986). Like the dresses in the Slavick family, passed down from mother to daughter, Mann has continued the process of acquisition and exchange by passing down the Easter dress to her daughter Jessie. In Mann's photograph, Jessie holds the bright white pleated cotton skirt, sprinkled with flowers, out into a wide smile for the camera. A little sister in a white baby dress hunts in the weeds for what? I am charmed. But I am also haunted, not only by Jessie's brother who pulls himself along the wire fence (his face strangely hooded, his legs in shorts), but especially by the torn nightdress that hangs on the clothes-line. The nightdress – caught in the gentle breath of the Blue Ridge

'. . . Jessie holds the bright white pleated cotton skirt, sprinkled with flowers, out into a wide smile for the camera. . . . I am charmed. But I am also haunted . . . by the torn nightdress . . .'

Source Sally Mann, *Easter Dress*, 1986. Copyright © Sally Mann, courtesy of Houk Friedman, New York.

Mountains, caught between the movement of a grandfather's dancing steps and the blur of a winged creature – is ripped at the back and at the hem. This dress is a horrible dress. Hanging and blowing like shed skin – it is a souvenir of loss, among shadows of change.

I am reminded of my children's little baby sweaters, and the grief that I felt (and still feel) when I discovered that they had been ravished by moths. I try to convince myself that the loss tears at my body, not theirs. I try to console myself with Barthes' words on the pleasure of 'abrasions', the pleasure found in 'the site of loss, the seam, the cut, the deflation'. But one hole gives way to another tear. I become acutely aware of my futile attempts to fill the holes with family albums of perfect pictures.[35]

But now I know, at the very least, to hold my tongue when my son Oliver turns his back on me and my camera, dodging the (maternal) frame.

Notes

I am grateful to Jane Blocker for inviting me to present an initial version of this article at a conference, 'Seeing through the body', at Wayne State University, Detroit, April 1995. I also want to thank Jerry Blow for his generous help with photography.

1 Sigmund Freud, Minutes From the Vienna Psychoanalytic Society, 1909, published as 'Freud and fetishism: previously unpublished minutes of the Vienna Psychoanalytic Society', ed. and trans. Louis Rose, *Psychoanalytic Quarterly*, LVII, 1988, 159. As cited by Emily Apter in 'Splitting hairs: female fetishism and postpartum sentimentality in Maupassant's fiction', in *Feminizing the Fetish: Psychoanalysis and Narrative Obsession in Turn-of-the Century France*, Ithaca: Cornell University Press, 1991, p. 102.
2 Lynn Gumpert, *Christian Boltanski*, Paris: Flammarion, 1994, p. 110.
3 Emily Apter's book, *Feminizing the Fetish*, has been very influential in my approach to writing this text.
4 Apter, 'Splitting hairs', p. 102.
5 Susan Stewart writes: 'The term *à-bric-à-brac*, which we might translate as "by hook or crook", implies the process of acquisition and exchange, which is the (false) labor of the collector.' (*On Longing: Narratives of the Miniature, the Gigantic, the Souvenir, the Collection*, Baltimore and London: The Johns Hopkins University Press, 1984, p. 159.)
6 James Clifford, 'On ethnographic allegory', in *Writing and Culture: The Poetics and Politics of Ethnography*, J. Clifford and G. Marcus, editors, Berkeley: University of California Press, 1986, p. 106.
7 Clifford, 'On ethnographic allegory', p. 121. Here, since Clifford is writing about ethnographic allegories/stories, I am twisting his intended meaning a little. Clifford's exact words are, 'If we are condemned to tell stories we cannot control, may we not, at least tell stories we believe to be true.'
8 Roland Barthes, *Camera Lucida*, trans. Richard Howard, New York: Farrar, Straus & Giroux, 1981, p. 63.
9 Ibid., pp. 64–5.
10 Ibid., p. 65.
11 Ibid., p. 81. Barthes is quoting Susan Sontag.
12 Ibid., p. 92.

13 Ibid., p. 94.

14 André Breton, the 'Pope of surrealism', ends the most famous of the surreal-ist novels, *Nadja*, with the line, 'Beauty will be CONVULSIVE or will not be at all' (André Breton, *Nadja*, trans. Richard Howard, New York: Grove Press, 1960, p. 160). Interestingly enough, the novel's 'convulsive beauty' is sub-stantially derived from the book's fragmented presentation of photographs that are provocatively, if only tangentially, related to the text's already incom-prehensible narrative. But the most profound absence in the book is the lack of any photographic images of Nadja, an absence which only emphasizes her haunting presence in the text. Nadja's striking non-materiality is later and similarly mirrored in *Camera Lucida*. For Barthes' treasured Winter Garden Photograph (which propels the narrative, yet never appears among the twenty-five photographs which illustrate the book), is all the more present by its absence.

15 Virginia Dodier, 'Lady Hawarden', from the pamphlet that accompanied The J. Paul Getty Museum's show 'Domestic Idylls: Photographs by Lady Hawarden From the Victoria and Albert Museum' (Malibu: The J. Paul Getty Museum, 1990).

16 Peter Wollen, 'Fire and Ice', *Photographies* 4 (1984). As quoted by Christian Metz, 'Photography and fetish', *October* 34 (Fall 1985): 84.

17 Barthes, *Camera Lucida*, p. 94.

18 *Roland Barthes by Roland Barthes*, trans. Richard Howard, New York: Farrar, Straus & Giroux, 1981, p. 61.

19 Milan Kundera in 'After word: a talk with the author by Philip Roth', in *The Book of Laughter and Forgetting*, trans. Michael Henry Heim, New York: Viking Penguin, Inc, 1981, pp. 234–5. Quoted in Lynn Gumpert, 'The life and death of Christian Boltanski', from the exhibition catalogue *Christian Boltan-ski: Lessons of Darkness*, curated by Lynn Gumpert and Mary Jane Jacob and co-organized by the Museum of Contemporary Art, Chicago, The Museum of Contemporary Art, Los Angeles and The New Museum of Contemporary Art, New York, p. 64.

20 Melanie Pipes, unpublished essay, 1994.

21 Susan Sontag, *On Photography*, New York: Farrar, Straus & Giroux, 1973, p. 149.

22 Elin O'Hara Slavick, artist's statement, in *Embodiment*, a catalogue prepared in conjunction with the *Embodiment* exhibition, organized by Angela Kelly, Randolph Street Gallery, Chicago, 22 November–28 December 1991, p. 13.

23 Angela Kelly, Introduction to *Embodiment*, p. 6.

24 Reynolds Price, 'For the family', Afterword to Sally Mann's *Immediate Family*, New York: Aperture, 1992 (no page numbers).

25 Price, 'For the family'.

26 Hirsch, 'Masking the subject: practising theory', in *The Point of Theory*, Mieke Bal and Inge E. Boerr, editors, New York: Continuum, 1994, p. 122.

27 Ibid., p. 109

28 Barthes, *Camera Lucida*, p. 34.

29 Russell Ferguson *et al.*, editors, *Out There: Marginalization and Contemporary Cultures*, New York and Cambridge: The New Museum of Contemporary Art and The MIT Press, 1990.

30 Barthes, *Camera Lucida*, p. 71.

31 Nadar addresses this in his discussion of Balzac and the daguerreotype: 'Accord-ing to Balzac's theory, all physical bodies are made up entirely of ghostlike

images, an infinite number of leaflike skins laid one on top of the other. Since Balzac believed man was incapable of making something material from an apparition, from something impalpable – that is, creating something from nothing – he concluded that every time someone had his photograph taken, one of the spectral layers was removed from the body and transferred to the photograph. Repeated exposures entailed the unavoidable loss of subsequent ghostly layers, that is, the very essence of life.' (Nadar, 'My life as photographer', trans. Thomas Repensek, *October*, 5 (Summer 1978): 9.

32 Barthes, *Camera Lucida*, pp. 80–1.
33 Gumpert, 'The life and death of Christian Boltanski', p. 51.
34 Roland Barthes uses this phrase to describe the voice of Proust in *Roland Barthes by Roland Barthes*, 'Odors', p. 135.
35 Barthes, *The Pleasure of the Text*, p. 8.

▪REVIEWS▪

Madonna – Mother of Mirrors
John Castles

■ Cathy Schwichtenberg (ed.), *The Madonna Connection: Representational Politics, Subcultural Identities and Cultural Theory* (Allen & Unwin and Westview Press, 1993)

In her essay 'Material girl: the effacements of postmodern culture', Susan Bordo makes the point that the celebration of difference in 'academic postmodernism' is in many ways complicit with a popular discourse which actually functions to pre-empt recognition of significant socio-cultural distinctions. Her discussion centres on talk-shows like *Donahue* and the familiar, recurring patterns they display. Any participant's attempt to advance 'some critically charged generalization' is drowned out in the automatic reassertion of a censoring individualism: What I do or you do is 'not something sociological' and to suggest that it is amounts to a personal affront. Here, or – the reverse side of the same coin – where guests display some superficially bizarre activity or appearance in conjunction with the assertion that they are perfectly 'normal' and the demand that they be treated 'just like anyone else', difference is neutralized as spectacle and then distributed evenly so that it is at once significant and insignificant. 'Everything is the same in an unvalenced difference' (p. 275) because difference is possessed absolutely and equally by whoever is speaking. Difference can only ever be aligned with the 'positive' as lived or embodied critique of some 'prejudice' or celebrated because it originates and is entirely contained inside the volition of the subject concerned, or, ideally, by a sort of magic that only this logic can accomplish, it can be both at once – social critique and entirely personal choice. It must always be expressed at the level of the particular individual so that sameness – read 'hypocritical moralism' or (in the academic version) 'totalization' – can be positioned outside or beyond the individual concerned in any particular case. This is individualism's false modesty – it rhetorically secures for itself a place which may be particular, but by virtue of this is absolute.

Perhaps it is appropriate then that Bordo's frustration with all this emerges plaintively from the midst of a collection which exemplifies her point. For the most part *The Madonna Connection* is bad cultural studies in a host of familiar ways, not least because it divides and rules its self-actualized social critic guest star like a *Donahue* show. Rather than criticizing it chapter by chapter I have taken three terms from the book's subtitle ('Representational politics, subcultural identities and cultural theory') to show how I think some of its prevailing themes reflect problems in the theorization of stardom and fandom and in contemporary cultural studies more generally.

Subculture

The *Madonna Connection* orthodoxy is that 'There are currently different aspects of Madonna's presentation that have specific appeals to different sorts of people,

that are interpreted in different specific ways and have different specific cultural uses' (this from David Tetzlaff, one of the few who contests it). Standing in for the individual, an array of discrete subcultures serve as containers of all these different interpretations. In her introduction, editor Cathy Schwichtenberg declares that 'subcultural' identities is a key term in the book's subtitle.' 'By integrating symbolic aspects into her performance that reference subcultural groups, Madonna has become a mainstream artist who addresses African Americans, Hispanics, gay men, lesbians, bisexuals, feminists and others who represent minority or subordinate positions in relation to the dominant powers that be' (p. 2–3). The significance of these statements now lies not so much in any contestation of Frankfurt School or productivist mass-media sociology assumptions as in the constitution of an academic position which blends Birmingham CCCS and 'postmodern' theories to form something entirely palatable to the liberalism they set out to oppose.

The chapters in the first two Parts employ either audience response to or critical interpretation of Madonna videos in which the overriding concern is to connect the content of the videos with the concerns of specific minority or subcultural groups, most particularly people of colour (Ronald B. Scott), gays and lesbians (Cindy Patton, Lisa Henderson). Thus, to Scott, Madonna's success on the black charts is 'due, in part, to' [her] acknowledgement and celebration of African musical roots and style' (p. 63). And the same goes for all the other marginalized constituencies Madonna represents. Gays and lesbians likewise appreciate her to the extent that she 'references' them. A video (or selection of videos) is understood as it alludes to, appropriates, or is appropriated by a subculture. So Henderson 'focus[es] on *Justify My Love* and its reception in the mainstream and gay press to consider Madonna's resonance in lesbian and gay culture (p. 108).

The references are signs the communities recognize – the black church, Vogueing – and presumably appreciate (or resent) seeing in a mass-mediated context. But the interest in each case *originates in the subculture*; the star simply happens to represent its concerns. The implication is that Madonna's stardom is to be explained as the accumulation of these discrete 'grounded' subcultural receptions. The secret of Madonna's success mounts up as the subcultures different facets of her image appeal to are aggregated together.

This is the significance of the 'Madonna connection' trope which recurs throughout the book in various guises. In all of them Madonna is a centre where diverse strands intersect, or a prism with multiple surfaces, 'a multifaceted site of contestation' (p. 4). For Schwichtenberg this is the 'Madonna paradigm' which 'serves as a touchstone for theoretical discussions of issues of morality, sexuality, gender relations, gay politics, multiculturalism, feminism, race, racism, pornography, and capitalism (to name a few)' (p. 4, 3). For E. Ann Kaplan it is 'the Madonna phenomenon' or 'MP', a related notion which highlights Madonna as the sum of multiply inflected interpretations rather than a 'real' identity. For Thomas A. Nakayama and Lisa N. Penaloza she is associated with a 'racial prism, revealing a range of colours' (p. 51). This figure is not only convenient to the maintenance of existing academic demarcations, it is also crucial to an interpretation which must find subversion in such a dominant figure, marginality in someone so mainstream. Only by dividing Madonna's audience into discrete 'cultures' can the cosy consensus that her massive audience are all subordinate resisters be maintained. Like *Donahue*, everyone can be a rebel, and oppression, whilst it exists, is, in each instance, conveniently elsewhere. Even as they question this consensus Laurie Schulze, Anne Barton White and Jane D. Brown invoke 'multiple sets of interests all along the scale of power, in shifting and frequently contradictory patterns' in order to salvage 'insubordination' for both

Madonna fans and 'Madonna haters' (p. 32–3). Resistance becomes a fetishized object which is only ever contingently connected to the meaning through which it is expressed.

Representation

As the language in these quotes might suggest, this vision of Madonna is frequently authorized with appeals to French poststructuralist theorists, though here they are called postmodernists and the transposition is not insignificant. Figures as diverse and antagonistic as Foucault, Baudrillard and Derrida have all expressed a bewilderment at the way they became co-opted into debates about postmodernism as they crossed the Atlantic. By their own admission they were initially either ignorant of or actively hostile to many of its key themes (see, for example, Baudrillard, 1993: 21–3; Foucault, 1989: 250; Gane, 1991: 46, 54–7). Here they are blithely lumped together as so many advocates of 'postmodernist theory'. For Schwichtenberg, Foucault has 'advocated a postmodern proliferation of bodies' (p. 136), for E. Diedre Pribram Baudrillard has a 'postmodern view'(p. 204) and so on. Postmodernism serves as a catch-all term through which all these theorists become advocates of an 'anti-realist' theory (the feminist chapters consist of 'a dialogue between realist and postmodernist positions' (p. 7)), the simple obverse through which all the familiar representationalist couples – truth/fiction, essence/construction, etc. – can be preserved and returned. It also serves as a term through which poststructuralists can come around to being theorists of fragmentation and incoherence, postmodern themes which can more easily be assimilated into an anodyne pluralism. Postmodernism makes poststructuralism safe for democracy.

Emphasis on a myriad set of linkages connecting the content of the MP's videos to the divergent interests of subcultural communities is more or less determined by the adaptation of subcultural theory to identity politics. But the problem with this model is that it simply does not map on to 'typical' fan experience or motivation. The fantasy that Madonna is a star to the extent that she represents a large set of pressing local concerns, like some popular cultural Congresswoman, functions to divert all attention from the specificities of the cultural form she exemplifes – stardom itself. As a cultural form stardom is produced as stars and fans are constituted in, experience and interpret a particular range of recorded and broadcast mediums. It is common knowledge that a star's fascination is to a large extent an effect of their integration in and reception through these processes.

At least since Boorstin the tautological aspect of star attraction has been recognized. Their fascination lies as much in the fact that they are themselves as stars, the ones who are massively replicated, as in the trivial stylistic differences which might have led to their being replicated in the first place. Semiotic analyses of stars, those that explain a particular star's popularity in terms of the images and discourses they represent, are now commonplace. But if star analysis was exhausted by this then there would be no readily recognizable generic form – stardom – into which each new star is inserted. Each star would emerge *sui generis* in response to the already existent expressive needs of a given social group. However incisive these accounts might be they miss the process which then takes over, is far more important and much less understood: How stardom becomes a sign in itself in its relation to the mediums which convey it. If the studies were to locate themselves in the actualities of atomized, private fan practices and fantasies, some interesting observations might emerge. But an emphasis on Madonna as exceptional, unprecedented (as if, for all the bravado about popular culture, this were the only reason she would

be worth studying) leads away from consideration of the dynamics of form to a preoccupation with the minutiae of content.

Stardom and fandom are produced in arrangements and experiences of time with their own distinct properties and effects. Stars are received in *repeated, replicated and extended* passages of recorded time, for example. These receptions produce their own meanings which are constantly changing as mediums (video, CD) and contexts change. None of these specificities are explored. Instead Madonna's significance is found as the content of her songs and videos elaborate yet more versions of the universal and entirely static paradox of reality and representation (as the cover, showing Maddona in a Vogue pose enframing her own face – self-presentation-as-act – suggests). The analogies are from literature, drama, or the static visual arts. Madonna uses 'Brechtian estrangement effects', she is 'like Genet' (p. 96, 221). For Schulze, Barton White and Brown she is 'a striking contemporary instance of what Peter Stallybrass and Allon White (1986) call the "low–Other" ', a category the latter generated in studies of carnivalesque in eighteenth-century Britain. The various forms within Madonna's oeuvre – the videos, the movie *Truth or Dare* (subject of Chapters 7–9), the press and TV interviews, and the singles and albums themselves, are treated as so many undifferentiated repositories of images and discourses whose exceptional content implicitly explain her circulation. Henderson discusses *Justify My Love* in relation to censorship debates around the work of photographers Andres Serrano and Robert Mapplethorpe. She segues smoothly from Madonna's interview on TV's *Nightline* to the images of the video, to the lyrics of the song. The distinctions between the effects and meanings of the productions and receptions of these media, the very things that make Madonna the star and Forrest Sawyer the interviewer, are smoothed over.

Identity

The emphases on subcultural subversion and on static visions of representational paradox come together in the feminist chapters at the book's centre. A basic set of propositions defines these chapters: those of Schwichtenberg, Kaplan, Pribram and Morton (Roseann M. Mandziuk seems to concur with the interpretation of Madonna as postmodern feminist while disagreeing with its efficacy as a political strategy). It can be summarized in three steps. One, in the bourgeois culture of the modern West, patriarchal relations find their justification in conceptions of 'natural', 'unified' individual identities which serve to determine gender roles. A man *is* this, a woman *is* that. In Kaplan this is 'the bourgeois illusion of "real" individual gendered selves' (p. 150), in Morton it is 'the centrality and naturalness of the masterful bourgeois subject', a 'belief in the individual as a free, autonomous, unified subjectivity' (p. 214–15), and so on. Two, these conceptions find their justification in turn with recourse to the various representationalist dichotomies: original and copy, real and artificial, depth and surface, private and public. Three, Madonna, by 'deconstructing' these oppositions, by ceaselessly 'reinventing herself', becomes the exemplar of a feminist politics which exposes the illusion of representationalist dichotomies and hence fixed gender identities.

This is a tall order, given that just about everything that gets said by or about Madonna slots immediately into the most traditional individualism and representationalism: 'I do everything of my own volition. I'm in charge' (p. 171), 'she's what she wants to be' (p. 15), 'I am my own painting', 'she's her own masterpiece' (p. 167). How can pronouncements like these be interpreted as in any way challenging to conventional conceptions of the self-making subject? Because these theorists

make the elementary mistake of confusing doubling with deconstruction. In the postmodern feminist argument the fact that Madonna continually makes, masks, mirrors, paints, is another self, becomes evidence of a critical point she is supposedly making – that there is no identical' self. But as the articulated structure of the quotes above shows, the establishment of an identical self always depends on precisely the same act of self-alienation. Identity is not singular, the rhetorical establishment of an original unity as self-same *requires* doubling. This, if anything, is what 'postmodernists' like Derrida and Deleuze have taken such pains to show. If 'one' begins, as they do (though in quite antagonistic ways) with the idea that difference is an immanent force prior, to identity, then the various representational doublings (identity – A = A, opposition, negation) are revealed as a particular structure by which this immanent force is bounded or controlled. Channelling the flow of differentiation into *two* moments is *functional to* the retrospective establishment of a prior identity. This priority can move forwards or backwards. That is, it doesn't matter whether it 'turns out' that the copy was real or vice-versa. As long as the doubled relation is established one side will always re-establish its relative priority.

Pribram's interpretation of *Truth or Dare* provides a good example. The movie is divided in the usual, clichéd manner: colour film for the 'public' stage show, grainy black and white for the intimate, private 'real' Madonna. Pribram points out, in laborious detail, the moments when this opposition is reversed: colour for 'private', black and white for 'public'. For her they show how 'Madonna' 'collapses' and 'blurs' this particular structural opposition through which the fiction of the private self is maintained. Yet the 'postmodern theorizing' she appeals to stresses that these reversals are always already part of the signifying economy. For Derrida (even for Baudrillard) the film would be far more remarkable if it *didn't* reverse itself this way, because such supplementary reversals are necessary to the maintenance of the primary term's 'myth' of sovereignty 'in the first place'.

This is the root of a paradox which produces its own set of absurdities. Theorist and star become a kind of comedy duo, each mirroring and misunderstanding the other. Madonna's perpetual assertions of an entirely formulaic star identity – one that is itself, that recedes, that is or isn't here but is somewhere at any rate – become evidence of a deliberate deconstructive agenda. (Kaplan finds Madonna's announcement in *Vanity Fair* that 'you will never know the real me. Ever' to be an 'arresting' counter?/example of the way she 'deliberately plays with surfaces, masks, the masquerade' (p. 149)). Irony, a manoeuvre often deployed defensively in an *ad hoc* manner by someone who doesn't really 'know what they're talking about', which allows an avenue of escape ('I was only joking'), becomes the record of a continuing, coherent critical strategy.

Madonna tells Arsenio Hall that she likes being spanked and giving head. She tells Carrie Fisher that she doesn't, and that she was 'just playing with Arsenio'. For Pribram, Fisher's reaction – 'This is a very important piece of news' – is evidence of her naivety. 'It apparently doesn't occur to Fisher that she might be tailoring her answers to suit her immediate audience' (p. 200–01). But it doesn't occur to Pribram that this is anything but a playful strategy designed to reveal 'the definitive absence of any possible barometer for the definitive truth.' It is part of a 'game' of 'seduction' she is not only playing but demonstrating, representing. For her this is an aspect of the phenomenon which shows how Madonna, in *Truth or Dare* and its publicity, 'can be viewed as a contemporary application of' 'postmodern theorizing, in particular Jean Baudrillard's version' (p. 189). Her inability to decide whether giving head is politically correct feminism or not 'suggests parallels with Baudrillard's concept of simulacra' (p. 201).

TV interviewers and commentators frequently serve as scapegoats in the postmodern feminist chapters. They don't 'get the point' of Madonna's intentional irony. But the irony of their own position escapes them. The irony is that irony is always intentional. It always works rhetorically to constitute an intending subject (in the banal, motivational rather than the phenomenological sense), a subject prior to its environment at any given moment. Thus what starts out as a critique of representation and the identical subject becomes an occasion for the representation of an identical subject! The theorists distinguish their accounts from the standard journalistic perplexity over who the real Madonna is because they come to the conclusion that there is no 'real' (i.e., originally identical) Madonna. But they do so only at the price of implying or arguing that the display of this loss of self is the overt and deliberate content of Madonna's oeuvre. Only, in other words, by reinscribing the subjective identity/representation double on a new plane.

Madonna becomes an identical subject to precisely the extent that the critique of representation is seen to take place within her own image, as critical play. This play is then supposed to be the key to her success, it explains, her popularity. The fans love a critic.Madonna's relation to 'the historical avant-garde' 'lend[s] support to her arguments. As Michel Foucault insists' (p. 215). 'Madonna's work is informed by a keen insight into the connection between subjectivity, power, and ideology. As Foucault describes it' (p. 220). 'The politics of sex and gender representations as they relate to identity has not been lost on Madonna.' '[M]ulti-Madonna' knows 'the sly deployments of a strategic postmodern feminism' 'only too well' (p. 142).

No wonder Schwichtenberg betrays a sensitivity to Meaghan Morris's critique of 'Banality in cultural studies'. For Morris this banality occurs in texts where 'against the hegemonic force of the dominant classes, "the people" in fact represent the most creative energies and functions of critical reading. In the end they are not simply the cultural student's object of study ... The people [in this case the subcultural fans who made Madonna a star by 'getting' her masquerade] are the textually delegated, allegorical emblem of the critic's own activity' (Morris, 1988: 17). Schwichtenberg uses the power of numerology to banish Morris, conjuring up the magic number 3 in a dismissal which is never elaborated on. Morris 'is in fact, self-involved – a self-consciousness three times removed from popular culture which traps Morris in a purely academic introspection' (p. 4).

The effects of this will to identify the star with the postmodern theorist are sometimes unintentionally funny, but usually just boring. The theorists simply extend and then retrieve themselves through their privileged object. Stars become critics, critics become stars (e.g. Seigsworth: 'It is at times an awkward dance. Turn this way and you stare into the camera (as [Eric] Michaels concludes "I have bought another five minutes of fame"). Turn the other direction and you might see Baudrillard, Frith, Jameson, Morris, Deleuze, or Barthes. These are complicated pleasures of being interpreted and interpreter ... of being a star and starstruck' (p. 310). And the versions of Baudrillard and Foucault produced as they are identified with Madonna prove to be strange indeed. In this process accounts of networks which constitute the subject become apologias for some sort of leap into a pure, contentless, disengaged subjectivity, a breaking free from 'oppressive power' into 'pure freedom'. In Pribram, for example, Baudrillard's concept of 'the obscene' comes around to having something to do with the way Madonna 'shocks' some people with the 'representation of sexuality' while the new postmodern generation don't mind, about changing, culturally relative 'social attitudes towards sexuality', about liberation from the 'culturally repressed', from 'repressive and oppressive' 'socially constructed definitions of obscenity' (p. 200).

But this tendency reaches its nadir in Melanie Morton's account of Madonna as avant-garde Genet-Foucault, deconstructing Fritz Lang. To Morton Madonna 'stages both [the] construction and deconstruction' of the 'repressed and brutal maxims of liberal humanism', she is engaged in 'combat against the norms of representation' (p. 215, 217). But in her every formulation Morton reveals her own position to be an intensified version of the liberal humanism and representationalism she attacks. She continually uses poststructuralist *descriptions* of form as pretexts for *critiques* of their functioning, as if they describe some particular oppressive structure which can be abstractly transcended: discourse reverts back into ideology. Madonna 'examines' things like 'narrative closure', 'representation' and 'identity' and their 'connection with domination', where all these things are contentless forms, self-evident evils to be avoided.

Foucault's description of power relations gets mixed up with a residually Marxist conceptualization of 'domination' which it was explicitly designed to counter. This produces all sorts of confusions. Sometimes Madonna's strategies *exemplify* the power relations Foucault describes (p. 226). sometimes they are *exposés* designing to facilitate escape from their oppressive workings, 'politically subversive' 'displays' 'making conscious' the 'connection between sex and power', revealing 'the interests of state [Foucault? The interests of state?] that require docile bodies for a governable populace' (p. 220).

In one paragraph Morton discusses how *Express Yourself* 'undermines the stability of domination' while 'dominance is not clear or stable' (p. 229). Still this bizarre amalgam enables her to write sentences like 'Madonna insists that we not be conquered by the power relations to which we are subject' (p. 233). Foucault attempted to describe power relations as at once inescapable and open, as producing productive subjects in particular positions, in order to move away from the humanism and representationalism implicit in both liberal and Marxist formulations. When he is used to rouse an undifferentiated 'we' to 'conquer' 'power relations' or 'men's voyeuristic and dominating desires to see, to know, and to possess' the critical import of his work has obviously been almost entirely lost.

Morton sees Fritz Lang's *Metropolis* ('with its patriarchal, racist and capitalist constructions') as an oppressive work so that Madonna's *Express Yourself* song and video can be shown to deconstruct it point by point. Strangely, given her interpretation of Madonna's representations as ironic exposure, Morton seems to think that because *Metropolis* depicts certain things it must be arguing for their truth. Because it represents factory drones the film 'claims that the workers do not have any minds' (p. 218). By contrast the fact that the word 'self' in *Express Yourself* is sung in a number of different keys is no coincidence. It is all part of Madonna's 'mediations on the constitution of a decentred subjectivity ... the word as well as the concept gets divided and put in motion, articulating agency through positions that remain partial and temporary' (p. 228) (who was supposed to be trapped in a purely academic introspection again?).

In interpretations like this the radical potential of a critique of representational categories is contained and neutralized as representation. Nothing is what it seems, even the critique of representation itself is already representation, already a display originating elsewhere designed to 'reference' something else. Everywhere the celebration of a collapse of depth and surface, reality and artifice, but only as they are firmly trapped inside the receding depths of Madonna's intentional representations. In this context the most innocent declarations of liberal egalitarianism become poststructuralist manifestos. Singing 'it makes no difference if you're black or white, if you're a boy or a girl' is not 'liberal catharsis' but the articulation of a 'postidentity

space' (p. 96). Surely that is ironic! ... Or am I missing something here, maybe I just don't get it, maybe this whole book is a playful masquerade, etc., etc.

References

Baudrillard, J. (1993) *Baudrillard Live*, London: Routledge.
Foucault, M. (1989) *Foucault Live*, New York: Semiotext(e).
Gane, M. (1991) *Baudrillard: Critical and Fatal Theory*, London: Routledge.
Morris, M. (1988) 'Banality in Cultural Studies', *Discourse* 2 (Spring/Summer): 2–29.

In theory: classes, nations, literatures
Dipesh Chakrabarty

■ Aijaz Ahmad, *In Theory: Classes, Nations, Literatures* (London and New York: Verso, 1992) viii + 358pp., ISBN 0-86091-372-4, £34.95 Hbk

Ahmad's polemical book has already received much attention and comment in the academic press. This is a combative piece of writing, aimed at scholars who in Ahmad's reckoning have abandoned their former Marxist, or at least socialist, loyalties to embrace postmodernism and/or poststructuralism. Among such people he counts Frederic Jameson, Salman Rushdie and Edward Said. Ahmad devotes individual chapters to criticizing particular pieces written by them – an essay by Jameson on 'Third World literature', Rushdie's *Shame*, and Said's *Orientalism*. Ahmad is also hostile to the work of the *Subaltern Studies* group of historians of India (the present reviewer is one of them), and to what he calls 'Colonial Discourse Analysis (CDA)'. These developments he classifies among the baneful effects of Said's *Orientalism* and of the rise of poststructuralism.

Ahmad obviously thinks that he writes as a Marxist. His Marxism, however, is of a very particular kind. Terry Eagleton describes it on the dust jacket of the book as a 'devastating, courageously unfashionable critique' that 'has not forgotten' the 'radical critics [who] may have forgotten about Marxism'. Ahmad's prose is reminiscent of a long tradition of Communist Party writing in which the 'enemy within' is always considered far more dangerous than the 'enemy without'. The spirit of the book is, therefore, moralistic, inquisitorial and fratricidal. Poststructuralist thinkers are 'reactionary', is the summary judgement of the book. With this near-universal tradition of CP-style criticism, Ahmad blends the very particular flavour of what, after his own fashion, may be termed Official Indian Marxism (OIM). OIM is the Marxism that has always found favour either with the Nehruvian, 'secular' state in post-Independence India or with the official hierarchies of the Indian Communist Parties. This tradition is Stalinist at least in temperament and in its debating techniques even when the intellectual propositions it defends are not specifically or explicitly grounded in Stalin's own writings. It is extremely suspicious of Marxists raising any fundamental questions about Marx. And its debating techniques have three prominent characteristics: absence of any serious interest in the intellectual–philosophical traditions from which Marx's own thoughts arose (so that the basic categories of Marxist thought could be treated as being beyond criticism); a tendency toward unsubtlety in polemical positions; and plain double standards including the unwillingness to submit one's own thoughts to the same tests as one

requires of one's opponent, and blatant suppression of facts. Ahmad's polemics exhibit all of these characteristics in varying degrees.

There are some things that Ahmad does well. In parts of the book, beginning with Ahmad's well-known debate with Jameson over the nature of 'Third World literature' and going on to the conclusion, there runs a sustained critique of the theoretical limitations of the 'Three Worlds Theory'. While Ahmad overlooks the political and descriptive uses of the category 'Third World' in certain contexts – for example, in bargaining between groups of governments over ecological and environmental issues – many 'Third Worldist' positions are admittedly internally inconsistent and Ahmad's criticisms of them, in particular that of the category 'Third World literature', are well-taken. Sections of his interesting – though weak because he sets out to prove an *inevitable* connection between 'poststructuralism' and 'pessimist' politics – discussion of Rushdie's novel *Shame* show a capacity for getting beyond the formulaic (as when he writes with visible affection and sensitivity of everyday life in Pakistan: see p. 139). Even his criticism of the ahistoricism that sometimes afflicts Said's category of 'orientalism' has some force to it, though the chapter is marred by its meanness of spirit and its total incapacity to understand why Said's epoch-making book by the same name has spoken to so many people in so many different contexts. Ahmad can only see the book's influence as a sign of a 'world supervised by Reagan and Thatcher', and being due to Said's methodological invocation of Foucault and of 'the way it [*Orientalism*] panders to the most sentimental, the most extreme forms of Third Worldist nationalism' (pp. 177–8, 195).

There are three rather weak chapters in the book – those on 'Marx on India', 'Indian Literature' and 'Ideologies of Immigration'. The first of these reads like a crash-course that Ahmad appears to have taken on Marxist historical scholarship on/in India. His knowledge is shaky. He thinks, for example, that it is only as a result of Said's influence and that of CDA that 'Colonialism is now held responsible not only for its own cruelties but, conveniently enough, for ours too' (pp. 196–7). Clearly, he is not even aware that this position that he ascribes to CDA was one of the most prominent characteristics of OIM in the 1970s, and famously so in the case of Bipan Chandra whom he adoringly mentions in his list of Indian Marxist scholars whom he thinks Said should have read. As to the chapter on 'Indian Literature', I can only agree with Ahmad's own judgement: that 'there are many in India far more competent than I who can and do write on these matters' (p. 14). The chapter on 'Ideologies of Immigration' and some sections in the preceding chapter on 'Literary Theory' belong to what Ahmad has written from the spleen and carry chunks of pure viciousness. It is here that Ahmad's polemics acquire a certain shrillness of tone and he makes points that are neither true nor fair. For example, in criticizing a statement of Homi Bhabha's in the latter's *Nation and Narration*, Ahmad concludes, hitting somewhat below the belt: 'it takes a very modern, very affluent, very uprooted kind of intellectual to debunk both the idea of progress and the sense of a "long past", not to speak of modernity itself' (p. 68). Again, one can think of scores of Indian intellectuals – Ashis Nandy, Ramachandra Gandhi, Partha Chatterjee, Gautam Bhadra, Vivek Dhareshwar immediately come to my mind – who are perhaps much less modern, affluent and transnational than Ahmad himself and yet whose intellectual positions would be close to that which Ahmad criticizes. But Ahmad conducts his polemics in such black-and-white terms and with such a fantastic sense of political activism and urgency – he mentions in several places a 'determinate socialist project' in which he is located – that he does not leave himself much time or space within which to consider the complexities of any question.

The book would appeal to people who already think that poststructuralist philosophers necessarily lead us to 'cultural relativism' and political passivity. But it will disappoint anybody looking for any deep philosophical engagement with the intellectual traditions Ahmad denounces. There are about a couple of pages on Foucault, but more characteristically 'Levi-Strauss, Foucault, Derrida, Glucksmann [,] Kristeva' are usually dismissed as 'reactionary anti-humanists' (pp. 192, 194). There is a one-sentence formulation about 'Nietzschean ideas' that makes the philosopher sound like an undergraduate student from an English department today: 'the Nietzschean idea that no true representation is possible because all human communications always distort the facts' (p. 193, see also pp. 197, 199). It is amazing that there is not even a mention of Spivak who would have otherwise provided such a sitting target for Ahmad's kind of critique. Spivak mixes Marxism with feminism and deconstructionist philosophy, she associates herself with *Subaltern Studies* and calls herself a 'post-colonial critic' – who could be more guilty in Ahmad's eyes? It is possible that even a 'devastating' and 'courageously unfashionable' critic like Ahmad did not have the courage to take on feminism, who knows, but Spivak's omission makes Ahmad's book literally fratricidal, an intellectual 'pub-brawl' among the boys. And for someone who is so rough on academics from the subcontinent who make a living in the West, Ahmad is remarkably silent on his own long years of teaching in the United States. It is not that he shies away from autobiographical references – he tells us that he was born in India, is 'from Pakistan', writes poetry in Urdu and now works in Delhi (see pp. 96, 104, the blurb) – yet there is not even a hint in the book of Ahmad's having spent years in the US academy. Instead, while every use of the first-person plural by Said (and Nehru) is seen as 'strategically deployed' and therefore 'decoded' and while Said is taken to task for his ahistoricisms and essentialisms (pp. 171, 297), Ahmad blithely writes of the '*essential* unity in structures of feeling' that has, according to him, produced a civilizational 'unity' (Ahmad says 'our unity') in the Indian subcontinent for millennia and cites, completely overlooking the nationalisms that gave birth to the two nation-states of Pakistan and Bangladesh, Nehru's *Discovery of India* as a text of '*our* canonical nationalism'! No decoding now of his own 'we', no reflection on his own textual strategies. Ahmad talks of 'us' as if somehow his 'we' were more natural than Said's. Yet that use of 'our' reveals how close Ahmad's position is to the official line of post-Independence Indian nationalism. This is again something he shares with OIM.

If Ahmad had written a non-polemical book, he would have avoided these pitfalls but his claims would have been modest. The importance of this book derives from a larger scene. Some Marxist academics are now rueful that Marxism has lost the prestige it used to enjoy in the Western academia in the 1970s. They look on poststructuralism as a ploy of the reactionaries. Ahmad's book comes out of that sentiment. It is not a deep or thoughtful intervention but it has its place – to give Ahmad the last word – among 'the signs of our time'.

The Jewish Question and the limits of (post)modern inclusionism
Adam Katz

- Ammiel Alcalay, *After Jews and Arabs: Remaking Levantine Culture* (Minneapolis: University of Minnesota Press, 1993) 288pp. ISBN 0-8166-2154-1, $16.95 Pbk
- Jonathan Boyarin, *Storm from Paradise: The Politics of Jewish Memory* (Minneapolis: University of Minnesota Press, 1992) 192pp. ISBN 0-8166-2094-4, $14.95 Pbk

- Marc H. Ellis, *Beyond Innocence and Redemption: Confronting the Holocaust and Israeli Power* (Maryknoll, NY: Orbis, 1990) 214pp. ISBN 0-06-062215-6, $21.95 Hbk
- Michael Learner, *The Socialism of Fools: Anti-Semitism on the Left* (Oakland: Tikkun Books, 1992) 147pp. ISBN 0-935933-05-0, $10.00 Hbk

Just as Marx's 'On the Jewish Question' addressed the question of Jewish demands for civil rights in terms of the contradictions of political emancipation within bourgeois civil society in order to place the question of social emancipation on the agenda, it is similarly necessary today to address the Jewish demand for entrance into the new (post)liberal middle-class political practices of identity politics, postmodernism and cultural studies as a way of advancing a critique of the present-day status of civil society and social emancipation. Postmodern cultural theory invariably formulates the question of civil society in terms of a conflict between a monolithic technocratic mass-mediated public sphere and a series of marginalized identities or counter-publics struggling to pluralize the public sphere and transform it into a site where differences can be articulated and negotiated (see Fraser, 1990). However, this blocks the needed intervention into the global reconstruction of capitalist hegemony, which is currently enabled by precisely such a pluralization of the mainstream and the opening up of new sub-discourses and identities. That is, the ruling class now allows for a degree of cultural autonomy which stands in direct proportion to the amount of economic autonomy it expropriates from exploited classes. This in turn compels the middle class or new petit-bourgeoisie to compete for the available positions in this new mode of social reproduction.

When Michael Lerner, in his *The Socialism of Fools: Anti-Semitism on the Left*, argues that Jews have been prominent in demanding that 'cultural and intellectual institutions open their doors to reflect the diversity of intellectual and cultural traditions that had previously been ignored' (p. 122), but have 'rarely demanded that Jewish culture and Jewish history be included in the newly emerging diversity' (p. 122), he is pointing to a contradiction in liberal and left Jewish practices between a 'modern' support for universalist goals (anti-racism, intellectual choice, etc.) and the modes of particularism through which such demands are currently articulated and which depend upon a rejection of this modern modality. He is, that is, advancing a demand for the 'emancipation' of Jewish intellectuals and progressives from outmoded liberal/modern positions which hinder their ability to participate in the new postmodern power/knowledge regime of the West. It is precisely the contradictory character of such a demand for inclusion which can allow for a critique of the politics of inclusion itself.

That is, what the postmodern understanding of civil society cannot recognize is the global effects of the reconstruction of social relations in post- 'essentialist' terms (that is, 'beyond' the conflict between freedom and totalitarianism, as articulated by the right, and capitalism and socialism as advanced by the left, and between self-determination and national oppression as anti-colonial movements insisted). In other words, the 'beyond' of left, right and center proposed, for example, by Kobena Mercer (who claims that the 'vocabulary of right, left and center is no longer adequate' (1992: 424)) conflates the formulation of the social in essentialist terms proposed by the right (dependent upon liberal humanist modes of subjectivity) with the radical insistence upon addressing historically determined conflicts over the production and distribution of resources by stigmatizing both as essentialist. This aids in the construction of a new cultural and political center better equipped to regulate global, transnational modes of capital accumulation.

Within this context, a series of recent books, which inquire into the stakes for Jews and 'Jewish discourse' in emergent arenas of knowledge and politics like identity politics, cultural studies, and postmodernism takes on some interest. The current crisis in mainstream Jewish politics (largely an effect of the liberal self-definition of this politics and its growing conservatism) has been anticipated by recent discourses of dissent from an increasingly rigid orthodoxy: progressive organizations like the New Jewish Agenda (which was recently accepted into the American Congress of Presidents of Jewish organizations), and the Journal *Tikkun* (founded in 1986) are now well prepared to stop carving a space at the margins of American Jewish organizations and move toward the center. This internalization of conflicts over 'Jewishness' enables a foregrounding of the historicity of the 'Jewish' as a site of struggle. The question now is, will these tendencies work to hold together an increasingly fragile and crisis-ridden center (by producing a postmodern annex to the modern regime of Jewishness), or will the accumulation of contradictions involved in the reorganization of the center serve to produce a breach in the apparently seamless move toward a New World Order governed by an economic rationality which renders 'essentialized' antagonisms obsolete? That the stakes involved are recognized by those poised to exploit the post-essentialist regime in Israel/Palestine in the wake of the Israel–PLO agreement can be seen from the following remarks of Steve Grossman, president of AIPAC:

> [I]t will be a tremendously exciting period. We face the prospect of an explosion of investment in the entire region by both public and private entities. If these changes in the peace process become reality, you're going to see unprecedented economic progress in that part of the world, in which Israel will be at the center of the board. AIPAC is going to play a very central role in that.
>
> (Quoted in Besser, 1993: 15)

Michael Lerner, who has recently published *The Socialism of Fools: Anti-Semitism on the Left* is an exemplary representative of these tendencies. Lerner is the founder and editor of *Tikkun*, a progressive Jewish journal, and is now in the process of writing a book together with Cornel West on black–Jewish relations. Lerner's notion of the 'politics of meaning' was recently employed within the mainstream by Hillary Clinton as part of the Clinton administration's own attempt to mark out a space 'beyond' obsolete antagonisms. Lerner, like postmodern cultural criticism in general, argues for the autonomy of a 'politics of meaning' (struggles to reclaim subjectivity within the cultural realm) which can be carried out separate from labor relations, and are even seen as a precondition for struggles against exploitation.

The contradictions of a 'politics of meaning' based upon identity can be seen in the way in which Lerner deploys Jewish identity as a means of demanding its inclusion within postmodern civil society. For example, Lerner argues that only 'self-affirming Jews' have a right to deploy their Jewishness as a site of critique; while 'self-hating Jews' only have the same rights of critique (of Israel, in particular) as everyone else: such anti-Zionist critiques can only be made by Jews as 'citizens' (see pp. 101–3). However, this reproduction of the split of the Jew into 'Jew' and 'citizen' is extremely problematic because it compels Lerner to distinguish between 'authentic' Jews who can be relied upon to fight consistently for emancipation and 'unauthentic' ones who must, according to the logic of his argument, be inherently untrustworthy (since they deny the need for their own emancipation). In this way, Lerner's argument provides the grounds for policing, within the left, those revolutionary, secular, anti-Zionist Jews who are not quite Jews, not quite citizens, and necessarily only superficially committed to the causes they espouse. In other words,

the politics of inclusion Lerner wishes to support is dependent upon some very specific exclusions: in particular, those Jews who, like Marx and Spinoza, take a critique of Judaism as a privileged site for advancing a revolutionary critique of capitalist civil society. This contradiction in Lerner's understanding of Jewish identity follows from his assumptions regarding the articulation of 'culture' (identity) with 'economics' (class), which are the same assumptions now predominant within postmodern cultural studies.

That is, postmodern cultural studies, as for example, in the work of John Fiske (1992) 'recognizes' the fact of economic inequality and oppression: Fiske argues that the 'materiality of popular culture is directly related to the economic materiality of the conditions of oppression' (pp. 154–5). However, at the same time Fiske valorizes what he calls a 'bottom-up' (pp. 161) theory of subjectivity which enables an accounting of the 'popular differences' which 'the people bring to the social order' (p. 161). That is, oppression can be understood as a 'top-down' process organized along lines of economic class, while resistance should be seen as a 'bottom-up' process (experiential) articulated by 'the people'. Insofar as economic oppression is systemic (it can be 'traced back to the complex elaborations of late capitalist society' (p. 161) it requires a theoretical analysis; meanwhile, experiential resistance negates the possibility of 'distance' (theory) and demands a Foucauldian analysis of the specificities and immediacies of the disruptions of mechanisms of power (which are disarticulat[ed] . . . from a direct correlation with the class system' (p. 161), i.e., the 'body'. This move, despite claims that it removes the privileges of the academic investigator which depend upon a 'distanced' discourse, in fact reinforces that privilege because the positing of the appropriation of 'cultural capital' (in the form of transforming and complicating the 'signs' of oppression (p. 157) as a mode of resistance privileges the accumulation practiced by those with access to the most valuable 'signs' (like advanced theory) – just as the valorization of the proliferation of small businesses in order to argue for the democratic effects of the market actually privileges the multinational corporations which accumulate most effectively on the 'free market'.

In Lerner's case, we can see an interesting analysis of the specific oppression of Jews in terms of their class position within Gentile society as a kind of 'middleman' caste (pp. 13–14), which is privileged in relation to the masses but at the same time extremely vulnerable insofar as the ruling class uses their ambiguous and dependent position to direct the resentment of the oppressed at Jews rather than itself. However, this analysis serves no real purpose in Lerner's understanding of the politics of Jewish identity. For example, if we were to follow through on Lerner's analysis, we would have to arrive at the conclusion that Jews as a 'people-class' (Leon, 1970) or 'caste', could be expected, in general, to be located somewhere near the progressive end of middle-class liberal movements, with an overriding interest in social stability and the blunting of social antagonisms. Lerner, however, only uses this (class) analysis to 'prove' that Jews are oppressed, even if it doesn't always appear to be the case, and that they are therefore deserving objects of progressive politics (pp. vi–vii). In seeking out the content of a specifically Jewish politics, meanwhile, Lerner abandons this theoretical terrain altogether and asserts that the Jewish religion itself has an essentially and transhistorically revolutionary content (pp. 3–6), no matter how much it has at times been concealed or distorted by the realities of Jewish life.

In other words, the articulation of economics and culture once argued for by cultural studies (for example, in the work of Stuart Hall in the 1970s) has become a disarticulation of the two through the claim that while oppression is determined

structurally, resistance can only be understood in a 'bottom-up' manner, through the self-definition and self-identification of oppressed groups. In this way the autonomy of culture grounds the negotiations between different identities (which are represented by those in possession of the means of cultural authority, those who represent the group within the dominant institutions), and these negotiations become the main register of political discourse. Lerner's discourse reflects and capitalizes on this shift and therefore aggravates its contradictions and exposes its limits. To take one particularly telling example, Lerner argues for 'left-wing' Jewish self-defense organizations as a counter to 'black antisemitism' (pp. 127–8): however, regardless of the left-wing 'intentions' of such organizations, what Lerner is unable to recognize is that due to the structural relations between blacks and Jews, such organizations cannot be anything other than vigilante groups defending Jewish property against the most dispossessed elements of the black proletariat.

In Lerner's proposal for a Jewish identity politics, then, the petit-bourgeois character of identity politics in general emerges in particularly sharp relief. This is because, with regard to the identity politics articulated by feminists and representatives of people of color, there is at least a substantial working class (those who are oppressed within the economic) that one can presuppose as a 'background' to one's cultural negotiations. This is impossible for a Jewish identity politics, since no significant Jewish working class exists outside of the state of Israel (whose struggles against Israeli and international capitalist exploitation would, significantly, have to take on a completely different form from that of the assertion of a Jewish identity, since it would involve a radical split within the Jewish state). This is why Lerner, in *Tikkun*, argues for a politics of meaning that *transcends* classes, that is, that can be based upon a moral critique of contemporary American society.[1] In other words, postmodern civil society cannot exclude the Jews – it has no basis for denying the legitimacy of Jewish identity as a negotiating position on the postmodern exchange – but in including them, it necessarily exposes itself as a fundamentally petit-bourgeois politics, interested in the terms of inheritance of the cultural capital 'freed' by the cultural reorganizations of the post-1960s period and therefore directly interested in suppressing a global class theoretics.

Jonathan Boyarin, in his *Storm from Paradise: The Politics of Jewish Memory*, sues for entrance not, as Lerner does (by way of a cultural essentialism), into activist politics and multiculturalism; rather, Boyarin advances a Jewish 'post' identity (i.e., discursively constructed, and therefore fluid and unstable) more appropriate for the academic regime of postmodern theory. Boyarin, an ethnographer, argues for the significance of the intersection of 'Jewish practices' (p. xi) and postmodernism and cultural studies. On the one hand, Boyarin argues against the 'exclusion' of Jewish voices from these discourses:

> [M]ost generally, what I find 'unacceptable' in cultural studies is the suppression of an autonomous Jewish voice, no matter where that suppression may come from. That suppression should be a concern not only to Jews, for it leaves larger blind spots – some of which I hope to expose in these pages – in the articulation of theory and history, thus pointing as well to some unexpected 'possibilities of saying and doing otherwise'.
>
> (p. xix)

Thus, both Jews and cultural studies have an interest in extending the chain of 'inclusion' to Jews. This further requires that Boyarin assert his 'living Jewish voice' against the allegorization and abstraction of 'the Jew' in postmodern theoretical writing, as well as maintain the properly postmodern character of his own writing:

'to help guard me against an objectivized arrogation of the female or postcolonial other in my theory building' (p. xiv). Boyarin, then, identifies his writing as an amalgam of 'theory' and 'experience': '[A]s in much feminist anthropology, then, ethnography for me is a practice that grows out of the material conditions of my life' (p. xii). Rather than the cultural essentialism which characterizes Lerner's positing of a Jewish identity, then, Boyarin opts for an 'unstable' identity ('I never expected to reach a final, stable identity' (p. xiii), which is constructed by 'knitting together patches without obliterating seams' (p. xi), in particular, the 'patches' of 'Jewish practice, anthropological fieldwork, and recent ideas about how to be human at the end of the twentieth century' (p. xi). In this way, the 'fragments' of the past can be articulated in a critical relation to the ongoing 'catastrophe' (p. xvi) of the present, enabling the construction of 'strategic cultural linkages that are chronotopically specific – that is, neither generalized nor eternalized' (p. xviii). Hence, the subtitle of Boyarin's book: 'The politics of Jewish memory'.

In other words, Boyarin is arguing for a non-essentialized, destabilized cultural identity for Jews which will enable their inclusion within an academic postmodern identity politics. His argument also points to the terms of inclusion: 'our' respective theories stop at the point at which identities are 'asserted', with 'theory' thus becoming a contractual agreement regarding the distribution of cultural capital. The political limits of this agreement emerge especially forcefully when this Jewish post-identity (an identity which self-reflexively recognizes itself as 'socialized' within the regime of postmodern theory which articulates identities as a differential series) is confronted with the pressures of contending social forces, which cannot be negotiated away, such as those concentrated in Israel/Palestine, or imperialist relations. Pressured by a critique by Edward Said of his and his brother's earlier argument that Palestinians had an obligation to incorporate into their politics an understanding of Jewish anxieties,[2] Boyarin attempts to respond in *Storm from Paradise* with a more developed position on the question. He wants, Boyarin asserts, 'to take the *intifada* as an opportunity to question the strategy – hegemonic in post-World War Two Jewish discourse – of grounding Jewish identity primarily in a territory "we" control (not, for most Jews, even a space "we" live in!), rather than in our nuanced collective memory' (p. 118). Hence, the 'politics of memory' Boyarin proposes can operate as a critique of the essentialized Jewish identity advanced by Zionism.

But Boyarin's critique is not of Zionism as such ('[I]t seems almost gratuitous to state that my point is not to dismantle the state of Israel' (p. 118)), but rather of an Israeli state which, 'once established, is implicitly understood by its own elites as a *static* reality dependent on functional equilibrium.' In this case, 'a threat to any of its parts (including its self-generated history) is a threat to its very existence' (p. 118). In other words, Boyarin is arguing for more 'flexible' Zionist élites, who are capable of modifying an essentialized and territorialized Jewish identity and giving up 'some of its parts' (first of all Gaza and Jericho?). 'Ultimately,' Boyarin declares, 'I am in favor of the "no-state" solution. The problem is, I also grant to Israelis and Palestinians the right to self-determination, and neither is willing to give up claims to a state right now' (p. 126). In his attempt to argue for a more flexible Jewish identity, Boyarin works to deconstruct the essentialized identities of Jew and Palestinian; however, in doing so, he also seeks to escape from the antagonistic site altogether, like Lerner taking refuge in historical relativism (what the Jews did in Palestine was no different from the general European project of nation formation) and moral balancing (insofar as a Palestinian critic like Edward Said is 'caught up in the rhetoric of "organic nationhood",' he is himself reproducing the Eurocentric

ideology 'that he would certainly abhor in Zionist, let alone direct European great power imperialist, contexts' (p. 119)). Thus, Palestinian and Israeli claims can be placed, at least from an overarching 'historical' standpoint, in a relation of moral equivalence, and the critic can register his judgement and stake out a 'negotiating' position without being obliged to explicitly take sides in the struggles actually being waged now.

This project of multiplying cultural identities so that historical antagonisms can be dispersed and even dissipated conforms to Boyarin's understanding of contemporary global politics. He argues that Jews can be seen as paradigmatic of the general diasporic condition of postmodernity. This new role for Jews within the global division of labor, though, is predicated upon the separation of 'cultural identities' from economic processes which bring various 'others' into interdependent and unequal relations with one another. The 'equitable distribution of access to discourse' (p. 115), or 'cultural autonomy', in this case, presupposes economic heteronomy. Contrary to Boyarin's assertions, then, the kind of 'common purpose' he suggests for Jews does strikingly resemble the role of 'cultural and economic broker' (p. 129) (middleman) that both Lerner and Boyarin identify as historically linked to the oppression of Jews. In other words, Boyarin's proposals offer an identity for Jews insofar as they occupy that site which can contribute to the blunting of antagonisms and the imaginary resolution of social contradictions. Since this role of mediating and containing global contradictions is that adopted by postmodern cultural studies (by displacing economic contradictions on to negotiations between experientially differentiated cultural identities), Boyarin's formulation of the Jews as brokers among brokers as their 'ticket of entrance' into these practices is well founded. This role as 'broker', moreover, is likely to become more attractive to those determining the structure of Jewish discourse, especially if, as appears likely, we are witnessing a gradual 'de-Zionization' of Israel and a de-essentialization of Jewish discourse in general. The function of advocate for this role is going to be especially attractive to those academic intellectual Jews situated in relation to 'advanced' theoretical discourses – who can enable other Jews to 'catch up' to the multiculturalization of the mainstream – and who are themselves compelled to re-situate themselves in relation to 'theory' in the Humanities and Social Sciences. However, this simply means that the positions of Jews will once again be determined by the competition between the outmoded and emergent sections of the middle class, and the antagonisms between the middle and working classes (management and labor).

Lerner's and Boyarin's responses to the crisis in the Jewish mainstream (a refraction of the crisis of welfare state liberalism) involve attempts to occupy spaces within the emergent (post) liberal pluralized mainstream constituted by cultural identities engaged in negotiations (over the distribution of available institutional places). In at least one regard, Marc Ellis's *Beyond Innocence and Redemption: Confronting the Holocaust and Israeli Power* is a very different kind of book from both Boyarin's and Lerner's. It is much more unequivocal in advocating a progressive political position for Jews, eschewing the historical relativism, theoretical eclecticism and questionable moral bookkeeping so prominent in Lerner's and Boyarin's arguments. Ellis's book, which develops in substantial ways arguments he had already outlined in *Toward a Jewish Liberation Theology*, is especially refreshing insofar as in it Ellis responds to the Palestinian *intifada* by radicalizing his earlier positions, rather than by expressing 'discomfort'. Ellis's book accomplishes three things. First, it offers a sustained critique of what Ellis calls 'Holocaust theology', which is predicated upon the epochal significance of the Holocaust and the

foundation of the state of Israel for contemporary Jewish life and thought. As Ellis explains, Holocaust theology, as developed by figures such as Rabbi Irving Greenberg, Emil Fackenheim, and Elie Wiesel, articulates a seamless and essentialist historical narrative linking the Holocaust (the Jews as powerless victim – the 'innocence' of Ellis's title) and the formation of the Jewish state (reflecting the empowerment, or 'redemption' of Jews) in a quasi-teleological manner so as to legitimate the increasingly (neo)conservative and pragmatist accommodation to existing power relations on the part of representatives of the Jewish community. Second, it draws upon Christian liberation theology's own response to the Holocaust, which has argued that the only viable place for Christians in the post-Holocaust era is with the victims of Auschwitz. Ellis advances a persuasive argument that in the era of Jewish empowerment, the place for Jews is with the victims of that empowerment (the Palestinians). Third, Ellis identifies a powerful and yet suppressed tradition of Jewish dissent (both from dominant trends within Judaism and within the culture as a whole), represented by figures such as Martin Buber and Hannah Arendt, and advocates the recovery and resumption of this position (which Ellis, following Arendt, terms the 'conscious pariah') as a model for a progressive Jewish politics today.

However, while Ellis, unlike Lerner and Boyarin, is willing to state unequivocally that '[W]hat Jews have done to the Palestinians since the establishment of the state of Israel in 1948 is wrong' and that '[i]t is only in the confrontation with state power in Israel that Jews can move beyond being victim or oppressor' (p. xv), he is still careful to qualify these remarks with the assertion that the 'task of Jewish theology is to establish a new relationship to the State of Israel rather than to challenge its legitimacy' (p. xv). The contradiction inherent in a 'confrontation with state power' that defers from 'challenging its legitimacy' follows from the paucity, in Ellis's argument, of any materialist theorization of the conditions of possibility of transformation, either in Israel or among American Jews. So, his call for introducing a critical 'boundary position' (p. 174) into contemporary discursive and political exchanges between peoples and between the religious and the secular, seems restricted to the end of creating a greater range of sympathies, and even that among theologically defined communities. Also, critical thought is seen as emerging through a 'dialogue with our former enemies, Western Christians, and our present "enemies", Palestinians', and as 'provid[ing] an avenue for healing and repentance so crucial to the emergence of critical thought' (p. 177), rather than as a result of material contradictions. Finally, critical thought is given an autonomous – independent, that is, of its connections with social conflicts and collective agencies – capacity to produce material effects: for example, it 'may push the state of Israel to do what states are loath to do – act beyond their perceived and often enshrined interests' (p. 188). In other words, Ellis's often quite radical proposals always remain on the level of discursive transformations, moral discourse, and theological thought. As in postmodern cultural studies, the negotiations Ellis proposes remain within the (post)disciplinary community of identities (in this case, liberation theology) engaged in up-dating mainstream academic discourses: the connection to broader material interests and possibilities is never made.

This is of crucial importance even for Ellis's project of reviving the 'hidden tradition' of dissent he finds so useful, since one aspect of the thought of, at least, Hannah Arendt, and an earlier figure like Bernard Lazare, that has been most systematically suppressed by the hegemony of Holocaust theology is the inquiry into the complex and often contradictory interests which situate Jews in relation to other classes and peoples. Ellis's notion of 'empowerment', of course, does hint at the dra-

matic transformation in 'Jewish interests' following the Second World War and the transformation of Jews into a predominantly middle-class population in the US and a settler colonial population in Israel. However, Ellis never examines this transformation too closely, or asks whether it contains any difficulties for the confrontation of 'empowerment' with critical thought that he urges. Thus, rather than developing a radical Jewish politics out of a theoretical analysis of these conditions, he develops a critique of empowerment which ultimately addresses some of its uses and abuses, and the discourses which protect it, rather than its structural social and economic supports.

This also accounts for the almost complete absence, in Ellis's argument, of the questions of nationality and ethnicity which have been so central to Jewish discourses since the Enlightenment. Ellis does argue that

> [t]he reality is that Jews are connected together, though in ways different than the command of state loyalty in the name of religion. That part of the literature of dissent that argues the sense of peoplehood as false, stressing primary loyalty to the state the Jew lives in – for example the classic Reform dissent of Elmer Berger – is ultimately superficial as a way of opposing Zionism.

(p. 162)

Ellis is here suggesting that the Jews constitute some kind of 'people', or community, who have common interests and ends even when living within different national states. However, he doesn't get beyond a theological answer to this question, that draws upon the 'hidden tradition' to argue for a concept of Jewish particularity as witness in history. But this conclusion neglects the need to address one of the central supports of Holocaust theology and the politics it represents: the obsessive concern with assimilation (as a question of 'survival' – i.e., the protection of concrete material interests), expressed, in both Israel and the US, by the equally obsessive fixation upon demographics as the definitive sign of the Jewish people's well-being and future prospects. (In Israel, the obsession is with Arab birth rates; in the US, with 'intermarriage' rates). This obsession, I would argue, represents what Lenin (1974) called the 'reverential awe of the rear aspect' of Jewry, which 'clamors against assimilation' (p. 110) and produces the insertion of Jews into the middle-class/caste positions described by Lerner: that is, by protecting their own specificity, Jews simultaneously are compelled to protect the entire regime of specificity (private property) from irreconcilable conflicts and contradictions.

Ammiel Alcalay's *After Jews and Arabs: Remaking Levantine Culture* explicitly situates the 'Jewish Question' within the framework of (post)colonial theory, extending Edward Said's critique of Orientalism, and of Zionism as a particularly urgent instance of 'practical Orientalism', though an inquiry into the cultural articulations produced by the confrontation between Orientalism and its others. Alcalay, by advancing a critique of the Orientalism of dominant (Western) Jewish discourses, places on the agenda the question of racism practiced by Ashkenazi Jews against Middle Eastern Jews, which Lerner, Boyarin and Ellis completely neglect. This question problematizes the entire attempt at arriving at even a de-stabilized Jewish identity, because it foregrounds the contradictions between what hegemonic discourses in both Israel and the US consider 'Jewish identity' and the position of those Israeli Jews who have historically been oppressed with the aid of precisely that identity (which requires, among other things, that they no longer see themselves as 'Arab', i.e., as intimately connected to the cultures they have participated in for the past millennium (p. 51)).

Alcalay addresses the conditions of possibility of a post-Zionist Israeli culture in relation, in particular, to the cultural status of Israel's 'Arab Jews' and the profound links between Middle Eastern Arab and Jewish cultures. He argues that a description and recovery of the cultural linkages, that, in Arabic culture, have made 'Jew' and 'Arab' non-exclusive terms, is a useful way of combating what he refers to as the 'neomodern' (p. 232) Israeli culture which is predicated upon their mutual exclusion and essential antagonism. This leads to some extremely provocative analyses of alternative political directions that were available to the Zionist movement in Palestine and useful analyses of the direction taken by Israeli politics and culture in recent years, for example, the emerging challenge by 'Sephardic' intellectuals to the cultural center. Alcalay advances what could be described as a dialectical analysis of the geo-problematics of the 'Middle East' insofar as he sees the very processes which result from the realization and exacerbation of Israeli/Arab antagonisms as creating the condition of possibility for a radical transformation of social and cultural relations in the region:

> [m]any realities and realizations (a growing awareness of Israel/Palestine as the country of the people living in it, rather than some ever-expanding 'home' for all Jews; the progressive re-localization of the Arab-Israeli conflict and its dwindling significance on the international agenda; an altered Israeli economy relying more on an internally colonized local Arab market than on the undated blank check of American aid), have all contributed to the creation of a potential for one of those 'significant cleavages in history where a cut will separate different types of happening.' This cut (a truer rapprochement between Israelis and Palestinians and the Levantine and Arab worlds that could turn the potential into the actual, reconnect old and familiar routes, and realign the cultural constellations of the region) has little to do with current 'official' discourse. Despite the bleakness of the present climate . . . the very desperation involved serves as an indication of precisely how high the stakes are.
>
> (p. 110)

This analysis of the possibilities of transformation emerging precisely out of the intensification of antagonisms, though, is grounded more in categories of cultural analysis, like those addressing the transformation of 'modernity' into 'post-modernity', than in any sustained economic or social theorization of these possibilities – in other words, it is an idealist rather than a materialist dialectic. That is, how will the 'New Levant', as a 'space that can propose new models for a world rapidly losing sight of the dependence of each part upon every other part' (p. 281) contribute to the production of political practices which address in a progressive way the 're-localization' of the Arab-Israeli conflict, especially since this process, and the 'interdependencies' it foregrounds, are every bit as likely to aggravate and deepen, rather than alleviate the conflict. The problem here is that Alcalay understands the process by which the Israeli/Arab conflict took shape and intensified as an instance of the installation of the regime of modernity in opposition to pre-modern cultural articulations. For example, Alcalay argues that it was the collision between Jewish and Arab nationalisms which allowed the more 'unofficial' connections and intersections between Jewish and Arab cultures to be suppressed by 'modern' regimes interested in a 'homogeneous' national population (p. 91).

Alcalay's argument thus depends upon a binary opposition between 'official' discourse and culture, such as that of the state and related institutions, which is seen as externally imposed (by colonialism, Zionism, or new ruling classes within the Arab world), and more complex and variegated cultural articulations between

peoples, which resist these impositions. Alcalay contrasts the more immediate and reciprocal relations of the communal and experiential to the presumably more abstract and alienating relations of the 'national', while at the same time implying the impossibility of ever completely obliterating the former set of relations. This leads to a postmodern politics of difference in which subversion is understood in terms of the 'disruption' of dominant regimes of meaning rather than dominant power or property relations, as becomes even clearer in Alcalay's claim that

> [i]n a world governed by 'indeterminacy and the code,' words and sites become whatever one invests in them. It is up to the reader, the 'seer,' to declassify the material, renegotiate the signs and produce intelligible and defensible meaning. Ideologies of power, on the other hand, assure secure returns by suppressing, denying, or co-opting the ambiguities and particulars of experience that stand in contradiction to the ideology.
>
> (p. 59)

The lines of political struggle drawn here are not between classes and nations, but rather between 'ideologies of power' (which classify, exclude, and suppress experience), and the particulars of experience as rearticulated through narrativized memory, an 'excess' which cannot be contained within the ideologies of power which seek to control or extirpate it. This is why, for Alcalay, the accumulation and concentration of antagonisms in the current Middle East situation can be transformed into a rearticulated series of reciprocally sustaining differences without any decisive actual resolution of the material oppositions along class and national lines: that is, through the 'complexification' and dispersion of antagonisms rather than through oppositional concentrations of social forces. In fact, a cultural re-ordering of the Middle East of the type indicated in Alcalay's title would be possible only through a supersession of the Jew/Arab antagonism by way of a class struggle which would unite Jewish (mostly of Arabic origin) and Arab workers and which will be made possible by the regionalization of the Middle East as a site of transnational capitalist exploitation (as Israeli élitists like Shimon Peres hope for). According to the postmodern logic of Alcalay's argument, though, any such resolution (involving a revolution which would produce and mobilize historically new collective agencies for the purpose of overthrowing a state) could only be the result of the hegemony of one or another 'ideology of power' which denies the particulars of experience in favor of the *concepts* that any revolutionary movement requires. This is why, I would argue, Alcalay's text cannot really enable us to understand the contradictory possibilities that are emerging out of the processes his text is responding to and to some degree accurately describing: the crisis in the respective national projects which have defined the region since 1948, as a result of their own internal class contradictions and the ongoing 'liberalization' of global economic, political and cultural relations (rather than the 'exhaustion' of modernity). Alcalay's argument, that is, tries to facilitate this process, to make it 'smoother' by displacing it on to cultural negotiations, rather than seize upon its contradictions to advance a collective political project.

In fact, what Alcalay's book evades, along with those of Lerner, Boyarin, and Ellis, is the problem of the Jewish Question as a national question. This is a consequence of the project all these texts share: the insertion of 'Jewishness' as a recognized 'identity' within the framework of postmodern identity politics (and its various theoretical and institutional levels), which requires that it can be defined culturally and discursively. However, the national question can only be avoided as

long as one refuses to situate 'Jewish identity' within a materialist framework which addresses the actual conflicts and alignments which derive from the positions of Jews within existing economic, social, and cultural divisions of labor. In addition, I would argue that it is precisely the problematic status of the category of 'nationality' when applied to Jews (as a quasi nation within a nation, a civil society in permanent crisis located within the crisis of civil society) that enables Jews to arrive at a revolutionary position through a critique of Jewish identity and Judaism. That is, the process of assimilation, coupled within the internal fragmentation of the Jewish 'people-class' under the pressure of capitalist (post)modernity aligns the ultimately unassimilable Jew (unassimilable because fixed within the capitalist division of labor) with the revolutionary vanguard interested in abolishing the present division of labor – and which therefore no longer wishes to idealize or theologize 'civil society'. It is in this sense that the Jewish condition is symptomatic of the contradictions of (post)modern civil society, organized through the bloc of the semi-assimilated (to the new order of global capitalism) (post)colonial petit-bourgeoisie engaged in establishing a 'cultural contract' which defers the necessity of class struggle by seeking to micro-manage it at its margins. The critique of 'Jewish identity' is thus a critique of identity politics (civil society) as such, aimed at the production of a revolutionary vanguard interested in exposing and explaining the opposition between cultural emancipation (of the middle classes) and economic emancipation (of the exploited working class) and thereby capable of taking up a proletarian position within theory – which should be the project of cultural studies.

Notes

1 See Lerner (1992b: 9):

> The Democrats need to forge an alliance between the interests of middle-income people and the interests of the poor. But this can't be an economic alliance *only*, because the needs of middle-income people are *also* 'meaning' needs. In fact, the only way middle-income people will ever be willing to provide massive support for the poor is if they come to understand that doing so is in their interests. The Left can help people understand that what they want and need can best be served by building a society based on a principle of mutual caring and ethical seriousness. In making the case for a commitment not just to self-interest but to the disadvantaged as well, we advance the interests of the poor and those who are still victims of racial and sexual discrimination, oppression, and harassment. Moreover, poor and oppressed people face the same crisis in meaning as everyone else.

The class basis of a 'politics of meaning' is expressed here with complete clarity; what needs to be further clarified are the political consequences of potential and actual conflicts between the 'self' interest and 'meaning' interest of 'middle-income people'. Or, more problematically, what if their 'meaning' interests are, in the end, merely transmutations of their 'self' interest, which requires, among other things, as both the Clinton Administration and the *Tikkun* 'Platform for a Politics of Meaning' suggest that the poor show its own 'ethical seriousness' (willingness to 'work hard', to demonstrate 'responsibility', etc.) before they are deemed worthy of 'massive support'?

2 See Edward Said (1985); Robert J. Griffen (1989); Daniel Boyarin and Jonathan Boyarin (1989); Said (1989).

References

Alcalay, Ammiel (1993) *After Jews and Arabs: Remaking Levantine Culture*, Minneapolis: University of Minnesota Press.

Besser, James (1993) 'Opportunity of peace accord will also create new challenges for organized Jewish community', *Syracuse Jewish Observer*, 16(1): 15.

Boyarin, Jonathan (1992) *Storm from Paradise: The Politics of Jewish Memory*, Minneapolis: Univeristy of Minnesota Press.

Boyarin, Daniel and Boyarin, Jonathan (1989) 'Toward a dialogue with Edward Said', *Critical Inquiry*, 15(3): 626–33.

Ellis, Marc H. (1989) *Toward a Jewish Theology of Liberation: The Uprising and the Future*, Maryknoll, NY: Orbis.

—— (1990) *Beyond Innocence and Redemption: Confronting the Holocaust and Israeli Power*, San Francisco: Harper & Row.

Fiske, John (1992) 'Cultural Studies and the culture of everyday life', in Grossberg, Nelson and Treichler (1992): 154–73.

Fraser, Nancy (1990) 'Rethinking the public sphere: a contribution to the critique of actually existing democracy', *Social Text* 25/26: 56–80.

Griffin, Robert J. (1989) 'Ideology and misrepresentation: a response to Edward Said', *Critical Inquiry*, 15(3): 611–25.

Grossberg, Lawrence, Nelson, Cary and Treichler, Paula (1992) *Cultural Studies*, New York: Routledge.

Lenin, V. I. (1974) *Lenin on the Jewish Question*, edited by Hyman Lumer, New York: International Publishers.

Leon, Abram (1970) *The Jewish Question: A Marxist Interpretation*, New York: Pathfinder.

Lerner, Michael (1992a) *The Socialism of Fools: Anti-Semitism on the Left*, Oakland: Tikkun Books.

—— (1992b) 'Can the Democrats be stopped from blowing it again?', *Tikkun*, 7(4): 7–10.

Mercer, Kobena (1992) ' "1968": Periodizing postmodern politics and identity', in Grossberg, Nelson and Treichler (1992): 424–49.

Said, Edward (1985) 'An ideology of difference', *Critical Inquiry*, 15(3): 33–58.

—— (1989) 'Response', *Critical Inquiry* 15(3): 634–46.

Tikkun (1992) 'Platform for a "politics of meaning" ', 7(4): 11–23.

It's a rotten, crooked business, but it can't kill the music
Stephen Hartnett

■ Anthony DeCurtis (ed.), *Present Tense: Rock & Roll and Culture* (Durham: Duke University Press, 1992), 317 pp., index, ISBN 0-822-31265-4 $15.95 Pbk, ISBN 0-822-31261-1 $39.95 Hbk

'Rock & Roll is both fully woven into the fabric of the American corporate structure and endlessly the subject of efforts to censor its rebellious, anarchic impulses.' This claim, made by Anthony DeCurtis in his editor's preface to *Present Tense*, highlights two of the most obvious and extreme poles of possibility within 'rock & roll and culture'. The devastating paradox within these two movements, however, oscillating between commercial neutralization on the one hand and rock's 'anarchy'

on the other, is that so much of what DeCurtis calls the 'effort to censor' rock & roll actually occurs at the hands of rock's corporate structure. Indeed, the major labels, magazines, and radio gurus – under the pressure of what is perceived as market-driven 'realities' – act as little more than fashion factories that incorporate, streamline, homogenize, and then make billions of dollars off of rock's rebels of the season. The remarkable speed with which 'grunge' flew from Seattle's grassroots scene to worldwide MTV super-stardom to the latest line of mall-fashion pre-ripped flannels is testament to this process, as the specter of commodity fetishism appears ever more inescapable for even the most well-intentioned musicians. The flipside to this claim, however, is that lurking beneath the voracious monster-world of incorporation, there are grassroots music scenes flourishing across the nation, with fantastic music being made in every imaginable genre. It is therefore absolutely crucial when talking about 'rock & roll and culture' to specify whether one means the grassroots world of clubs, independent studios, rehearsal spaces, and so on, or whether one means the mass-produced corporate labyrinth of stadiums, MTV, and malls.

Readers of *Present Tense* will quickly discover that this collection of fifteen essays concerns itself almost exclusively with the latter, yet even here there is a curious absence: specifically, none of the contributions to *Present Tense* addresses in any detail the question of the political-economy of mass-media music. There are numerous articles in this collection that explore intelligently the semiotics of rock videos, or that attempt to provide heuristic road maps to the development of a specific genre or artist (hence the connect-the-dot history of rap music, or the mandatory and tedious analysis of Springsteen), yet none of the essays actually explores the question of how the political economy of rock & roll functions. On the other hand, *Present Tense* is full of insightful pieces concerning various aspects of the historical development of rock & roll as both an art form and a series of cultural practices, as well as containing two brilliant works of creative writing. Indeed, Paul Evans's stunning fictional vision of rock & roll in 'Los Angeles, 1999', and Jeff Calder's autobiographical 'Observations on life in a rock & roll band' alone make *Present Tense* an important collection. In the following pages I review some of the more interesting pieces in the collection, and provide a personal narrative of my reading of *Present Tense* while on the road with my own struggling rock & roll band.

Thursday, November 2nd

We were scheduled to play at Otto's in DeKalb, Illinois, a town that boasts of Northern Illinois University and the world's most awesome corn seed as its two major claims to fame. The band met at noon to load gear and was on the road by 1:30, cranking northwards on route 65, heading for what would surely be a rewarding gig (we based our assumption on the fact that we had confirmed 'press' in two separate papers and confirmed radio play on the college station; rule #1 is that press isn't a guarantee, but it sure helps). The only problem here was that our transmission decided to fall out; literally, it started to grind and mash and wheeze and before you knew it there we were on the shoulder wondering what the hell went wrong. After a tow job (courtesy of State Farm insurance – all bands must have towing insurance, it's kind of an unwritten law) and an inspection by the guys at Guaranteed Transmissions ('Get it done right the First Time!') we were informed that we were looking at about a $1,000 repair job which, 'at the earliest, might be done tomorrow afternoon'. U-haul was out of rental vans, no one would rent us a truck at a price affordable to anyone who isn't an IMF shyster, and we have too much

gear for all of our friends' borrowed cars strapped together, so there you have it: lotsa press, a nice club, 80 per cent of the door, a warm, glowing afternoon for travelling, and by 5:00 I was home in bed cursing the bastards from Dodge and cracking open *Present Tense*.

The first substantive essay in *Present Tense* is Robert Palmer's 'The Church of the Sonic Guitar,' a loving tribute to the players who have contributed to the construction, sanctification, and continual regeneration of our culture's mania for guitars and guitarists. Palmer constructs a winding history that meanders from the leading players of 'the Southwest's white western swing bands', such as Bob Dunn and Leon McAuliffe, into Texas blues legends T-Bone Walker, Guitar Slim, and Clarence Gatemouth Brown; from early Jazz players such as Charlie Christian into the Chicago sounds of Muddy Waters and St Louis' Ike Turner and Chuck Berry. Palmer also discusses the crucial role played by Sam Phillips, who – along with founding Sun Studios in Memphis in 1953 – was one of the central figures in co-opting the many sounds of Black artists for a mainstream white audience, and the industry's first rock & roll producer to wield power as both artistic director and business manager. The essay is therefore a quick history of the evolution/co-optation of various indigenous regional musical styles into the more homogeneous (and therefore marketable) genre of 'rock & roll'.

I have two problems with Palmer's essay. First, he links the chosen players in a sort of mythical lineage of great men, without explaining in any detail why these players, stylistically, musically, made the impact that they did. Second, it strikes me that a crucial question to ask this essay is 'what about the evil, machismo-pumping demons that haunt this "church"?' I would argue that with the advent of MTV it is almost impossible to think of the guitar without simultaneously addressing the question of how it has become a dominant cultural marker of patriarchy gone hog-wild. Palmer is a highly respected aficionado whose knowledge of the blues in particular is widely recognized, and his tribute to this deserving list of important players is no doubt heartfelt and sincere, yet by not addressing the two problems mentioned above his essay cannot help but add further force to the unfortunate *myth-making* process that has turned the guitar into a strutting, testosterone-laden farce.

It is interesting to note then, that the hollow commercialized swagger that so dominates MTV was initially, in rock's earlier days – when Elvis's gyrations still terrorized parents and censors across the land – part of a raucous upheaval (fueled by an unholy aesthetic alliance between Blacks and poor whites) that the fledgling culture industry and dream police sought either to co-opt or squash. This brings me to Trent Hill's 'The Enemy Within: Censorship in Rock Music in the 1950s', a fascinating examination of two Congressional hearings on the troublesome question of the cultural implications of early rock & roll. Hill explains that the first hearings, in 1958, were ostensibly called to address the inner-workings of the rapidly expanding political-economy of commercial music, particularly the battle between ASCAP and BMI over publishing and distribution rights. The second set of hearings, in 1960, was called to address the question of 'payola', and featured the now famous testimonies of Alan Freed and Dick Clark, perhaps the two most important media figures in promoting early commercial rock & roll to a mass audience. Hill's astute conclusion is that these hearings 'worked, as it were, to bring the music industry from the age of liberal/competitive capitalism into the age of monopoly capitalism.' Within the historical framework of this claim, Hill explains how early rock & rollers – 'the cultural others of the McCarthy era' – were engaged in political, commercial, and aesthetic warfare not only with the conservative dingbats in Congress and the burgeoning lawyers and bankers intent on merchandising their

music, but also with such infamous culture industry goons as Frank Sinatra and Pat Boone. Hill's essay therefore exhibits a refreshing combination of political, economic, and aesthetic savvy that left me hoping that this essay will be expanded into the book length study that the subject deserves.

Much of the force of Hill's essay follows from his rigorous historical perspective, which strives to place aesthetic and cultural activities within a discernible politico-historical milieu. No such attempt to historicize is made in Greil Marcus' 'A corpse in your mouth: adventures of a metaphor, or modern cannibalism', a wickedly playful montage of quotes and images from a wacky cast of culture critics, artists, and performers including Theodor Adorno, the Sex Pistols, Jamie Reid, Guy deBord, Siouxsie and the Banshees, Elvis Costello, and so on. Marcus' central metaphor of 'a corpse in your mouth' revolves around the notion of carrying commodity fetishism and pop stardom to the maniacal level of paying big bucks to munch dead superstars reprocessed in the grisly form of Presleyburgers, or Lennon-burgers, etc. The lurking irony of Marcus' lament, of course, is that such psychotic consumption-at-all-cost is precisely the kind of deranged energy necessary to launch the culture industry's would-be superstars into the stratospheric sales patterns required to sustain global culture-capitalism. One of the many eccentric and oddball quotations cited by Marcus says as much, as the authors of *Starlust: The Secret Fantasies of Fans* quip that: 'It is hardly surprising, when stars offer themselves so lavishly for consumption, that some fans will take the invitation literally.' The point being, of course, that the various steaming corpses in the voracious mouths of the consuming public have been spoon-fed to them with the tacit approval of the very performers who constitute this season's main course.

This is all quite amusing, as far as ironic culture critique metaphors go; the essay thus cannot help but remind the reader of the towering sneer of Adorno, the Marcuse of *One-Dimensional Man,* deBord's theory of the 'spectacle', or even, at its most extreme, the rantings and ravings of late Baudrillard. The problem, however, with both this entire critical tradition and Marcus' essay, is that the dynamics of cultural production (from the artist's standpoint) and consumption (from the fan's standpoint) are much too complex to be reduced to the tired old charge of commodity fetishism gone wild. Indeed, there is a world of particularity that gets lost beneath the knowing laughter of this approach; while the metaphor is unquestionably hilarious and powerfully indicative of the insanity that lies at the heart of mass-market rock & roll, it none the less tells us nothing of how or why this insanity is produced, how critics and fans can engage in popular culture without falling into its trap, or how artists can avoid becoming next season's chosen chow-for-the-masses.

Friday, November 3rd

We got word by mid-morning that the van would be road-ready by 3:00, so, after a morning of re-stringing guitars, xeroxing flyers, making phone calls trying to drum-up promo support for next week's shows, and plowing through a few more essays in *Present Tense*, we were off for the Beat Kitchen. The transmission cost us a cool $1,138 – which no self-respecting independent rock band in the world has lying around – so the drive to Chicago was tainted by the paralyzing realization that we were now in debt for the rest of the imaginable future not only to all of our friends and a handful of lefty arts supporters, but also to one of our lead singers' financially stable sisters. The Beat Kitchen is a wonderful club in Chicago, with an excellent stage, lights, and PA; the management treats musicians like human beings

(which is rare), and the kitchen actually has a few vegetarian choices (which is even more rare), so gigs there are always a treat. We shared the stage with *Las Toallitas*, a remarkable band featuring two percussionists, bass, keys, dueling gypsy/bebop horns, vocals that invariably end up in Greek or Yiddish, and an awesome xylophone player. Our set went extremely well, with the band feeding off of the crowd's dancing and in turn cranking things up to a frenzied pitch; we featured mostly songs from our latest CD, but gladly played requests from our previous albums and eventually left the stage drenched, exhausted, and glowing with the satisfaction of a gig well played. *Las Toallitas* also put on a stunning show, combining elements of rock, blues, jazz, gypsy, Klezmer, and zydeco in a wacky yet driving carnival of exotic sounds and ferocious licks. The cats in *Toallitas* are wonderfully laid-back, easy-to-work-with types, so the end of the night found our two bands loading-out gear together, sharing a beer in the once again quiet and empty club while counting out the night's pay, and collectively reveling in the transcendent post-gig sensation that speaks of artistic freedom, musicians' camaraderie, and a show well played to appreciative listeners. On nights like these there is no doubt, no fear, no debt, no MTV, and no question that being an independent musician is the only worthy calling on the face of the planet.

All of which leads me to Robert Ray's 'Tracking', a series of observations, or 'tracks' if you will, concerning the thesis – via deBord's theory of the 'spectacle' – that 'everything that was directly performed has moved away into a construction, a recording composed of performance's surviving fragments.' Hence, according to Ray, 'where once records hoped only to provide a souvenir of a live performance, concerts now exist to promote records.' There is no doubt that this is the case for those bands whose careers are linked primarily to their status as commodities. For example, Liz Phair's *Exile in Guyville*, an album featuring an artist with *no history of club dates, no touring, no 'following', etc.*, can none the less, due to its getting mega-hyped by damn near every industry outlet imaginable, sell a godzillion units. The 'over-night' sensation of Phair's *Exile* is a perfect example then, of Ray's argument that 'concerts now exist to promote records', for without the commodity/record to push, there would be no reason for Liz Phair concerts (indeed, Phair is outspoken concerning her distaste for performing live).

It seems to me that it could be argued just as convincingly, however – by considering a different set of examples – that performing live is not so much a thing that musicians do in order to promote their records, as one of the central and defining moments of *what musicians do*: we perform live because it is the ultimate test of our abilities, the source of most of our energies, and – if you can live through endless van repairs, truck stop coffee, late nights driving through abandoned lands, and the various trials and tribulations of visiting a different club in a different town every night – one hell of a lot of fun. Now Ray *may* know all of this, as he is a member of *The Vulgar Boatmen*, a damn good band that plays more than its share of gigs around America and Europe; however, the Boatmen are really two bands, one that tours out of Indianapolis, and another that records out of Florida. Ray is part of the 'Florida' contingent and therefore does not tour with the band, instead choosing his stationary role as Professor of English, songwriter, and producer when the band is in the studio. Ray is fully aware of the paradox of this situation, thus commenting that 'having two bands of Vulgar Boatmen enacts the performance/recording dichotomy at the heart of so many debates about contemporary rock & roll.' The point here is that while Ray's observations on the relationship between recording and performing may reflect his own circumstances and one possible set of relations within the industry (in which artists' performances are market-driven

promo-appearances to boost sales), it is simultaneously possible that this relation is actually reversed by a majority of the bands that are out there playing their hearts out and hoping to sell a few independently produced CDs out of the back of their van so as to cover gas expenses for the night. And mind you, it's not that these bands don't want to be hyping monster discs, it's just that they haven't gotten that far in their careers; the point here, however, is not about musicians' *intentions,* but rather, about the actual relationship between their role as performers and their role as salespeople for mass-produced commodities.

The question then, is not so much about performing vs. recording (or, to use Ray's vocabulary, between *the modernity of performance vs. the post-modernity of 'construction'),* as it is about the extent to which one's recordings exist as commodities. This brings me to Michael Jarrett's important essay, 'Concerning the Progress of Rock & Roll', in which Jarrett offers a schematic yet highly useful methodology for analyzing the dialectical process by which performers and styles challenge and/or verify the inescapable commercialization that follows increased popularity. Jarrett's thesis is that there are four dominant moments in this dialectic: 1) *Conventionalization,* the stage in which different styles and players, engaged in competition for 'a cut of the market', attempt to elaborate their 'code' as conventional; 2) *Aberration,* the stage in which the struggle for ascendancy has produced market-driven homogenization of sales-effective sounds and styles. This moment of homogenization has the simultaneous effect, however, of driving innovative artists to greater lengths to attack existent norms and, accordingly, to produce what Jarrett calls 'aberrant' 'mis-readings' of the conventionalized codes. 3) *Disputation,* the stage in which innovators compete with conventionalized codes 'over which musics are and are not innovative, legitimate, authentic, original, etc.', and 4) *Ratification,* the stage in which 'a perceived innovation gains legitimacy by soliciting, gaining, or, in some cases, inventing institutional support.'

The connection here, between Jarrett's four stages of development and my reading of Ray's essay, is that Ray's theory speaks exclusively to those performers whose work has achieved a certain level of 'ratification'. It is a hard-luck reality of rock & roll, however (again, regardless of the intentions of musicians), that for every artist who reaches the sought-after level of ratification, there are another 1,000 artists struggling on the levels of 'conventionalization', 'aberration' and 'disputation'. The importance of Jarrett's method of analysis is that it enables us to recognize clearly that Ray has mistaken *one* moment in the dialectic of an artist's career as indicative of the overall status of 'rock & roll and culture'. Ray's essay therefore reflects the fact that his band has been signed by a major label and has arguably achieved 'ratification', whereas my band is still struggling along with thousands of other bands at the levels of 'conventionalization', 'aberration', and 'disputation'. And mind you, I am not copping an attitude about this in terms of which moment in the dialectic is or isn't 'authentic' or musically creative: I am simply arguing that there are, numerically, thousands of bands in my position for every single band in Ray's 'ratified' position. The importance of Jarrett's essay is that it allows discussion of these categories to proceed *not as value-laden aesthetic judgments, but rather, as descriptive developmental stages* along the arduous path towards popularity (which is, regardless of what they tell you, what every musician either openly or secretly longs for).

Saturday, November 4th

The drive from Chicago to Detroit was a five-hour unguided tour of the rust-belt. We drove through the smoggy shadows of the giant steel mills that tower over the

abandoned neighborhoods of Gary (a city that claims the highest per capita murder rate in America), around the boarded-up factories that ring the crumbling bypass in Toledo, and then on into the eerie, post-apocalyptic never-land of Detroit, where nuclear power plants linger on the horizon, glass towers glitter blindingly from the armed enclave of 'downtown', and mangled, rusted thickets of steel and concrete encircle the bombed-out ghettos. Amidst the decay, nestled amongst the forgotten homes that must have been tributes to 'progress' back in the 1950s, we came upon the fabled 'Cass corridor', a loosely knit neighborhood of artists, poets, squatters, musicians, activists, crackheads, and missionaries. We were scheduled to perform at the Trumbull Theater, a community reclamation project that presents poetry readings, live music, and experimental theater. The organizers were nowhere to be found when we arrived, so half the band napped in the van while the rhythm section played catch in the abandoned lot next to the theater. When we finally got inside the 'theater' we found puddles of rain water on the stage, no PA, and a pre-historic heating unit that probably hadn't worked since the Lions left town for Pontiac.

To make a long story short, we eventually scraped together a PA, salvaged the stage, put on extra layers of long-johns, plastered the room with political papers, had ourselves a swell community dinner of pesto and tea, and had a damn fun show with *Roberto Warren* (a local African poet who brought along five percussionists), *The Blanks* (a Detroit punk band whose drummer doubles as editor for the anarchist mag, *Fifth Estate*), and *The Yell Leaders* (a band from Milwaukee featuring a fantastic female percussionist/vocalist). By the time we took the stage the entire band was bundled in so many clothes that we looked like floats for a rag-tag parade; the audience was forced to dance, however, just to stay warm, so once again the music took over, the strange erotics of sound and dance crept through the hall, and, by the end of the night, it all somehow seemed strangely 'worth it'. I guess the point here is that while everyone involved lost money and caught a cold, we also produced a remarkably multiracial, cross-class, artistic and political smorgasbord that doubled as a playful community meeting space within which to dance, politick, or simply enjoy the company of neighbors. On my better days I would like to believe that such nights foreshadow the kind of grassroots, neighborhood-based organizing and politicking that might somehow allow us to reclaim our culture from the Fortune 500; then again, it would be just as easy to argue that such nights exemplify why the Left is where it is, why professional music promoters and organizers rule the world, and why, first and foremost, I should get the hell out of rock & roll.

The paradox I'm trying to outline here, of the magic of the music taking over and providing a glimmer of transcendence – or at least momentary catharsis – amidst the numbing wreckage of everyday life, is expressed with terrifying brilliance in Paul Evans' 'Los Angeles, 1999'. Evans' contribution to *Present Tense* is its only piece of fiction and, along with Jeff Calder's autobiographical essay to be discussed below, one of the collection's most engaging pieces of reading. Indeed, Evans' story presents a prophetic postmodern apocalypse that is structured, much like Sartre's *The Reprieve* or Robert Altman's films, around shards and fragments of character sketches that slowly interweave, eventually bringing unimagined force to bear on each other's story. Evans' cast includes 'the bad rappers' of Compton scorching the freeways, 'stupid Gary' playing screaming guitar clichés down in the plastic pre-fab hell of the valley suburbs, the tortured alienation of 'Father Diego' in the barrio, 'Lorretta May Brown', an alcoholic would-be star seeking refuge in LA from the slow, creeping rural death of the deep South, and 'Baby Catherine, the first baby born at the end of the world':

No dumb college for Baby Catherine, no sad job for this little sister, no stale gum to chew, no telephone calls, no clothes to buy, no drugs, no therapy, no endless search for love, the search so hard it's like stepping on razors, like bashing your head again and again and again on rock. None of that noise, and Baby knew it. She saw love coming on strong in fireball fury, in a deep and sudden kiss. Just love and love only at the end of the world.

If Baby is the electric seer, the loving foreteller of the end of the world, then the god-head of destruction, the strung-out hyped-up burned-out bringer of the big one is 'Solo Jones', a cancer-ridden DJ whose every selection is 'another bulletin from his percolating soul – one more private fuck-the-programmer's-playlist song for his people'. Solo is one of those forgotten cultural treasures, a living museum stocked with tunes from 'Monk, Trane, St. Louis Armstrong, Johnny Ray, Little Richard, Ronnie Spector, Sweet Gene Vincent, Eddie Cochran,' and so on – i.e., all the spirits and life-givers and tellers of truth whose impassioned sounds rip the bullshit veneer from 'Parents, The ratfuck FCC, Mothers Against Drunk Driving, Advertisers, Radio call-in psychologists, Buttinskis, The Dream Police.'

Evans' essay is brilliant. I imagine that if you read it before the other essays in *Present Tense*, then there simply won't be any reason to read on; if, like me, you read the essays in order (Evans' is the eleventh essay in the book) then don't be sur-prised if the preceding essays seem strangely out of touch by comparison. This is frightening stuff, bold, loud, prophetic and strong – rock & roll as prose. Along with Evans' essay, the other contribution to *Present Tense* that most desperately needs to be assigned as required reading for all rock & roll critics, fans, and per-formers, is Jeff Calder's 'Living by Night in The Land of Opportunity: Observations on Life in a Rock & Roll Band'. You know that you're in for some powerful stuff when you begin Calder's essay by encountering Rule 1: 'under no circumstances should anyone take seriously anything anybody at a record company ever says.' Calder's essay proceeds along this line of thought, as he interweaves biting insights on the power politics of the biz while illustrating each of his points with poignant examples of personal experiences with his band, the Swimming Pool Qs.

The real power of Calder's autobiographical essay is that he explains (in won-derfully sarcastic passages) the seemingly endless hoops through which bands must repeatedly jump if they want to 'make it' to that holy grail level I discussed earlier (via Jarrett's essay) as 'ratification'. The crucial part of this first-hand lesson in the untold nightmare world of rock bands, however, is that Calder reveals the inner workings of the 'industry' for what they are: the clueless bumblings of record company morons whose jobs are determined solely by sales charts, whose egos are larger than the artists they are supposed to represent, and to whom 'displays of humanity are a sign of weakness' and 'being nice is a liability'. The point is that the culture industry, like all other major capitalist industries, is not a tightly knit band of efficient conspirators, but rather, an anarchic labyrinth of chance, inter-depart-mental warfare, and endless patriarchal posturing, with the one constant factor being the assumption that musicians are expendable. Indeed, as Calder describes it, 'nothing makes sense at the record company and the artist is always to blame.' And yet, knowing all of this full well, *musicians continue to make music, bands continue to play live, and listeners continue to find pieces that answer their needs* – and that, for Calder and the rest of us out there making the music every night, is the inex-pressible magic that 'means everything'.

Heavy Metal
Andrew Goodwin

■ Robert Walser, *Running With the Devil: Power, Gender and Madness in Heavy Metal Music* (Hanover & London: Wesleyan University Press, 1993), 222 pp. ISBN 0819562602 $15.95 Pbk

At the heart of Robert Walser's excellent and illuminating book on heavy metal lies a tension about the relationship between pop culture and high culture which has yet to be resolved. This tension, as old as cultural studies itself, is the conflict between text analysis and political economy. For Walser's account, superb in its virtuoso displays on the fret-boards of several different instruments (musicology, semiotics and audience analysis), ultimately argues a position which I find absolutely convincing but also limited in one key respect.

For all the persuasive material here on gender, on video and on the politics of heavy metal, the most riveting section deals with aesthetics. Cultural studies folks are fond of announcing that pop culture is complex; here Walser uses music theory (and his experience as a musician) to demonstrate just how complicated (musically and politically) heavy metal truly is. And in his chapter on 'Eruptions' (named for an Eddie Van Halen guitar piece), Walser makes a claim that is so astounding I did not at first comprehend it. Without being glib, pleased with himself, or arch (this being the manner now of too much pop cult studs) Walser demonstrates that the influence of so-called classical music on heavy metal is so fundamental to the form that we must re-think the development of, say, Bach or Vivaldi, so that the traces of this music might be seen as culminating (for the time being, of course) not in concert hall performances of the 'Brandenburg' Concerto, nor even in the techniques of modernists such as Milton Babbitt; no, instead we should look at the guitar solo on Deep Purple's 'Highway Star', or at the development of the song cycle in the work of Queensrÿche.

To anyone who has listened with open ears to Metallica, Led Zeppelin or Living Colour, this assertion is transparently correct. Indeed, Walser's experience as an accomplished musician (this reviewer has heard him play the trumpet and can vouch for Walser's skills in that department), along with his background in music theory, allow him to make his case for the aesthetic complexity of pop culture more convincingly than anyone else in the field of pop music studies today. Sensibly enough, Walser does not commit the bourgeois sin of claiming that metal can be justified because it is like 'classical' music. His claim, more modest and more radical, is that a relativist aesthetics would allow us to see the similarities between these examples of high culture and pop culture, and in light of that fact begin listening to Bach in a new way.

What is brilliant about this idea is also where its limits are to be found, in my view. Having demonstrated that the myth of high culture is the myth of aesthetic autonomy, and having shown that heavy metal shares many features with high cultural musical forms, Walser then performs a reduction by omission (the missing link being institutional analysis) when he implies that aesthetic form in pop can be understood without looking at the conditions of production. No one should criticize this book (or any other) for not providing the Theory of Everything. *Running With The Devil* is text analysis backed up with historical data and an extremely rich audience survey. It would be childish to demand that Walser also provide a fully worked-out political economy of metal: this book already contributes more to cultural studies than can reasonably be expected. But the problem with this gap is that

we are left with a Postmodern Romanticism, whereby (if you did not know any better) you might assume that the conditions of production which made possible the Berlioz *Symphonie fantastique* in 1830 were still in place when Dave Davies cranked out 'You Really Got Me' in 1964. ('It wasn't called heavy metal when I invented it' was, if memory serves, Davies's grandiose take on that moment, despite claims that Jimmy Page had a hand in developing the sound of the Kinks.) The Kinks song might well parallel some of the sentiments behind Berlioz's efforts to court Harriet Smithson (pop and high culture joined in desire), but formally and at the point of reception, there are clearly some radical differences. That the doctrine of aesthetic autonomy is incorrect (a point made by Adorno and by other members of the Frankfurt School, who are soundly criticized here) does not relieve us of the task of discovering how different moments of relative autonomy actually operate.

Two *lacunae* can be identified here, if we take the view (as I do) that texts do not result purely from a world of discourse. (Walser *knows* that, it's just that his book does not fully take account of this feature of cultural analysis.) The first problem concerns the pressures and limits which contemporary capitalist culture industries place upon musical production. It is now widely recognized that scholars in cultural studies must return to some of the questions asked by political economy. Adorno is blasted throughout this book for his reductionism, élitism and racism; yet his famous analysis of the formal features of the pop song, while out of date now, remains an important element in accounting for how classical music is structured, as compared to pop. That some 'progressive' metal departs from the form of the pop song is important, and can be explained, perhaps, if we turn from aesthetics and think about the national-cultural origins of heavy metal.

This is the second issue I want to raise – why did metal turn out the way it did? Reading Walser's account, it is striking that so many of its creators are British. Whether it is the proximity of a Western classical tradition, the influence of the art-school trained musician or (as I suspect) the domestic media environment in which British record companies once operated, the discourse of heavy metal as a departure from mainstream pop forms (never more obvious than in the music of Led Zeppelin) needs to be explained *institutionally*. Walser lists three albums which 'definitively codified' heavy metal, in 1970: *Led Zeppelin II, Deep Purple In Rock* and Black Sabbath's *Paranoid*. It is no accident, in my view, that each of these acts is British. (My other quibble about Led Zep's place in this book is that Walser's focus on guitar – his other instrument – allows for insufficient attention to rhythm in metal; this leads to a neglect of the essential role played by drummer John Bonham in establishing one aspect of metal coding upon which so many more or less funky utterances have since been based.)

I have picked on the institution-text issue because it seems to me to be one that is in urgent need of further consideration in cultural studies, not only for what it tells us about production, but also for its effects on consumption. Some metal fans can hear 'Highway Star' as if it were a piece of serious music, but not everyone does that – and the reasons for this lie not only in discourse but also in access to cultural capital, in media policy and in the operation of political pressure groups (here Walser's critique of the Parents Music Resource Center is especially useful).

Robert Walser has written a superb book which provides a cogent and convincing account of what heavy metal is and what it is *about*. Everyone involved in the study of popular culture should read his book, which is blessed with clear and engaging prose. Apart from occasional moments in which he drifts into the wrong key (a problem most of us will recognise from our own efforts), Walser sticks to a writing style which is clear and direct. Many 'outsiders' off campus will appreciate

this book. It remains sophisticated not *in spite* of that, but I suspect *because of it*. Cultural studies needs more books like this one.

The local, the global, and the culture of music
Gilbert B. Rodman

■ Susan D. Crafts, Daniel Cavicchi, Charles Keil and the Music in Daily Life Project, *My Music* (Hanover, NH: Wesleyan University Press, 1993), 218 pp. $15.95 ISBN 0819562645 Pbk
■ Mark Slobin, *Subcultural Sounds: Micromusics of the West* (Hanover, NH: Wesleyan University Press, 1993), 127 pp. $14.95 ISBN 0819562610 Pbk

On the surface, *My Music* and *Subcultural Sounds* describe two very different projects: one empirical, the other theoretical; one focusing on what Barthes has described as the 'impossible science of the individual' (quoted in Grossberg, 1988: 386), the other concentrating on 'the big picture' of all the 'little musics' of Euro-America. At the heart of each of these volumes, however, lies a shared assumption concerning the relationship between music and culture, as each starts from the laudable premise that the role of music in contemporary society is far more complex than it has typically been assumed to be: that the social, cultural, and/or political significance of music is not something readily visible (or audible) on the surfaces of its texts, in the nature of its production and distribution, or in the various uses that its audiences make of it. For example, in his foreword to *My Music*, George Lipsitz argues that most of the stories that we tell about why and how music matters are ultimately inadequate accounts of the shape of the musical terrain:

> Expert musicologists, journalists, and social scientists have written many important and interesting works about music, but only rarely have they confronted the complicated and contradictory ways that people use music to make meaning for themselves. . . . Musicologists, journalists, and social scientists all illumine parts of the truth about music, but they have not as yet produced an adequate way of understanding (and theorizing) how interactions among artists, audiences, and apparatuses collectively create the world of musical production, distribution, and reception.
>
> (p. x)

Similarly, in outlining the larger project of *Subcultural Sounds*, Slobin describes music as a constantly shifting, multi-faceted range of phenomena that has too frequently been studied as if it were merely a static body of texts or a rigidly bounded and well-defined set of practices:

> We need to think of music as coming from many places and moving among many levels of today's societies, just as we have learned to think of groups and nations as volatile, mutable social substances rather than as fixed units for instant analysis. . . . There are no 'simple' societies any longer, yet 'complex' is too flat a word to describe the nestings and folding, the cracks and the crannies of the lands of Euro-America. . . . Overall, the music of Euro-America in the 1990s is at least as complicated as that of anyplace on the planet, especially since Euro-America is the place to which much of the rest of the world has moved or longs to migrate.
>
> (pp. x–xi)

What binds these books together (above and beyond the fact that they both belong to Wesleyan University Press's new 'Music/Culture' series) is that each attempts to open up the field of music scholarship – in ways that it generally hasn't been opened up before – to the messy complexities of the circulation and function of music on the contemporary cultural terrain.

Despite their shared commitment to moving beyond reductionist approaches to the study of music, however, these two projects remain markedly dissimilar from one another: so much so that it is tempting to see them as complementary counter-parts to each other, with each book providing a piece of the larger puzzle that the other, because of its quite different focus, cannot supply. *Subcultural Sounds*, for instance, is primarily a theory-driven project that operates at a relatively abstract level of macro-analysis (even though its formal subject is 'micromusics'), and Slobin is ultimately far more concerned with constructing broadly applicable theoretical models[1] of music and culture than he is with analyzing particular facets of specific local musics. While Slobin refers to an incredibly broad spectrum of musical sub-cultures at various points throughout the book (enough so that one can't help but be impressed by his fluency with such a wide range of musics), these brief dips into the real function primarily as illustrative examples supporting the more abstract models that Slobin is trying to build. *My Music*, on the other hand, is a more empir-ically oriented project dedicated to fleshing out the minute details of a tiny corner of the musical terrain: the various ways in which individual members of an urban community (Buffalo, NY) make use of music in their daily lives. While the Music in Daily Life Project (hereinafter referred to as MDLP) doesn't seem to be antago-nistic towards theoretical work on music, the study at hand is far more interested in uncovering and presenting a picture of the real world than in constructing (or applying) abstract of models of that world. Consequently, this volume is devoted almost exclusively to transcribed excerpts from forty-one interviews conducted with Buffalo-area residents on what music is about to them (a brief foreword by Lipsitz and an even briefer introduction and appendix by Charles Keil comprise the entirety of the critical commentary on the study and its findings included here). Taken together, then, the implicit promise of these two books is that *My Music* will provide us with a key to unlocking some of the more perplexing mysteries of 'the local', while *Subcultural Sounds* will help us understand the ways in which the various locals of the world get stitched together to form 'the global'.

In the end, however, only Slobin's volume lives up to its side of this unspoken bargain very well. This is not to say that *Subcultural Sounds* is entirely without flaws. For instance, Slobin repeatedly conflates hegemony and ideology,[2] he flirts with the intentional fallacy school of semiotics (i.e., the meaning of music is deter-mined by those who make it),[3] and his argument overemphasizes the role of musi-cians and music-making in shaping musical subcultures – so much so that audiences and the music industry often appear to be standing somewhere outside the realm of culture looking in at the music-makers who are the real story here. And while Slobin's comments on the music and the people who make it are generally quite sharp, there is still much more to a musical subculture than musicians. After all, though the lines between performers and fans can become exceptionally blurry at times (as in the case of the British punk subculture of the 1970s), even the most mar-ginalized Western micromusic possesses *some* variety of audience: concertgoers; dance-hall patrons; fans who purchase independently distributed tapes, records, and compact discs of local music, and so on. Similarly, while many subcultural musics deliberately and explicitly reject the commercial trappings of 'mainstream' music, few (if any) Euro-American micromusics can be said to exist completely

outside the sphere of influence of either that mainstream or the industry that keeps it alive.[4] Slobin's book doesn't actively deny the relevance or usefulness of questions of audiences and industry, but his own silence on the crucial roles that fans and institutions play in the formation and maintenance of local musical cultures leaves an otherwise very strong argument noticeably vulnerable on some crucial points.

Overall, however, the strengths of Slobin's project compensate for its weaknesses very well . . . though for some readers, one of *Subcultural Sounds*' greatest strengths might be seen to be its most fatal flaw. More specifically, Slobin's book raises far more questions than it answers, and thus it 'fails' to provide more than the sketchiest of frameworks from which we might better come to grips with the tangled network of Euro-America's thousands of local musics. To dismiss this book on the grounds that it isn't the definitive text on what a 'new and improved' ethnomusicology or popular music studies might look like, however, is to do Slobin and his project a gross disservice. Slobin doesn't pretend to have solutions for all of the theoretical and methodological problems that he poses (in fact, providing adequate answers to even a fraction of these questions would be a formidable task for a multi-volume encyclopedia on micromusics), but this slim treatise delivers more than admirably on the relatively modest promises that it does make, insofar as it provides an insightful, provocative, and – by Slobin's own admission – preliminary set of guidelines for future scholarly work on the relationship between music and culture. While *Subcultural Sounds* may be short on answers, it asks all the right questions, which makes it a far more valuable resource than an entire shelf of books that answer all the wrong questions in extensive detail.

Perhaps the central question that drives this book forward is the thorny (and all too frequently overlooked) problem of *culture*. How do we recognize a culture – particularly a subculture – when we come across one? What are its defining features? What (if anything) distinguishes a local culture from a mere scene? How do we identify (or perhaps construct) boundaries between 'neighboring' cultures? How should we think about the interplay that inevitably takes place between different cultures? And so on. Though Slobin's primary focus here is music, and consequently the main audience for his book will probably be scholars working in the fields of ethnomusicology and popular music studies, *Subcultural Sounds* is also a potentially valuable resource for cultural studies researchers whose objects of study don't include music. In particular, Slobin's extended discussion of the categories of 'superculture', 'subculture', and 'interculture' provides a useful way of thinking about a broad range of cultural phenomena – from literature to television, from fashion to social customs – and the various ways that local and/or minor[5] inflections of these phenomena relate to and interact with mainstream culture.

My Music, on the other hand, is not at all likely to be taken up by non-musically-oriented scholars – and, in the long run, its value even to critics concerned with music is somewhat limited. To be sure, this collection of interviews picks up some of the slack left over by Slobin's 'musician-centric' account, insofar as it focuses exclusively on the uses that 'ordinary people' make of music in their daily lives. Moreover, the MDLP manages to offer some interesting insights on the question of how people choose and use the music that they do, as the accumulated data reproduced in *My Music* provides strong evidence against the commonsense idea that musical tastes fall into readily predictable patterns of taste (e.g. the stereotype-laden notion that if you're a member of demographic group X, you're likely to enjoy music Y and hate music Z; or that if you're a fan of music A, you probably also like music B, but couldn't care less about music C, etc.). Thus, within these pages, we find such supposedly unlikely characters as Abby (pp. 85–9), whose musical tastes

simultaneously encompass the likes of Elvis Costello, early (i.e., pre-soul) Aretha Franklin, and Ghanian high life music; Edwardo (pp. 52–3), a fan of 'classic' rock who listens to rap when away from his rock-centered peer group; and May (pp. 54–60), a classical music aficionado who also enjoys new wave music and happily hums television theme songs (e.g. *The Flintstones, My Three Sons*) to get her through the day. Similarly, the interviews published here demonstrate that the uses different people make of music in their daily lives are at least as varied and unpredictable as their tastes: people use music to reinforce their moods *and* to alter those moods, to define themselves as unique individuals *and* to blend in with their peers, as background music that requires little conscious attention *and* as a focal point of activity that precludes the possibility of all other activities, and in any number of other seemingly contradictory ways.

One of the main problems with *My Music*, however, is that, in paying so much attention to individuals, it misses its own point concerning the complex *social* functions of music. Lipsitz's foreword to the book begins with an insightful discussion of music as a social practice[6] that, oddly enough, is not reflected at all in the body of the larger project (except on those relatively rare occasions when interviewees raise the subject themselves). So while it's not altogether surprising that, in his introduction, Charles Keil expresses concern that 'all these headphoned people [are] alienated, enjoying mediated "my music" at the expense of a live and more spontaneous "our music"' (p. 3), the real problem here seems to be that the MDLP focuses exclusively on *individual* uses of music, rather than on how people are using music to alienate themselves from one another. Having based their entire project on one-on-one interviews with individuals who don't know one another (at least not as far as one can tell from this account) on the question of their idiosyncratic relationship to music (i.e., 'what does music mean to you?'), it would have been highly surprising if the MDLP had found out anything of significance about the social role of music. In fact, it might have made for a more interesting study if the MDLP had interviewed already existing social groups (e.g. family units, bands, musical ensembles, high school classes, sets of housemates, etc.) – both as groups and as individuals – about their musical tastes and practices and then attempted to map out the complex relationships between individual and social uses of music. Methodologically speaking, this would undoubtedly have resulted in a much more difficult and unwieldy project than the one presented here, but such a study would also have been more useful in addressing questions of 'the social' and 'the cultural', instead of being able to speak only about 'the individual'.

Even more problematic than its too-narrow focus, however, is the fact that *My Music* is ultimately little more than a collection of data in desperate need of some sort of broader analytic framework. A footnote in the book's appendix (i.e., a comment in the margins of the book's margins) reveals that, at one point during the study, the authors had intended to include a selection of critical essays commenting on the interviews. Unfortunately, however, this plan was eventually abandoned, as one of the MDLP's goals was to get beyond what critics and scholars had to say about music (a discourse that, presumably, can no longer tell us anything new or worthwhile) and let these 'ordinary people' speak for themselves:

> We hope this book will find its place on the still small shelf of books where people not ordinarily heard from get to have their say at last. Music critics, experts, commentators, authorities, all hope (or make believe) that they know who they are writing for and why. Well, here is what some people out there have to say for themselves.

<div align="right">(p. 3)</div>

The problem with this argument (which comes at the very end of Keil's introduction), however, is that the people interviewed for *My Music* ultimately don't – and *can't* – speak for themselves . . . at least not within the pages of this volume, as the far-from-invisible hand of the MDLP editorial team intrudes upon (and interferes with) what these people have to say in obvious and problematic ways throughout the book. For instance, the raw tapes of the interviews needed to be transcribed (with an unavoidable loss of various non-textual nuances – context, facial expression, tone of voice, etc.), then the transcripts had to be trimmed to a usable length (a process that presumably left large chunks of data on the cutting-room floor), and finally the edited texts were resituated in the alien context of the finished book (where the themes raised in one interview suddenly resonated in new and different ways because of their juxtaposition with other interviews). At one level, of course, these are the sorts of problems with representing the ethnographic Other that all researchers collecting data from and about 'ordinary people' have to face and, as such, they are potentially excusable. The problem here, however, is not simply that the book's editors helped to shape the ways in which these people could be heard to speak – after all, other studies of 'ordinary people' work around such difficulties all the time – but that the MDLP is completely lacking in self-reflexivity about their role in speaking for their subjects. Instead of acknowledging the impossibility of (re)presenting other people's thoughts without distortion (and, in doing so, perhaps providing some clues as to how we might be able to compensate for those distortions as we read), the MDLP assumes that they have provided their readers with unmediated (and thus, presumably, uncontaminated) access to the thoughts and ideas of the individuals they've interviewed.

Even if one is willing to treat these very 'cooked' interviews as if they were accurate reflections of the real world, the MDLP simply doesn't provide enough information about these 'ordinary people' for readers to come to any conclusions of their own that aren't limited to the highly localized level of the individual people interviewed here. A handful of the book's interviews are preceded by factoid-ish blurbs that provide a few demographic and biographical details about the interviewees, and the transcripts themselves occasionally contain additional clues as to who these people are when they aren't busy being research subjects for the MDLP, but this sort of information appears too infrequently and inconsistently to make any broader social or cultural patterns apparent. To be sure, the body of data collected here is often anecdotally interesting, and it does support the MDLP's claim regarding the complexity of the musical terrain quite well, but ultimately this is the only broader conclusion of any sort that these interviews render possible.

To be fair, this is undoubtedly part of the book's point: that there are no significant patterns to be found in the sea of data gathered by the MDLP, and that the absence of such patterns demonstrates the folly of trying to impose overly-neat meta-narratives on a world where they simply don't apply. For instance, of the approximately 150 interviews conducted for *My Music*, evidently no two of them (besides those done with a few Grateful Dead fans) were sufficiently alike to fall into readily identifiable patterns. As Keil puts it,

> That is the main point of this collection of interviews. Each person is unique. Like your fingerprints, your signature, and your voice, your choices of music and the ways you relate to music are plural and interconnected in a pattern that is all yours, an 'idioculture' or idiosyncratic culture in sound. This may seem obvious or will seem so by the time you have read half of these interviews, but we believe most people think of the musical tastes of others in highly stereotyped ways that

are based on layered prejudices and prejudgments. . . . We hope this book convinces you that our musical lives are much more complicated than that.

(p. 2)

While there *is* a certain seductive appeal to an argument that questions simplistic stereotypes (e.g. 'rap is music for black people, country is music for white people, and never the twain shall meet'), Keil's comments here also point to a pair of larger problems with the book as a whole. First, the fact that no two interviews were sufficiently alike to create (or reveal) affinity-groups of any kind once again raises the question of whose voices are really being heard in these pages: if these were truly 150 heterogenous, diverse, highly idiosyncratic interviews (of which only those conducted with Deadheads were at all interchangeable), then why were *these* forty-one people – and not some other cast of characters – chosen to represent the MDLP's work? By what criteria did the book's compilers decide, for instance, that four-year-old Heather's brief (if amusing) discussion of 'Dude Looks Like a Lady' (p. 7) was worthy of inclusion while some other interview wasn't? While it is certainly possible that a version of *My Music* that reproduced excerpts from a completely different subset of the larger body of interviews would have demonstrated the validity of the MDLP's larger argument in much the same way, the fact that no two of these interviews were similar enough to be exchanged for one another (coupled with the lack of an explanation as to how those that were chosen were chosen) leaves a few too many unanswered questions concerning the authors' standards regarding what they considered to be valuable findings. More specifically, if the 110 or so interviews not included in the book were really that different from those that were, then it would be helpful to know why the editors thought that the voices they *did* include produced a 'better' (or 'more accurate', or 'more entertaining', or whatever the relevant standard here actually was) mosaic than some other set of voices would have.

Second (and perhaps more perplexing), if Keil is right to say that it would only take half of the interviews in this book to demonstrate the book's primary thesis (and this is a claim that I would agree with entirely), then why are all 210 pages of the book's main text still given over to interviews? Why, for instance, didn't the MDLP trim the number of interviews included in the final volume back to twenty and use the remaining space for critical essays on the study's broader implications? Having demonstrated (just as convincingly, but in only half as many pages) that 'our musical lives are much more complicated' than most critics and scholars seem to think they are, the MDLP could then have offered some tentative suggestions as to what this conclusion might mean for the future of research into music, culture, and society. How, for instance, might we need to reformulate our current theoretical models of music and culture to account for the complexities that *My Music* uncovers? What changes should ethnomusicologists and popular music scholars consider making in their research methods in light of the MDLP's findings? Is there any evidence here to suggest that we need to rethink our approaches to studying other cultural phenomena as well? And so on.[7]

In the end, then, both *Subcultural Sounds* and *My Music* attempt to convince us that everything we know about music and culture (or at least an awful lot of what we know) is wrong. And, in their very different ways, each of these volumes makes a persuasive case to support such a conclusion. The most telling difference between the books, however, is in the way that they deal with the obvious follow-up question to that claim: so what do we do next? Slobin can't answer this question in any definitive way (which will probably frustrate some readers, even if it shouldn't), but, to his great credit, he doesn't pretend to do so. More importantly, what he *does* do

is offer enough in the way of 'suggestions for future research' to make it clear that he is pointing out the flaws in our current ways of thinking about music and culture because he is very much interested in correcting those flaws. The MDLP, on the other hand, seems perfectly content simply to point out that those flaws exist; the question of what (if anything) might be done about those flaws, however, doesn't seem to have crossed their minds at all.

Notes

1 It is possible that Slobin would object to the notion that his project is focused on building theoretical models, as he insists that, 'above all, *I do not mean to present a model, nor will I come up with one-sentence definitions of terms*' (p. 12, emphasis in original). I take Slobin's objections here, however, to mean that he isn't trying to construct *static* or *rigidly prescriptive* models from which future critics dare not stray, and not that the various abstract categories and concepts he lays out cannot – or should not – be seen as models (albeit deliberately loose ones) of recurring patterns on the (micro)musical terrain.

2 See, for example, his claims that 'societies (nation-state bounded regions) have an overarching, dominating – if not domineering – mainstream that is *internalized* in the consciousness of governments, industry, subcultures, and individuals as ideology. Let us call it hegemony' (p. 27); that 'ideology reflects hegemony' (p. 28); and that 'hegemony begins at home, with the penetration of ideology as a part of every citizen's inner life' (p. 75).

3 See, in particular, his use of the concept of codeswitching (borrowed from sociolinguistics) in order to explain the meaning of particular micromusical texts (pp. 85–97). To be sure, this is a creative and interesting approach to the question of how performers and composers engage in stylistic bricolage in the creation of subcultural musics, but Slobin's argument here effectively reduces the social and cultural meaning of music to a question of authorial intention, insofar as he ignores the role that audiences inevitably play in the production of that meaning.

4 If nothing else, those local musics that consciously set themselves up in opposition to the mainstream inevitably (and ironically) depend on its continued presence and good health in order to be able to define themselves as oppositional.

5 My use of the term 'minor' here is taken from Deleuze and Guattari's notion of *minor literature*: 'A minor literature doesn't come from a minor language; it is rather that which a minority constructs within a major language' (1975/86: 16). Unlike the subcultural micromusics that Slobin describes, a minor cultural formation (whether centered around literature or some other phenomenon) does not necessarily revolve around a local community, but its relationship to the hegemonic mainstream may be similar enough to that of micromusics to render Slobin's categories of use in describing and analyzing such formations.

6 'In the United States and in all advanced industrialized countries, ... musical practices do not "start" when we pick up an instrument or when we pay attention to what is happening in any given song. *We enter a world of music already in progress around us*. ... We encounter music everywhere – at the schools and at symphony halls, in the churches and the taverns, on the radio and the television. Our musical practices ... function as nodes in a larger network, as complicated and diverse ways for people to reaffirm old identities and to forge new ones' (pp. xx–xi, emphasis added).

7 To be fair, Lipsitz's foreword does raise questions of this sort in an engaging and insightful way, but expecting a ten-page introductory essay of this sort to serve

as the only extended critical commentary on the ramifications of the study is to place an unfair burden on Lipsitz's shoulders.

References

Deleuze, Gilles and Guattari, Félix. (1975/86) *Kafka: Toward a Minor Literature*, translated by Dana Polan. Minneapolis: University of Minnesota Press.

Grossberg, Lawrence. (1988) 'Wandering audiences, nomadic critics', *Cultural Studies* 2: 377–91.

Catachresis is her middle name: the cautionary claims of Gayatri C. Spivak

Amitava Kumar

■ Spivak, Gayatri Chakravorty, *Outside in the Teaching Machine* (New York and London: Routledge, 1993), 350 pp. ISBN 0-415-90489-7 £12.99 Pbk

'*Akloo kursi par kyon nahin baitha?*' (Why didn't Akloo sit on the chair?) This question came at the end of an anecdote narrated by the veteran Indian Marxist historian, Ram Sharan Sharma. In 1937, Sharma told me, he and some of his friends, while they were students at Patna College, decided that they would no longer subscribe to oppressive principles of hierarchy and would henceforth consider Akloo, their low-caste hostel attendant, their equal. They agreed that Akloo would now be asked to sit on a chair in their company.

Akloo was asked, but he refused. So, his enthusiastic well-wishers held him and forcibly seated him. Akloo left the chair the moment he was released and never appeared again.

Sharma's largely rhetorical query, posed at the end of his tale, was designed to make the point that social power is maintained both through economic and ideological control. In some ways, Gayatri Spivak's writing in the past decade has been enormously influential in inserting the wedge of another answer to that question, a response committed to the teasing out of complicities between those who occupy different positions on the social map, divided and joined by lines of oppression and the urge to freedom.

This deconstructive gesture has often been flatly interpreted by lit. crit. practitioners in the American academy as nothing more than a mournful declaration of despair. (In fact, 'can the — speak?' finds its hollow echo in the fluorescent stillness of conference-rooms, in all those attempts to discover yet again the silencing of the subaltern, though I'm happy to report its use at a recent Duke University conference where the presenters, with a delicious sense of irony, asked the audience to consider the question 'can the suburban speak?') In a more energetic and complex sense, the collection of essays in *Outside in the Teaching Machine* suggest that academic-cultural work is a modest but serious, political enterprise. And that the scepticism of Spivak's readings isn't to be complacently adopted (or, for that matter, dismissed) as a signature of 'failure' understood in only one way; rather, it is to be read as a reminder that 'whenever they bring out the Ayatollah, remember the face that does not come on the screen, remember Shahbano. . . . When the very well-known face is brought-out, remember the face that you have not seen, the face that has disappeared from view, remember Shahbano. Woman in difference, outside in the machine' (241).

This raises another question: In remembering Shahbano, do I need to remember Spivak?

Perhaps, yes. These essays, in particular the readings of Rushdie's novel *The Satanic Verses* and films like *Genesis* and *Sammy and Rosie Get Laid*, re-cite the formula for what Spivak terms 'a new politics of reading': 'not to excuse, not to accuse, establish critical intimacy, use (or ab-use) the seeming weak moments for scrupulous ends' (251). What gives this formula its charge is the recognition of what Spivak calls, in the opening interview with Ellen Rooney, 'the full share of ... ambivalence toward the culture of imperialism' (10). This is not only a case of one of 'midnight's children' warily eyeing freedom's morning and announcing in the manner of Faiz Ahmed Faiz: 'This stained brightness, this morning marked by night/This is not the dawn we had waited for.' If Spivak's ambivalence is more than another name for the dilemmas of the postcolonial negotiating the limits of nationalism, it can perhaps best be described as the productive unease of the migrant intellectual in the Western academy who occupies a space she 'cannot not want to inhabit and yet must criticize' (64). There is no disavowal of the institutional positioning of the subject here, even while there is an incessant fretting, or even fighting, at its limits. The postcolonial question in this context is a very specific one: how will one *teach* 'Shahbano' in the classroom? In remembering Shahbano, one struggles with Spivak because *Outside in the Teaching Machine* is, in a very certain sense, a response to that pedagogical question.

As 'the post-colonial critic', as 'a highly commodified distinguished professor', as Rushdie's 'tall, thin Bengali woman with cropped hair' ('Society was orchestrated by what she called grand narratives,' Rushdie writes of that character he names Swatilekha in *The Satanic Verses*), as the *one* who can be reduced to a token for all diasporic folk, for all Indians in the US, for all Indians, period, all Third World women, or for all high-profile, tenured faculty with an investment in multiculturalism or the feminist battles – Spivak knows very well that she is trading in identities. That is why she often repeats in this book that, inside the academy, 'names like "Asian" or "African" (or indeed "American" or "British") have histories that are not anchored in identities but rather secure them' (53). The goat of cultural criticism is quite clearly tethered to the pole of non-identitarian work. Here, Spivak knowingly treads on shaky ground: the founding basis for her work is the instability of language itself, its fundamentally catachrestical nature. The question, of course, is 'Why is this lesson about proximate naming a very useful thing to teach your students?'

The *OED* defines catachresis thus: 'Improper use of words, application of a term to a thing which it does not properly denote, abuse or perversion of trope or metaphor.' In Spivak's writing, the idea of catachresis as a metaphor without an adequate literal referent becomes a model for all metaphors, all names. In the heavier air of the post-colonies, that is to say in that air heavier with history, the concept of catachresis allows Spivak to script the appeals to 'Western' ideas in a challenging and novel way. The calls for proper 'citizenship' or 'nationhood' are seen in those theaters as catachrestical claims to concept-metaphors for which no (pre)existing adequate referent may be advanced from the postcolonial spaces. What gives this point greater force is that the graphic of mis-naming allows Spivak to gesture towards the female subaltern in the post-colony who occupies an unnameable space, a position outside the easily recuperable spaces of both benevolence and resistance.

In her last chapter on the question of cultural studies, when Spivak racily concludes 'The proof of the pudding is in the classroom' (274), one returns to her

opening interview where she offers a way of providing productive critique to students who, forgetting the female subaltern in the post-colony, might claim marginality for themselves:

> [I]t seems to me that one can make a strategy of taking away from [students] the authority of their marginality, the centrality of their marginality, through the strategy of careful teaching, so that they come to prove that that authority will not take them very far because the world is a large place.

> (p. 18)

Beyond the dodging of attributions of marginality, Spivak's interest in catachreses seems also tied to a critical practice that can always gesture at an *elsewhere* – so much so that even history enters 'as catachresis, rather than as the real nitty-gritty about materiality' (1990: 157). This 'elsewhere' could be the 'outside' of Spivak's title, but, at another level, it also provides an alibi for the persistence of 'failure', the failure of readings, of texts, and of the possibility of attaining the 'purity' of beginnings or ends. Spivak should interest us, finally, as a reader of failed texts.

Inhabiting a general postcolonial paradigm, like C.L.R. James who recognized that it was impossible to abstract his own history or the history of his peoples from the deep entanglement with the culture of the colonizer, Spivak produces in this book readings that are motivated, in her case, by the Derridean insistence that something can serve as both medicine and poison. While the stricter guardians of leftist cultural politics might fault such an approach for its eclecticism, Spivak's point might well be that eclecticism, redefined as the irreducible impurity of culture and its influences, is inescapable. In her engagement with Mahasweta Devi's fiction, Spivak negotiates 'failure' in a more immediately visible, political context. It is not so much as the limit where the text reveals its radical heterogeneity but the site where the narrative of postcolonial liberation reaches a crisis. Spivak writes of the displacement of the subaltern, gendered body on to, quite literally, the national map in Devi's story 'Douloti the Bountiful'; even in her recording of the less-than-ordered postcolonial space, the division of interests is not in the least obscured:

> Where everything works by the ruthless and visible calculus of super-exploitation by caste-class domination, the logic of democracy is thoroughly counter-intuitive, its rituals absurd. Yet here too, the line between those who run and those who give chase is kept intact.

> (p. 87)

Yet, it is precisely in Spivak's reading of Devi where, perhaps most impressively, the encoding of a woman's body by 'usurer's capital, imbricated, level by level, in national industrial and transnational global capital' is demonstrated; it is there too that I'd argue we should address the limits of that text. In other words, let's ask the same question which interests Spivak: what are the conditions that make *Outside in the Teaching Machine* fail?

When Spivak points out that in Devi's 'Breast-Giver' it is cancer rather than clitoral orgasm that is the excess of the woman's body, she illuminates the limits of the more universalizing brands of Western feminism (90). The indifference of capital to such scrupulous distinctions is pathetically in evidence in the continued state of affairs reported by Spivak several years ago: 'whereas Lehman Brothers, thanks to computers, "earned about $2 million for . . . 15 minutes of work", . . . a woman in Sri Lanka has to work 2,287 minutes to buy a t-shirt' (1987: 171). Rather than denounce the role of theory, my point here is to foreground the variety of ways

in which such important work remains on the outside. In this book, Spivak presents us with good reasons for taking seriously the slow task of teaching the humanities. At the same time, the example of Mahasweta Devi that Spivak uses so well also serves to provide another challenge to cultural activists and teachers. That is the challenge of an irruption into the public sphere. It is the example of what we might call a contemporary subaltern historiography, serving at once as journalism and theory, sociological analysis and art, a manifesto and appeal.

References

Rushdie, Salman (1988) *The Satanic Verses*, New York: Viking.

Spivak, Gayatri Chakravorty (1987) 'Scattered speculations on the question of value', in her *In Other Worlds: Essays in Cultural Politics*, New York: Methuen.

—— (1990) 'The new historicism: political commitment and the postmodern critic', interview with Harold Veeser in Spivak's *The Post-Colonial Critic*, Ed. Sarah Harasym. New York and London: Routledge.

—— (1993) *Outside in the Teaching Machine*, New York and London: Routledge.

Film theory into the nineties: beyond Marxist modernism and populist postmodernism?
Richard L. Kaplan

■ Judith Mayne, *Cinema and Spectatorship* (New York: Routledge, 1993) 187pp. ISBN 0-415-03416-7 $17.95 Pbk, ISBN 0-415-03415-9 $49.95 Hbk.

Early American cinema developed in tandem with a crisis of social control. Turn of the century intellectuals, fraught with worries over the ever-growing 'dangerous classes', asked how could American institutions pacify the threatening mass of alien immigrants, feebleminded criminals, and anarchistic workers? At the same time and in response to these perceived dangers, America's political and social élite adopted a multitude of new measures for control and containment, such as: immigration quotas, the institutionalization and sterilization of the feebleminded, Americaniz-ation campaigns to teach the newcomers proper American habits, deportation of 'Bolshevik' aliens, and reformatory schools for sexually promiscuous young women. The cinema, too, was one more arena for the acting out of these fears and trepidations. Social reformers variously condemned movies for promoting the vices of undisciplined masses, especially sexual misbehavior and desire. Or, alternatively, movies were viewed as a novel, efficacious tool for indoctrinating and Americaniz-ing the mass viewer. Jane Addams, for instance, believed that film could 'make over the minds of our urban population', and she appreciated that the 'good in it is too splendid ... to allow the little evil to control and destroy it.[1] In this context, the first sociological studies of the movies arose and were intimately connected with queries over the power of film and its capacity to support social control.[2]

Fifty years later, practitioners of film theory again took up these fears and the desire for social control via the cinema, but from the opposite viewpoint. Radicalized by the movements of the 1960s, they saw the cinema as a prime cul-tural institution of indoctrination of the ruling-class's ideology. With its concern over power, 1970s film analysis moved from the realm of purely formal or aesthetic considerations to an investigation of the social implications of cinema. This

theoretical turn is the starting point of Judith Mayne's informative survey and critique of the development of film theory from 1970 to 1990. The first half of *Cinema and Spectatorship* largely describes the fascinating theoretical innovations of these writers as they repeatedly probe the issues of power and ideology in a mass cultural institution. The second half is a series of case studies meant to test Mayne's theoretical conclusions.

In the early 1970s, film studies were invigorated by a heady theoretical mix of Freudian psychoanalysis, structuralist Marxism and semiotic literary theory. This perspective, which Mayne labels 'apparatus theory', was variously invoked, criticized, and elaborated upon in the ensuing twenty years. Over these two decades, as Mayne observes, film analysis in particular and cultural theory in general moved from assigning all power to the cultural text, with the audience a mere passive recipient, to giving all power to the audience, while the cultural text became flexible and open to the diverse interpretations of the viewer. Elsewhere Michael Schudson (1987) has summarized this movement as 'the validation of popular sensibility', which involved not only a re-evaluation of the active role of the audience in the accomplishment of any reception or interpretation, but also a change in the very notion of the cultural product. In French literary theory, this transformation in cultural theory resulted in a shift from a structuralist semiotics to poststructuralism. In the United States, says Mayne, under the impact of the Birmingham School and postmodernism, the tendency towards re-evaluation took its most extreme, populist form.

Mayne considers such a straightforward reversal of the earlier apparatus theory a mistake. Instead, her goal is to arbitrate between these two opposed theories, not simply to dispense with past theories, nor to forget the most recent insights. She claims her desire is not to resolve the contradictions in any 'Pollyanna dialectic', taking a bit from here and there of what is best in both. Rather, she works to take apart the dichotomies that seem to plague the two opposed positions.

Mayne offers an incisive and convincing account, which I will shortly detail, but two problems injure the usefulness of her book. First, she provides an inadequate explication of apparatus theory. Mayne devotes two chapters to such an elaboration but does the job poorly. Admittedly this theory has been discussed in countless other volumes, but it is the central starting point of her book and needs to be explained. Secondly, when she expresses her own innovative analysis she has an overly pedantic style. Some parts are explained in excessive detail, while others are presented without the necessary background information and, thus, will remain remarkably obscure, at least for the beginning student in film theory. This combination of pedanticism and innovation will doubtless make her book exciting and irritating for both experts and novices in cinema studies.

Following Eugene Lunn's formulation (1982), we may say that original 1970s 'apparatus theory' rested on a 'Marxist Modernism'. The aesthetics of modernism was melded to the politics of Marxism. Apparatus theory claimed that classical Hollywood cinema successfully promoted an illusion of realistic representation. The passive viewer was caught up in this proclaimed realism and was absorbed in the workings of the plot. The audience was oblivious to the set of cinematic mechanisms that produced the highly stylized and ideological world of the Hollywood film. Apparatus theory dissected these mechanisms as the workings of a regressive Freudian fantasy. In the darkened room of the theater, the spectator participated in various Oedipal scenarios. These Oedipal fantasies assured the male viewer of his power and his necessary superiority over women, as long as he accepted the norms and values of a bourgeois society. Thus film was seen as capably

indoctrinating the viewer into the values of a hierarchical and sexist, industrial civilization.

Against this great ideological machine of Hollywood, the 1970s film theorists pitted avant-garde films. Such experimental films offered none of the easy pleasures gained from absorption in the secure, melodramatic fantasies of Hollywood. They, in fact, attempted to disrupt the passive viewing of the audience by rejecting the illusion of realism. The film did not pretend to be a transparent window on to reality. Instead, it consisted of complex and ambiguously signified images which the viewer must help decode. Only avant-garde film, which resisted cinematic illusions, could initiate the spectator into critical reflections on the socially produced nature of capitalist roles and gender relations.

Mayne astutely notes various problems with this apparatus theory. The theory created a sharp split between the critic and society. Films were considered part of a seamless web of society's bourgeois ideology to which the critic opposed his or her scientific truth. Furthermore, every Hollywood movie embodied this ideology without contradiction. The individual viewer was passive before the ideological workings of the film; he or she lacked all resistance and agency. In the end, it became very difficult to see how the criticisms of the theorist would ever be able to pry the individual out of this entrancing web of ideology.

'Reception' film theorists of the 1980s effectively rejected this portrait of Hollywood as an all-encompassing, ideological machine enforcing conformity. But for Mayne these 'postmodern' theorists simply reversed the position of apparatus theory without overcoming its simplifications and dualisms. Postmodernists shifted the emphasis from the cultural object to the receiving audience. Now the cultural text was seen as inherently open and requiring the activity of the audience to complete its message – an audience who might elaborate different interpretations of the movie's essential meaning depending upon their socio-economic background. Mayne observes that such writers gave all power to the audience, yet they analyzed the audience's interpretations as activities of resistance and contestation. Having dismissed apparatus theory, they cannot explain the power of the text against which the audience is resisting. In addition, reception theorists, and here Mayne is referring to the ethnographies of the Birmingham School, still adopt the dualistic categories of apparatus theory.[3] The movie is considered a mere extension of a larger cultural domination while the audience's interpretive resistance is necessarily liberating.

In the development of her critique, Mayne subtly complicates this analysis. Such theorists, she argues, are still entranced by the romantic image of a contesting agent, uncontaminated by ideology and power. But, it is too easy to claim that all audience activity is liberating without scrutinizing the ideas and relations being advocated by the subordinate group. Furthermore, the supposedly unified dominant ideology is better characterized as multiple, fragmented and contradictory discourses. Consequently, there is no simple oppressive dominant ideology from which one could rebel. Finally, Mayne provocatively queries whether cultural positions can be so easily labeled as progressive or reactionary in abstraction from the way those ideas are used and applied by social groups, that is: in abstraction from real politics.

Mayne demonstrates that the history of film theory over the last two decades presents a series of important interrogations of the ideology and domination in the mass culture industries. In her discussion of these theories, Mayne renders problematic any easy answers to the questions of power in popular culture. *Cinema and Spectatorship* complicates and, at the same time, opens up the future research agenda.

In the second half of her book, Mayne presents a series of case studies meant to build upon her theoretical reflections. However, since she has abandoned apparatus theory's overarching indictment of Hollywood for more 'specific local studies', her own work lacks the excitement of such totalizing conclusions about the operation of power and ideology today. The chapters take up in turn the major issues of spectatorship: textual analysis, intertextuality, reception, and subcultures as critical audiences. In general, the chapters constitute a series of thoughtful explorations, but they never resolve the question of the relation between textual power and the audience's resistance to any one set of imposed meanings.

Chapters 5, 6, and 7 present a series of close readings of cinematic texts and the various commercial discourses which form a permanent penumbra to Hollywood's stars. Against apparatus theory, Mayne argues that the gendered spectator positions constructed in films are more multifarious than the simple dichotomy of active male viewer and passive female spectacle. Furthermore, she draws explicitly on post-structuralist theory to assert that cinematic texts are necessarily contradictory and open to varied interpretations. However, films also attempt to police their own meanings, deter illicit readings, and establish closure. Thus, despite her criticism of apparatus theory, Mayne reaffirms a determinacy and, hence, power to the film text.

Chapter 6 is an intertextual analysis of the variegated commercial discourses involved in the production of Bette Davis as a star. Attention to a range of texts typically functions to undermine the idea of a single hegemonic code imposed upon the viewer. Here Mayne paradoxically points to a unitary narrative that seems to transverse the diverse representations surrounding Bette Davis. From her multiple starring roles to fan magazine gossip to autobiographical accounts, Bette Davis often assumes the image of a more active female. But, while both apparatus theory and its critics might valorize such an image of female self-determination, Mayne suggests they need to reflect upon the content and goals of such activity. In the case of Davis, her assertive autonomy often takes the form of rivalry and competition with other women.

Chapter 7, labeled an investigation of 'white spectatorship', scrutinizes the way race still operates as a powerful signifier in Hollywood's fantasies for an audience that is implicitly white. In her fascinating discussion, Mayne suggests that Blacks function, in part, as signs of an inclusive redemptive community and, in part, as liminal figures, marking boundaries and transitions. Since the nineteenth century, African-Americans have been depicted in commercial popular culture as the sign of the primitive, still in tune with their raw instincts (see Rogin, 1992). As carriers of this surcharge of primitive energy, they are often invoked in such films as *Ghosts* and *Field of Dreams* to reinvigorate a rationalized white civilization that has lost its expressive and imaginative powers. Feminist film theory has long recognized that the assumed viewer for Hollywood's movies is male. Now Mayne points out that not only is the viewer gendered, but he is also implicitly white. Chapter 7 along with the earlier two chapters is a subtle and convincing reading, but, as a reception study, the chapter is notably weak. It is unclear how the audience's active interpretations will contest or inflect the ones that Mayne has traced out as academic analyst.

The book's concluding essay, 'The Critical Audience', discusses the reception of Hollywood movies and stars by gay and lesbian audiences. The chapter is less an extended empirical analysis than a series of critical queries on how to frame the issues. Contemporary reception studies have often downplayed the significance and power of commercial culture. They have demonstrated that a movie is one limited cultural document, incomplete in itself, and requiring contextualization within the audience's

broader interpretive framework. Placed within the audience's everyday cultural life-world, the individual film loses much of its ideological significance. Cinema is no longer the most exemplary and strategic instance of the operations of capitalism's ideological machinery. Mayne participates in this shift of theoretical attention from the film text to its socio-cultural context, that is, to the more general culture of society and its diverse subcultures. For example, on page 166 she remarks: 'From this per-spective . . ., the question is not what characterizes the gay/lesbian spectatorship as common responses to film texts, but rather what place film spectatorship has had in the cultivation of gay/lesbian identity.' Such a shift of focus opens up film study to the analysis of the construction of meaning by contending groups in society.

In sum, Mayne's case studies are innovative and sophisticated explorations of Hollywood's films and their audiences. The analyses reject any easy drawing of political consequences from the complicated mix of power and representation in the cinema and society. And, they are certain to enhance the reflexive questioning of any critic studying the movie industry, as she makes problematic any simple di-vision between ideology and resistance, control and freedom. Mayne forthrightly acknowledges that her own research ventures represent not a new theoretical syn-thesis of the interconnections between power and mass cultural industries in con-temporary America. Instead, they mark the initial, tentative steps of exploration after the breakdown of a paradigm.

Notes

1 Addams (1909) as quoted in May (1980: 53 and, in general, see chs. 2–3).
2 See, for example, Blumer and Hauser (1933).
3 Mayne in particular refers to Angela McRobbie (94–8), Richard Dyer (126–7) and Stuart Hall (92–3).

References

Addams, Jane (1909) *The Spirit of Youth and City Streets*, New York: Macmillan Company.

Blumer, Herbert and Hauser, Philip (1933) *Movies, Delinquency and Crime*, New York: Macmillan Company.

Lunn, Eugene (1982) *Marxism and Modernism: An Historical Study of Lukacs, Brecht, Benjamin and Adorno*, Berkeley: University of California Press.

May, Lary (1980) *Screening Out the Past: The Birth of Mass Culture and the Motion Picture Industry*, New York: Oxford University Press.

Rogin, Michael (1992) 'Making America home: racial masquerade and ethnic assimilation in the transition to talking pictures', *Journal of American History* 79(3): 1050–71.

Schudson, Michael (1987) 'The new validation of popular culture: sense and senti-mentality in academia', *Critical Studies in Mass Communication* 4(1): 51–68.

Virtual geography

Mark Gibson

■ McKenzie Wark, *Virtual Geography – Living with Global Media Events* (Bloomington and Indianapolis: Indiana University Press, 1994) 252 pp. ISBN 025320894-7 $14.95 Pbk

> We live every day in a familiar terrain: the place where we sleep, the place where we work, the place where we hang out when not working or sleeping . . .
> We live every day also in another terrain, equally familiar: the terrain created by television, the telephone, the telecommunications networks crisscrossing the globe . . .

McKenzie Wark's project in *Virtual Geography* appears in this preface to the book as one of deceptive simplicity. It is to explore the second terrain outlined – what Wark calls 'third nature' – and the form of experience characteristic of it, that of 'telesthesia' or perception at a distance. The approach, too, seems straightforward enough. Wark develops his exploration through a series of case studies, four 'weird global media events': the Gulf War, the fall of the Berlin Wall, the Tiananmen Square 'democracy' movement and the stock market crash of October 1987. He cites as his inspiration what for cultural studies could hardly be more classical sources: the work of Stuart Hall and colleagues at Birmingham and, more distantly, Marx, Gramsci and Benjamin. The book is very recognizably cultural studies in so far as it sustains an overtly political interest in the media and consistently thematizes the relations between cultural forms and power.

Yet in many ways *Virtual Geography* is an unusual work, even for a 'field' as wild and diverse as cultural studies. Most strikingly, perhaps, it is a book about the *failures* of power rather than its successes, its moments of impotence rather than mastery. Wark is interested in those instances within the vector field of the media when 'information bites back' against the hand that feeds it (23), those instances when it becomes difficult to present events as the outcomes of actions either of those on the side of 'domination' or 'resistance' (34). He locates points where the mechanisms and strategies devised by power begin to work against themselves – where the means of instantaneous transmission of information devised by military and corporate interests obliterate the time required to develop effective narratives of legitimation, where Cold War strategies of 'othering' lose their physical and imaginative base of support, where 'unicorporate' rulers stand helplessly exposed to chaotic chains of events outside their control, or where the speed and sophistication of the international financial system produces an ornery dynamic of its own.

From a certain perspective, the pursuit of this theme might seem a recipe for complacency. If we are treated to the spectacle of power rendered helpless, confounded not by resistance but by its own accretions, what is there left for politically motivated criticism to achieve? Why does Wark not give us more sense of the hard edges and brutal knocks of power – the points at which it transparently *succeeds*? The treatment of Tiananmen is illustrative: he appears more interested in a televised dance between advancing tanks and an unarmed protester than he is in the later *un*televised stage of the event when the same military hardware actually *connected* with soft human tissue. The latter is mentioned almost offhandly as an epilogue to the mediated spectacle which Wark narrates. To this concern one might add another about theoretical *rigour*. While few could accuse Wark of being under-read, there is a certain looseness and eclecticism in the way he weaves other voices into his text.

Marx, Foucault, Said, Douglas Kellner, Noam Chomsky, Herbert Schiller, Paul Virilio, Jean Baudrillard – all have something to say but seem oblivious to the scholarly ink that has been spilt in articulating their relations and differences. The book is remarkable for the absence of apparent theoretical contradictions or systematization of argument.

Wark has, in fact, become something of a node around which some chronic anxieties about the possible direction of cultural studies tend to crystallize. In Australia at least, he is a ubiquitous figure, appearing everywhere from esoteric journals to a regular column in the Murdoch daily, *The Australian*. (Much of the book has been worked up in earlier forms in these forums and the general themes will be familiar to those who have read his essays elsewhere.) He is unapologetic about his crossovers into journalism and generally disrespectful of the boundaries between academia and the media. There is also a distinctly urban cultural identity and TV generation knowingness frequently written into his texts. Early in *Virtual Geography* we are told, for example, of his flat in inner city Ultimo, the TV playing continuously in the bedroom, the toxic coffee and vodka which are used as writing aids. The persona is clearly one which some find irritating, or perhaps worse, a nightmare symptom of cultural studies' loss of seriousness, its drift from grounding references either to sober theoretical argumentation or to the harder realities of power.

But to charge *Virtual Geography* too easily with trivialization would be to fail to read it against its claims. Indeed one might ask whether certain criticisms of Wark say more about the seriousness of the reading than of the texts being criticized. For the claim is neither to theoretical systematization nor to a revelation of suffering and oppression which have not previously been unearthed. It is rather to a style of writing and an assemblage of concepts which is up to engaging with the novelty, and above all the *temporality*, of highly mediated cultural terrains. Wark is a believer in the postmodern, but not in the sense of the concept which has been so elegantly demolished by John Frow (1991). Certainly, it implies that 'everything has changed', but not in ways we can easily predict or reduce to neat tables of oppositions. The shifts we must recognize are in many cases unexpected: the ease with which electronic vectors traverse space in some cases means *increasing* not decreasing centralization; the globalization of finance has required a *greater* not a lesser role for the national state in 'administering its referents'.

At its best, Wark's is a genuinely aporetic voice, assuming little but working in a principled way with imperfect materials at hand. We must, he argues, 'face up to the fact that [the postmodern] challenges all the procedures, assumptions and categories of the modern, including those of scholarship, writing and publishing. Is there still a place in this brave, bloody new world for a kind of critical writing? If so what kind and where? How can one practice it? I must confess, I really don't know?' (xiv) It is in the acceptance that there may really *not be* a ready answer that the seriousness of the book lies.

A similar point might be made about the question of political commitment. In one of the few directly argumentative passages of the book, Wark enters into a debate with Greil Marcus over an earlier essay on Tiananmen Square. Marcus is disturbed by the way Wark treats the event as if it were 'just a movie' (145) and urges a return to the lived experience of those who were actually in Beijing. For Wark, it is not so much that the latter project would be misguided as that it is not the one which he set out to undertake. But the injunction against an exploration of the televisual experience of the event betrays an inability to accept this as *another reality*. To be sure, the students and residents on the street experienced the event in all too physical and material ways. But for millions of others who were hooked into

and implicated in the event, the experience was on another, more mediated terrain. The politics of this terrain may be more nebulous and indirect, but it is no less significant in its effects. The exchange is one which touches centrally on the question of cultural studies' real faith in its own founding claims about the specificity and effectivity of cultural mediation.

Wark's response to other cultural studies approaches is in general a 'yes, but also . . .'. At one point, he sets side by side the various influential approaches to thinking critically about power – Marx's analysis of relations of production, Foucault's of techniques of discipline and surveillance, de Certeau's of the tactics of everyday life, Virilio's of the power of the vector. The aim is neither to select one above the others, nor to reconcile them in a cultural studies version of unified field theory. It is rather to relativize them in relation to the contexts or terrains in which they are effective, so that they become a flexible resource. In thinking about the architectural space of Beijing, Foucault has an obvious relevance. But in taking account of the way in which space is transformed by the presence of international television crews, he cannot provide the whole story and Virilio has rather more to say. The result of such an approach is a quite radical theoretical pluralism. While *Virtual Geography* is about deterritorialization, it also *enacts* a deterritorialization of cultural studies. Instead of appearing as a single field to which one might lay claim, it becomes an intersection of numerous tracks each heading off in different directions.

The one cultural studies tradition for which Wark clearly has limited sympathy is the semiotic 'reading' of texts: 'Theory isn't the customs department, unpacking every bag to inspect its contents for immoral smugglings. Theory is the baggage department, loading images onto and off their vectoral flights' (159). In a world where texts and images proliferate, and are routinely dislocated from their 'original' contexts, it is futile to believe that the correct reading could get to the bottom of any one, to determine its 'true' political valence. It is better, Wark argues, to work with the freedoms this situation allows, experimenting with what can be *made* of cultural material, rather than attempting to judge what it *is*. This is why it makes sense *not* to rush to condemn the cynicism and brutality of the Gulf War allies or Deng Xiaoping. It is also why it makes sense to examine their weaknesses as much as their strengths – it is these which reveal openings for alternative realities. The politics is one which measures its success more by its possible effects than by the strength of its oppositional claims. It is allied more closely to creative media production than to established canons of 'critical theory'.

If I have a reservation or anxiety about *Virtual Geography*, it is over the hint of assurance with which Wark proclaims the 'emergent'. An example is his criticisms of the work of Tony Bennett, Stuart Cunningham and Ian Hunter, which he sees as dealing only with 'dominant' or 'residual' cultural forms – literature, museums, schools and national broadcast TV. It is not so much the specific criticisms of Bennett, Cunningham and Hunter which are the problem – I think they are good ones – as the possible *direction* the argument might run: a re-establishment of precisely the kind of territorializing hierarchies of value which Wark rejects elsewhere. At another point, Wark compares his writing with 'marginal and radical art' – and a suspicion begins to form. Is the radical, urbanite, mediaphile critic of CNN to claim a place at the top of a heap overlooking the dusty academic-of-the-archive at the bottom?

Such a conclusion is more a possible tendency than a real problem in the text. One gets a sense, reading Wark, of a fragile state of temporary and groundless equilibrium – rather like that of the stock markets which he analyses in the book. Perhaps this captures the present state of cultural studies – hedged with anxieties,

not quite sure if it should return to ground. If so, however, we should be careful to remember that the temporal ordering of 'emergent' over 'dominant' or 'residual' offers no more certainties than anything else. As Joshua Meyrowitz argues, the emergence of any new medium cannot be considered in isolation, for it transforms the entire 'media matrix' into which it is inserted (1985: 19). Dominant and residual cultural forms are not, therefore, quite what they were before and their difference from the emergent is never straightforward. Museums now have touch-screen interactives; Shakespeare resides on CD-ROM. It would do less than justice to *Virtual Geography* if the game were to become one of ranking the analysis of 'weird global media events' above or below the analysis of more obviously 'traditional' cultural forms. Why not find the points at which it can productively *articulate* with work on schools, museums – perhaps even literature?

References

Frow, John (1991) *What Was Postmodernism?*, Sydney: Local Consumption Publications.

Meyrowitz, Joshua (1985) *No Sense of Place*, New York/Oxford: Oxford University Press.

Other journals in the field of cultural studies

COLLEGE LITERATURE

Special Focus Issue: (De)Colonizing Reading (Dis)Covering the Other
Forum: The Life of the Mind

Contents: Editor's Note. **Essays:** *Thomas E. Recchio* A Monstrous Reading of *Mary Barton*: Fiction as 'Communitas'; *Juliana M. Spahr* Postmodernism, Readers, and Theresa Hak Kyung Cha's *Dictee*; *Rachel N. Baum* 'What I have learned to feel': The pedagogical Emotions of Holocaust Education; *Christopher Wise* The Garden Trampled: or, The Liquidation of African Culture in V.S. Naipauld's *A Bend in the River*; *Ning Yu* A Strategy Against Marginalization: The 'High' and 'Low' Cultures in Kingston's *China Men*; *Bisman Basu* The Black Voice and the Language of the Text: Toni Morrison's *Sula*.

Notes: *Ameila Simpson* Black on Blonde: The Africanist Presence in Dorothy Parker's 'Big Blonde'; *Michele Mock* Spitting out the Seed: Ownership of Mother, Child, Breasts, Milk, and Voice in Toni Morrison's *Beloved*

Forum: The Life of the Mind: *Jeffrey Williams* The Life of the Mind and the Academic Situation; *James Phelan* The Life of the Mind, Politics, and Critical Argument: A Reply to Jeffrey Williams

Review Essays: *Patrick Colm Hogan* Colonialism and the problem of Identity in Irish Literature. Review of G.J. Watson, *Irish Identity and the Literary Revival: Synge, Yeats, Joyce and O'Casey* and Anthony Roche, *Contemporary Irish Drama: From Beckett to Mcguinness*; *Lisa Jadwin* Critiquing the New Canon. Review of Timothy Morris, *Becoming Canonical in American Poetry*, Charlotte Templin, *Feminism and the Politics of Literary Reputation: The Example of Erica Jong* and David Palumbo-Liu, ed., *The Ethnic Canon: Histories, Institutions, and Interventions*; *Patrick Colm Hogan* Ireland, Colonialism, and the Fancy of Difference: A Tale. Review of Terry Eagleton, *Heathcliff and the Great Hunger: Studies in Irish Culture*

Book Reviews

Paulo de Medeiros Review of Charles Bernheimer, ed., *Comparative Literature in the Age of Multiculturalism*; *Glen A. Steinberg* Review of Linda Cable; *Carnal Rhetoric: Milton's Iconoclasm and the Poetics of Desire*; *Nancy Lusignan Schultz* Review of Mason I. Lowance, Jr., Ellen E. Westbrook, and R.C. De Prospo, eds., *The Stowe Debate: Rhetorical Strategies in Uncle Tom's Cabin*; *Cynthia Lowenthal* Review of Terry Castle, *The Female Thermometer: Eighteenth-Century Culture and the Intervention of the Uncanny*; *Maureen T. Reddy* Review of Marty Roth, *Foul and Fair Play: Reading Genre in Classic Detective Fiction*; *Peter Okun* Review Nancy Bentley, *The Ethnography of Manners: Hawthorne, James, Wharton*; *Celia Esplugas* Review of Marta E. Savigliano, *Tango and the Political Economy of Passion*.

Notes on contributors

KATYA GIBEL AZOULAY is Assistant Professor of Anthropology and Chair of the Afro-American Studies Concentration at Grinnell College. Her forthcoming book, *Black, Jewish and Interracial: It's Not the Color of Your Skin but the Race of Your Kin and Other Myths of Identity*, is to be published in autumn 1997 . . . JOHN CASTLES recently graduated from the University of Technology, Sydney, with a doctoral thesis on stardom . . . DIPESH CHAKRABARTY is a historian and has recently moved from the Ashworth Centre at the University of Melbourne to the University of Chicago . . . JOHN NGUYET ERNI teaches Media and Cultural Studies in the Department of Communication, University of New Hampshire. He is the recipient of the 1996–7 Gustafson Fellowship from the Center for the Humanities at UNH for his work on a forthcoming book about AIDS in Asia, sexual politics and the global velctors of orientalism. He is the author of *Unstable Frontiers: Technomedicine and the Cultural Politics of 'Curing' AIDS* (University of Minnesota Press, 1994) . . . ANDREW GOODWIN is Associate Professor of Communication at the University of San Francisco and author of *Dancing in the Distraction Factory: Music Television and Popular Culture* (1992) . . . STEPHEN HARTNETT is Assistant Professor at Ball State University and also teaches in the Department of English at Loyola University in Chicago . . . RICHARD L. KAPLAN is Visiting Researcher in the Department of Sociology at the University of California, Santa Barbara. He recently completed his dissertation on transformations in the public sphere and American journalism, 1865–1920 . . . ADAM KATZ recently completed his dissertation 'Postmodernism and the politics of culture' at Syracuse University and currently teaches at Onondaga Community College. His work addresses cultural studies, postmodern critical theory, Marxism, and discourses on the Holocaust . . . P. G. KNIGHT is a British Academy Postdoctoral Research Fellow in the Department of American and Canadian Studies at the University of Nottingham, UK, working on conspiracy culture in postwar America . . . AMITAVA KUMAR teaches in the English Department at the University of Florida. He is a columnist for the Indian journals *Samkaleen Janmat* and *Liberation*. He also works as a documentary photographer for Impact Visuals. Most recently his work has appeared in *Critical Quarterly*, *Modern Fiction Studies* and *College Literature* . . . KATHLEEN McHUGH teaches Film and Critical and Cultural Theory in the Comparative Literature Program at the University of California, Riverside. She is the author of *Swept Away: The Uses and Abuses of Domesticity* (forthcoming) and has published articles on domesticity, documentary and feminist experimental film and video in journals such as *Screen*, *JumpCut* and *Semiotica* . . . CAROL MAVOR is an Associate Professor of Art at the University of North Carolina, Chapel Hill and serves as adjunct professor for Communication Studies. Her publications include *Pleasures Taken: Performances of Sexuality and Loss* (1995), 'Becoming' (*Genre*, Autumn 1996), and forthcoming articles on the Victorian photographer

Clementina Hawarden. She is currently completing a book on Hawarden, which emphasizes a queer focus on maternal and adolescence eroticism . . . PATRICK D. MURPHY is Assistant Professor in the Department of Mass Communication at Southern Illinois University at Edwardsville. His current research includes the ethnographic study of audiences in rural Mexico and analysis of the political economy of Mexican television conglomerate Televisa . . . GILBERT B. RODMAN is Assistant Professor of Communication at the University of South Florida. He is the author of *Elvis After Elvis: The Posthumous Career of a Living Legend* (Routledge, 1996), and the manager of the CULTSTUD-L listserv. His research and teaching interests include cultural studies, media criticism and the study of popular culture . . . GILLIAN ROSE teaches Social, Cultural and Feminist Geographies at the University of Edinburgh. Her research interests focus on the politics of the production of geographical knowledges. She is the author of *Feminism and Geography* (1993).

THE MYTH OF POLITICAL CORRECTNESS

The Conservative Attack on Higher Education
John K. Wilson
"A meticulous, eye-opening rebuttal of the claims that leftist philistines have taken over US higher education. Point by point, Wilson shows that conservative bosses and traditional scholars still call the tune on campus. A vital corrective to the anti-PC frenzy of the mainstream press."—*New Statesman*
240pp, £13.95 pb

RACE AND THE EDUCATION OF DESIRE

Foucault's *History of Sexuality* and the Colonial Order of Things
Ann Laura Stoler
"Ann Stoler has given us an ingenious and compelling reading of the apparent absence of race and colonialism in Foucault's account of modern power . . . Written with verve, erudition, and a sense of engagement."—Partha Chatterjee, Centre for Studies in Social Sciences 248pp, £14.95 pb

THE RULING PASSION

British Colonial Allegory and the Paradox of Homosexual Desire
Christopher Lane
"Lane's work displays a quite astonishing intellect. *The Ruling Passion* is expertly researched . . . and advances our understanding of the complexities involved in representing cross-cultural and cross-class homosocial and homosexual desire. . . a work of considerable academic stature."
—Joseph Bristow, University of York
344pp, £15.95 pb

AIDS TV

Identity, Community, and Alternative Video
Alexandra Juhasz
With a Videography by Catherine Saalfield
"Juhasz's perspective as an academic, activist, and videomaker produces an analysis that combines broad social analysis and a culturally informed feminist politics with the work of producing AIDS video."—Paula Treichler, coeditor of *Cultural Studies*
352pp, 22 b&w illus., £16.95 pb

SHAME AND ITS SISTERS

A Silvan Tomkins Reader
Eve Kosofsky Sedgwick and Adam Frank, editors
"*Shame and Its Sisters* will have a major impact on the study of culture in the coming years and on several fronts. It is a significant contribution to the current rethinking of emotion and affect that promises to explore the limits of Freudian and dialetical models of the self."
—W.J.T. Mitchell, Editor, *Critical Inquiry*
312pp, 3 illus., £14.95 pb

EARLY POSTMODERNISM

Foundational Essays
Paul A. Bové, editor
In the decade that followed 1972, the journal *boundary* 2 consistently published many of the most distinguished and must influential statements of an emerging literary postmodernism. Paul Bové the current editor of *boundary* 2 has gathered many of those foundational essays and, as such, has assembled a basic text in the history of postmodernism.
336pp, £16.95 pb

TECHNOLOGIES OF THE GENDERED BODY

Reading Cyborg Women
Anne Balsamo
"Balsamo takes us further into cyborg territory than any intelligent book has done. Her surveys provide a surefoot guide to the survival of both women's health and feminist politics in many of those new and unfamiliar areas of hi-tech experience that have already, almost unconsciously become part of our daily lives."—Andrew Ross
272pp, 29 b&w photos, £16.95 pb

SKIN SHOWS

Gothic Horror and the Technology of Monsters
Judith Halberstam
"*Skin Shows* is the Gothic book that many of us have been waiting for, and it is every bit as smart as we had hoped it would be. Halberstam's notion of monstrosity will change Gothic studies for good. The results are dazzling."
—George E. Haggerty, University of California
240pp, 6 b&w photos, £14.95 pb

CHANGING SEX

Transsexualism, Technology, and the Idea of Gender
Bernice L. Hausman
"Changing Sex makes a landmark contribution to gender studies and the understanding of transsexualism. It is thorough and accessible in its combination of medical analysis, social criticism, and application of critical theory. It is original, provocative, and will be controversial in the best sense."
—Julia Epstein, Haverford College
320pp, 17 b&w photos, £16.95 pb

THE BODY IN LATE-CAPITALIST USA

Donald M. Lowe
"Lowe has produced an impressive argument about the transformation of the body in recent society. He presents in lucid prose a complex argument for a revised Marxism in conjunction with various poststructuralist positions as the basis for a new analysis of contemporary capitalism." —Mark Poster
224pp, £14.95 pb

ANIMALS AND WOMEN

Feminist Theoretical Explorations
Carol J. Adams and Josephine Donovan, editors
Offering a feminist perspective on the status of animals, this unique volume argues persuasively that both the social construction and oppressions of women are inextricably connected to the ways in which we comprehend and abuse other species. 360pp, £15.95 pb

BAD OBJECTS

Essays Popular and Unpopular
Naomi Schor
"This is an impressive volume of elegant essays that will confirm Schor's reputation as one of feminism's finest scholars, and one of the most expansive and precise minds in French studies."
—Judith Butler 232pp, £14.95 pb

TROUBLED BODIES

Critical Perspectives on Postmodernism, Medical Ethics, and the Body
Paul A. Komesaroff, editor
"*Troubled Bodies* presents an excellent introduction to the philosophical and cultural settings of a postmodern medical ethics."—Mark Seltzer, Cornell University
296pp, £15.95 pb

DUKE UNIVERSITY PRESS, AUPG, 1 Gower Street, London WC1E 6HA (0171) 580 3994

Rethinking History
The Journal of Theory and Practice

Editor: Alun Munslow
Staffordshire University, UK

- What is the nature of historical evidence and what function does it perform in the reconstruction or deconstruction of the past?

- Can empiricism constitute history as a separate mode of knowledge creation?

Rethinking History explores how historians today are challenging accepted ways of "doing" history - rethinking the traditional paradigms. The journal addresses aspects of historical theory and empirical history that attempt to deploy a variety of contemporary approaches including the postmodernist.

Issued three times a year, historians will read *Rethinking History* for evidence of theory in practice. The journal will have broad accessibility and contain a balance of features including a "Notes & Comments" section and a regular "Invitation to Historians" feature in which historians will be asked to explain how and why they write history. Through its regular Editorials *Rethinking History* will aim to generate, stimulate and sustain an enthusiasm for the study of the past in all its representations.

Scholarly and lively *Rethinking History* will appeal to all historians irrespective of period, place or field of personal interest.

Publication Details:
Volume 1 is published in 1997, 3 issues per volume. ISSN: 1364-2529

1997 Subscription Rates
US Institution:	US$120	US Individual:	US$48
EU Institution:	£90	EU Individual:	£35
RoW Institution:	£90	RoW Individual:	£35

Call For Papers: for further information please call Alun Munslow Tel:+44 (0) 1782 294 532
Fax: +44 (0) 1782 294 363 Email: artam@staffs.ac.uk

Code:RHRJ97

To Subscribe or to request a FREE Sample Copy please contact:
UK/Row: Nicki Stow, Routledge Subscriptions, ITPS Ltd, Cheriton House, North Way, Andover, Hampshire SP10 5BE, UK.
Tel: +44 (0) 1264 342 755 Fax: +44 (0) 1264 343 005 Email: info.journals@routledge.com
EC: Sarah Goddard, Routledge Subscrtiptions, ITPS Ltd, Cheriton House, North Way, Andover, Hampshire SP10 5BE, UK.
Tel: +44 (0)1264 342 741 Fax: +44 (0) 1264 343 005 Email: info.journals@routledge.com
USA/Canada: Routledge Journals Department, 29 West 35th Street, New York, NY 10001-2299
Tel: (212) 244 3336 Fax: (212) 564 7854 Email: info.journals@routledge.com

New Titles from Routledge

DUKE UNIVERSITY PRESS

Pop Out
Queer Warhol
Jennifer Doyle, Jonathan Flatley,
and José Esteban Muñoz, editors
Series Q
280pp, 53 illus., £15.95pb

Fatal Advice
How Safe-Sex Education Went
Wrong
Cindy Patton
Series Q
200pp, 10 illus., £14.95pb

The Spectacle of History
Speech, Text, and Memory at the
Iran-contra Hearings
Michael Lynch and David Bogen
Post-Contemporary Interventions
352pp, 8 b&w photos, £17.95pb

Nietzsche's Corps/e
Aesthetics, Politics, Prophecy, or,
the Spectacular Techno-culture
of Everyday Life
Geoff Waite
Post-Contemporary Interventions
432pp, £17.95pb

Displacement, Diaspora, and Geographies of Identity
Smadar Lavie and Ted Swedenburg,
editors
344pp, 6 b&w photos, £15.95pb

Shadows of Empire
Colonial Discourse and
Javanese Tales
Laurie J. Sears
352 pp, 23 b&w photos, £15.95pb

Fantasizing the Feminine in Indonesia
Laurie J. Sears, editor
352pp, 17 b&w photos, £16.95pb

Clothing and Difference
Embodied Identities in Colonial
and Post-Colonial Africa
Hildi Hendrickson, editor
Body, Commodity, Text
304pp, 22 b&w photos, £15.95pb

Phantasmatic Indochina
French Colonial Ideology in
Architecture, Film, and Literature
Panivong Norindr
Asia-Pacific
240pp, £15.95pb

Passing and the Fictions of Identity
Elaine K. Ginsberg, editor
New Americanists
296pp, 6 illus., £15.95pb

Nothing Happens
Chantal Akerman's Hyperrealist
Everyday
Ivone Margulies
280pp, 26 b&w photos, £15.95pb

New Science, New World
Denise Albanese
240pp, 9 illus., £14.95pb

Ireland and Irish Cultural Studies
John Paul Waters, special issue editor
A Special Issue of *SAQ*
302pp, £11.00pb

AUPG, 1 Gower Street, London WC1E 6HA, Tel/Fax: (0171) 580 3994/5

ROUTLEDGE

Derrida and the Political

Richard Beardsworth, The American University of Paris

'**Richard Beardsworth's book is the first authoritative study of the political thrust of Derrida's work.**' - *Rodolphe Gasche, University of Buffalo*

'**Richard Beardsworth brilliantly performs a much needed and difficult task.**' - *Peggy Kamuf, University of Southern California*

Thinking the Political

October 1996: 234x156: 192pp
Hb: 0-415-10966-3: **£37.50**
Pb: 0-415-10967-1: **£12.99**

Nietzsche and the Political

Daniel W. Conway, Pennsylvania State University, USA

'**Develops an account of Nietzsche's thinking of the political which is clear, consistent and thought provoking.**' - *Howard Caygill, Goldsmiths College, London*

Thinking the Political

December 1996: 234x156: 176pp
Hb: 0-415-10068-2: **£37.50**
Pb: 0-415-10069-0: **£11.99**

Postnationalist Ireland
Politics, Culture, Philosophy

Richard Kearney, University College Dublin

'**This is a work of vision, which should be required reading for all those involved currently debating ways forward in Northern Ireland.**' - *Marianne Elliott, University of Liverpool*

November 1996: 216x138: 272pp
Hb: 0-415-11502-7: **£40.00**
Pb: 0-415-11503-5: **£12.99**

The Identity in Question

Edited and with an introduction by John Rajchman, College International de Philosophie, Paris

The Identity in Question provides a theoretical analysis of the recent resurgence of xenophobia and nationalism. The contributors to this collection look behind the familiar words of the discourse to rethink notions of universality and agency and the traditions of liberalism, nationalism and pluralism.

February 1997: 234x156: 272pp
Hb: 0-415-90617-2: **£40.00**
Pb: 0-415-90618-0: **£11.99**

For more information contact **Natalie Brightbard** at Routledge, 11 New Fetter Lane, London EC4P 4EE or **Marie Leahy** at Routledge Inc. 29 West 35th Street, New York, NY 10001-2299 or email **info.philosophy@routledge.com** A full listing of Routledge titles is available on the Internet by accessing: **http://www.routledge.com/routledge.html**